MAGDALENA ABAKANOWICZ

MAGDALENA

ABAKANOWICZ

BARBARA ROSE

HARRY N. ABRAMS, INC., PUBLISHERS

Editor: Eric Himmel
Designer: Maria Miller

1: The Making of the Artist

Perhaps at that time in Paradise while eating the forbidden apple they lost the balance proper to nature—as one loses the sense of smell or eyesight. And perhaps at the same moment they acquired the instinct of destruction of the surrounding world and of themselves.

Was there a mistake in the unfailing logic of nature or an act of will of an unknown power?
Magdalena Abakanowicz, 1992

What could have led us to predict, as we approach the year 2000, that one of the most startlingly innovative artists of our time would be a Polish woman, creating colossal works in public spaces in Europe, America, and Asia? The emergence of Magdalena Abakanowicz as a major force on the international art scene could not have been extrapolated from any of the available data. Beginning in Russia in the first hopeful decade of the twentieth century, artists conceived a new Golden Age. The promise of a steady advance toward an ideal order was expressed by the bright, clean, mechanically drawn abstract forms of the Constructivists. This optimism spread to Holland, Belgium, Germany, France, and ultimately the United States. In the regularity and universality of geometric shapes, artists discovered a formal vocabulary appropriate to a world where man and machine would be in harmony, thanks to the benign forces of industrialization.

Looking back from the closing years of the twentieth century, these idealistic art theories based on a utopian concept of progress seem foolishly naive. Over the course of the century, theoretical projections of the future of art based on past patterns or prescriptions for advancement toward preconceived goals, from "pure opticality" to "conceptual dematerialization," have been consistently contradicted by unfolding events. In the shadow of history itself, faith in the power of ideology has crumbled, and with it beliefs in a-priori theories and intellectually coherent strategies for predicting the future of art have also perished.

Such beliefs have been undermined by the unexpected arrival of highly original artists, whose formative experiences took place outside the mainstream, and who periodically replenish aesthetic values. For example, the English critic John Berger, in *The Success and Failure of Picasso*, postulates that Picasso's radicality depended on his "vertical entrance" on to the stage of world art. Unlike the smooth "horizontal" entrances of creators whose lives and values mesh with dominant cultural modes, the provincial Andalusian artist shot up from below with the force of a volcano erupting. A similar

Magdalena Abakanowicz

reading could be given to the appearance of Jackson Pollock, who grew up on the empty plains of Wyoming, far from the galleries and museums of Paris or New York.

Like Picasso and Pollock, Magdalena Abakanowicz matured in isolated provincial places where myth and folklore were still part of living culture. Her distance from the sophisticated mainstream intensified her vision. Cut off during her formative years from Western Europe and America, she resisted both the academicism and the authoritarian dogma that dominated postwar Eastern European art. Abakanowicz's search for an authentic artistic identity was long, painful, lonely, and even dangerous. Her drive to create universally compelling images out of her own life and experiences has propelled her on journeys to distant places and foreign cultures. Her continuing struggle for authenticity lead her to reject conventional concepts of beauty, order, and harmony and to invent an alternative set of values.

Abakanowicz's story is as tragic and dramatic as any in the history of art. She was born in 1930 in an elegant manor house on the wooded outskirts of Warsaw. Her parents were aristocrats, and she spent a peaceful early childhood on one of her grandfathers' estates that her mother inherited, 124 miles east of the Polish capital.

Magdalena's social class isolated her from other children. She enjoyed the woods, where she was allowed to wander without constraint. Alone, she had time—all the time in the world it seemed in those still and quiet days—to observe nature, opening the way to a private world that was full of pulsating life and unpredictable movement. In a memoir, she has described her curiosity about the cycles and forms of nature, which profoundly influenced her art:

I was a small child, crouching over a swampy pond, watching tadpoles. Enormous, soon to become frogs, they swarmed around the bank. Through the thin membrane covering their distended bellies, the tangle of intestines was clearly visible. Heavy with the process of transformation, sluggish, they provoked one to reach for them. Pulled out onto shore with a stick, touched carelessly, the swollen bellies burst. The contents leaked out in a confusion of knots. Soon they were beset by flies. I sat there, my heart beating fast, shaken by what had happened. The destruction of soft life and the boundless mystery of the content of softness. It was just the same as confronting a broken stem with sap flowing out, provoked by an inexplicable inner process, a force only apparently understood. The never fully explored mystery of the interior, soft and perishable.

As a child, Magdalena scratched drawings into the ground with sticks. Her talent was not appreciated like her elder sister's ability to play the piano. She amused herself by whittling creatures out of wood and twigs with her

Landscape near Abakanowicz's childhood home

penknife or modeling them with the claylike wet earth. The younger of two sisters and a tree-climbing tomboy who later trained to be an Olympic athlete, she suffered from the knowledge that her sex was a disappointment to her mother, who naturally wanted a male child to carry on the distinguished family line. So deeply did she feel the rejection of her gender that one year when her mother asked what she wanted from Santa Claus, she answered that she wanted him to turn her into a boy.

Much of the strength that Abakanowicz needed to survive and to create an unconventional, noncomformist art came from knowing who she was. Her father's family had been killed during the Russian Revolution, and only he and his brother escaped to Poland, their mother's homeland. Konstanty Abakanowicz traced his aristocratic lineage to the dreaded Tartar conqueror Genghis Khan, who swept down into China and Russia from Mongolia. The ancestor who gave his name to Magdalena's family was the fierce Abaka-Khan, or Abaqa, a twelfth-century Ilkhan of Persia. Her mother, Helena Domaszowska, was descended from knights of the ancient Polish gentry. She recalls being shown the parchments of the various kings who, begin-

ning in the fifteenth century, and again in the seventeenth and eighteenth centuries, gave lands and titles to her family in acknowledgment of battlefield valor.

As a child of the aristocracy, Magdalena did not attend primary school. Instead she had different tutors, who made her memorize facts and formulas, tasks alien to her inquiring and curious mind. Thoroughly miserable with this bookish knowledge, she learned by studying nature outside in the fields and woods. She was intrigued by peasant lore that told of forest spirits, both good and evil, and she soon came to feel that nature was animated by mysterious forces. Her family scoffed at these beliefs, but this early contact with the animism of an illiterate but powerfully imaginative peasant culture marked her for life. Perhaps because of such early experiences, she has always been suspicious of the polished veneer of so-called "civilized" society. This skepticism was reinforced by the events she witnessed when her peaceful family life was suddenly shattered by the intrusion of brutality and violence.

She was nine in September 1939 when the German army invaded Poland. She remembers standing with her family on the terrace of her house and watching German tanks rumble toward them down the allée that led from the edge of the park. Guns were fired, but that time no one was hurt. Her father taught her to shoot and to clean and assemble weapons. She was no longer allowed to wander. "The forest became alien," she remembers. "I no longer went there to talk to it as before." Armed groups, among them partisans and ordinary bandits, became aggressive. One night in 1943, a drunk shot her mother before her eyes. She remembers how abruptly the innocence of her childhood ended with the purposeless attack on her beloved mother: "A dumdum bullet tore her right elbow. It severed her arm from the shoulder, wounded her left hand. The capable, wise hand suddenly became a piece of meat, separate."

By the following year the battlefront approached, and the situation had become so dangerous that the family could not remain on the isolated country estate any longer. Magdalena's father ordered the horses harnessed to take them to Warsaw. The loss of her childhood home and the familiar surrounding forest made her feel "hollow. As if my insides had been removed and the exterior, unsupported by anything, shrank, losing its form." The house in which she had spent her childhood, her grandfather's, was destroyed after the agrarian reforms of 1945, and the possessions left behind by the family taken by peasants.

Warsaw in 1944 was hellish. On September 27, 1939, the city had surrendered to the German army, and air raids in the following years had reduced much of the city to rubble. In the spring of 1943 the Nazis had finally succeeded in quelling the unexpected resistance of the remaining Polish Jews herded into the Warsaw ghetto by razing it to the ground. Soviet troops

entered Polish territory in January 1944, creating further chaos wherever the German army retreated. On August 1, 1944, encouraged by the nearby Russian army, partisan forces in Warsaw began a doomed uprising against the German army occupying the city. Enraged by the armed resistance, Hitler ordered that the Polish capital be demolished stone by stone. The *verbrennungskommando* (literally, the "burn squad") systematically dynamited and set fire to everything still standing, while soldiers lashed women and children to their armored tanks to use as human shields. Magdalena was fourteen years old at the time of the Warsaw uprising: "I do not remember the beginning, the firing from all sides, mother and the two of us lying in the street. Later everyone was running, we too. Suddenly I was alone in a crowd of people. Strange faces. I shouted: 'Mama, Terenia!' Impossible to turn back; only forward. Suddenly Terenia was there. She grabbed me: 'Where is Mama?'" The girls found themselves with their father in Milanowek, outside of Warsaw, and it was two months before they were reunited with their mother. Magdalena worked at a school that had been turned into a temporary hospital for the wounded brought from Warsaw, carrying water and stretchers. Every day, more of the wounded arrived. "There were neither analgesics nor disinfectants. Too many damaged people. A crowd." Certain images proved impossible to forget: a boy with his face completely burned and another with both legs severed by shrapnel.

The interminable winter was bitingly cold and damp. On January 17, 1945, the new Communist authorities took over a crushed Warsaw. Historian Norman Davies, in *God's Playground*, described what they found when they arrived: "a city which six years before had housed 1,289,000 inhabitants, did not contain a single living soul; 93 percent of the dwellings were destroyed or damaged beyond repair. Such totality can hardly be matched by the horrors of Leningrad, Hiroshima or Dresden." The Communists persecuted the Polish aristocracy as "class enemies," confiscating their property and possessions and denying them the right to work or to send their children to school. To remain anonymous, Magdalena's family moved to Tczew, a small town near the ship-building center of Gdansk, where they were not known.

At seventeen, Magdalena was still deciding whether she would study architecture or fine art. Chance ordained that she enter the high school of art in Gdynia. After graduation, she continued her studies for a year at the Academy of Fine Arts in Gdansk while she earned money by giving private French lessons. Twenty now, she wanted to make a complete break with the past, to start life over again. As a symbol of her new life, she changed her given name, which had been Marta, to Magdalena. She sold her winter coat and bedding and bought a ticket to the devastated Polish capital, where the remnant of a brilliant intelligentsia was gathering.

While a triumphant and prosperous United States paid to rebuild Western European economies with the Marshall Plan, Poland was left to be

reconstructed in the image of Stalin's Russia. When Magdalena returned to Warsaw in 1950, the city was still digging out of the rubble. Among Polish priorities was the rebuilding of the city as a capital, including the historic old town, which had been completely demolished. It was painstakingly reconstructed on the basis of views depicted by Bernardo Bellotto (1720–1780), the Venetian painter who had worked at what was then the splendid and cosmopolitan Polish court. It was a symbolic gesture to show that neither the Nazi fascists nor the Soviet Communists could eradicate the history of the stubborn and resistant Poles.

In the early 1950s, the most energetic and creative young people in the country were converging on the capital. Knowing that her aristocratic background would prevent her from registering at the university, Magdalena pretended to be the daughter of a clerk so that she could enroll in the Warsaw Academy of Fine Arts. She earned money giving blood, cleaning streets, working on construction (including rebuilding the old town), and coaching sports. Stalinism was alive and dominated the Fine Arts Academy, where Socialist Realism was the official style. Magdalena found the atmosphere stifling; the rigid orthodoxy served only to feed her spirit of revolt and rebellion.

Abakanowicz questioned everything. Working at night in the academy's empty studios, she rejected the traditional scale of easel painting as being too small and inconsequential to communicate what she had to express. She thought of art as something floating and alive, a private world of color and motion that created an environment in which she was free, as the ocean was the nourishing medium of the tropical fish she loves to observe. She needed the freedom of unlimited space—the exact opposite of the cramped quarters she shared with other students who were strangers to her.

She painted huge watercolors and nine-foot-high gouaches on ordinary bed sheets that she stitched together to make a larger surface. Her palette was bright and transparent; her images were organic and biomorphic, reflecting a lifelong interest in natural phenomena. There is no way that she could have known it at the time, but her bannerlike unstretched gouaches and watercolors were technically related to the contemporaneous work of the American color-field painters, although her art was never entirely abstract. Its primordial protozoan imagery found echoes in Barnett Newman's early small-scale watercolors and gouaches, perhaps because Newman too had the ambition to take art back to its origins by rejecting all previous historical styles.

After graduation from the Academy of Fine Arts in 1954, she joined the Artists Union, which gave her the right to exhibit, sell works, and have her own studio. To earn a living she designed silk textiles at a factory close to Warsaw, continuing to do her own work at night. In 1956, two years after her graduation, Magdalena married Jan Kosmowski, a good-looking young

engineer whose upper-class background, when it was discovered, had caused his dismissal from the university. He only graduated in 1960, when de-Stalinization brought about a more liberal climate.

Abakanowicz was among the first Polish artists and art historians to tour Italy and have a rare glimpse of Western Europe after the war. During this eye-opening trip in 1957, sponsored by the Artists Union, she met a circle of Polish artists and intellectuals whose guiding light was the outstanding Constructivist painter Henryk Stazewski (1894–1988). He became a friend as well as an inspiration, not in terms of the geometric style of his art, but because of his uncompromising moral nature and his commitment to experimentation. While sympathetic to his art, Abakanowicz was unable to connect her experience with the utopian idealism of the prewar Polish avant-garde represented by the generation of Stazewski.

The history of Polish Constructivism is still relatively unknown in the West. The founders of the movement, the painter Wladyslaw Strzeminski (1893–1952), his wife, the sculptor Katarzyna Kobro (1898–1951), and Abakanowicz's friend Stazewski, were still alive when World War II ended. From 1945 to 1950, Strzeminski was professor of art history at the Academy of Fine Arts in Łódź, about eighty miles southwest of Warsaw. He taught his theory of vision, which remained consistent with the original principles of Constructivism, especially regarding issues of urbanism and industrial design that the group had addressed in the 1930s. In 1950 he was denounced as a "formalist" and stripped of his teaching position. Kobro's aesthetic theories, with their emphasis on spatial concepts, continued to find adherents in the academic underground, which became a refuge for advanced thinking after the war, although her last known sculpture was made in 1933 and her last text appeared in 1937. During the thaw of 1956 a joint Strzeminski/Kobro retrospective was held at the Muzeum Sztuki in Łódź, along with discussions concerning the original impetus behind Polish Constructivism. Thus there was a link, tenuous as it may have been, between the prewar and postwar avant-garde in Poland, which would have been inconceivable in the Soviet Union.

It was in this atmosphere that Abakanowicz was introduced to Henryk Stazewski. The most interesting people in Poland—artists and politicians, actors and poets, as well as many young people—gathered in the Stazewski's one-room apartment in Warsaw. Abakanowicz came and listened, fascinated by the extraordinary exchange of ideas. An anarchist by nature, she found an established movement like Constructivism a prison with rigid barriers. While not wishing to be associated with any movement or school, she was stimulated by the discussions.

Her own art, Abakanowicz decided, had to represent a total break with the past, as radical as the rupture between postwar Poland and its earlier history. She had to start from scratch, to build its very surface with her own

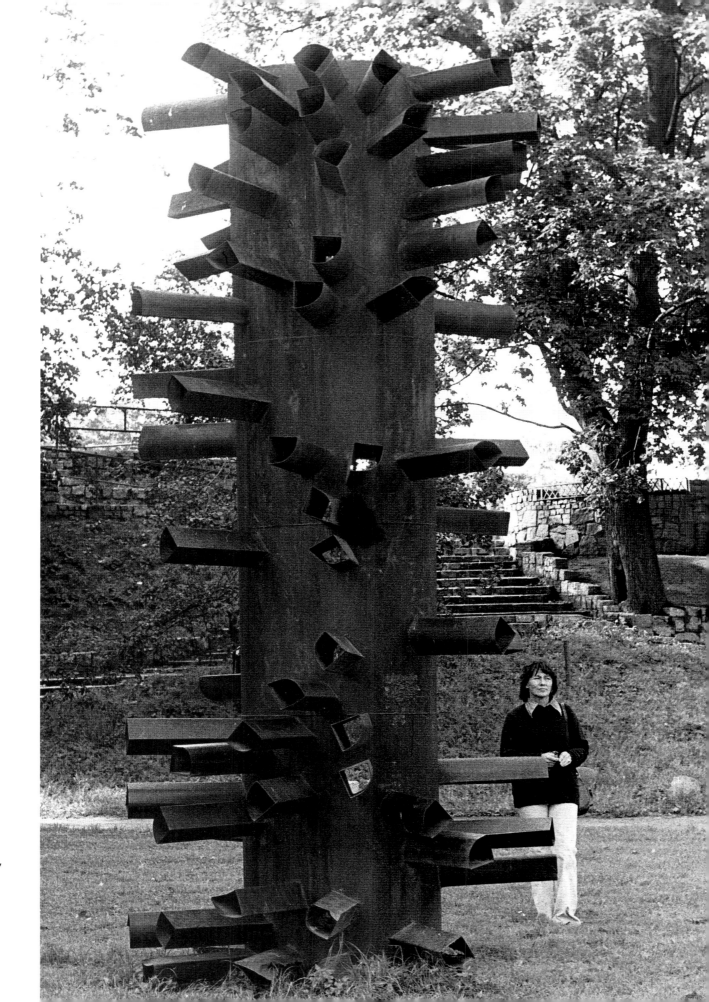

Steel sculpture in
the town of Elblag,
Poland. 1965

hands as she had helped to rebuild Warsaw brick by brick. She felt she must not only invent new forms but create the material support itself from which those forms were made. She would take art back to the time before humanity depended on machines to create necessities, alienating itself from biological and natural processes.

Abakanowicz's work did not, however, develop in a cultural vacuum. After the death of Stalin in 1953, Poland exploded with creative ideas. It was a time of intellectual upheaval, stimulated in an extraordinary way by the sudden freedom from Stalinist oppression: there was the avant-garde theater of Tadusz Kantor, Jerzy Grotowski, and Jozef Szajna; the Polish film school of Andrzej Wajda, Roman Polanski, and Krzysztof Zanussi; a flowering of graphics and avant-garde poster art; and the music of Witold Lutoslawski and Krzysztof Penderecki. When it became clear that the death of Stalin did not mean the end of Communism and censorship, many Polish artists and intellectuals fled to the West. Abakanowicz felt that whatever the consequences, she had to stay, identifying the fate of her art with that of her nation.

It was difficult to make nonconformist art in Poland, but not as impossible as it was in other Communist bloc countries. The Polish regime, although neither encouraging nor really supportive, did not forbid artists to work in unofficial styles. In the Soviet Union, the Constructivists who invented abstraction were later banned and persecuted, so that the break between the Russian revolutionary avant-garde and the Socialist Realists was total. This was not the case in Poland, where the Muzeum Sztuki, the first museum of abstract art in the world, was founded in Łódź in 1931. This museum continued to function even under Communism, albeit with great difficulty, and outstanding Constructivist and other avant-garde artists still worked and exhibited.

In 1958, in this context of Constructivist experimentation, Abakanowicz made two small maquettes for abstract sculptures. When she was invited, in 1965, to create a public sculpture for the first Biennial of Three-Dimensional Forms sponsored by the marine engine industry in the town of Elblag, near Gdansk, she recalled these abstract studies. The once prosperous town had been nearly obliterated by bombing, and the artists participating in the biennial worked with architects planning its reconstruction. Every site was carefully chosen as was the size of the sculpture and its style. The artists contributed their skill and effort: this kind of summer workshop, sponsored by different industries and towns, was common at the time.

In Elblag, Abakanowicz made friends with some of the workers from the factory, who helped her construct her sculpture. The result was a twenty-foot-tall oval tube, welded out of steel sheets, from which smaller tubes sprout. The main tube is open so that one can see inside. The motif of the cylindrical trunk with its inner cavity exposed, so central to Abakanowicz's

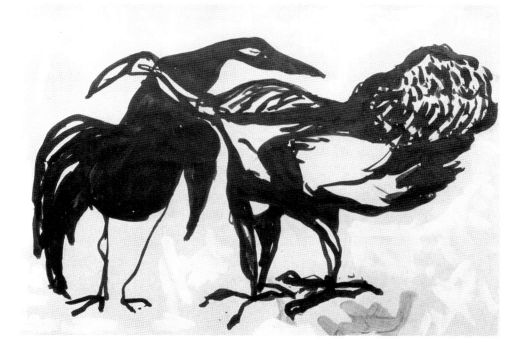

thought, would return in her work, but not until she had invented an entirely new vocabulary of expression, utilizing soft, irregular materials, textured surfaces, penetrable interiors, and vulnerable forms, all obviously created by her own hands.

Abakanowicz's participation in the Elblag biennial in 1965 was something of an exception for her. In the 1950s, she had thrown herself with youthful enthusiasm into urban planning projects—collaborations with sociologists, psychologists, architects, and other artists. In 1957, however, she was confronted with the reality of life in the Soviet Union while traveling in Russia and Georgia with her husband Jan. This depressing experience choked her youthful idealism. Gradually she became disillusioned with theoretical solutions and communal efforts. More and more, she looked within herself rather than to the external world for inspiration.

During the late 1950s, Abakanowicz continued to paint large-scale bannerlike watercolors and gouaches on sheets as well as on paper and on unstretched canvas. In 1960, she organized a show of these works in the

**This page:
From the cycle
Birds. 1957**

**Opposite:
Fish. 1956–57**

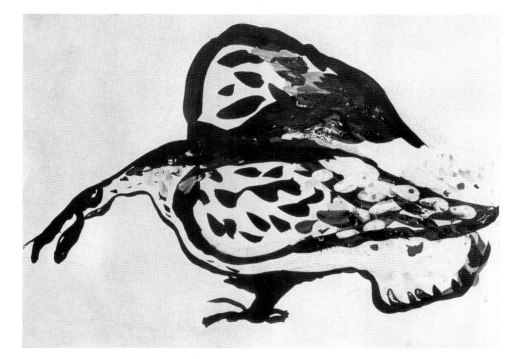

Kordegarda Gallery in Warsaw. Galleries at that time were, as a rule, uncommercial and owned by the state or the Artists Union. After reviewing the exhibition and finding the art revealed "formalist" tendencies, officials refused to permit it to open to the public. Abakanowicz was left standing with her friends outside the locked door of the gallery. The repression of free thought and nonconformism had begun again after the period of thaw, and Abakanowicz understood that at any given moment her art could be considered subversive.

Through an open window, the veteran sculptor and weaver Maria Laszkiewicz, who once had studied with Antoine Bourdelle in Paris, saw the young artist's censored works. These included a few small woven pieces done on a primitive frame. Laszkiewicz added Abakanowicz's name to the list of artists whose work should be shown to the international jury of the first Biennale Internationale de la Tapisserie, to be held in Lausanne, Switzerland in 1962. Founded by the famous French tapestry designer Jean Lurçat, the Lausanne biennial was intended to restore to weaving the prestige it had once known as an important branch of the decorative arts. Abakanowicz's inclusion in such an exhibition would be somewhat ironic. For an artist working behind the Iron Curtain, it would provide an important avenue for exposure to an international audience. On the other hand, tapestry design had no place in Abakanowicz's training as a fine artist. Enough of the original Bauhaus curriculum had survived in the training of Polish artists, however, so that she knew the basics of producing weavings as a means to experiment with surface and texture. She was young, and the idea of entering the biennial was a challenge. But there were practical problems to solve. The biennial accepted tapestries no less than twelve meters square—almost 130 square feet and the size of the entire space where Magdalena and Jan lived.

Maria Laszkiewicz, recognizing the talent of her budding discovery, proposed that Abakanowicz use the largest loom in her own workshop, a crowded basement space officially known by the grand name of the "Atelier Experimental de l'Union des Artistes Polonais." Magdalena often had to stand in line to use the big loom: "The place was dark and damp and without heat. I worked obsessively. Having no practice, I did not know really how to work. . . . Maria Laszkiewicz would bring me coffee. She was old, with a terribly wrinkled face, quick in her movements, energetic, strict. She considered work to be the most important thing, and self-discipline the most significant quality. She had contempt for comfort and all that is easy."

Abakanowicz started weaving old clotheslines into her pieces, working up rough-textured, coruscated surfaces. The transparent colors of her gouaches were transmuted into matte neutral hues of threads and fibers. Her characteristic biomorphic shapes also evolved into simpler abstract forms. Of the work created during this period, *Composition of White Forms* was selected to be shown at the Lausanne biennial in 1962. Its quality and

originality were immediately recognized, and Abakanowicz was offered grants by both the French and Polish Ministries of Culture, as well as her own exhibition in Paris at the Galerie Doutzenberg. She traveled around France visiting artists, among them Pierre Soulage, Mario Prassinos, and Victor Vasarely, as well as various workshops where tapestries had been made since the days of the ancien régime. She questioned and criticized strongly the concept of weaving as an applied art executed by artisans from cartoons prepared by fine artists. Against this tradition, she proposed the ideal of the artist as weaver creating his or her own works from the imagination, like the sculptor or the painter. Her ideas had a broad impact, and not only in France.

For the following seven years, Magdalena worked in the crowded Warsaw basement workshop of Laszkiewicz, who generously helped her to get materials. There she also employed her first assistant, Stefania Zgudka, who has continued to work with her throughout the years as her art dramatically changed. As Abakanowicz became an increasingly authoritative artist with an original vision and an unmistakable personal style, her reputation began to grow.

In 1965, Abakanowicz won the Gold Medal at the Bienal de São Paulo in Brazil. The repressive political situation at home did not permit her to travel, and she had neither money nor energy to struggle against it. Because she had made the works she showed at São Paulo in protest against conventions and accepted disciplines in the art world, she was not elated when she was rewarded for her protest. Her resounding success abroad provoked her to question all that she had made and to revolt against her own achievements. She renounced color, turning toward black and dark brown, and she began to build reliefs out of pieces of woven material, using metal frames for support. In 1966, she pulled her woven compositions away from the wall, so that they hung freely in space: "I did not want them to allude either to tapestries or to sculptures. I had striven to overcome the utility function of weaving, and, especially, to create an opportunity for the viewer to come into contact with the fleshy flexible structures on all sides. I wanted to allow him/her to penetrate, through the splits and openings, the innermost recesses, the inside of the composition. I am interested in the scale of tensions between the shapes of rich fleshy materials and the surroundings."

The result was three-dimensional forms that looked radically different from any other art. Appropriating and mutating weaving techniques to accommodate them to a new form, Abakanowicz arrived at a uniquely personal means of sculptural expression. Without her own studio and with a limited choice of materials at her disposal, she had to force materials and techniques to assume the form of her vision. In this case, a vision anticipated and caused the development of technical inventions.

II : SEARCH FOR A NEW BEGINNING

Whenever I succeed in discarding my former experience I feel that I have made progress.

There are too many fascinating problems to concentrate on one and no more. Repetition is contrary to the workings of the mind, to its forward movement; it is contrary to the imagination.

Magdalena Abakanowicz, 1969

Abakanowicz's individualistic temperament and volatile personality would undoubtedly have made her a rebel no matter what the circumstances of her birth and education. An eyewitness to the darkest chapters in European history, perhaps she could not avoid concluding that the growth of civilization was not necessarily a story of progress. To grow as an artist, she had to find a new beginning for her art. Naturally curious and adventurous, she was blessed by an immense physical energy and a body that she trained to be strong to compensate for a childhood brutally interrupted by the sufferings and horror of war.

Beginning in the late 1960s, when her works were being shown both in tapestry exhibitions and in international avant-garde shows featuring new materials and processes, Abakanowicz transformed the traditionally "feminine" activity of weaving into a means to produce monumental art. The fact that in Poland women designed and created tapestries was rather exceptional. During World War II, a generation of men was lost, and women took over many different kinds of masculine jobs. It was sometimes hard to deal with job and homework together, but it also gave women satisfaction and social status. As a result most Polish women were reluctant to limit their activity exclusively to housework and children.

Utilizing craft to create techniques for producing sculpture enabled Abakanowicz to challenge existing hierarchies of art. The level of her ambition became clear as her work evolved on an increasingly "heroic" scale, requiring considerable physical strength for its execution and installation. Abakanowicz's later manifestation of savage aggression toward materials, such as hacking and chopping as methods of carving sculpture, further defied traditional definitions of masculine and feminine forms of expression.

Throughout her career, Abakanowicz has utilized both soft and hard surfaces, in pursuit of analogies to the animal, plant, and mineral forms of nature. Even the "soft" human body can be approached as a "hard," or bony, structure. Abakanowicz was drawn to fiber as a medium largely on account of these associations: "The fiber which I use in my works, derives from plants

Black Garment.
1969

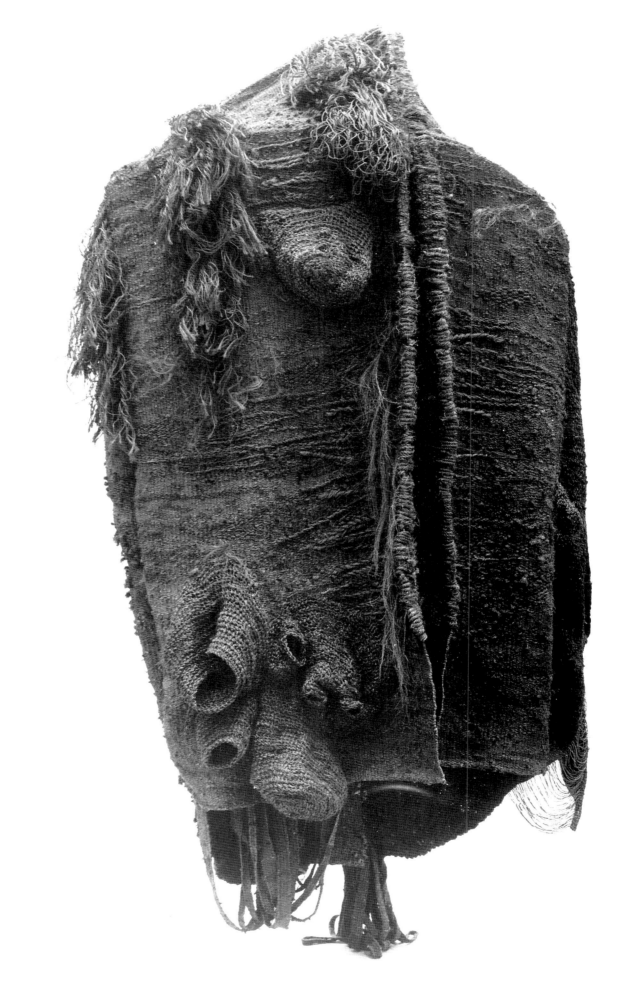

and is similar to that from which we ourselves are composed. . . . Our heart is surrounded by the coronary plexus, the most vital of threads. . . . Handling fiber we handle mystery. A dry leaf has a network reminiscent of a mummy. . . . When the biology of our body breaks down, the skin has to be cut so as to give access to the inside. Later it has to be sewn on like fabric. Fabric is our covering and our attire. Made with our hands it is a record of our thoughts." By the mid-1960s, she had begun to work exclusively in sisal: it was stiff and suitable for building three-dimensional forms that kept their

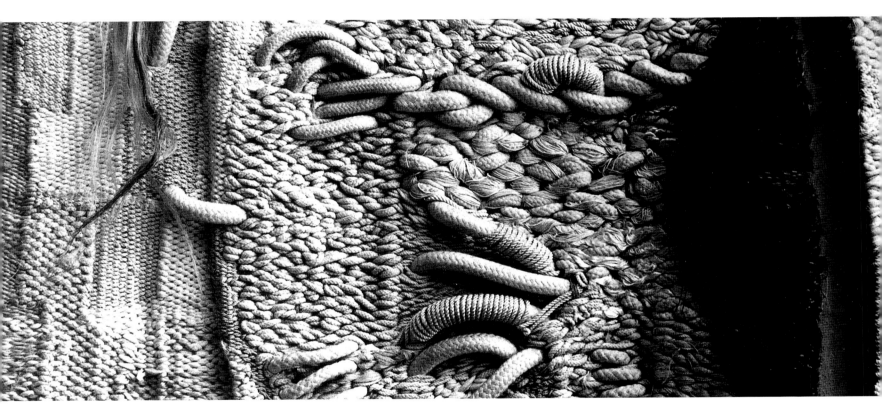

White (detail).
1966

shapes well without collapsing. Eventually, she incorporated string, hemp, flax, wool, and horsehair into her weavings, as well as very thick rope intertwined with sisal fiber. As she was unable to purchase raw materials, she bought old ropes in the harbor and, together with Stefa, patiently unwound, washed, and dyed them.

Magdalena and her husband, Jan, lived in a one-room apartment when she started to create her fiber works, not for lack of funds, but because in socialist Poland, flats were allocated by the state depending on the number of family members that would occupy them. Each person was limited to about ninety-six square feet. The strict application of these rules changed with time. Two years after winning the grand prize at the São Paulo biennial

in 1965, Abakanowicz had the opportunity to move into a studio of 215 square feet, with nine foot ceilings and three small separate rooms. At last she had a room—her studio for the next twenty-one years—of her own. There she began her series of weavings called *Abakans*. A Polish critic first used this word in 1965 to refer to the works that she was showing at Zacheta, the main exhibition hall in Warsaw, and it was then applied to the pieces at São Paolo. These strange three-dimensional woven forms could be folded and stacked. When fully opened, they became immense free-standing shapes that could be hung in groups to create an all-encompassing indoor environment. At first Abakanowicz worked on one at a time, but after some years it became clear that she was spawning an entire tribe of these dark, looming presences. Seen together they looked like a manmade forest of forms, whose rough barklike surface and verticality gave them characteristics of both man and nature.

Stretched flat, they could be circles or rectangles, but once suspended by wires and cables to swing freely in space, they no longer had any discernible familiar shape. Neither abstract nor representational, they were hybrids with tactile qualities and colors that invoked painting, but which were resolutely sculptural. They evoked phenomenological concerns: different kinds of information deduced from the perception of shape from different points of view by the eye and the hand had to be reconciled by the mind. Furthermore, they did not reveal themselves in a single instant like the gestalt structures of Minimal Art often fabricated by industrial processes, but demanded time to be perceived on account of the richness of their thick, irregular, and unusual surfaces. Indeed, it was obvious that their creation actually involved the making not only of their forms but also of their very matter. Once the viewer approached them, it became clear that exterior bulk did not mean solidity. Their interiors, revealed through openings and apertures in the fabric, could suggest, in a very generalized sense, wounds or orifices or the crevices of natural formations. Neither full nor solid, the *Abakans* were definitively hollow. Their elaborate textured surfaces made the viewer want to touch them, to explore their interiors, and some may be entered into. At once inviting and repellent, they clearly incarnated paradoxical and mutually contradictory characteristics that would become typical of Abakanowicz's unwillingness to permit literal representation to close off potential associations.

From 1967 to 1970, Abakanowicz devoted herself to creating her own "tribe" of *Abakans*, a family made by her own hands that could keep her company in her isolation and defend her from an uncertain political fate, as well as from the antagonism and incomprehension of others.

In 1970, the provincial Dutch government of North Brabant commissioned from Abakanowicz a large weaving for its headquarters in the town of s'Hertogenbosch (appropriately the birthplace of Hieronymus Bosch).

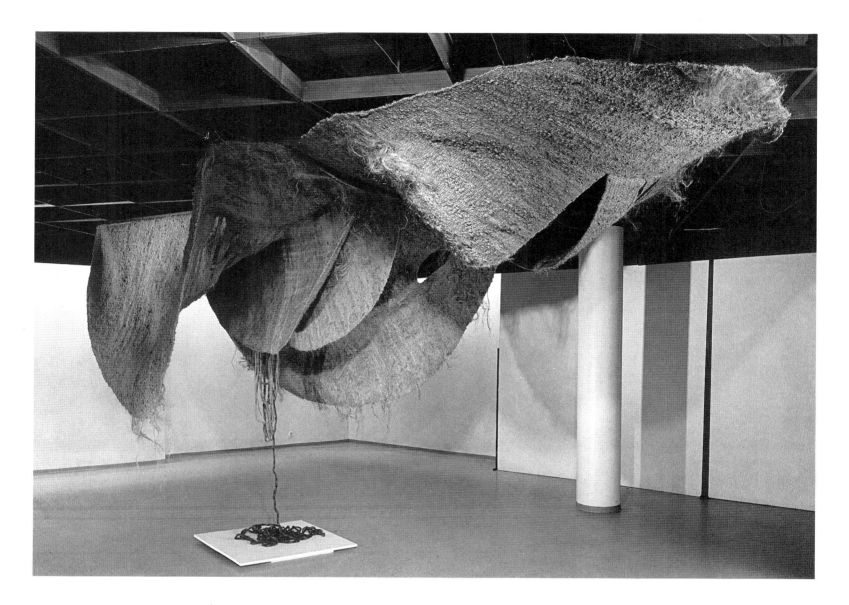

Producing the entire work on site with her two assistants, Stefa and Krystyna, and Dutch helpers over a six-month period in 1970–71, Abakanowicz created a floor-to-ceiling woven environment covering almost 720 square feet that was the culmination of the *Abakans*. The artist and her team worked on an enormous scaffolding erected in a paint factory in Utrecht, where tar dripped on them when it became hot. It is her largest single work, an enormous grouping of huge black/brown vertical elements, rectangular and oval in shape, that opens so that the spectator may walk into it. Like all of Abakanowicz's works, its title came after its execution. Eventually the huge woven environment became known by the town's French name, *Bois le Duc*—the duke's forest.

Above:
Baroque Dress. **1969**

Opposite:
Brown Coat. **1968**

Overleaf:
Abakans. **1968–75**

24

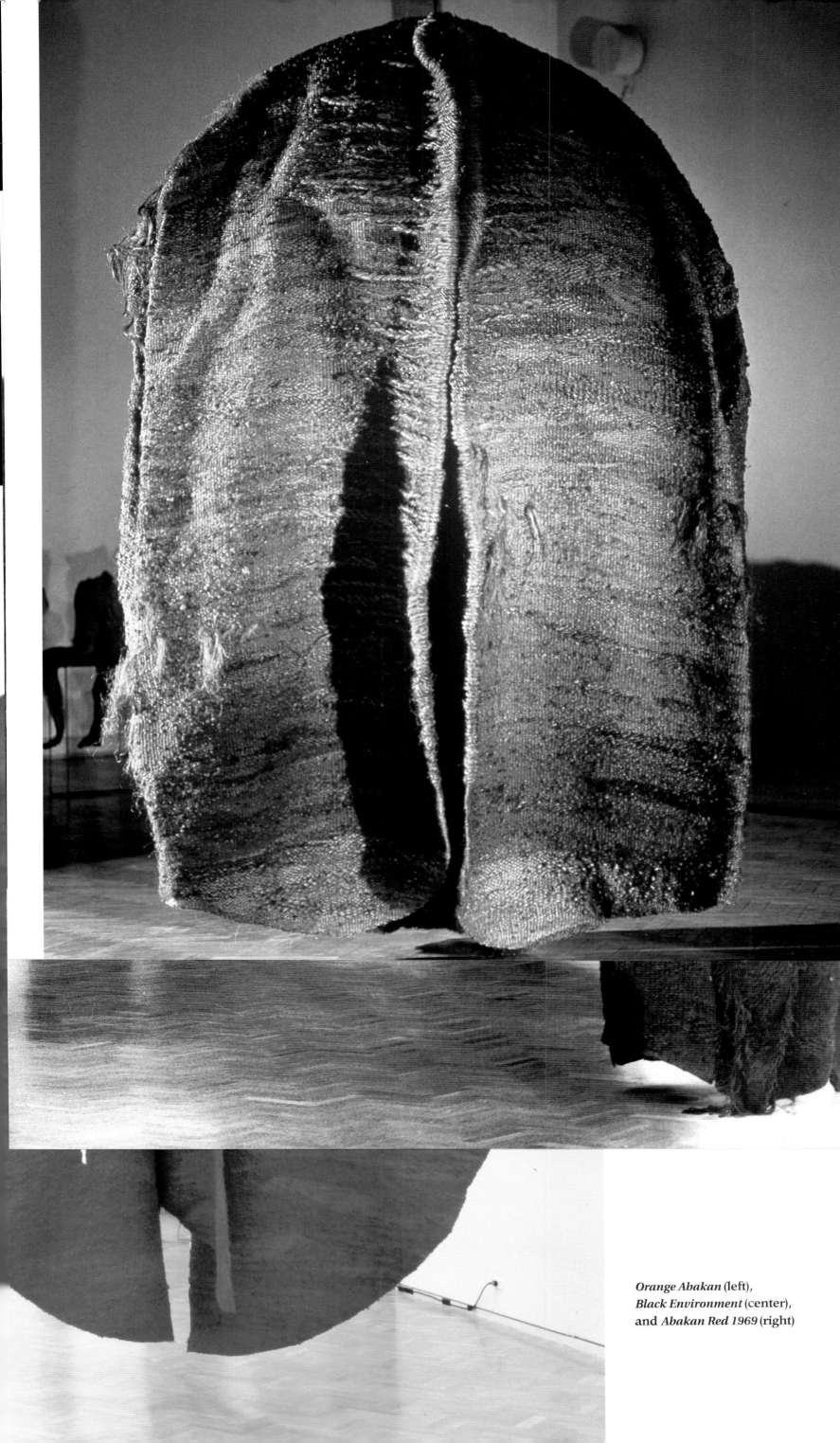

Orange Abakan (left),
Black Environment (center),
and *Abakan Red 1969* (right)

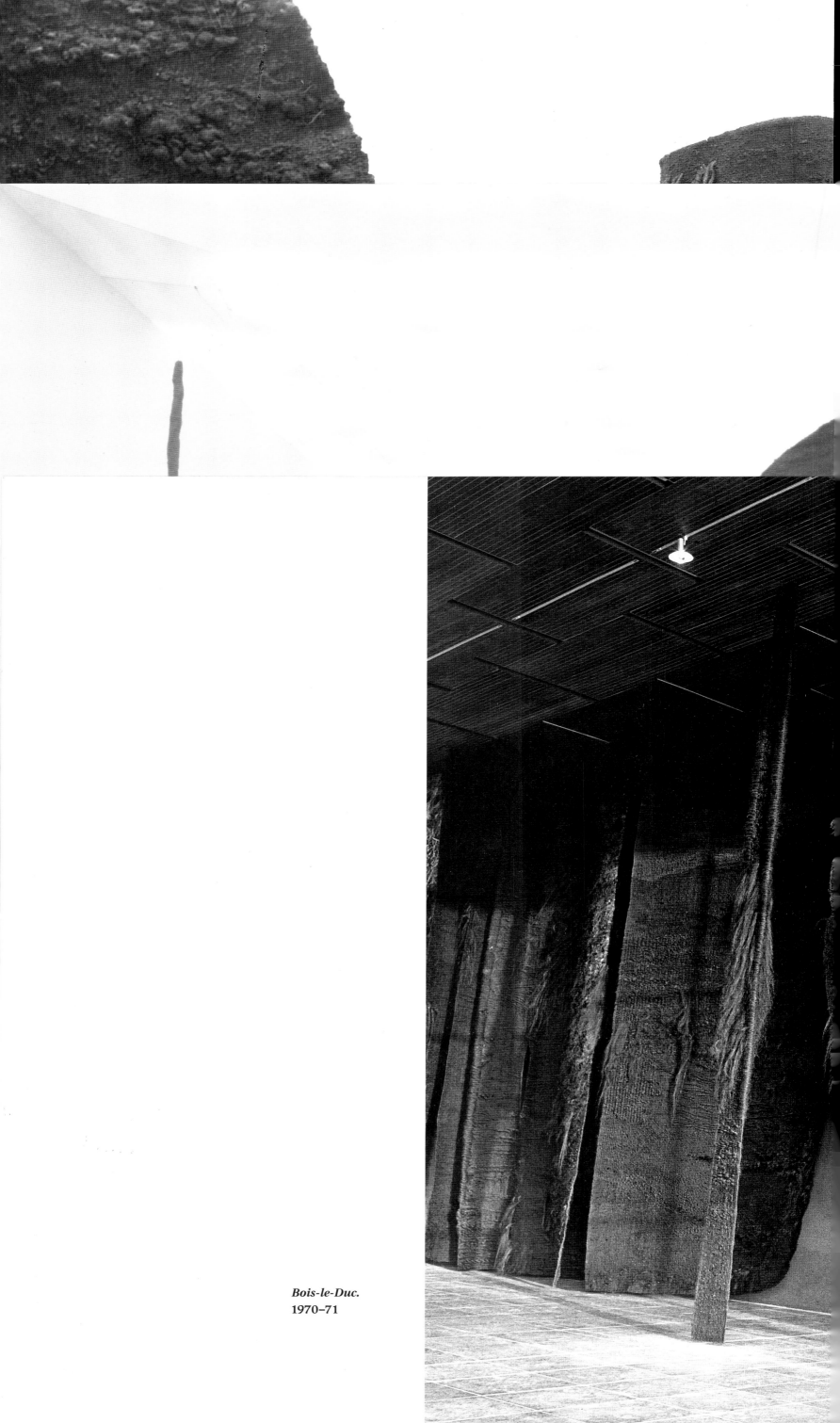

Bois-le-Duc.
1970–71

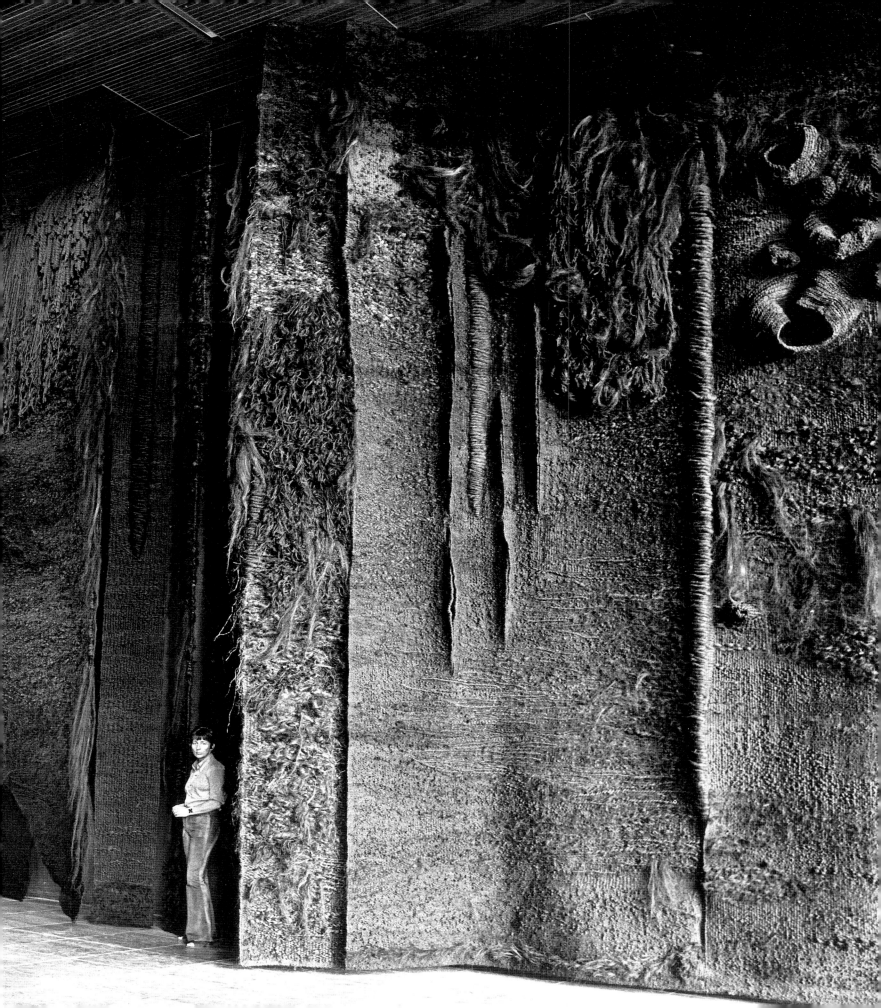

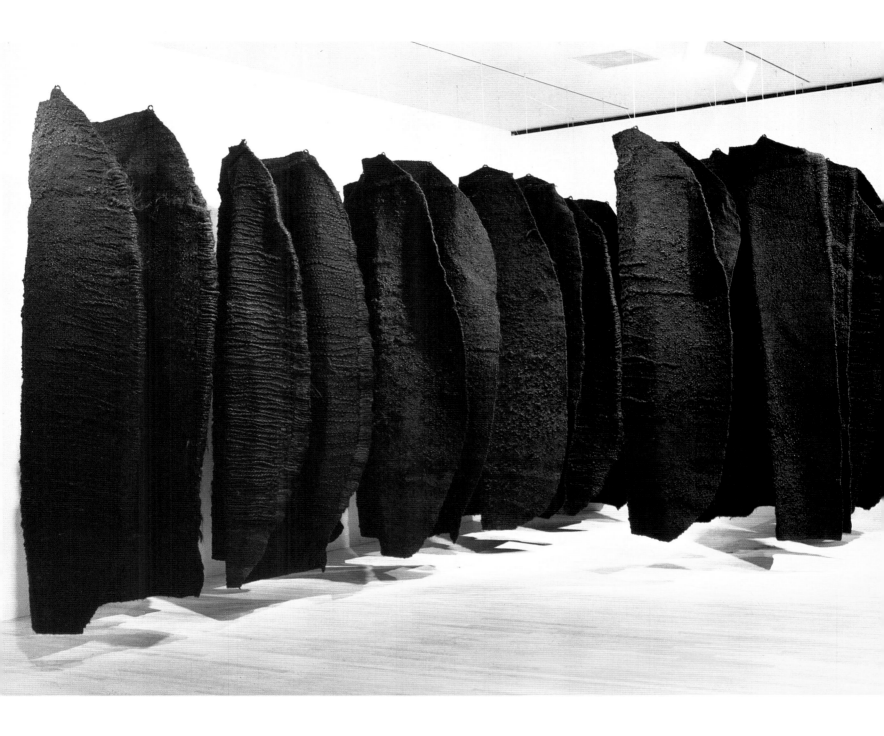

Black Environment. 1970–78

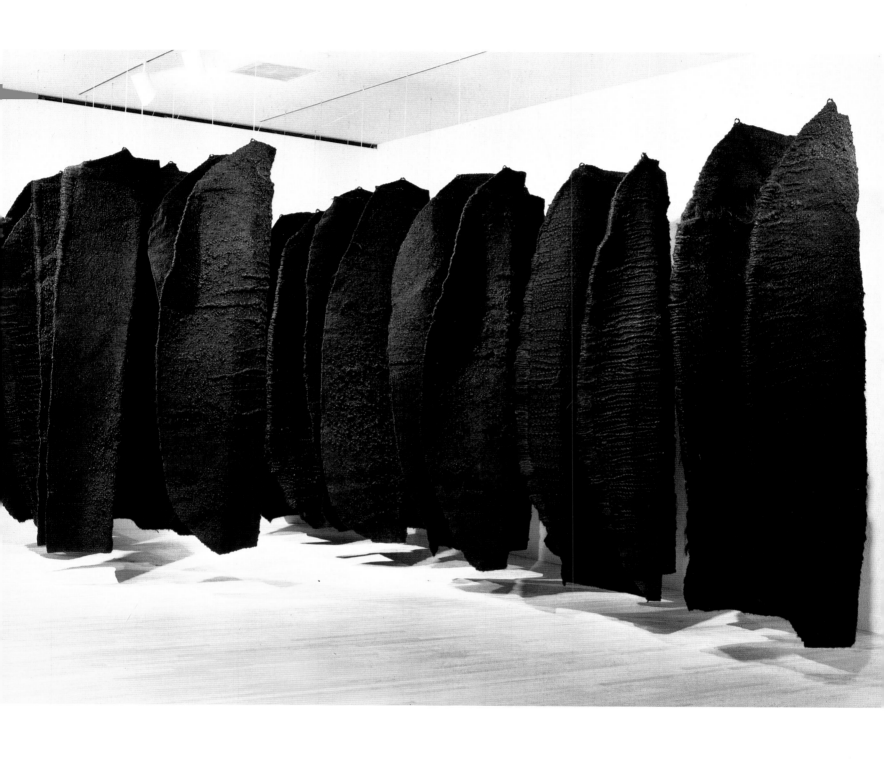

III : The Body Makes the Mind

At the very beginning of every creative process is mystery, the inexplicable. . . . One of the strongest motives of our time is the search for explanation, the need to explain everything away. Explanation is one of the means to tame the mystery of art. Talking about mystery has become indecent. Many people consider it pure mystification or a lack of intelligence. They want to identify mystery with a problem. And a problem is something which can be reduced into details susceptible to explanation. Mystery cannot be reduced to details. It is a whole which embraces us.

Magdalena Abakanowicz, 1983

Abakanowicz's reputation grew as the world came to know her work. In 1967, she began to show regularly with Alice Pauli, a Swiss dealer who had seen her works at the Biennale Internationale de la Tapisserie in Lausanne, and who was willing to cope with the immense difficulties of representing an artist living in Warsaw. That year a large exhibition of her work toured museums in Norway. In 1968, Jan Leering, the perceptive director of the Stedelijk van Abbemuseum in Eindhoven, Holland, invited her to exhibit at his avant-garde museum. Leering was prescient in the artists he chose to show, and among them had been Joseph Beuys, Robert Morris, and Carl Andre, all before their importance was generally acknowledged by the art world. His choice of Abakanowicz would prove similarly far-sighted.

Nineteen sixty-eight was a year of historic importance in both the East and the West; in America and across Europe, politicized youth movements tried to topple sclerotic governments through protest and other direct action. The situation appeared particularly promising in Czechoslovakia during the famous "Prague Spring," when the Czechs became convinced that they could free themselves from Communist domination. But these stirrings were to prove premature. Abakanowicz had been invited to participate in a conference of artists and art historians in the Czech capital that summer. Early in the morning of August 21 she was awakened in her Prague hotel room by a terrible but familiar sound: the rumbling of armored tanks. While the great powers of the West averted their eyes, the Russians rolled into the Czech capital. Abakanowicz ran into the street to find the tanks pointing their guns at the people. The airports had been closed, and she returned to Warsaw by using different local trains, a journey that took three days. She remembers the Prague station filled with Russian solders sleeping on the floor. In their summer linens, they looked like sacks strewn across the floor. This image of slumped over, sacklike bodies stayed with her.

Wheel and Rope.
1973

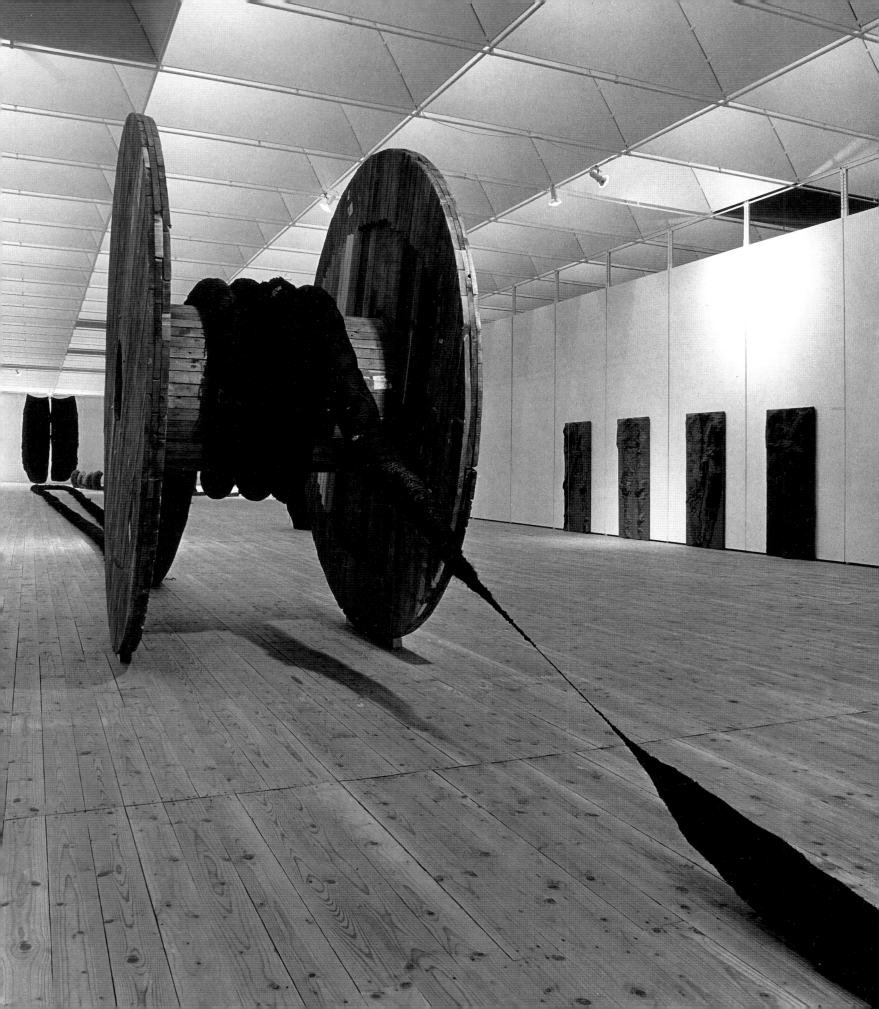

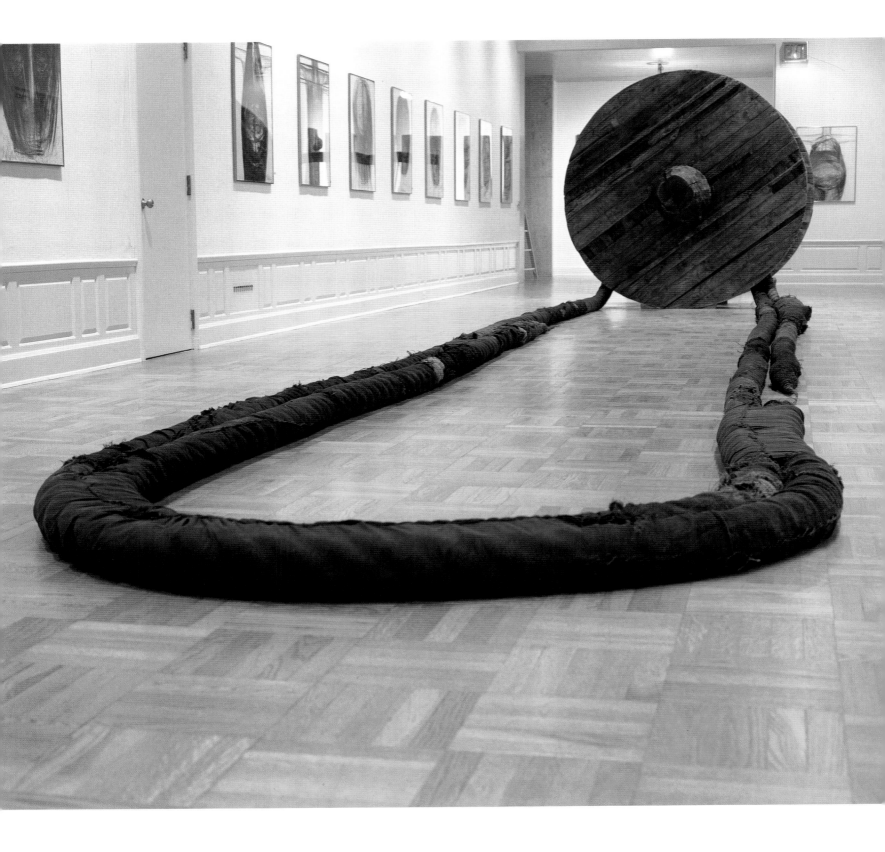

By now, arranging objects in space had become a primary focus of Abakanowicz's art, and a concern with the relationship of many objects in environmental installations began to take priority over the creation of individual objects. These interests intensified as a result of an ongoing dialogue with Stanislaw Zamecznik, a Polish artist who, after the war, had begun placing objects in space as a means of aesthetic expression. He had developed a theory that applied concepts from music to spatial problems. Zamecznik was among the precursors of what was later called environmental art, although he never used this term. Abakanowicz resisted his theories but she did share his focus on spatial relationships.

Because she produced monumental works in a relatively small studio, Abakanowicz could only see her finished objects in exhibition environments. By installing her own works, she could give them their final shape by arranging them in relation to each other, paying close attention to issues of context and meaning. For this reason, exhibitions became as important to her as the production of the single work in the studio, and this has continued to be true. Her participation transformed exhibition rooms into total works of art: spaces to be experienced intimately rather than galleries in which to view art from a physical and psychological distance. Issues that are usually of secondary importance to most artists, such as how a space where works are displayed is to be lit, were critical to Abakanowicz, whose art has always had a theatrical element. To create these unique installations, she began to travel around the world to each place where she was invited to exhibit.

In 1970–71, a period of political thaw in the Cold War permitted her to travel once again. Abakanowicz visited the United States and Mexico for the first time, giving lectures and exhibiting an important installation of *Abakans* at the Pasadena Art Museum in California. As her exhibitions grew in size, ambition, and complexity, the *Abakans* were attacked by members of the craft community as no longer being weaving. At the same time they were rejected by some art critics as belonging to none of the known or accepted categories of contemporary art. Eventually, however, sophisticated critics began to perceive the *Abakans* as works that situated themselves between the arts, transgressing categorical boundaries, a characteristic that would come to define the essence of avant-garde activity in the 1970s. It is hardly coincidental that this development was rejected by formalist critics throughout the world, who were still defending the ivory tower purity of art.

In this light, Abakanowicz's 1971 exhibition at the Pasadena Art Museum was more than just an isolated artistic success. Admirers applauded her work as bringing down the walls separating the crafts from the fine arts. Young people followed her as if she were a movie star. She was surrounded day and night; students even crept into her hotel and slept outside her bedroom door. The success of the Pasadena exhibition brought numerous

Wheel and Rope.
1973

invitations from American universities to lecture. Abakanowicz was fascinated by the United States, but she could never bear to stay longer than a few days. The vast scale of the continent and the emotionally distanced mentality of the people were foreign to her.

Meanwhile, her work was becoming well known in her native country as well as abroad. Like Jerzy Grotowski's and Tadeusz Kantor's artistically radical but nevertheless popular performances, Abakanowicz's exhibitions drew crowds. Indeed it is more in relationship with their highly charged synesthetic theater than with the content of contemporary Western art that her work can be best understood. This is particularly true of the solemn spirit of the ritualized physical performances of mute action pioneered by Grotowski. Avant-garde Polish art was isolated and developed out of its own deep problems.

Abakanowicz continued to participate in the tapestry biennial held in Lausanne since 1962, and the international jury always accepted her work, even when she showed pieces that questioned the premises of the exhibition and overturned the tradition of weaving. At the sixth Lausanne biennial, in 1973, she showed *Wheel and Rope*, her first sculpture related to a literal object. She constructed an immense wooden wheel, similar to those used to store cable, on which she wound a 3³/₄-inch-thick, 164-foot-long sisal rope she found at the Hamburg harbor. She wrapped each end of the rope tightly with black burlap. Partly unrolled, the end of the rope crossed the main hall of the museum in a straight line, dividing the space in half, passed through a window, and ended up in the museum garden. The piece was a succès de scandale. The self-reflexive gesture of trailing the rope off the wheel mimicked the means by which the weaving was made by unwinding fiber from a spindle. The large scale of the work and the implied action of rolling and unrolling the spool clearly related it to developments in Western avant-garde art.

By the late 1960s and early 1970s, Abakanowicz increasingly emphasized weight, gravity, and mutability in the *Abakans*. Three main configurations prevailed: The first consisted of black tubular forms roughly three feet in diameter and nine feet high. Some were opened to expose the interior, others were almost completley closed. In Pasadena, she also showed flat, round shapes, mostly in optically aggressive colors (yellow and red), that were nine to twelve feet in diameter. Finally, there were black and brown garmentlike forms, nine to fifteen feet in height from floor to ceiling. Each time these works were exhibited they were configured differently. Frequently, they were accompanied by a rope that divided the exhibition space: rope spooling off a wheel, rope twisted into a big knot and suspended in space, rope trailing down from the ceiling onto an immense metal bed. Abakanowicz became enchanted with the physical characteristics and metaphoric associations of rope:

Rope installation, 1970

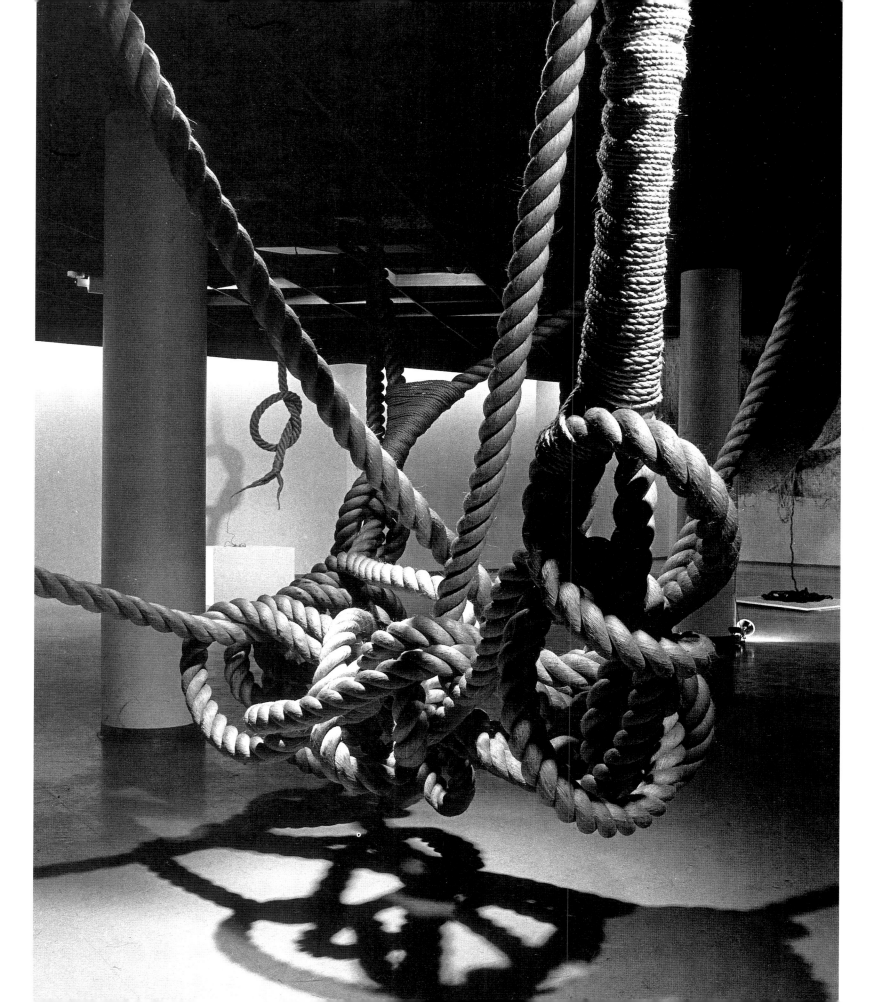

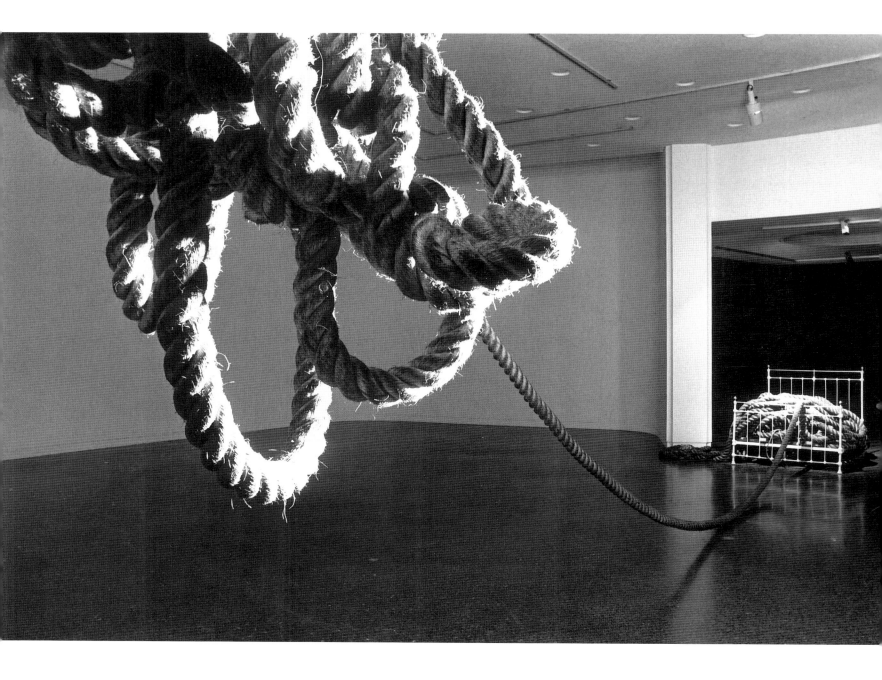

Rope installation, 1971

Rope is to me like a petrified organism, like a muscle devoid of activity. Moving it, changing its position and arrangement, touching it, I can learn its secrets and the multitude of its meanings.

I create forms with it. I divide space with it.

Rope is to me the condensation of the problem of thread, the thread composed of many fibers whose number nobody tries to establish.

Transported from one place to another it grows old.

It carries its own story within itself, it contributes this to its surroundings.

I used it in urban landscapes where it became an echo of the banished organic world. It enabled one to see architecture with all its artificiality of hard decorative shell.

I sense its strength which is carried by all intertwined elements, such as those in a tree, human hand, or a bird's wing—all built of countless cooperating parts.

In 1973, Abakanowicz was invited to the World Craft Council Conference in Canada. She decided to take the opportunity to go to Arizona to meet the visionary architect Paolo Soleri, who was building Arcosanti, his "city of the future," in the desert there. Her research in Warsaw in the 1950s on socialism and the ideal city taught Abakanowicz to analyze social situations in urban agglomerations. After this experience, Soleri's ideas seemed to her decorative and superficial. Nonetheless, a vivid discussion took place. Some years later Soleri returned her visit when he came to Poland at the invitation of the Architect's Union in Warsaw.

From the United States, Abakanowicz traveled to London to receive an honorary doctorate from the Royal College of Art. There she encountered three people who would help her to realize her projects: Artur Starewicz, then the Polish ambassador to Great Britain and an intellectual with broad contacts among scientists, politicians, and artists, who became a close friend and continues to be associated with Abakanowicz's different activities; Jasia Reichardt, a leading art historian of Polish background, who would write the main essay for the catalogue of her first retrospective exhibition, which traveled to several American museums in 1982–84, establishing her as a major figure of contemporary art; and Patrick Wall, a professor of neurology and embryology, whom she questioned about the problems of regeneration of the nervous systems of both humans and animals. Back in Warsaw, Abakanowicz continued to explore these issues with Professor Maria Dabska from the center for neurological research of the Polish Academy of Sciences.

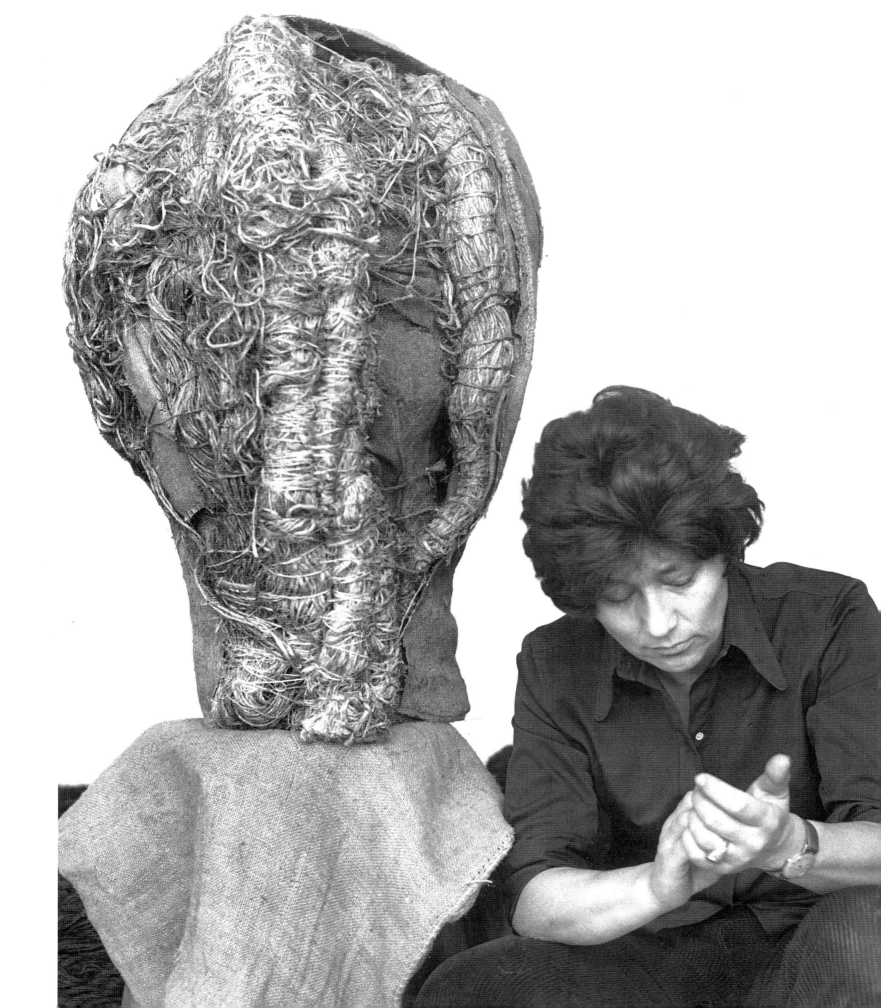

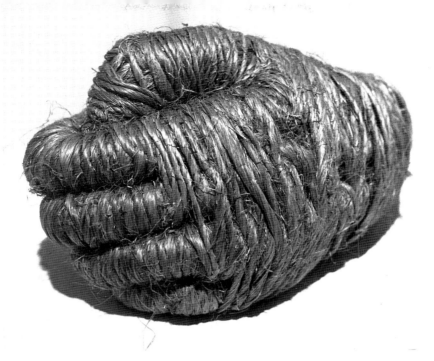

Here, one should note that Abakanowicz's fascination with the functioning of the brain was motivated more by philosophical than by scientific concerns. In her notes, she connected the making of art directly to the structure of the human brain:

Our brain bears the vestiges of our ancestors millions of years ago. The traces of primitive animals—first mammals. How the brain works is one of the most important questions of our time—questions which are not fully resolved until today . . . the brainstem: steers the physiological functions of the main vital processes of the body . . . the midbrain: is the material basis of all our instinctive inborn behavior. . . . Millions of years of past experience are accumulated in the midbrain. . . . The third part is the cerebral cortex. . . . It provides the material basis for our conscious experience. Although the brain isn't an entity

**Opposite:
Magdalena
Abakanowicz with
a piece from her
Heads cycle in her
studio, Warsaw, 1973**

**This page:
The Hand (two views).
1976**

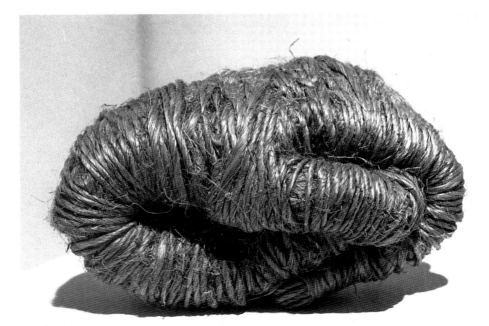

—one has to be aware of these different centers of power. They cause continuing and permanent struggle between wisdom and madness, between dream and reality in our nature. Art is a product in this struggle.

Abakanowicz saw man as fighting for control over his own contradictory nature, which she understood arose from the structure of the human brain itself, "formed of interdependent parts that originated during different stages of evolution." Concluding that civilization's battle to achieve balance and integration had proven futile, she found that this essential but unresolved human striving and its frustration were reflected in the conflicts recorded in myth and philosophy from the Assyrian Gilgamesh epic to Plato's writings to Goethe's Faust. Certainly, her study of neurology did not alter her own observation that the human brain is not able to keep destructive instincts in check. Her experience as well as her reading of philosophy and literature led her to formulate a personal conception of Existentialism, which despite its fundamental pessimism, was not defeatist. Even in the absence of hope, she believed that the struggle to achieve a mental and physical equilibrium through the cathartic and transformative capacities of art was a moral imperative.

The human brain, head, face, hand, and details of the body were the images she chose to focus on to express the problems of the human condition, both present and past, that now absorbed her thinking. Four cycles of figurative and nonfigurative sculptures related to the duality of mind and body came into being, under the common title of *Alterations*: *Heads* (1973–75), *Seated Figures* (1974–79), *Backs* (1976–82), and *Embryology* (1978–81). They occupied Abakanowicz during the decade of the 1970s. Using cloth, she made a total and conclusive break with fiber art: she exchanged the rich and complicated material of her own weaving for old burlap.

The *Heads* were sewn on metal armatures out of battered burlap. All sixteen are stuffed with sisal and rope. In some, pieces of rope and thread are visible through the broken burlap surface, so that they resemble an exposed brain or bursting bud. They belong to the more abstract works by Abakanowicz. According to the artist: "Those forms which I also refer to as *Heads* relate to my fear that to exceed the rate of one's biological rhythm leads to the loss of the ability to meditate. I am apprehensive about effects of artificial environment and unlimited stress."

Heads are members of a crowd. Each *Head* presents a different image of something organic metastasizing out of control. The bursting brain is a metaphor for insanity; indeed at one time Abakanowicz called them *Schizoid Heads*. Abakanowicz created headlike shapes because she had concluded that the features of the human face were too literal for her expressive purposes. When the war ended, she had observed that no matter how she and her family sought anonymity, aristocrats and intellectuals stood out

From the cycle
Heads. 1973

Overleaf:
Heads. 1973–75

44

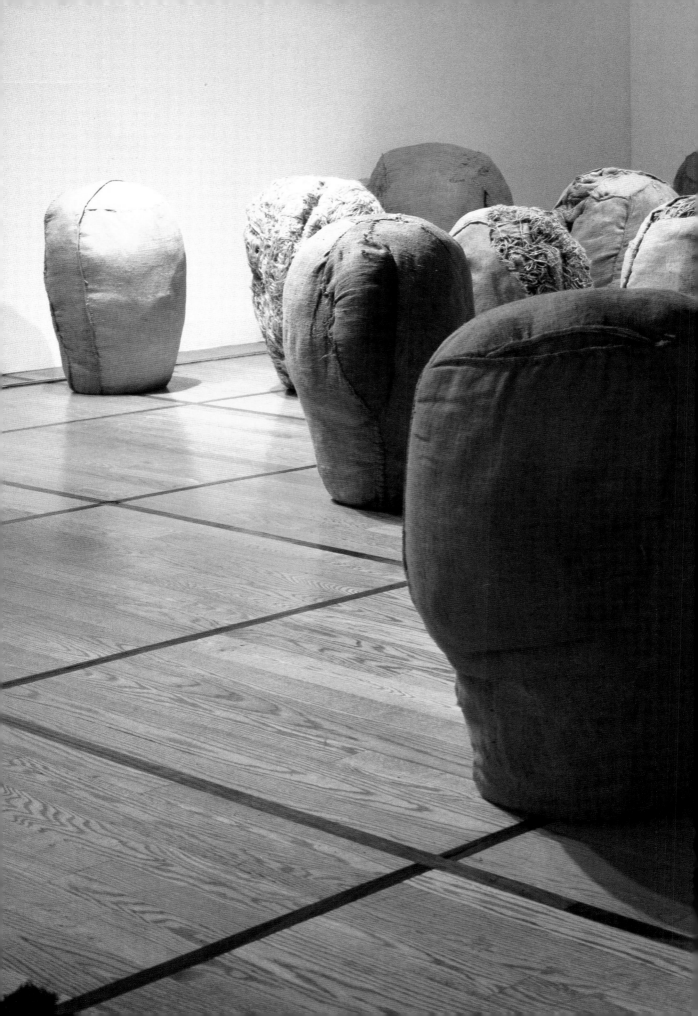

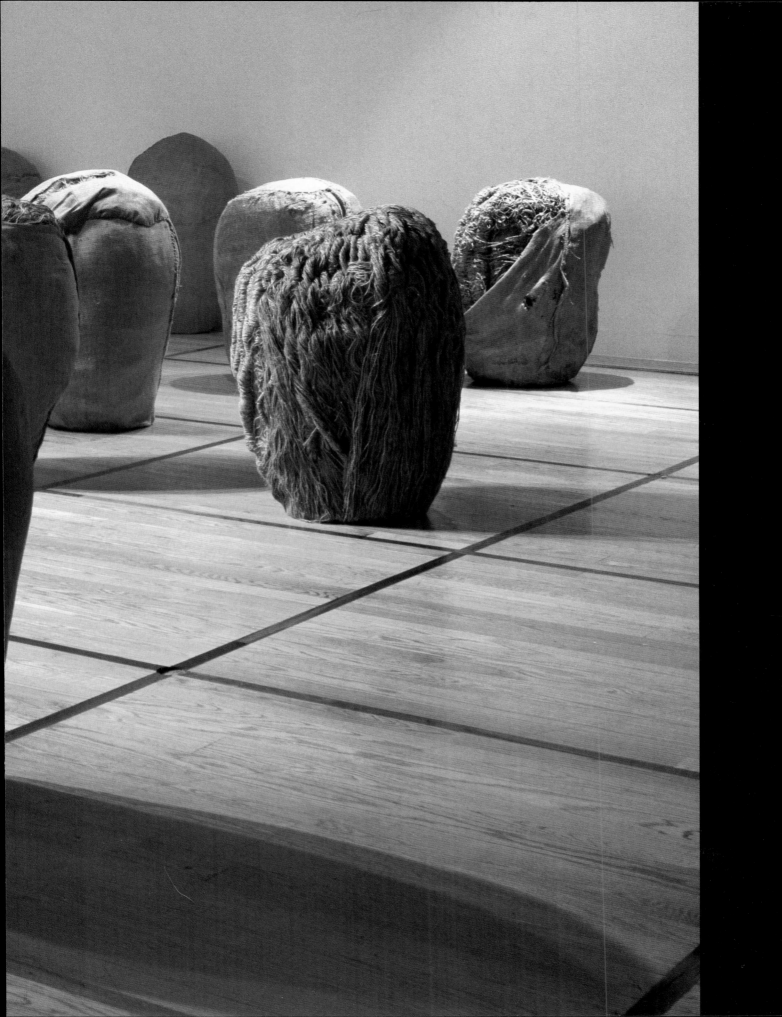

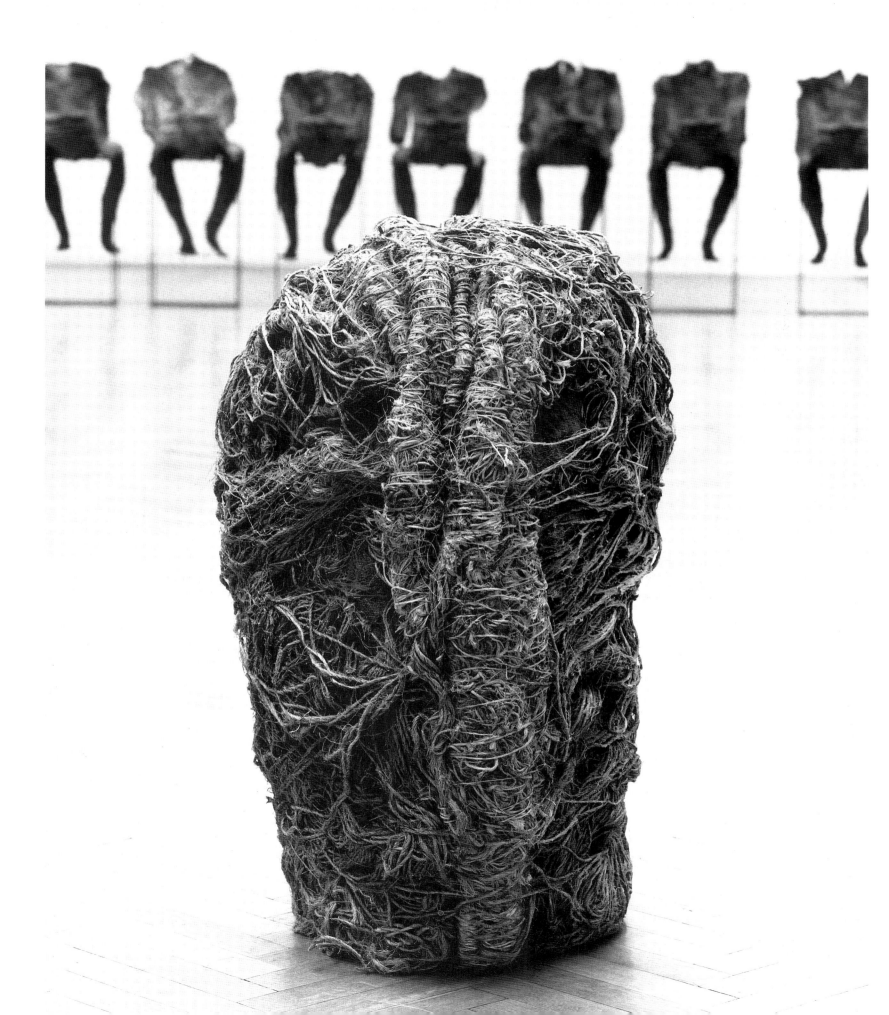

because they had a "face." Written on their faces were their individual experiences, family histories, cultivation, and sensitivity—all expressions anathema to the faceless herd of the collective. For all their rhetorical power, however, the *Heads* evolved out of Abakanowicz's emotional experience and not as an illustration of a political condition. This is in stark contrast with the mechanical strategic and conceptual styles in fashion in the West today, which emphasize irony rather than empathy.

Abakanowicz's cycles are born, take shape, are elaborated, and mutate into other hybridized forms once she feels they have nothing further to say. The *Seated Figures*, her first attempt to deal directly with the human figure, evolved this way. Toward the end of the *Heads* cycle, she decided to cast a man to break decisively with the immediate past, exchanging the superhuman scale of the *Abakans* for the scale of life. She started to work in human scale by making plaster molds, one of the front and one of the back, of a seated man. Discarding the idea of making a full figure, she focused on a fragment. She made multiple casts from the mold of the front of the figure by waxing the plaster and then gluing pieces of rough burlap sacking onto its surface. The burlap and glue formed a hard shell that could be pulled from the plaster mold; a headless, handless, sexless trunk, which she mounted on a fine wire pedestal that, unlike the traditional sculpture base, was transparent and ethereal. She used the same mold for the eighteen *Seated Figures* in the original sequence, and each time the surface obtained was different, as in a series of drawings of the same subject that reveal the hesitations and gestures of the artist. These seated figures, their legs and feet caught in frozen movement, their bodies disconnected from the controlling brain, are presented frontally. The viewer, however, is also meant to go around and among them and discover that they are concave shells. On close observation, their protruding threads and dangling cords suggest the human nervous system itself.

It was several years before Abakanowicz found a use for the back part of the original plaster mold, employing only the torso, without the legs but with parts of the arms intact. She began the series of *Backs* in 1976; the following year twenty of them were shown together as *The Session*, a title that suggests indoctrination or perhaps psychoanalysis. In the eloquence of their silence, these shells of humanity recall T. S. Eliot's "hollow men": "Paralysed force, gesture without motion."

Abakanowicz's exhausted, desexualized torsos are the antithesis of Rodin's energized and erotic body fragments. They remind us of the successive savage invasions and blood baths that is Polish history, whose diabolical senselessness caused the historian Norman Davies to choose "God's Playground" as the title of his account of the harrowing history of Poland.

Head and
Seated Figures

Overleaf:
From the cycle
Seated Figures.
1974

49

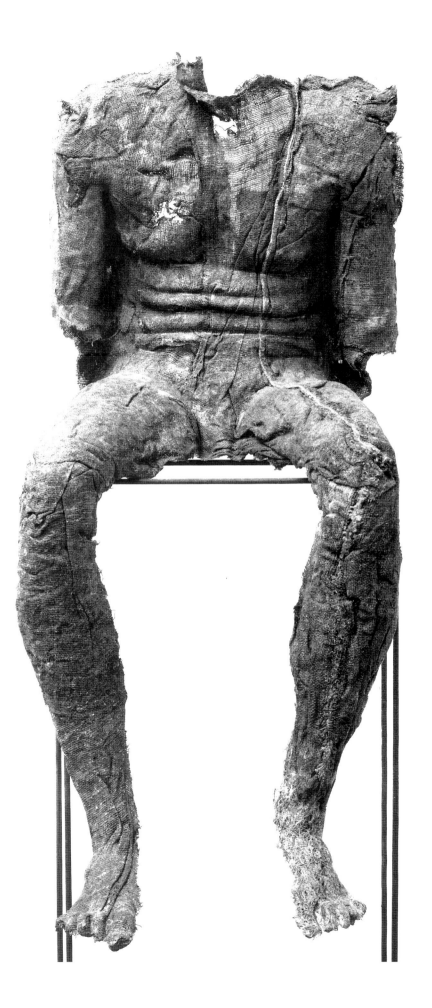

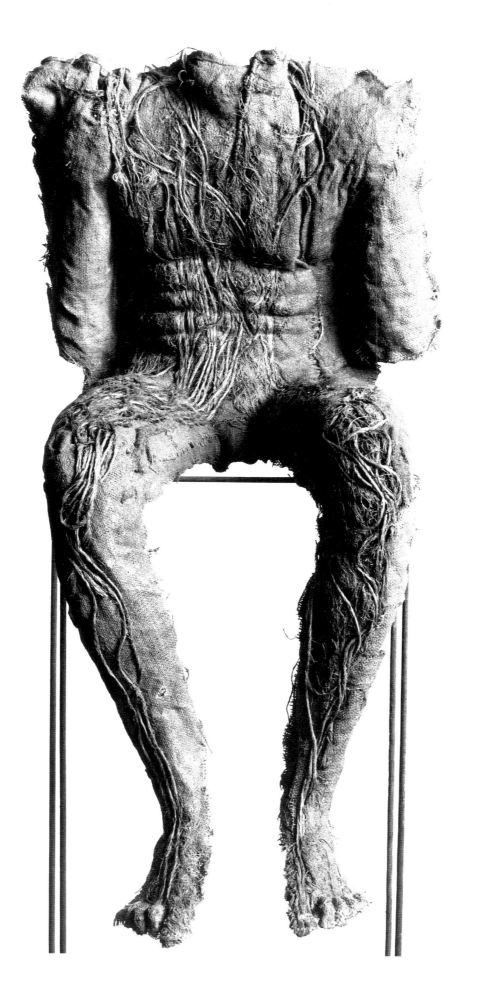

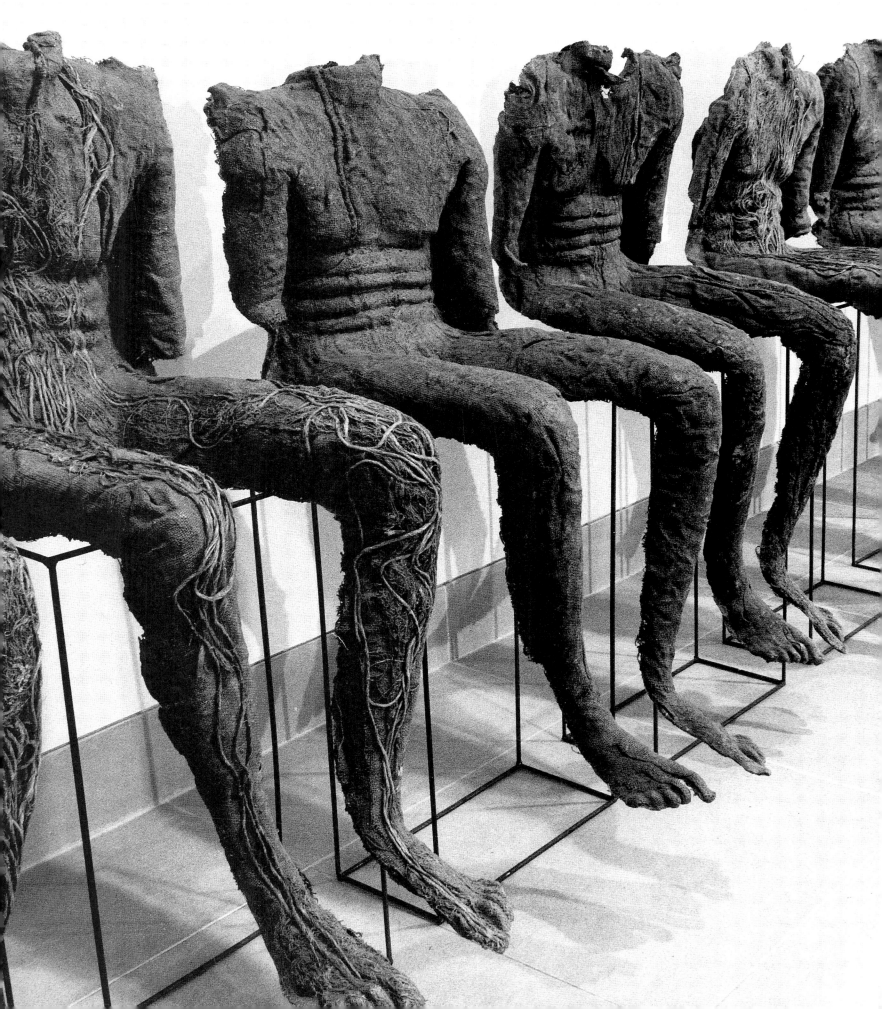

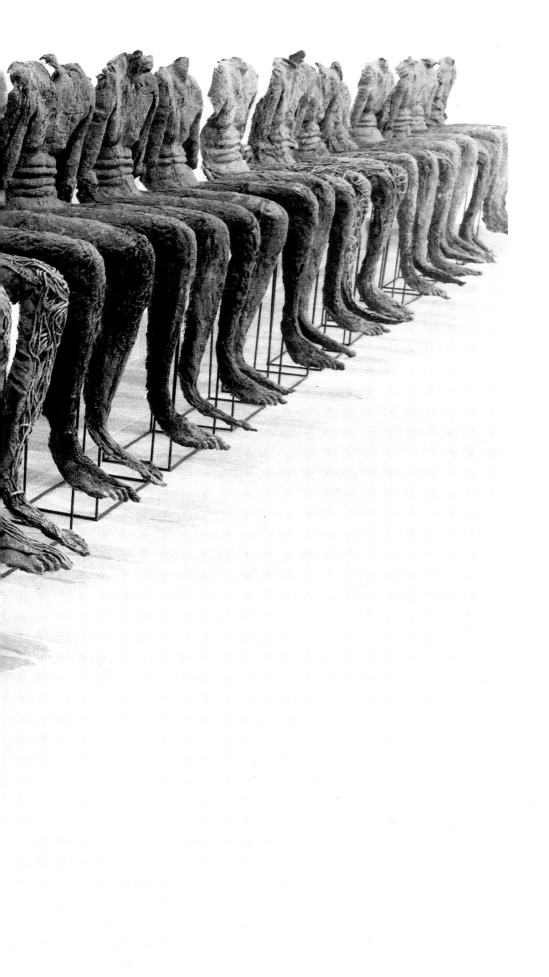

Seated Figures. 1974–79

IV : The Science of Growing

The shapes that I built are soft. . . . They conceal everything that I leave to the imagination. Neither through the eye nor the fingertips nor the palm that informs the brain can this be explained. The inside has the same importance as the outer shell. Each time shaped as a consequence of the interior, or exterior as a consequence of the inside. Only together do they form a whole. The invisible interior, which can only be guessed at is as important as when it opens for everyone, allowing physical penetration.

Magdalena Abakanowicz, 1979

As we have seen, the titles of Abakanowicz's works come after the fact of their creation, which involves a process of experimentation and research into techniques and materials not unlike basic research in science. Instead of using artistic precedents as a model, she measured her ideas against her direct experience and knowledge of the natural world. Like a biologist, she observes phenomena and asks new questions based on these observations.

During the 1970s, she visited scientific laboratories and traveled to distant landscapes. In 1976, she was invited to Australia, where she spent three months installing retrospective exhibitions at the Art Gallery of New South Wales and the National Gallery of Victoria, working on educational films for the Australia Council for the Arts, and conducting workshops. The grandeur of the Australian desert and of the coral reefs that fringe the subcontinent impressed her, but her real desire was to visit Papua New Guinea. Above all, she longed to see its tropical rain forests and to experience a natural environment relatively untouched by man and the products of civilization.

Once in the New Guinea jungle, Abakanowicz felt as if she were living an extraordinary dream. She traveled with her Australian friend Jutta Federson by different means of transportation to the Highlands and down the Sepik River by canoe, staying in isolated missions in the jungle. At night, the mysterious sounds and the enveloping darkness made her feel that she was inside the belly of a huge organism. Because she was able to communicate with the inhabitants of the jungle in a wordless language of gesture and mime, she was allowed to visit spirit houses and even to watch, with great respect, part of their ceremonies. Abakanowicz was deeply impressed that art and religion were one and played such an essential role in everyday life in this culture: in Papua New Guinea, art was a meaningful symbol, a synthesis of philosophy, and the visualization of mythology as well as a code for everyday behavior.

Back in Australia, she traveled with her husband and Jutta to the middle of the desert to the Ayers Rock and Mount Olga. A visit to the Great Barrier Reef provided her first encounter with coral structures, in which she discovered the capacity of nature to repeat its own forms by multiplying organisms. On the way back to Poland, Magdalena and Jan visited Indonesia and Thailand. Her first direct encounter with Asia and Australia overwhelmed Abakanowicz with the experience of multiplicity and diversity, both in man and nature.

Returning to Warsaw, Abakanowicz could not work for many months. Europe seemed overcrowded, its people nervous and aggressive: she could

find no relationship to an environment that now seemed foreign to her. The journey encouraged her to increase the number of *Backs,* first to forty, then to eighty. She saw these backs gathered in Polish churches in demonstrations, in the bowed backs of Indonesian Ramayana dancers, and in photographs from concentration camps. These images of the sacred and the profane suddenly came together in the idea of creating a group large enough to fill a whole space, and the result was the evocative, multivalent image of the mass of headless, limbless *Backs*.

In autumn of that same year, Abakanowicz was invited to Japan by Tadao Ogura, the chief curator of the National Museum of Modern Art in Kyoto. Still digesting the deep impressions of her trip to Australia and the Far East, she refused such a long journey at first. In the end she went for the opportunity to see yet another unknown world. She was fascinated by Zen gardens that are related to the cosmos in their use of space. Her lecture at

Magdalena Abakanowicz working on a piece in the *Embryology* cycle

Overleaf: *Landscapes I–IV.* 1976

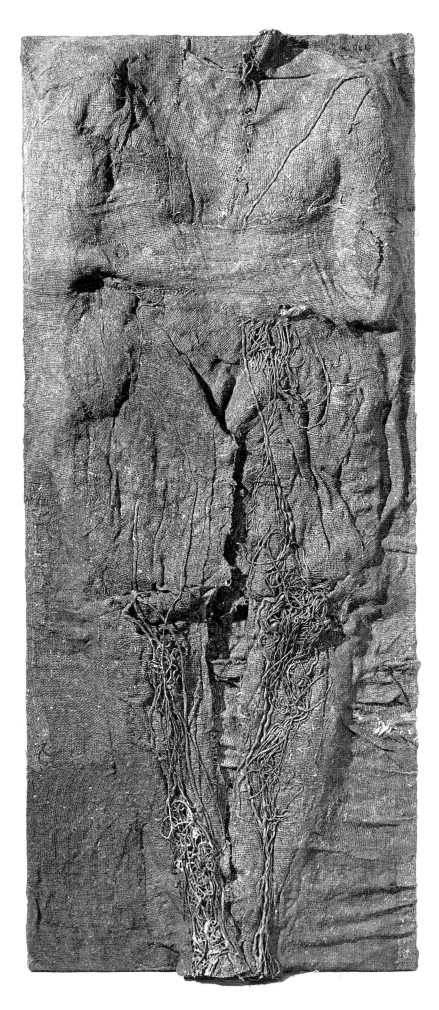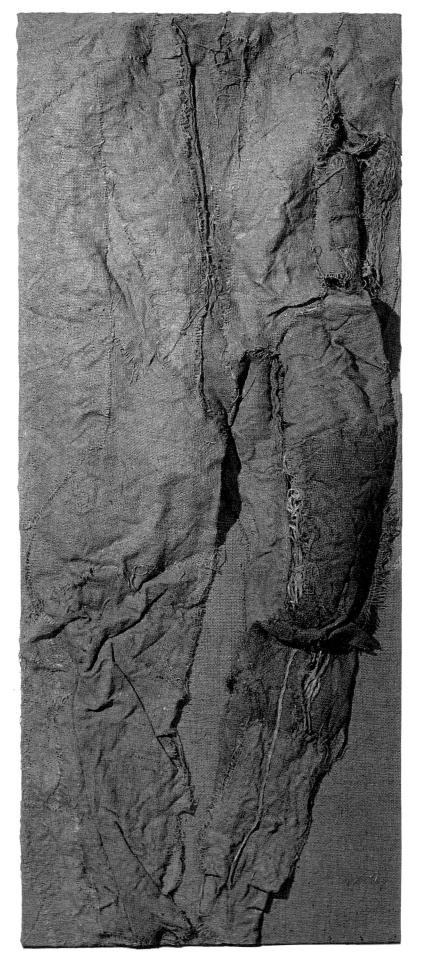

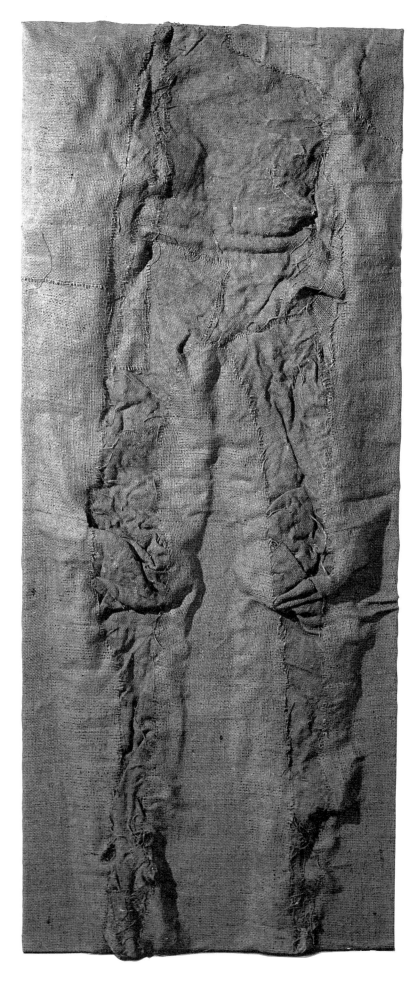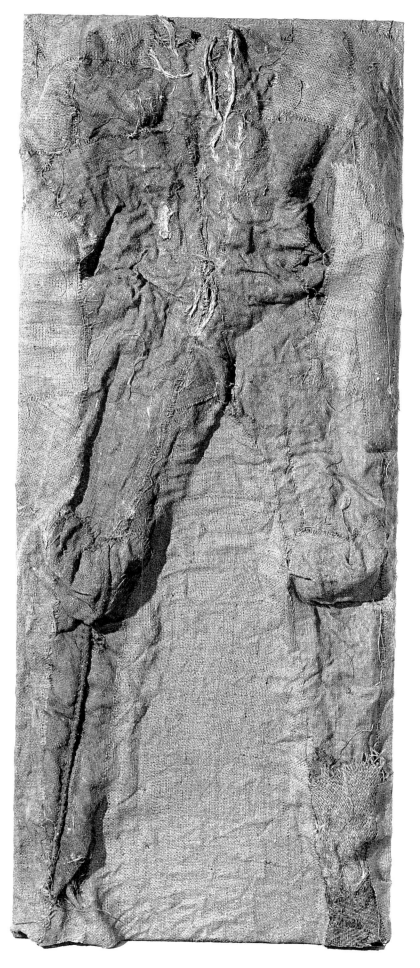

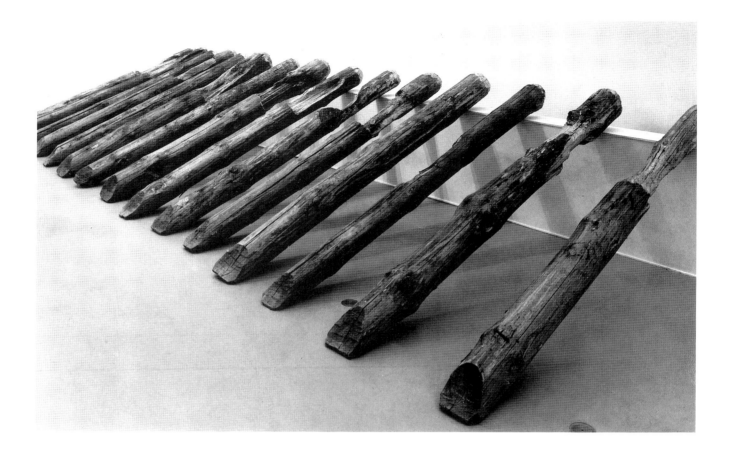

Trunks. 1981

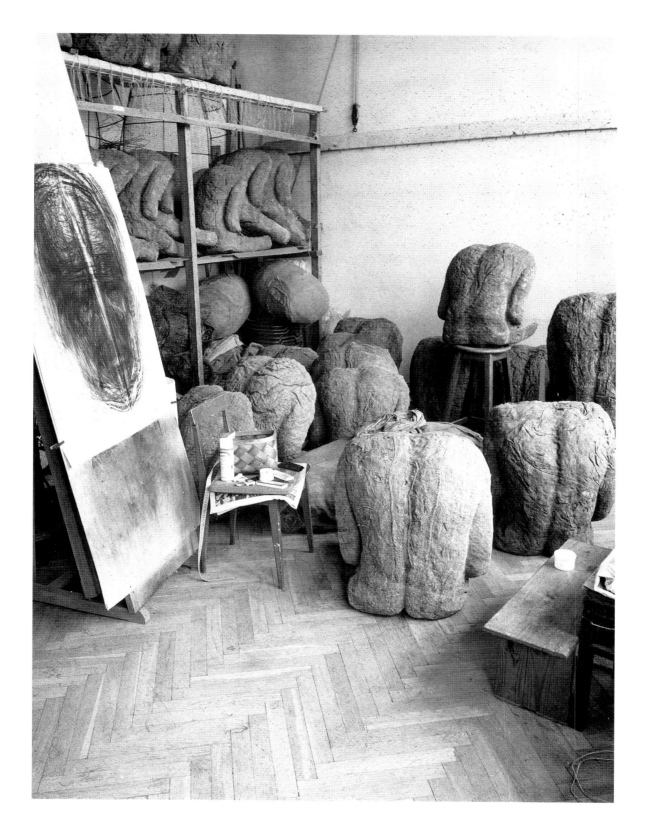

Backs at the artist's
studio, 1980

Overleaf:
Backs on the bank
of the Vistula River,
Poland, 1981

Pages 62–63:
From the cycle *Backs*.
1976–80

Pages 64–65:
Backs at the Musée d'Art
Moderne de la Ville de
Paris, 1982

Pages 66–67:
Backs near Calgary,
Canada,1982

59

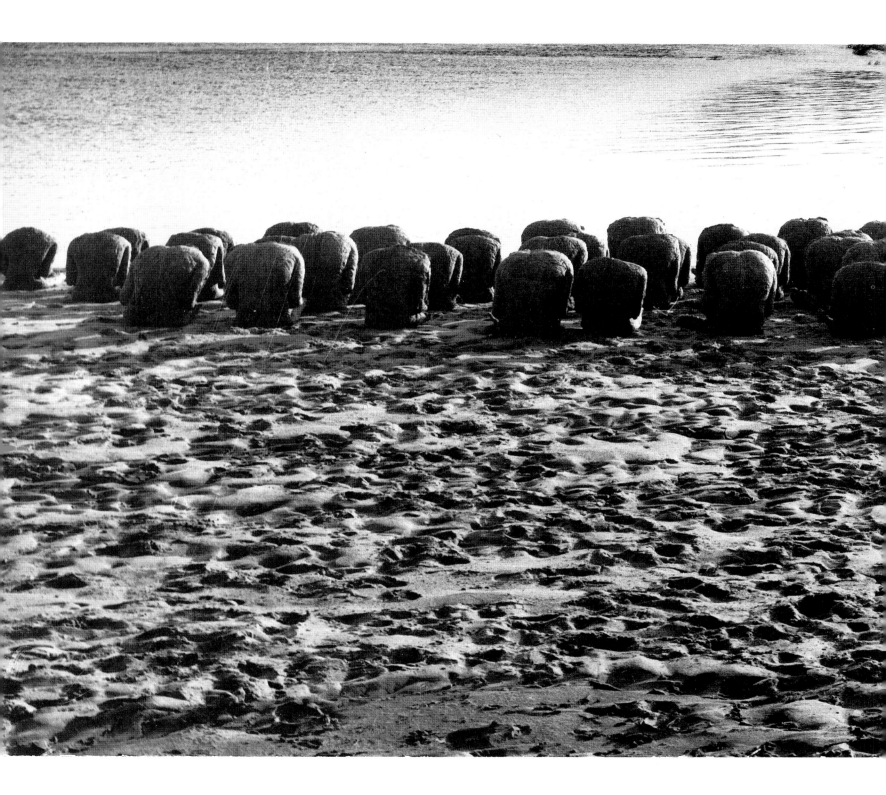

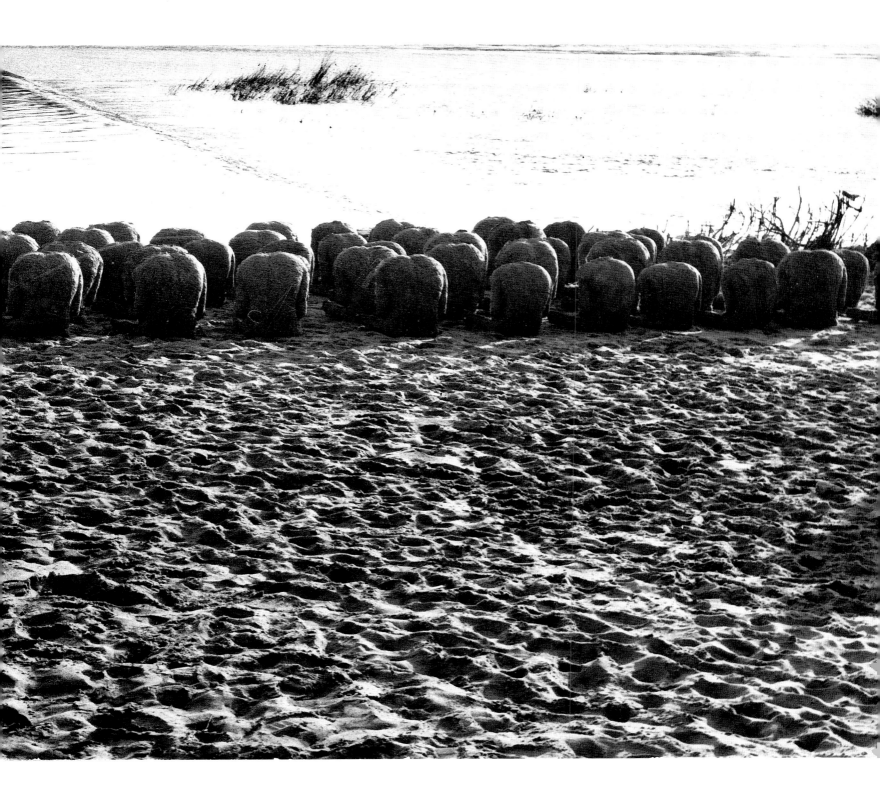

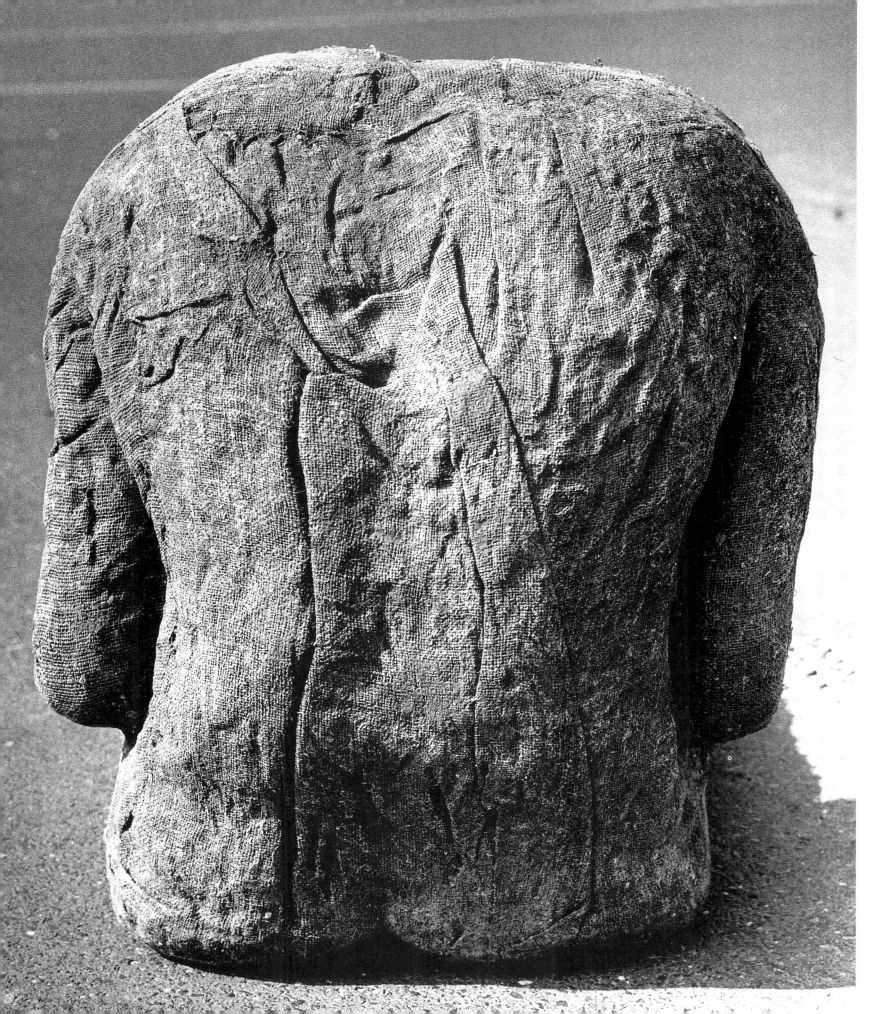

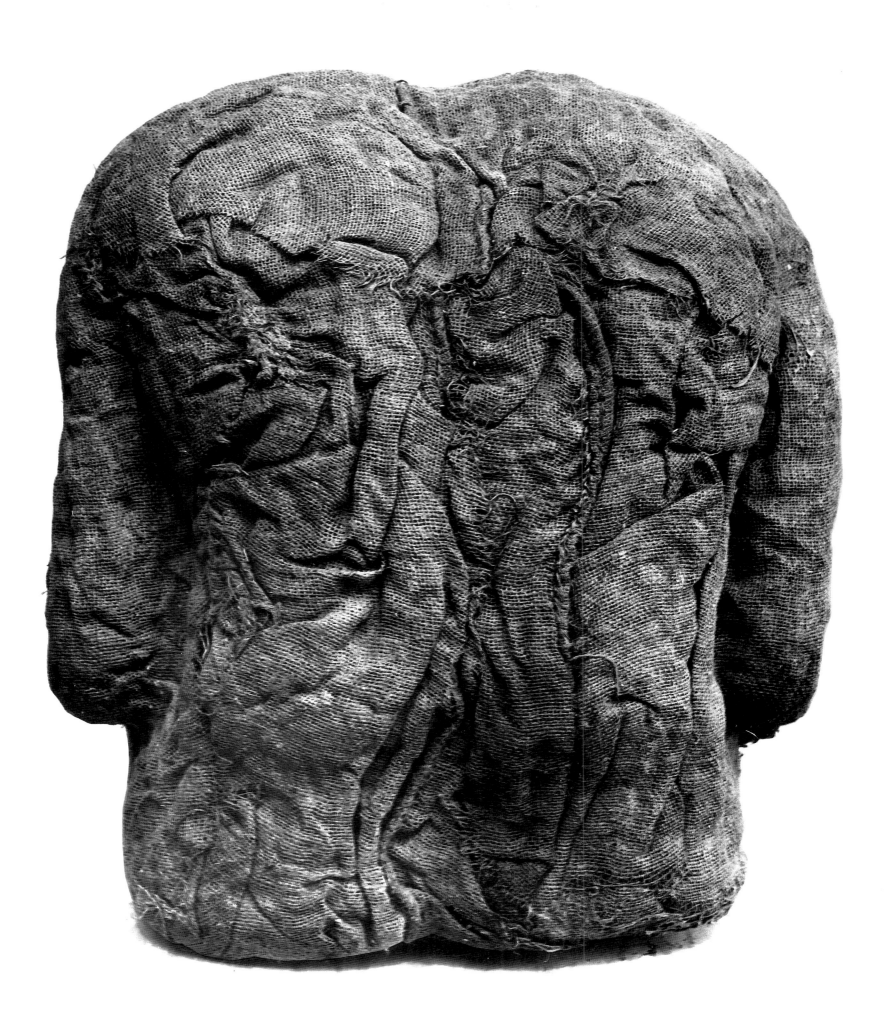

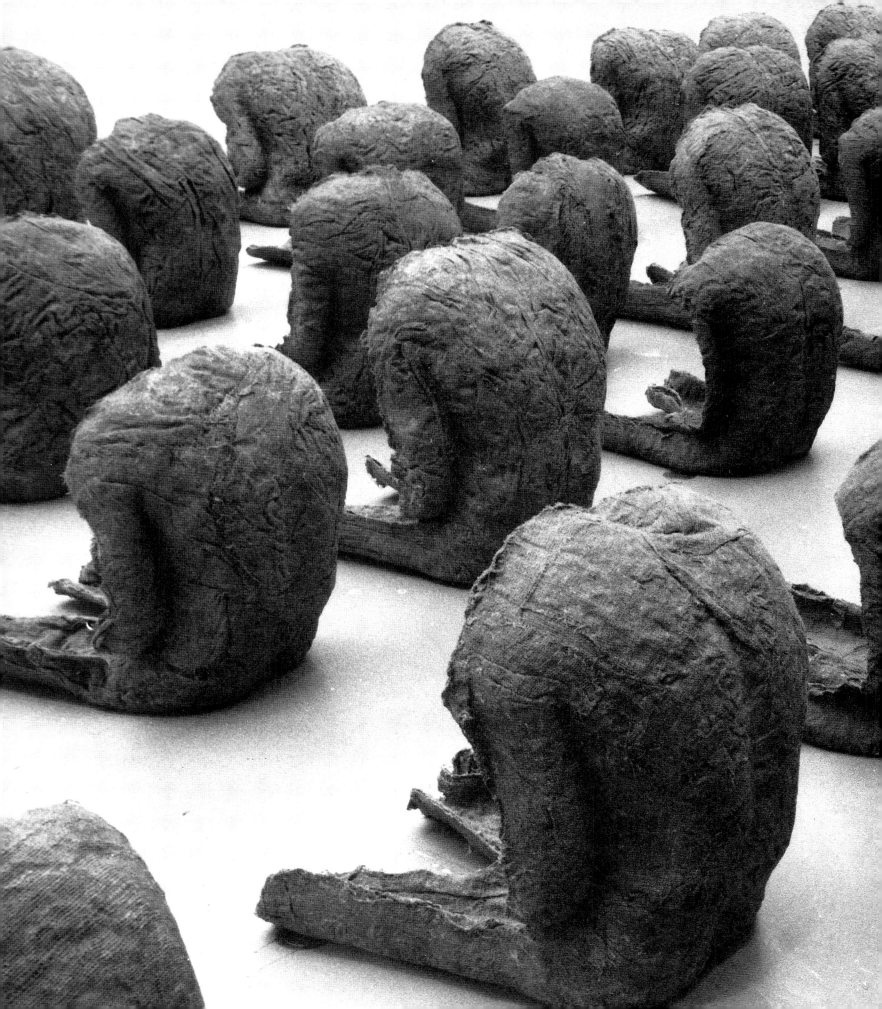

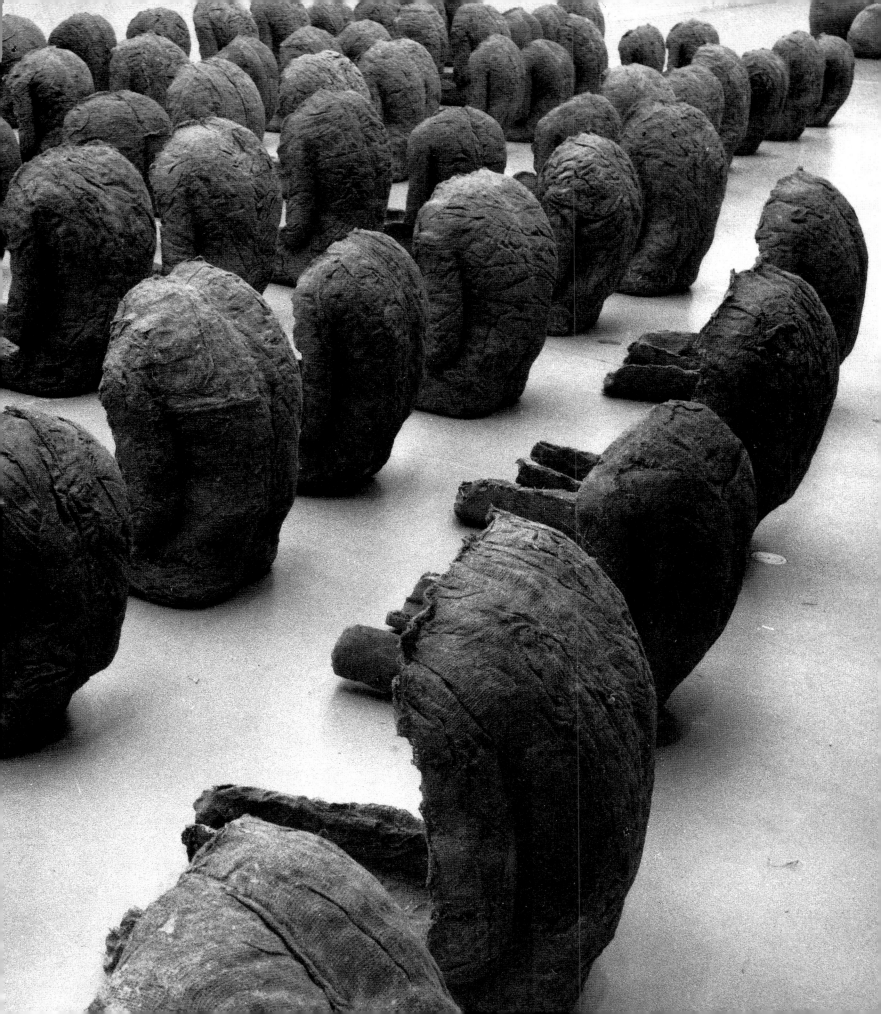

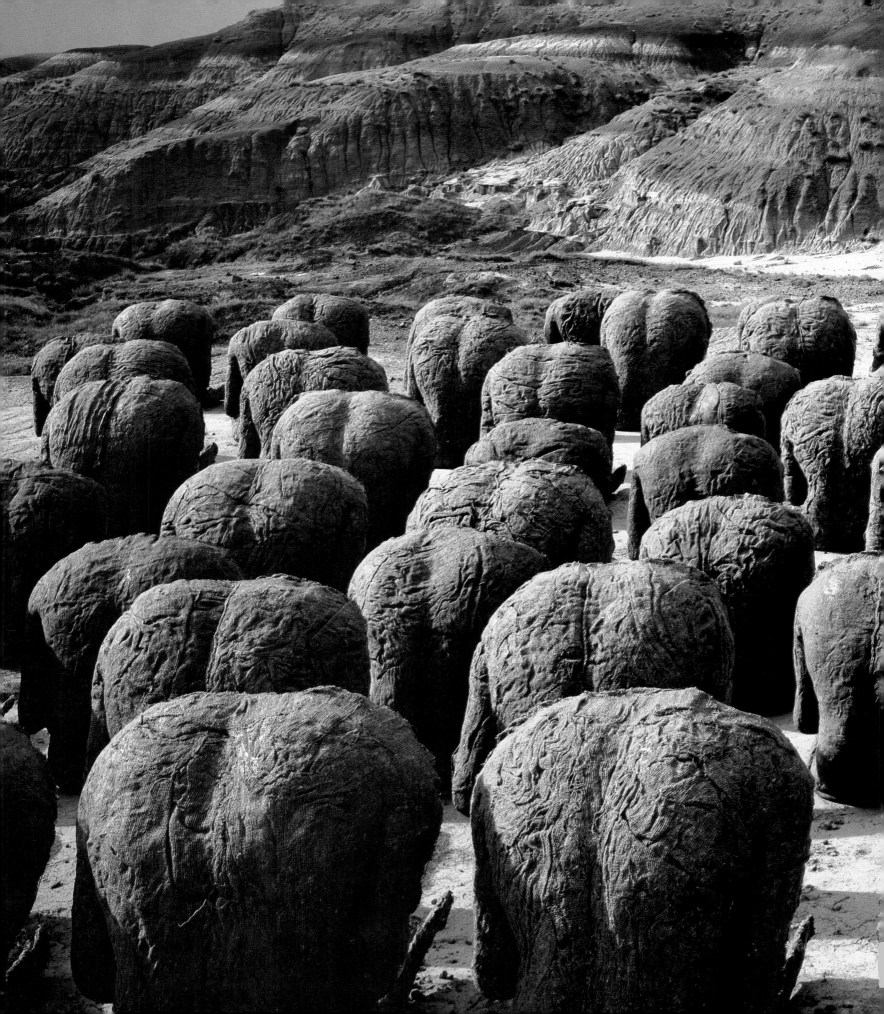

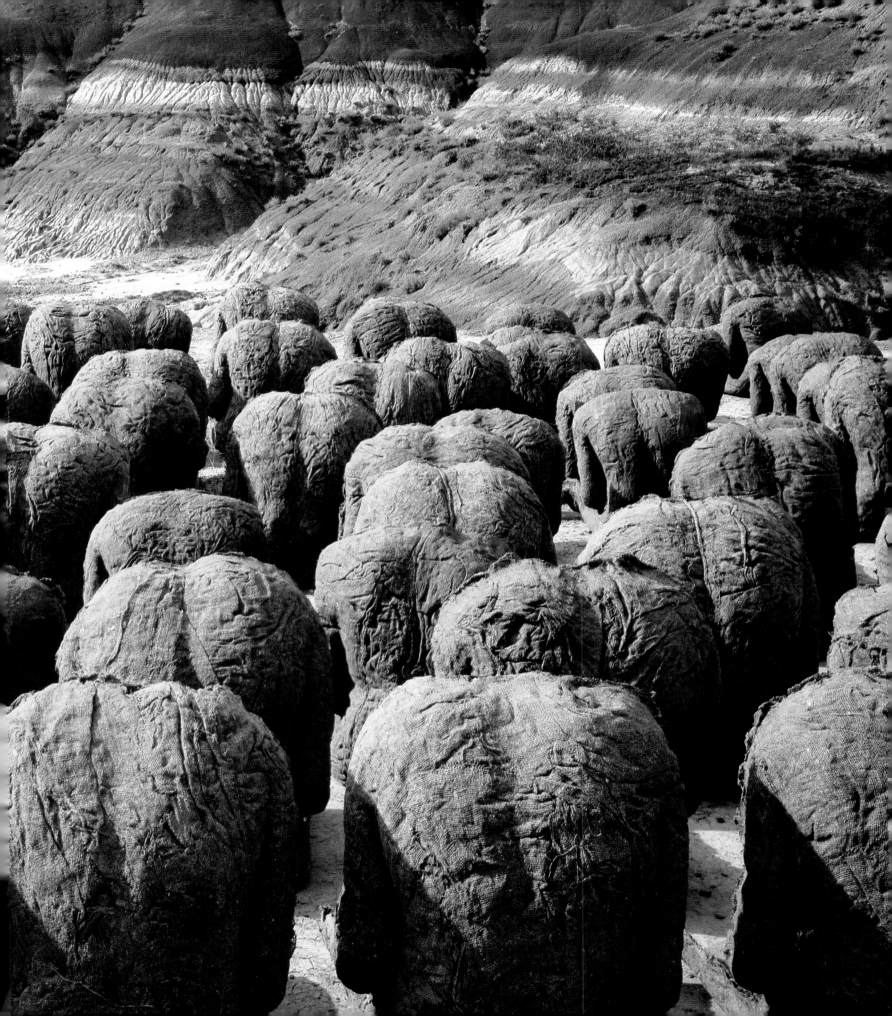

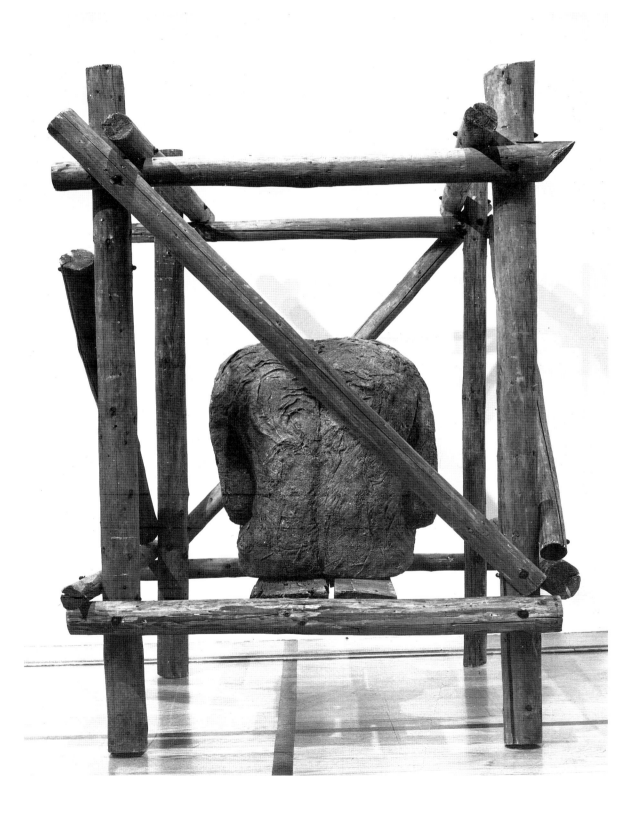

the museum was translated by a young art historian, Kuniko Lucy Kato, who became a lifelong friend. Growing interest in Abakanowicz's art and personality in Japan led to the founding a few years later of an association called Abakano-Kai to raise money to bring her back, and she returned in 1982 to lecture in university centers in Kyoto, Tokyo, and Sapporo.

In 1978, Abakanowicz began a new cycle of soft works, intended to be a coda to the *Alterations*. Eventually she gave it the title *Embryology*, to refer to a science rather than a familiar title from the world of art. For two years she worked, sewing materials like old burlap sacks, gauze, or cotton, and stuffing them with hemp or thread. The biggest were mounted on metal frames. Eventually 680 individual pieces made up the whole cycle; they range in size from tiny pebblelike objects to giant egg-shaped forms.

First seen in the 1980 Venice biennial, then in Abakanowicz's one-person exhibition at the Musée d'Art Moderne de la Ville de Paris in 1982, *Embryology* resembled a dry, stony streambed. Critics have likened the soft stuffed cloth pieces to potatoes and boulders, cocoons and brains. The roughly oval-shaped elements of *Embryology* bear a metaphoric relationship to natural forms and are in that sense neither figurative nor abstract.

Embryology occupied Abakanowicz from 1978 to 1980, a difficult time of tensions and strikes in Poland. Warsaw was gray and bleak, the opposite of the glittering gaiety of Venice where she installed her works in the Polish pavilion in 1980. In Venice, Abakanowicz exhibited a striking group of works that caused an immediate critical sensation: forty *Backs* (shown together for the first time), as well as the hundreds of pieces making up *Embryology* together with the dramatic *Wheel and Rope*. Outside the pavilion, she created wood and cloth constructions that manifested her growing urge to work outdoors. Two who saw the exhibition would play an important role in bringing her work to the attention of the international art world: Suzanne Pagé, then curator and now director of the Musée d'Art Moderne de la Ville de Paris, who scheduled a large exhibition of the work in France for 1982; and Giuliano Gori, a leading Italian art collector, who commissioned a piece for the Villa Celle, his foundation near Florence. This ambitious project would provide Abakanowicz with the opportunity to experiment with bronze in a way that would change our conception of the classical medium.

Even while she was installing her works at the Venice biennial in 1980, Abakanowicz had not known whether the Polish pavilion would be permitted to open. The Soviet Union did not take part in the exhibition, and Russian pressure on Poland was at a high point. In 1981, the Baltic shipping center of Gdansk began to make history as the birthplace of Solidarity and as the heart of the liberation movements that would eventually free Poland of Communism. By the end of the year, ten million Poles had joined Solidarity. Striking workers immobilized the country, and food and goods were disappearing from the shelves of stores. The country was gripped by crisis.

The Cage. 1981

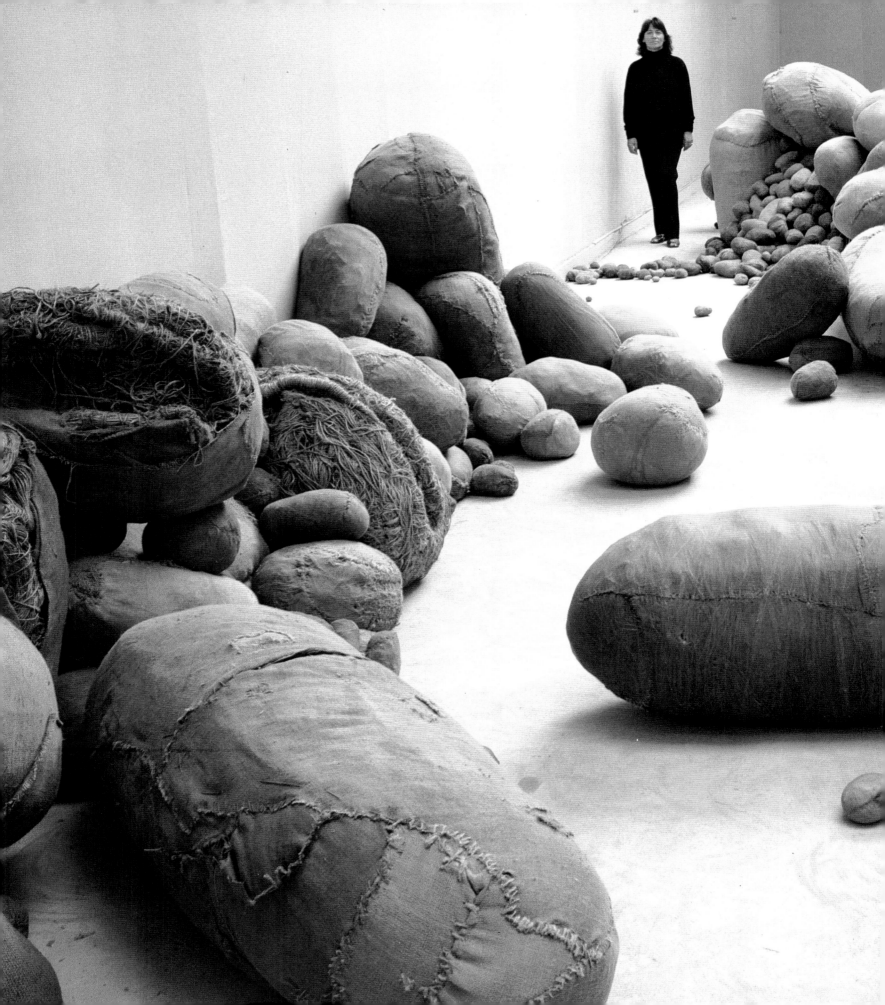

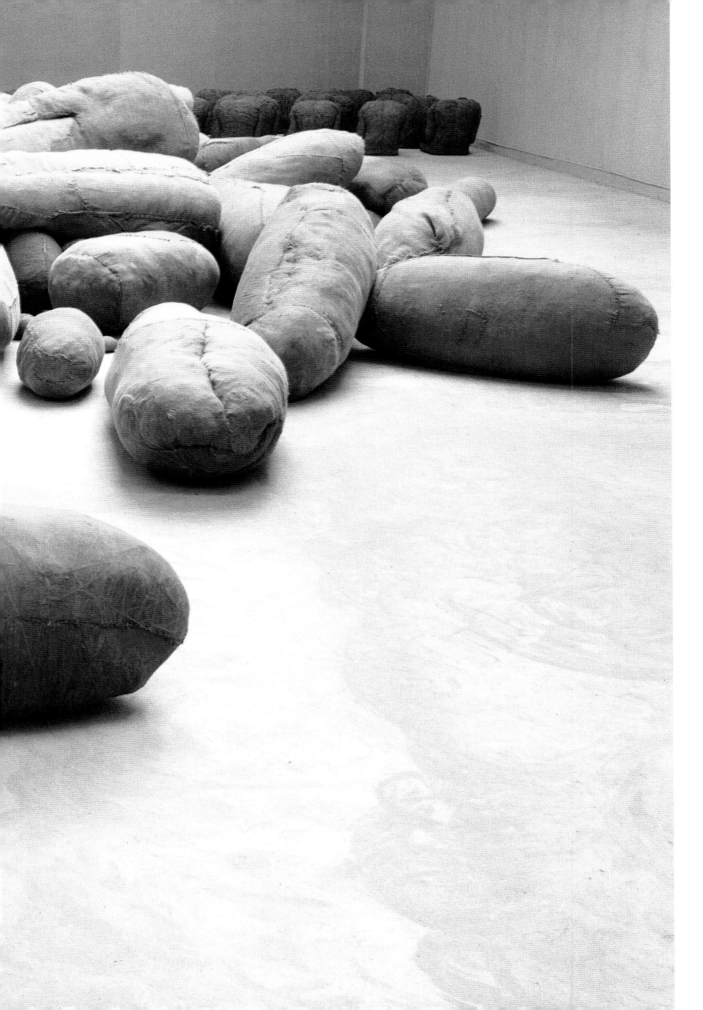

From the cycle
Embryology.
1978–81

That year, Abakanowicz created *The Cage* for an exhibition organized by Solidarity in Gdansk. She decided to make a work more literal than her other sculptures, a primitive construction of logs with one of her *Backs* inside. The seated figure in *The Cage* is one of Abakanowicz's unresolved resonating double images: is this a prisoner behind bars or a master seated on a litter? The metaphor is kept as open as possible; the subjective experience and psychology of the individual viewer determines what will be seen and interpreted. Ultimately, Abakanowicz made three versions of this monumentlike work: one was purchased by the Museum of Contemporary Art in Chicago, one by the National Museum in Budapest, and one by the Museum of Art in Lodz.

Knowing that the Soviets would impose an end to the rebellion, Abakanowicz urged Suzanne Pagé to ship her work to Paris immediately. The curator arrived in time for the pieces to be hurriedly packed and trucked to France. On the night of December 13, 1981, Magdalena and Jan were awakened by tanks passing under their windows. The Polish frontier was closed and martial law was proclaimed. Abakanowicz knew that she had little hope of leaving Warsaw. This made her doubly determined to install her work in the Paris museum, where no Polish artist had ever shown, to call attention to the suffering in her homeland. She was refused on exit visa. However, her prominence was now such that if the exhibition in Paris were cancelled, the world would know that the famous avant-garde artist was being held captive in Warsaw. Two months after the imposition of martial law, Abakanowicz received her passport. The French visa was dated January 11, 1982, the day before the exhibition was to open in Paris. She arrived exhausted and stayed up all night installing the show, which included the full cycle of eighty *Backs*, along with *Trunks, Pregnant, Wheel and Rope, Seated Figures,* and *Embryology*. An exhibition of twenty-one large charcoal drawings for *Faces* and *Bodies* opened at the Galerie Jeanne Bucher the same day. Depressed by the situation in Poland, Abakanowicz skipped the museum opening, the only one of her work that she ever missed. The French public and press considered the show a political manifesto, and the exhibition was widely attended and written about. If the Parisian public responded enthusiastically, however, at home Abakanowicz was reproached by the authorities because the work was seen as having a critical political message.

Abakanowicz had failed to realize how her art externalized and made concrete the pressures that influenced both the individual and the nation. She had worked in total isolation, seeking images from her uncensored unconscious. She was aware that viewers had strong emotional responses to her art and that various interpretations were possible. She once said, referring to the reaction to the *Backs* at the Venice biennial, "I was asked by the public: 'Is it about the concentration camps in Poland?' 'Is it a ceremony in old Peru?' 'Is it a ritual in Bali?' To all these questions, I could answer 'Yes'

Right and overleaf: From the cycle *Embryology*. 1978–81

72

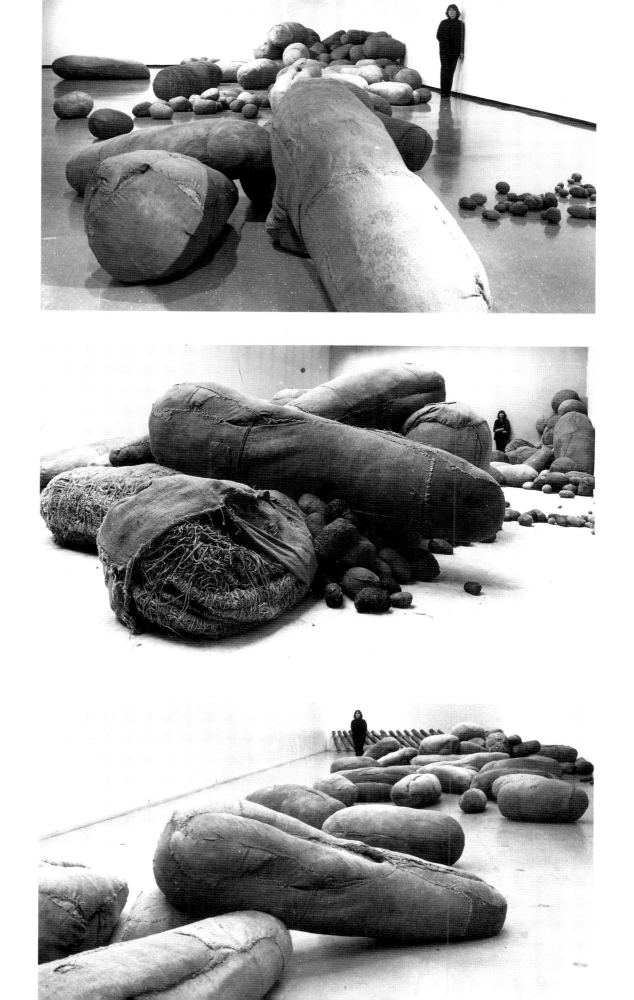

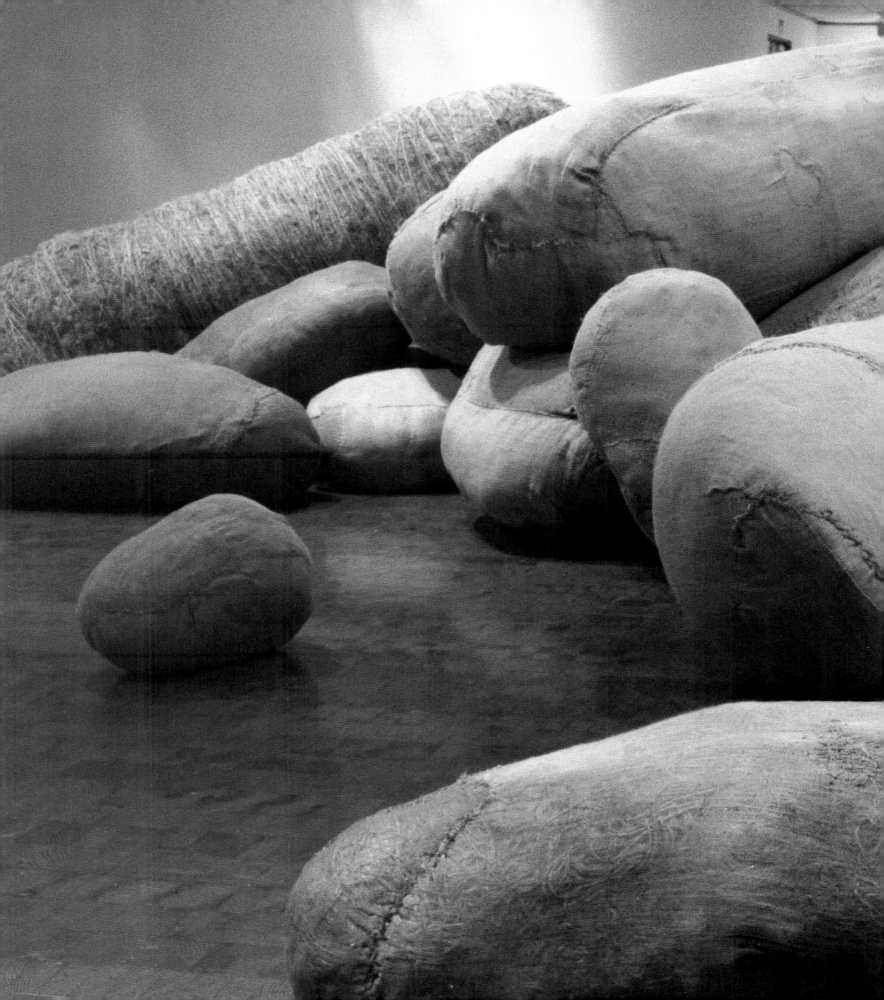

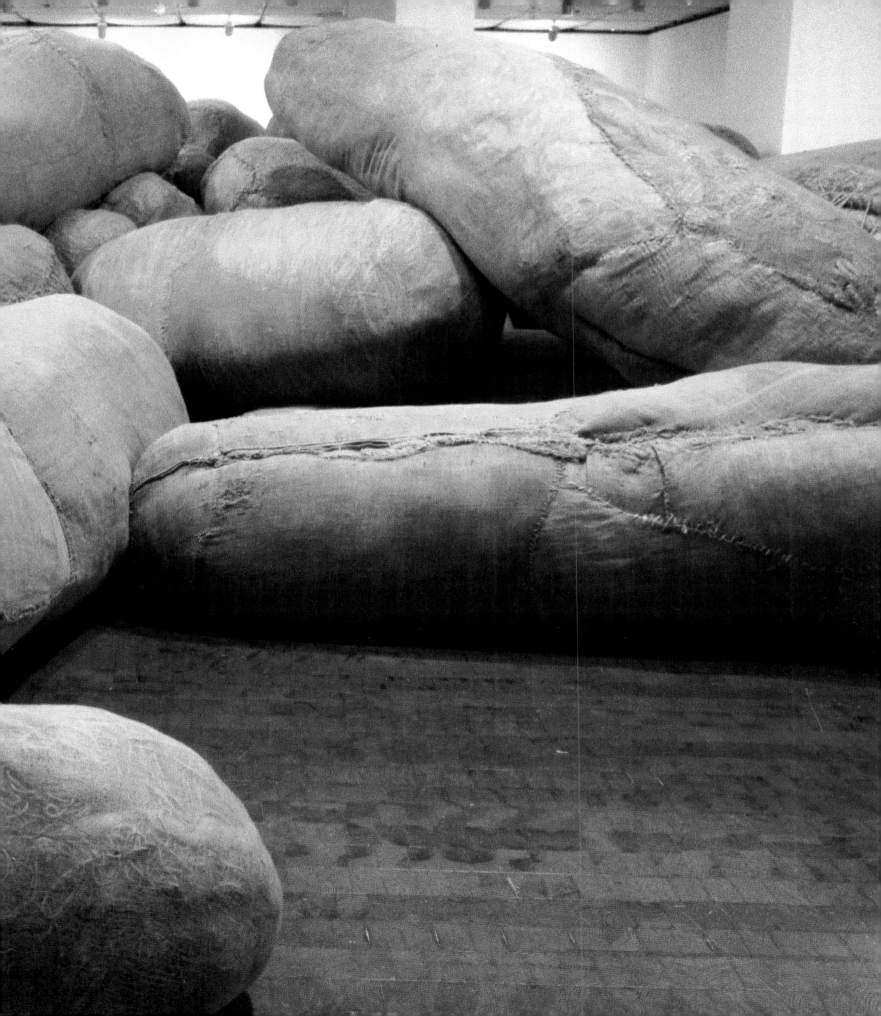

because my work is about the general problems of mankind." She was surprised that her art was seen in the West as a political statement: both inside as well as outside Poland, it was interpreted as a symbol of resistance to totalitarian conformity.

Getting her work out of Poland had always been an immense logistical and economic problem for Abakanowicz. Now the difficulty was aggravated by her notoriety. Her telephone was tapped and her conversations recorded, and she and those who worked for her were placed under surveillance. Yet her art was not officially prohibited or actually blocked from leaving the country, because of Poland's unique position in the Eastern bloc. Of all the nations that the Soviet Union had subordinated to satellite states, Poland remained the most stubbornly independent. The Soviets, mindful of the courage of the Polish people and of their historic animosity toward Russian conquerors, knew that a national reaction was to be avoided at all costs.

Abakanowicz was to return to the forms of her *Backs* a decade after completing the cycle. In the fall of 1992, after an exhibition of her work toured Japan, 6,241 people in Hiroshima signed a petition to the municipal authorities asking that Abakanowicz be commissioned to design a sculpture for that city, as a symbol. In the summer of 1993 she installed a bronze group of *Backs* for the city, a sculpture that she titled *Becalmed Beings.* These virtually abstract forms do not refer in any literal way to the incomprehensible tragedy of the Japanese city any more than the earlier burlap *Backs* made reference to European extermination camps. Yet somehow, we feel that they are appropriate memorials to unprecedented human tragedies.

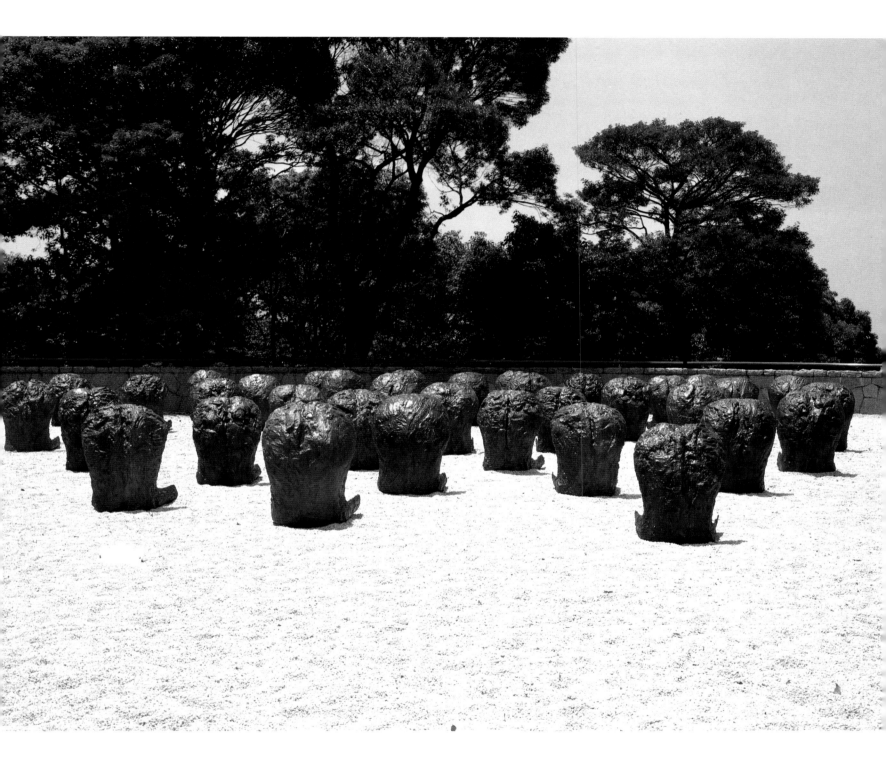

Becalmed Beings. 1992–93

V : Drawing and Painting

I did not yet know how to write. I drew in the earth with a stick. The marks were deeply etched. Then the rain erased them until they disappeared.

I no longer remember when I received my first paper. I drew kneeling on the floor. The lines escaped from the sheet, running along the floorboards, losing themselves in the shadow of the furniture. The drawing could be charged with secret power.

The village women inscribed on their doors signs and letters with consecrated chalk and charcoal. This warded off evil. I wished to know the spells but they were inaccessible to me. Only their presence could divide places into those which were safe and those open to all sorts of forces.

Now, when I draw, areas of those unguarded spaces appear on the sheet.

Magdalena Abakanowicz, 1981

Abakanowicz's earliest drawings done as a child were scratched into the damp earth with sticks. Watching the clay crack as it dried, she thought of the cracks as part of the drawing. However, after the pedantic and inhibiting instruction of the Academy of Fine Arts in Warsaw, where the professor "corrected" her drawings to make them neat and normal, she stopped making drawings for a time. In the early 1960s, as we have seen, she virtually abandoned painting for weaving and, subsequently, the creation of large installations. Although she continues to make schematic notebook sketches for works in progress, she rarely uses drawing to plan these works. Their forms emerge from the contact of her hands with the materials; their scale and arrangement is determined in relation to their sites or exhibition spaces.

In 1981, however, stimulated by her friend the Swiss art historian Jean-Luc Daval, she began to draw a series of *Faces* and *Bodies* in charcoal, and in 1993, she painted a series of heads in dark monochromatic colors that she called *Faces Which Are Not Portraits*. Her preferred position for painting or drawing is kneeling in front of the paper or linen. She used to work this way because of lack of space, then she found it comfortable. Drawing on the ground, as she had as a child, she could give more physical emphasis to her gesture. The *Faces*, which border on abstraction, are less generalized than the three-dimensional cloth and hemp *Heads*. It is significant that Abakanowicz chooses to work in this no-man's-land between figuration and abstraction. We shall see further evidence of her attraction to these border

Abakanowicz drawing

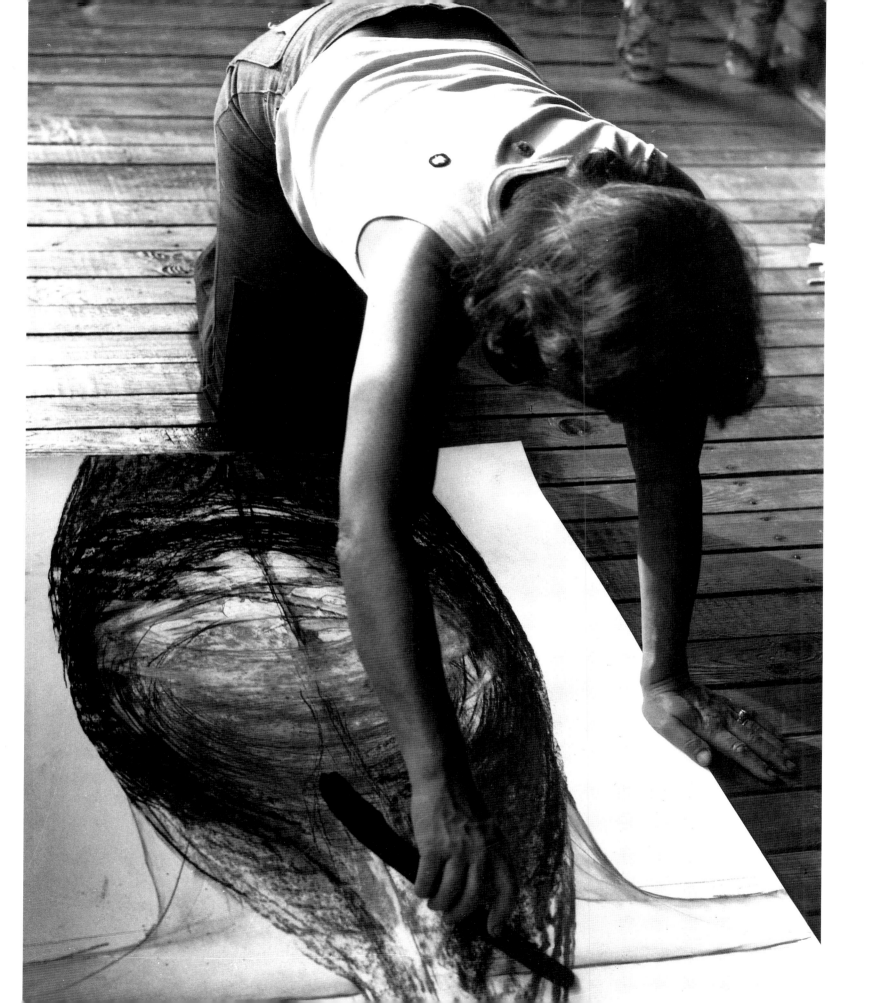

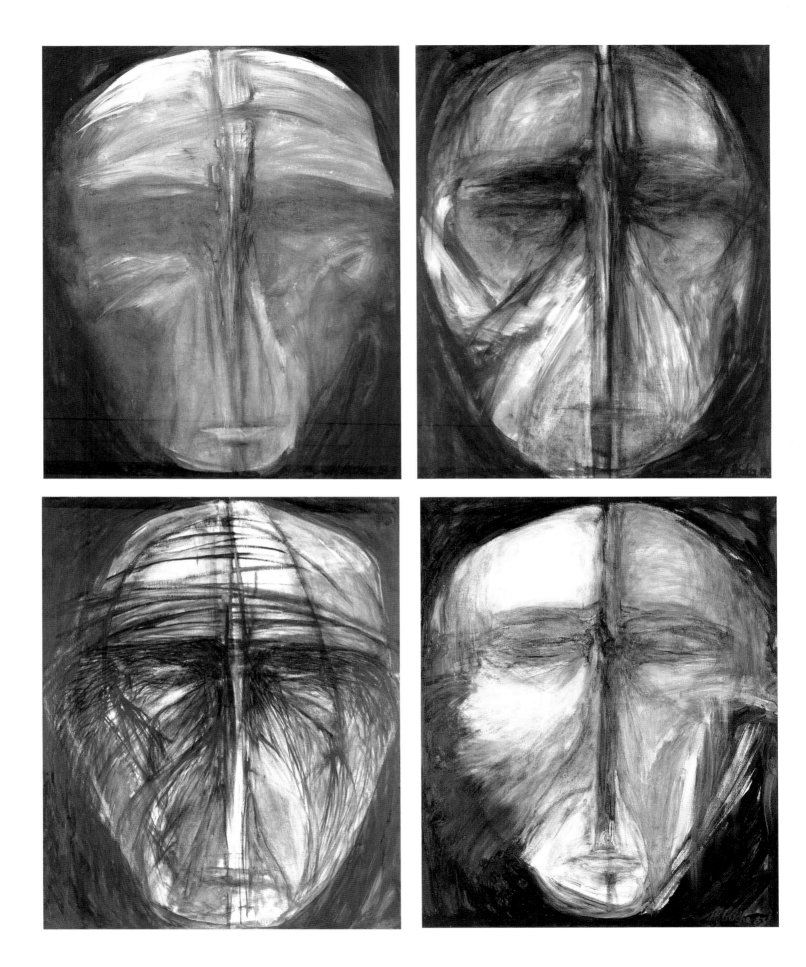

zones where forms and signs are mixed, confusing perception and challenging cognition with the unreconcilable duality of paradox. The amorphous and featureless *Faces*, with their multiple contour lines that radiate energy and their erasures revealing areas of white paper that seem to stand for light shining from within, are portraits of Everyman.

Abakanowicz's drawings with *Bodies* are life-size images of the human torso, elaborated by smearings and erasures, in some cases reflecting months of labor. The texture of these drawings is rich and mysterious, with many layers all but obscuring their inner structure. To start with a rough approximation of an actual size human body, Magdalena asked Jan to lie on his back on the paper while she drew the outline of his torso. Then she began working on the drawing in a very painterly way, bearing down on the thick carbon stick to black in some portions, erasing other parts to create stark contrasts, utilizing chiaroscuro effects for abstract rather than naturalistic modeling.

More complex than the *Faces*, the *Bodies* are double images: by rubbing the charcoal in a circular motion that counterpoints the horizontal/vertical axis of the torso, Abakanowicz gives the impression that the androgynous bellies are swollen. Creating an illusion of transparency through the adroit manipulation of light and dark, she suggests that we are seeing through the "skin" into the interior of the distended body, as through an X ray. Indeed she was once deeply impressed by a series of diagnostic X rays showing the interior of her husband's body. She looked at them carefully, astonished by the soft forms that they revealed.

From the cycle
***Faces Which Are Not Portraits*. 1983**

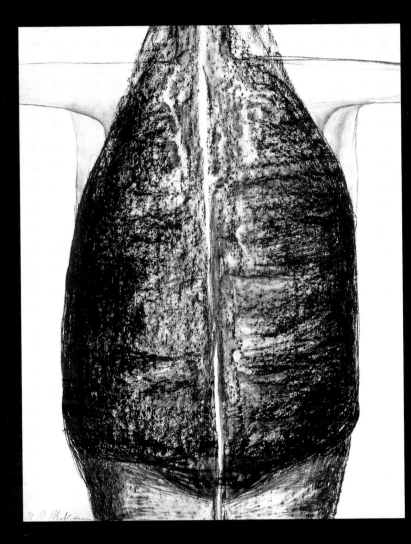

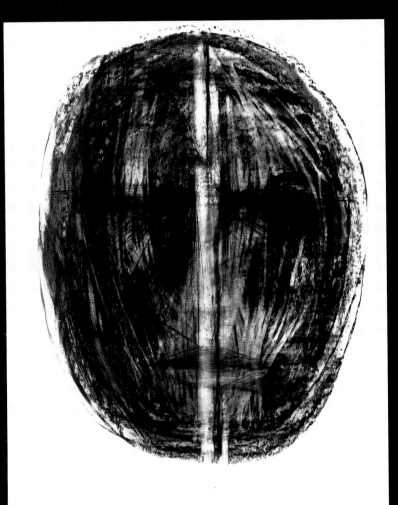

From the cycle *Bodies*. 1981 From the cycle *Faces*. 1981

82

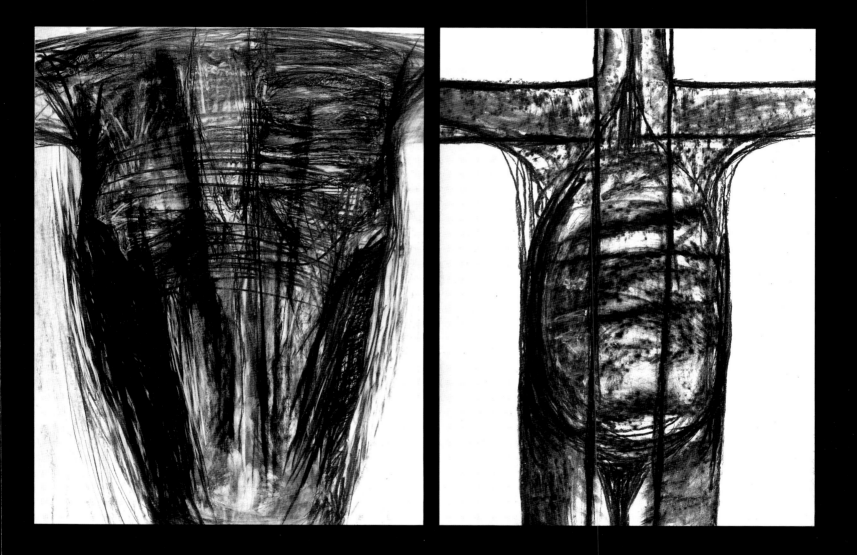

From the cycle *Faces.* 1985 From the cycle *Bodies.* 1981

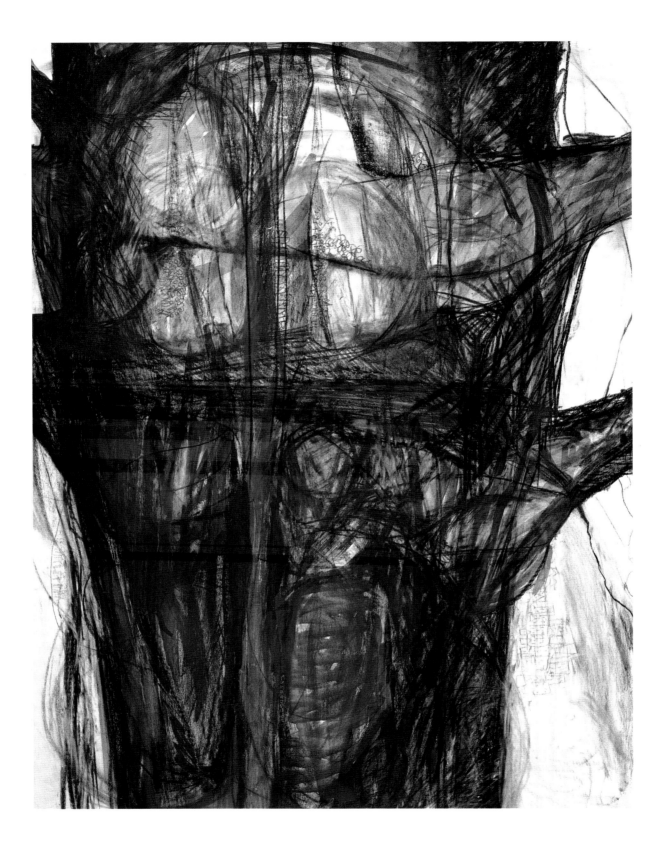

Inside Dwelling Trunk 1. 1992

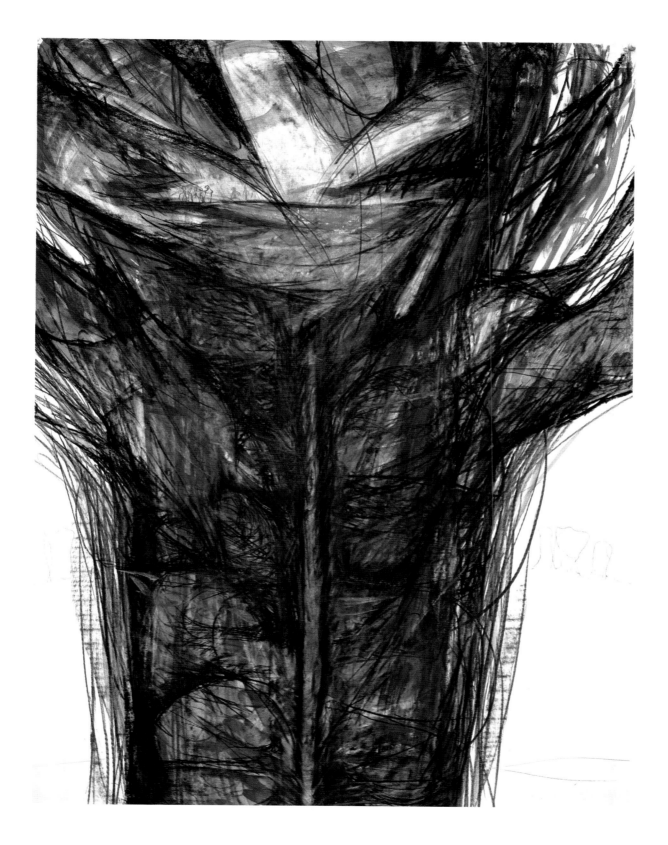

Inside Dwelling Trunk 2. 1992

VI : EXTERIOR/INTERIOR

I travel to America as a pilgrim who wishes to be absolved by others. As a missionary who wants to preach his own truth convinced that it will cure others. As a loner overcoming his timidity to get to know other people. Finally as somebody who carrying his own life displays it on the stall allowing strangers to touch it. And they look at it and touch it and wonder, because everything is so different, as their own life differs from that of the stall keeper. I utter my words of a stranger. They seem to melt in the air soundlessly. Beyond them—friendship of brief encounters, often most durable, based on mutual confidence.

Magdalena Abakanowicz, 1983

Abakanowicz's exhibitions in Venice in 1980 and Paris in 1982 began to establish her as a major presence on the international art scene. The originality of her vision and techniques brought increasing attention from art critics and institutions in the West. Such recognition and acclaim were unprecedented for an artist working behind the Iron Curtain.

During the summer of 1982 she lectured at the Banff Centre of Continuing Education in Canada. It was in the pottery studio there that she made a cycle of sixteen ceramic sculptures she called *Syndrome* that seemed like a return to her childhood experiences with clay modeling. She worked with the clay, as she had as a child, by treating it like dough—rolling out sheets, which she formed into metamorphic shapes, resembling heads or loaves of breads or stones. Fascinated by the materials at her disposal, she used clay in different colors and textures, leaving the resulting forms unglazed with cracks and fissures on the surface. Once again the result was a series of similar but not identical units that together represented a cycle of related but differentiated repetitions of a basic form. The title *Syndrome* refers to the condition that appears to characterize the internal organlike small molded clay pieces. When *Syndrome* was shown for the first time (at the Museum of Contemporary Art in Chicago in 1982), Abakanowicz was asked if she had ever studied the syndromes that effect the human cranium. The questioner was a doctor who later corresponded with the artist, sending her photos indicating skull deformations similar to those in Abakanowicz's clay forms.

In 1979, Mary Jane Jacob, then associate curator at Detroit Institute of Fine Arts, saw Abakanowicz's work in an art magazine and was inspired to visit the artist in Poland. During her stay, she broached the idea of an exhibition for American museums, which took three years to organize. As chief curator of the Museum of Contemporary Art in Chicago, Jacob brought Abakanowicz's first retrospective to the United States. It opened in Chicago

Standing Figure and the Wheel. 1983

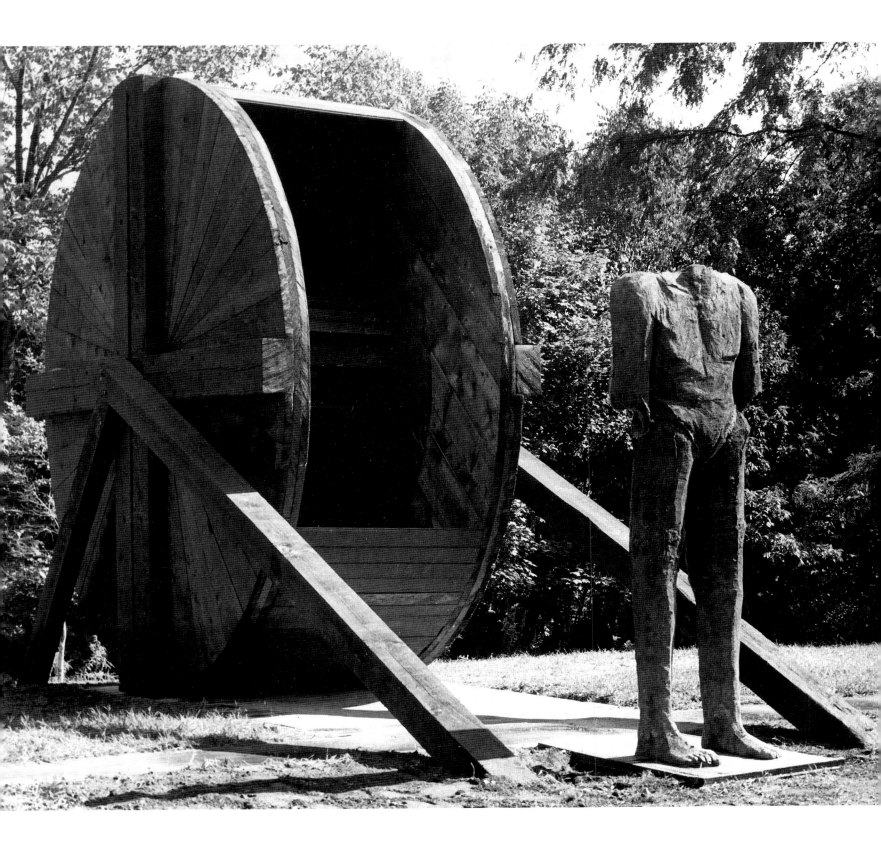

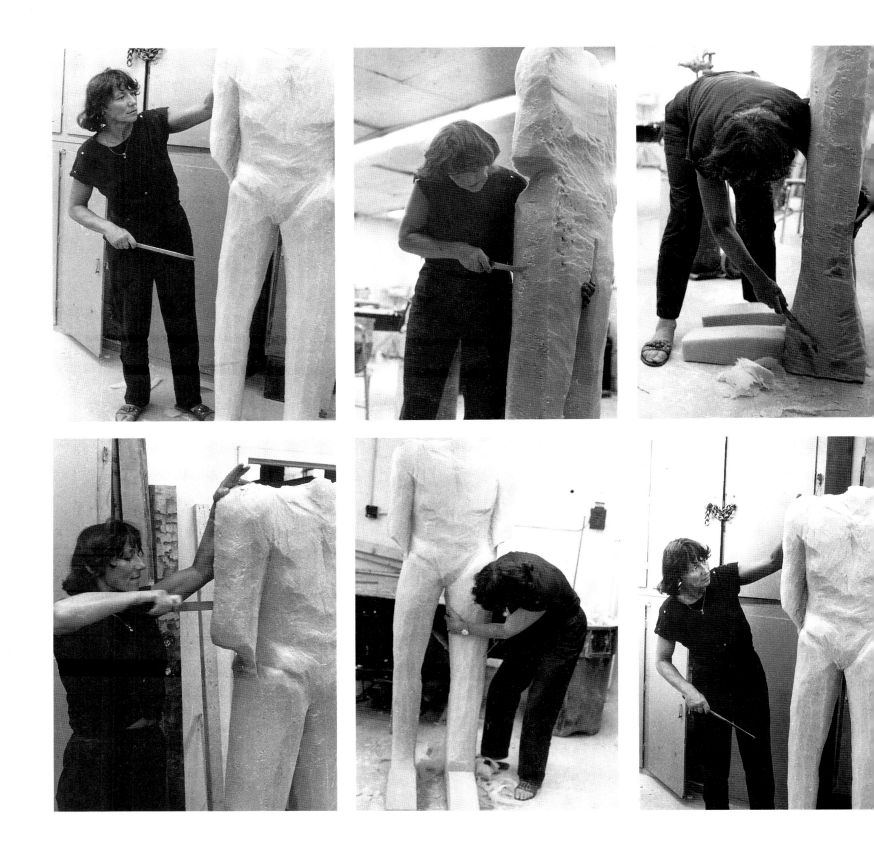

on November 6, 1982, and traveled throughout the United States and Canada for the following two years. At each venue, the artist created a different installation of the *Abakan* and *Alterations* cycles.

At the De Cordova Museum in Lincoln, Massachusetts, the artist was asked a week before the opening to make an additional outdoor sculpture to complement the show. Her idea was to create a huge wheel with a standing figure, related to *Four Standing Figures and Four Wheels*, which she had shown the previous summer at the sculpture biennial at the Openluchtmuseum voor Beeldhouwkunst Middelheim in Antwerp, Belgium. These four headless, standing figures had been made in her Warsaw studio, using the technique of making a burlap sculpture from the plaster mold. To protect them against humidity, she covered the figures with a layer of resin and sand. The enormous wooden wheels, which resembled the industrial cable spool in *Wheel and Rope*, on the other hand, were made from materials found in Antwerp, including railroad ties. The sculpture for the De Cordova Museum would require more durable materials.

The only permanent outdoor work Abakanowicz had made at that point was the welded steel sculpture in Elblag in 1965, almost twenty years earlier. At the De Cordova, she found that it would take a month to produce a bronze standing figure, but that she could cast an aluminum figure in a few hours using a Styrofoam model. Professor George Greenamyer of the Massachusetts College of Art became her adviser and helper. After carving a figure from a Styrofoam block, she cut it into three parts: one to use to make the mold for the torso and two for the molds for the legs. The Styrofoam models were buried in sand. Then the plastic foam was burned away as liquid aluminum was poured into the molds, making a memorable spectacle. The three parts were then welded together.

The figure in *Standing Figure and the Wheel* was not cast from a living person but from a roughly carved sculpture whose surface deliberately preserved Abakanowicz's emphatic knife marks. Again, Jan was her model. The process of sand casting gave the surface a rough, grainy texture resembling lava stone that pleased her, because she wished to avoid the slick and shiny quality of aluminum. There were defects as well, imperfections that she cultivated rather than eliminated: the perfection of the machine-made and the brand-new had always been anathema to her. Once cast, the aluminum was gray like certain rocks, which made it seem powerful and mysterious. The wooden wheel with its exposed interior was built by Artur Starewicz with the help of the students. The circle constantly makes an appearance in Abakanowicz's work: the *Red Abakan*, *Brown Abakan*, and *Yellow Abakan* are all great circles, as are the stone disks she would cut out of limestone in the Negev desert eight years later.

The De Cordova Museum aluminum figure became the prototype for a series of sculptures incorporating single figures, such as figures in cages, fig-

Opposite:
Abakanowicz carving the model for the figure in *Standing Figure and the Wheel.* **1983**

Overleaf:
Four Standing Figures and Four Wheels. 1983

Pages 92–93:
Androgyn With Bricks. 1984

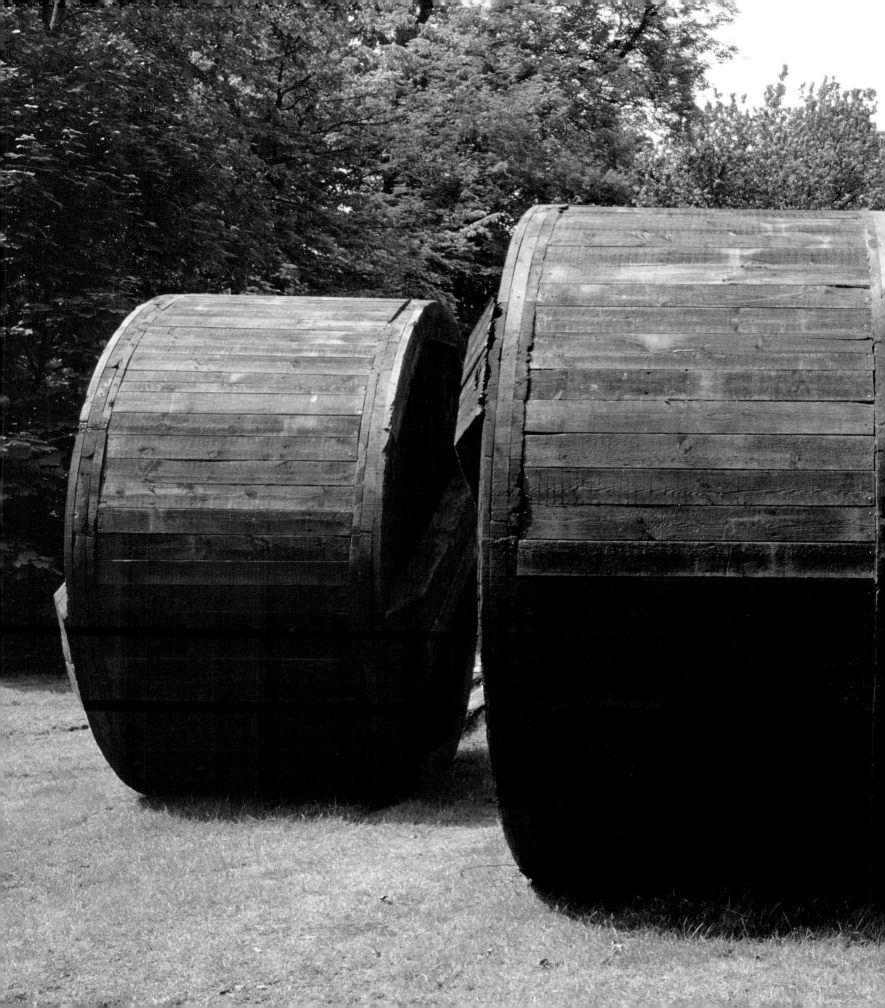

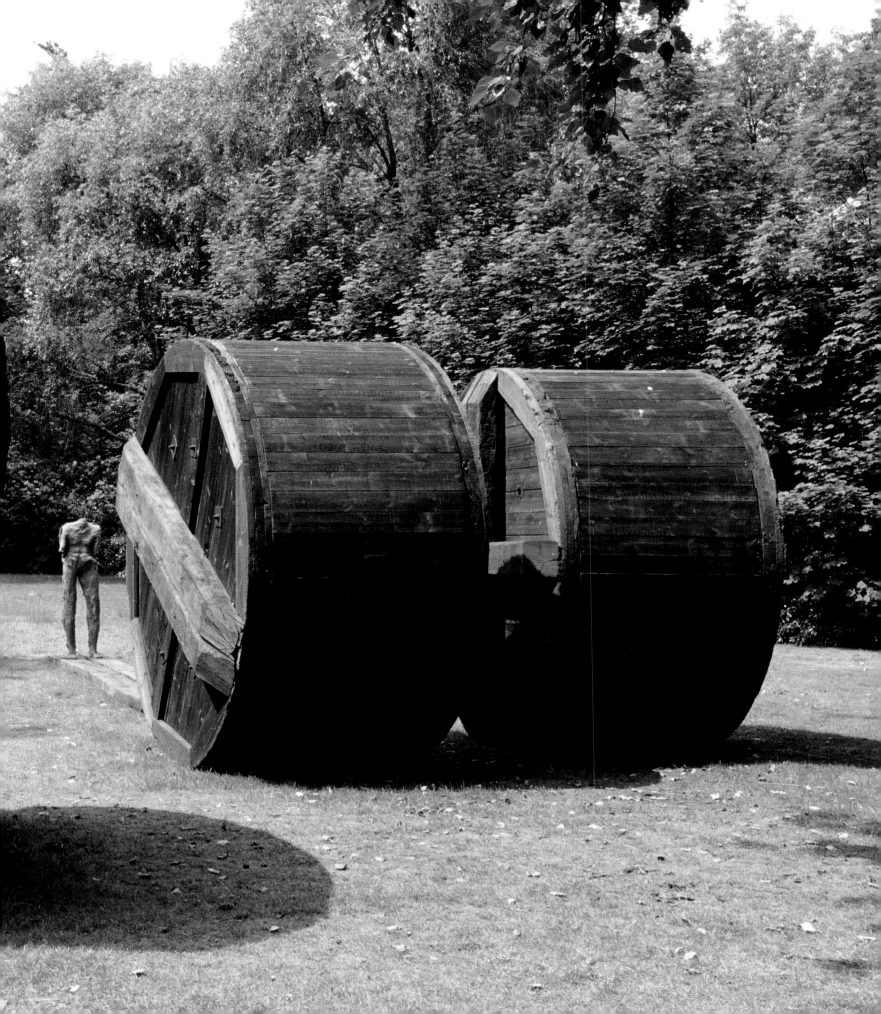

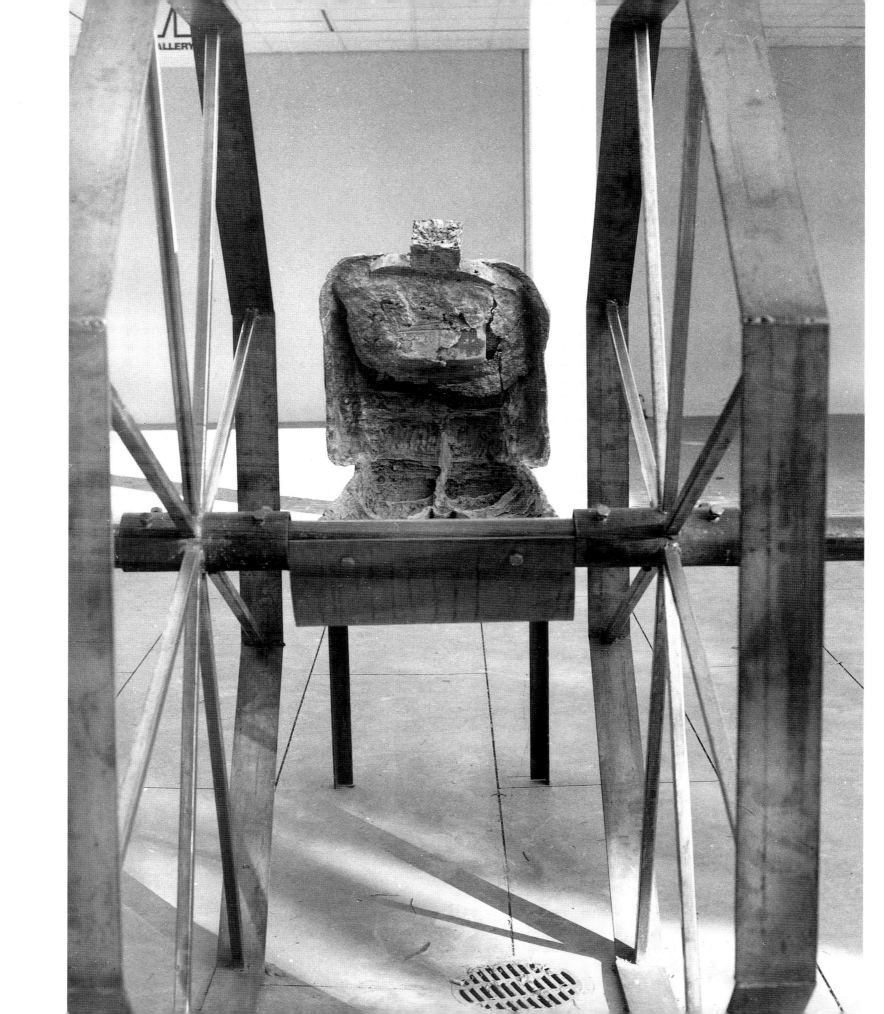

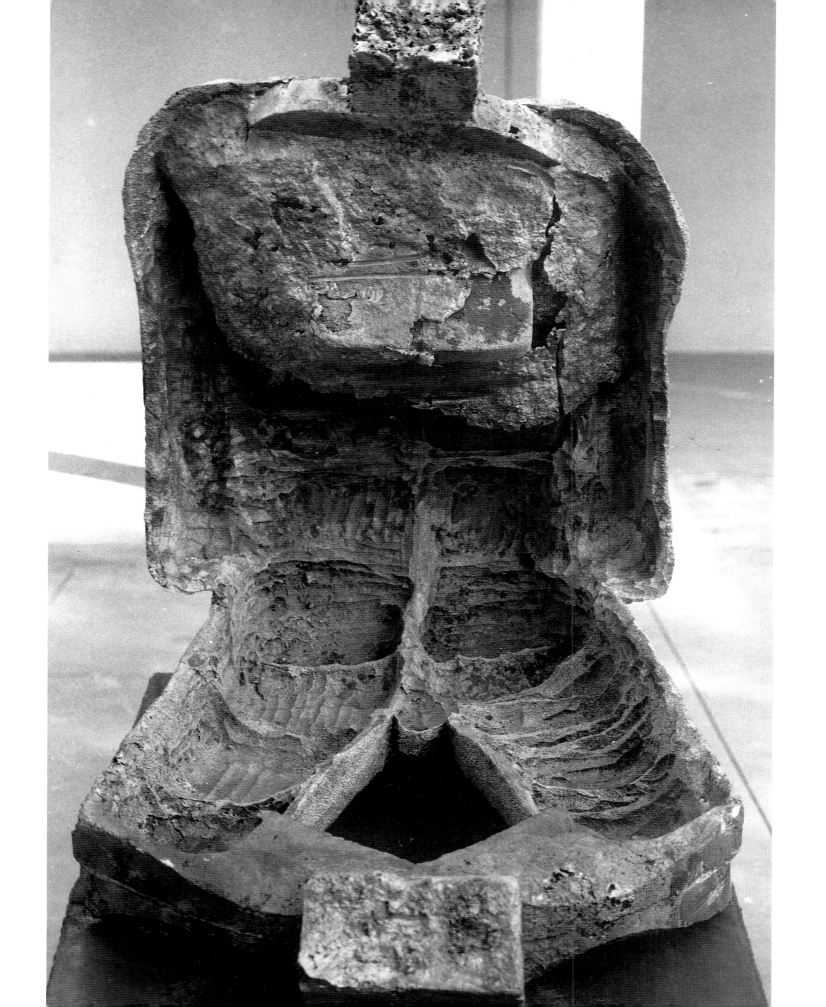

ures in pyramids, and also the *Androgyns*, many of which are figures sitting on different vehicles. All of Abakanowicz's figurative sculptures intentionally lack gender differentiation. Once again we find ourselves in a border zone of blurred definitions. This open-endedness is deliberate, because the artist does not believe in closed, finite, and easy identifications. Her experience taught her that human characteristics and behavior constitute a gray spectrum far more complex than the simple polarities of black and white. To segregate bodies by gender or race would limit the universality of her art.

The single figures also explore another constant in Abakanowicz's work: her concern with making the inside of a form as visible and as important as the exterior. In the *Abakans*, openings and slits offered literal means of entrance or else evoked the notion of penetration. It is significant that parts of the *Embryology* series; some of the twenty-three forms called *Pregnant* dating from 1981, made from birch twigs and wire twined on iron armatures; and the six pieces made a decade later that she called *Geminati*, a scientific name for complicated mineral crystallization structures, have transparent or semitransparent coverings through which their innards may be seen. These pieces all use highly textured, diverse types of materials with tactile qualities that intensify the viewer's response to them, provoking visceral sensations.

Abakanowicz's references to internal organs, her invitation to look inside the body cavity itself, implies an intimacy with the viewer that is emotionally far more shocking than the superficial sensationalism of "Body Art," in which the artist narcissistically exposes his or her own body in performances, photographs, and video. Much of the power and intensity of Abakanowicz's work derives from her daring to disgorge material from her deepest unconscious and make use of it in her charged images. The process is painful and difficult. She says that she does not fully understand what force is building up inside her. At first she was disturbed that she often gets physically sick while realizing a cycle of work. The original idea for a new work appears to her as a vague form, but its real shape and structure emerge as she works on it, adding and subtracting, accepting and discarding until she is satisfied with the result. Asked if she thought of her works as objects, the artist replied that on the contrary, to her they seemed slumbering existences that could come to life at any moment in the studio.

In this connection we must remember that Abakanowicz came to think of the role of artist as that of a shaman who absorbs the collective sickness of the tribe or society in order to effect a cure through spiritual exorcism or purgation of the psychically or physically toxic material. She experiences the creation of a sculpture cycle as a period of gestation followed by illness or near illness, which ends only when a work takes on final form, becoming a concrete entity, separate from the artist herself.

Abakanowicz's interest in shamanism is not unique to her. It could be argued that the major change effected by postwar art is the redefinition not

Androgyn With Wheels.
1988

Overleaf:
Androgyn I. **1985**

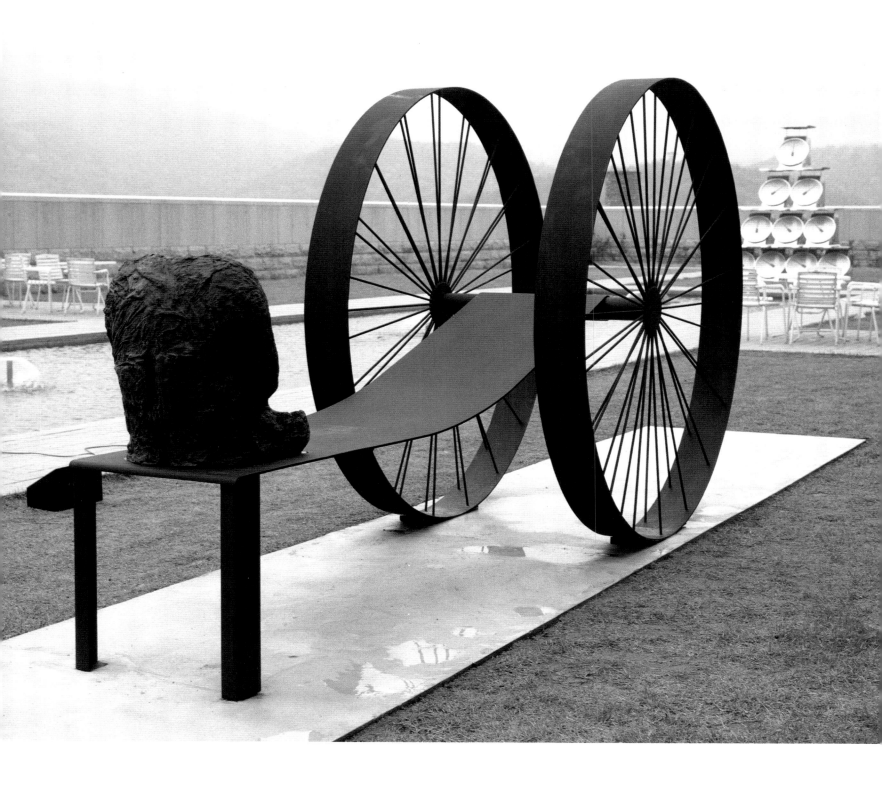

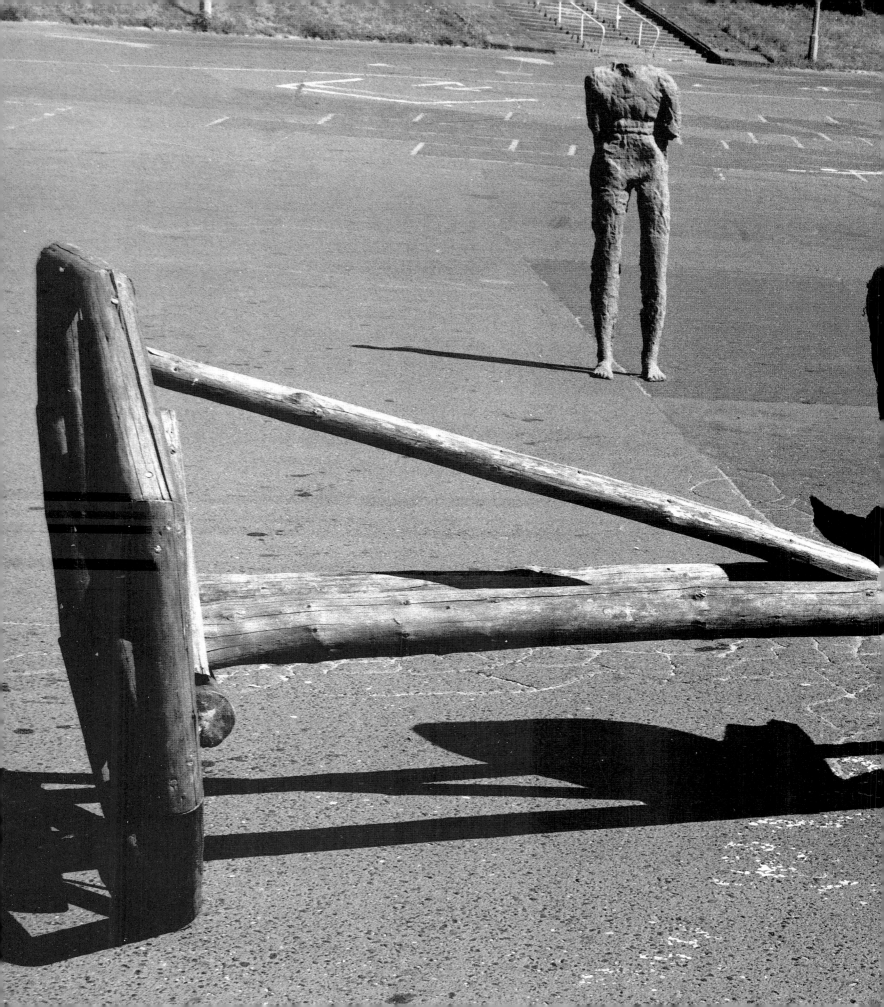

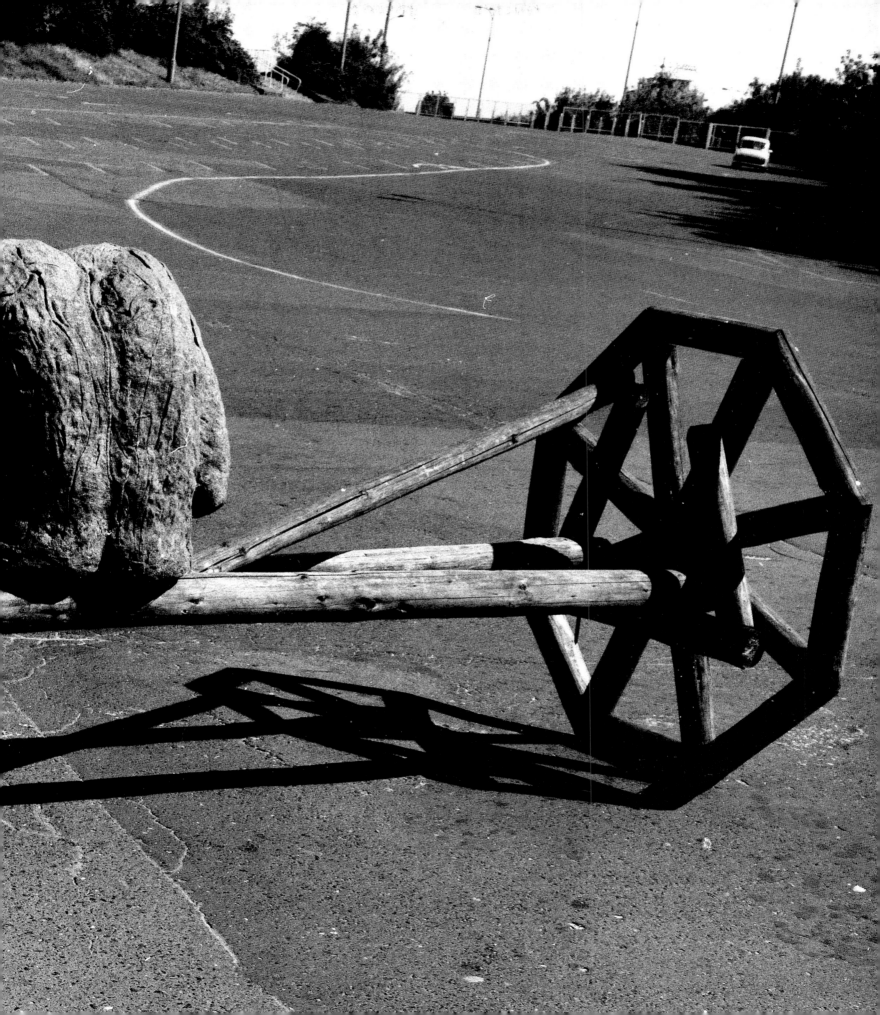

of the forms of art but of the role of the artist, who once again claims a priestly, as opposed to a court decorator's function. Certainly, by the time Jackson Pollock began working in a trance state, this transformation of the function of the artist was well underway. When Joseph Bueys made shamanism the central focus of his art, it began to be clear that not the forms of tribal art but *la pensée sauvage*—the authenticity of savage thought—was what was at stake. Abakanowicz grasped intuitively that if art were to have meaning, the artist would have to return to its origins in magic and mystery and accept suffering, not in the modern European sense of "romantic agony," but in the deeper psychic sense suggested by tribal thinking. This epiphany enabled her to absorb into her art much that otherwise would have been unbearable.

This page:
From the cycle
***Geminati.* 1990**

Opposite:
From the cycle
***Pregnant.* 1981–82**

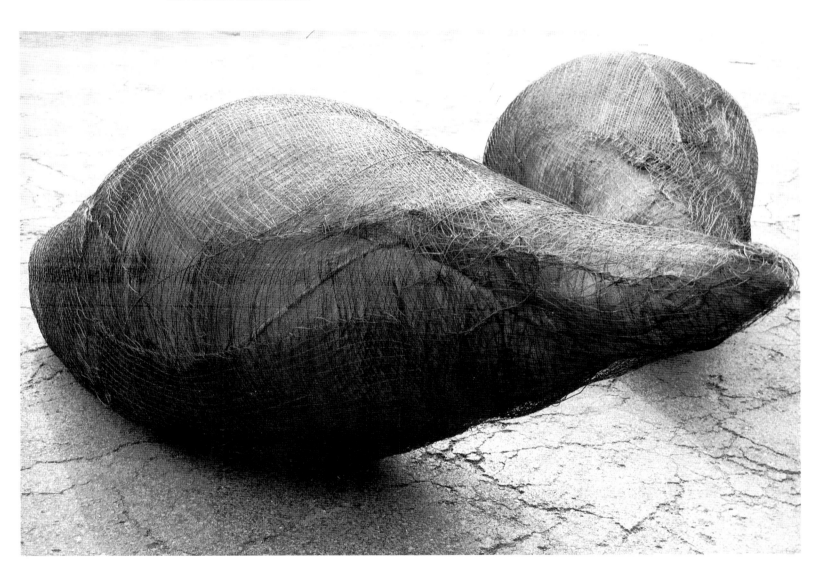

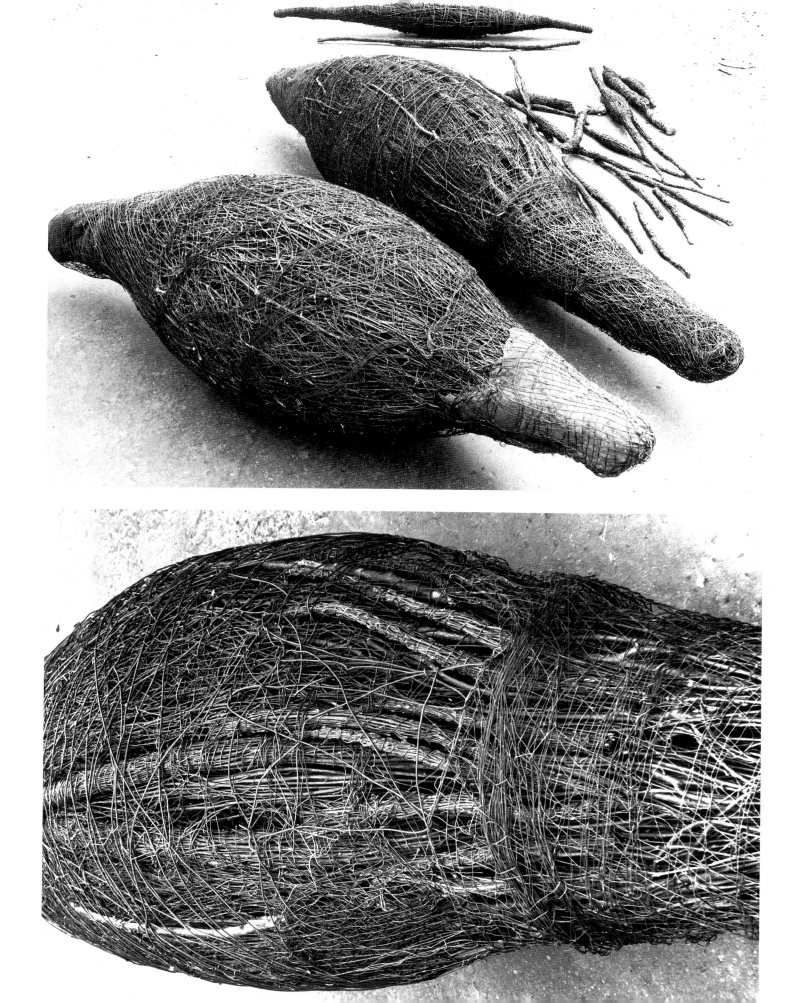

VII : KATARSIS

Katarsis is of a material more lasting than life. Perhaps because I hoped that the signs left behind would be for others a lasting anxiety. Perhaps it was a defiance of my own views, an urge to question the accomplished. Perhaps an awareness that constant immobility is stronger than changing situations. . . .

Katarsis could come into being only in Celle. I needed that polemic with the park full of sculptures. I needed that landscape in which one wants to remain as a permanent part.

Magdalena Abakanowicz, 1985

Casting a figure in aluminum was an important turning point for Abakanowicz. Until that time, burlap with glue and resin had been her primary media for making human figures. After her experience at the Massachusetts College of Art, she cast an aluminum figure with the students at Fullerton State University, during a stay in Los Angeles as a visiting professor at UCLA. *Androgyn with Bricks* (1984), a large aluminum cast figure on a welded vehicle, remains in the University Sculpture Garden.

In January, 1985, Abakanowicz went to Italy to visit the collector Giuliano Gori. Gori's Villa Celle in Santomato di Pistoia in Tuscany houses one of the best collections of contemporary art in the world, including an exceptional selection of sculpture in a large park. The encounter between a unique and difficult patron and a unique and difficult artist was intense. Its outcome was a masterpiece of twentieth-century sculpture. Gori had seen Abakanowicz's installation at the Venice biennial in 1980 and invited her to repeat the composition of seated *Backs* for his indoor museum, a task that did not interest the artist at all. Furthermore, when she finally came to the Villa Celle five years later, she was deeply disappointed. Walking through the grounds of the romantic park filled with modern sculpture, she felt art had been trivialized; forced into the same decorative role as waterfalls, flower beds, and tailored hedges.

In a defiant mood, she chose a scrubby piece of poor land in a grove of olive trees, outside of the luxurious sculpture park and fenced by a stone wall and barbed wire. The Italian patron had never intended to put an artwork on this site: Gori finally agreed, but balked at the idea of the large group of sculptures that Abakanowicz wanted to put there. Determined to convince him, she made a slide presentation on a wall of his eighteenth-century villa, showing dense arrangements of *Seated Figures* and *Backs*. Gori was

intrigued, but he was still hesitant about the ambitious and unprecedented group of standing figures that the artist was proposing. Returning to her hotel room, she composed a 1:100 model of a sample figure overnight. Her plan called for thirty to forty figures forming a large rectangle in the remote field.

With some trepidation, Gori accepted the project. Abakanowicz was willing to execute her idea in any material. Gori took her to the marble quarries of Cararra, but marble proved too costly. Casting the figures in concrete turned out to be too complicated. In the meantime, Abakanowicz carved the first full-size figure out of Styrofoam: it was 8½ feet high, almost 3 feet wide at the shoulders, and 1⅓ feet deep. Gori was elated, and he immediately took the prototype to the Venturi Arte Foundry in Bologna. Magdalena had no objections to casting the figures in bronze, although she had worked with the material only once before.

The Venturi foundry used a sand-casting technique that promised fast execution of the work. This was essential because after studies of the site and calculations made with her husband, Abakanowicz had decided that she would need thirty-three figures. They would have the appearance of having been sliced open, as if they were the skins of organisms bisected vertically: their general shell shape derived from the forms that she had used in her *Abakans*, *Heads*, *Backs*, and *Embryology*, and in her drawings.

She began by carving each full-size figure out of Styrofoam blocks with a heavy kitchen knife. Then, at the foundry, after the model was imprinted in a mixture of sand and resin that hardened into a mold, she formed the "interior" surface of each one in the mold itself, with Plasticine strips. A mold was then made of the interior with its skeletal structure, and this, with the first mold, was used to cast the figures in bronze. Nobody had ever used the interior of a bronze form as an integral part of a sculpture: the inside surface of a cast-bronze piece is normally invisible. The first bronze figure for *Katarsis* was so unusual, so unexpected, that both Abakanowicz and Gori were initially startled by it, then enthusiastic. Each of the thirty-two that followed was slightly different. Abakanowicz worked for months refining the angular indentations that articulate the simplified shell forms until they were as sharp and precise as cut gems.

Abakanowicz created the figures in a state of trancelike concentration, as she worked through the stages of alteration, rejection, and, finally, acceptance of the emerging figures. Later Abakanowicz recollected this creative process:

Katarsis—the decision came abruptly, in the way that excess must boil over. I seemed to be an onlooker, astonished by what was growing inside of me. Removed outside it swelled and took on force and personality. I felt oneness with the forms that were arising. I was happy in that unity.

Overleaf:
***Katarsis.* 1985**

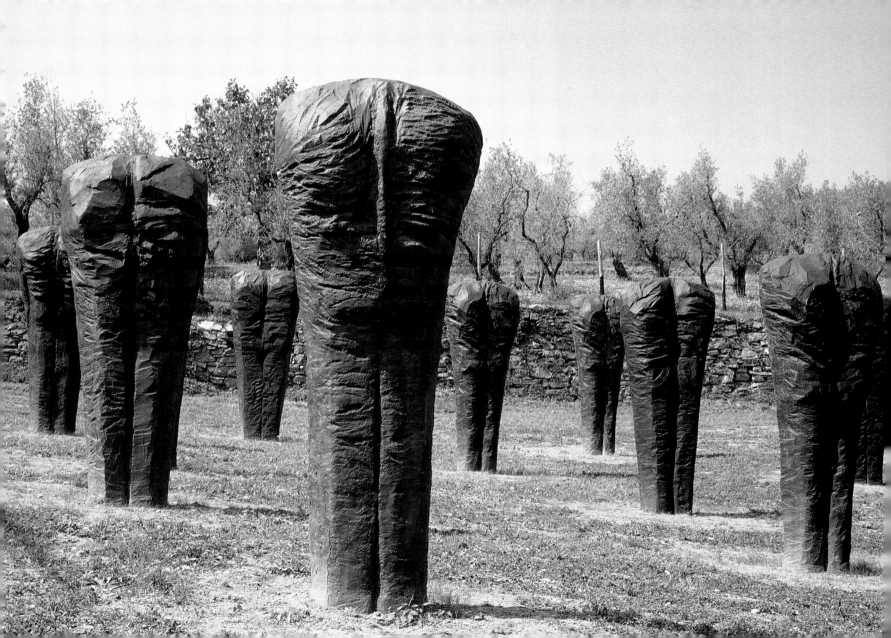

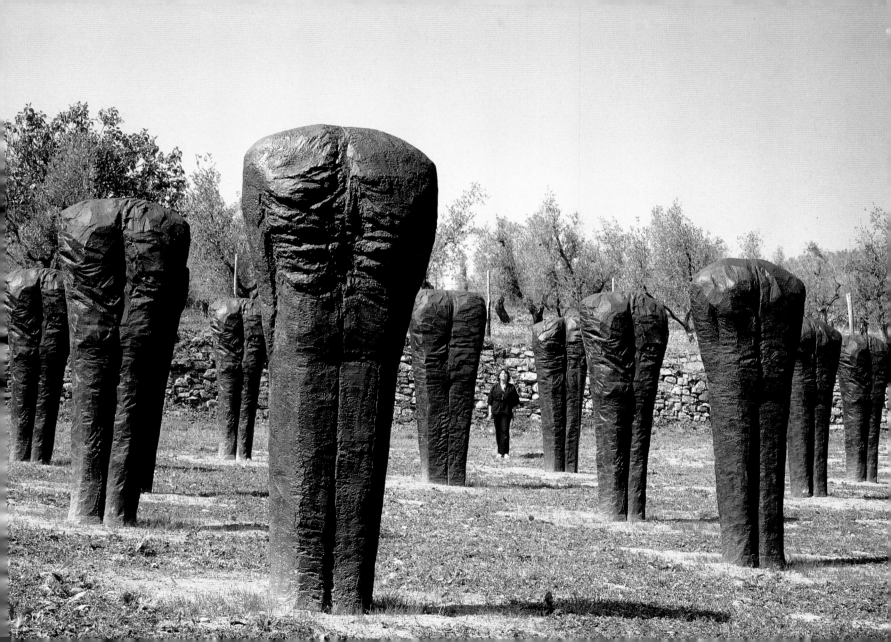

Below the house, a valley filled with mists stretched from Pistoia to Florence. I watched listened to the stillness.

Taken to the foundry, the white figures were brutally hacked into shreds. They were no longer needed once they had lent their impress to the earth, to be given enduring shape in bronze.

She did not finish the bronze in the traditional way, but left the patina in a raw state to be weathered by the elements. Each year the color of the bronze trunks is closer to that of the rough bark of the nearby olive trees. Even when using a material associated with the most sophisticated civilized art, she managed to avoid unnecessary refinement by leaving some of the rods that formed during the bronze-casting process and are normally cut off, and by allowing nature to create its own uneven patina as the pieces are exposed to the sun and rain.

To arrange the bronze sculptures, Magdalena and Jan built a maquette of the site and moved scale models of the figures around, breaking away from a straight grid pattern. The whole composition became for Abakanowicz a kind of counterpoint to, and an argument against, the adjacent sculpture park. The bronze trunks inevitably suggest the complex ongoing dialogue between nature and culture that has preoccupied philosophers since the Renaissance.

The truncated figures seem to grow directly from the earth. Abakanowicz heard their fate in the name she chose for them: "The Greek word *katarsis* embodies a group of sounds in which I hear metal, the rasp of cutting, the drama of destruction. There is a tension built up through the broad first syllables KA-TA and tightened in the knot of the hoarse ambiguous RSIS." She read in the *Encyclopaedia Britannica* that in Greek *katarsis* meant "purgation" or "purification," and specifically, in Aristotelian theory, the purgation of pity and fear through tragedy. In modern times, the concept of catharsis underlies the cure of trauma through the psychotherapeutic process of digging up and confronting repressed and buried memories. In both ancient and modern versions, catharsis is the release of the emotions repressed in the denial of a painful, wounding tragedy, either collective or individual. As familiar as we are with historic events that leave traumatic scars on all those who live through them, we understand how important this moment of creating a permanent monument to those experiences was for Abakanowicz.

Casting her shapes in bronze, the traditional material for commemorative and monumental sculpture, she made her peace with permanence. In retrospect she realized: "Katarsis is of a material more lasting than life. Perhaps because I hoped that the signs left behind would be for others a lasting anxiety. Perhaps it was defiance of my own views, an urge to question the

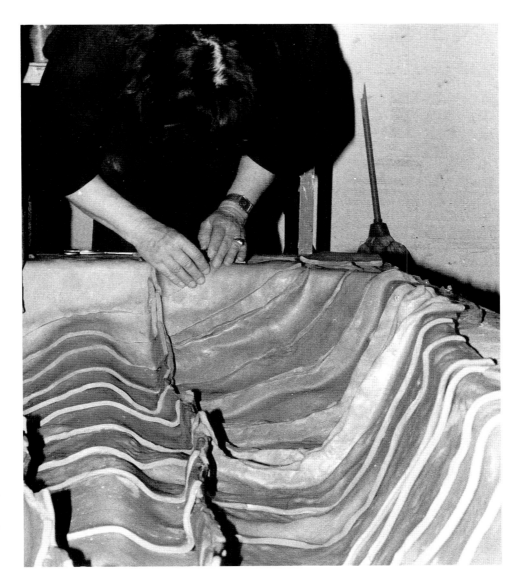

Abakanowicz preparing the model for the interior surface of one of the figures in *Katarsis*, Bologna

accomplished. Perhaps an awareness that constant immobility is stronger than changing situations." It is significant that Abakanowicz chose the Greek spelling of *katarsis* rather than the Latin term ("catharsis") for the psychoanalytic treatment. The Greek word relates to the collective experience of the audience explained by Aristotle as a theatrical purgation of empathetic feelings of pity and fear. The ancient Greek interpretation of the process of catharsis is directly descended from the prehistoric shaman's task of absorbing collective guilt and fear and other psychoneuroses. Through rites exorcising evil spirits to cleanse and purify the sick soul, the shaman reestablishes the balance between nature and man. As we have observed, this is how Abakanowicz conceives of her role as an artist.

Following pages:
***Katarsis.* 1985**

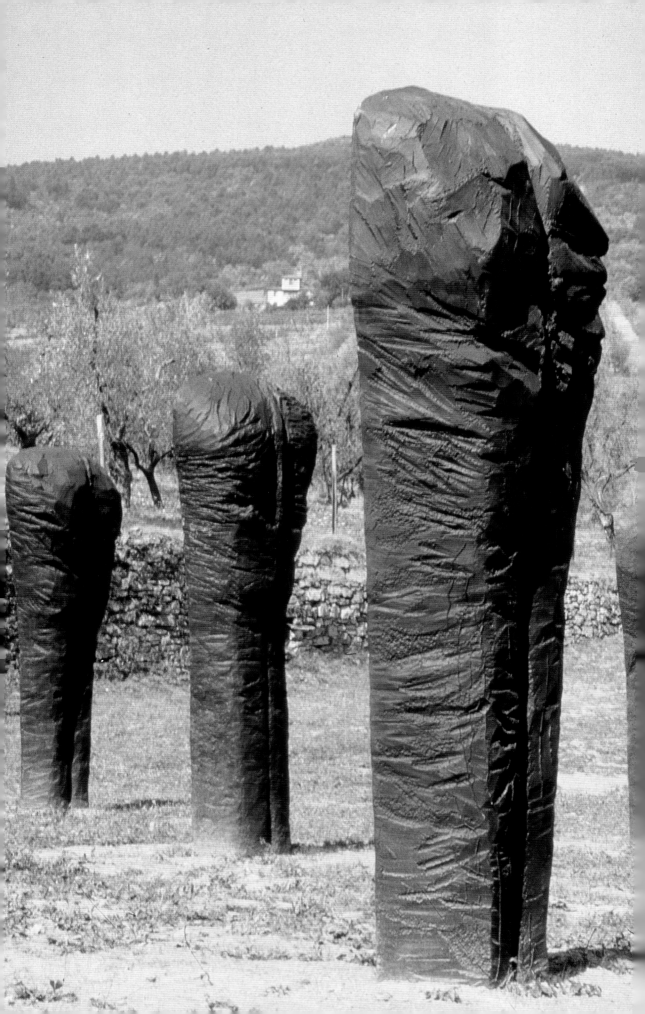

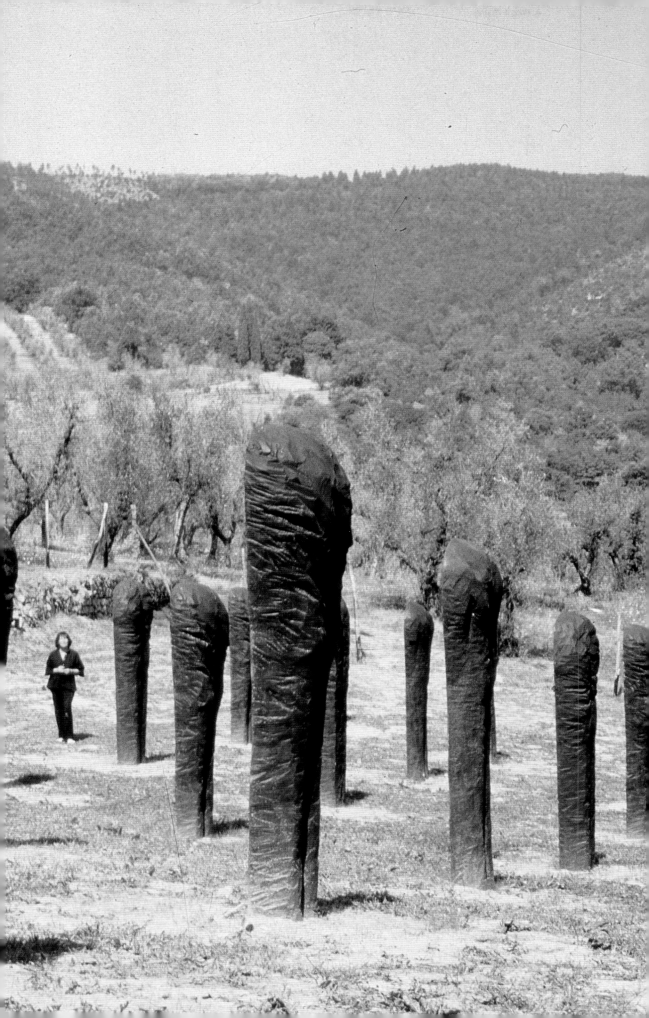

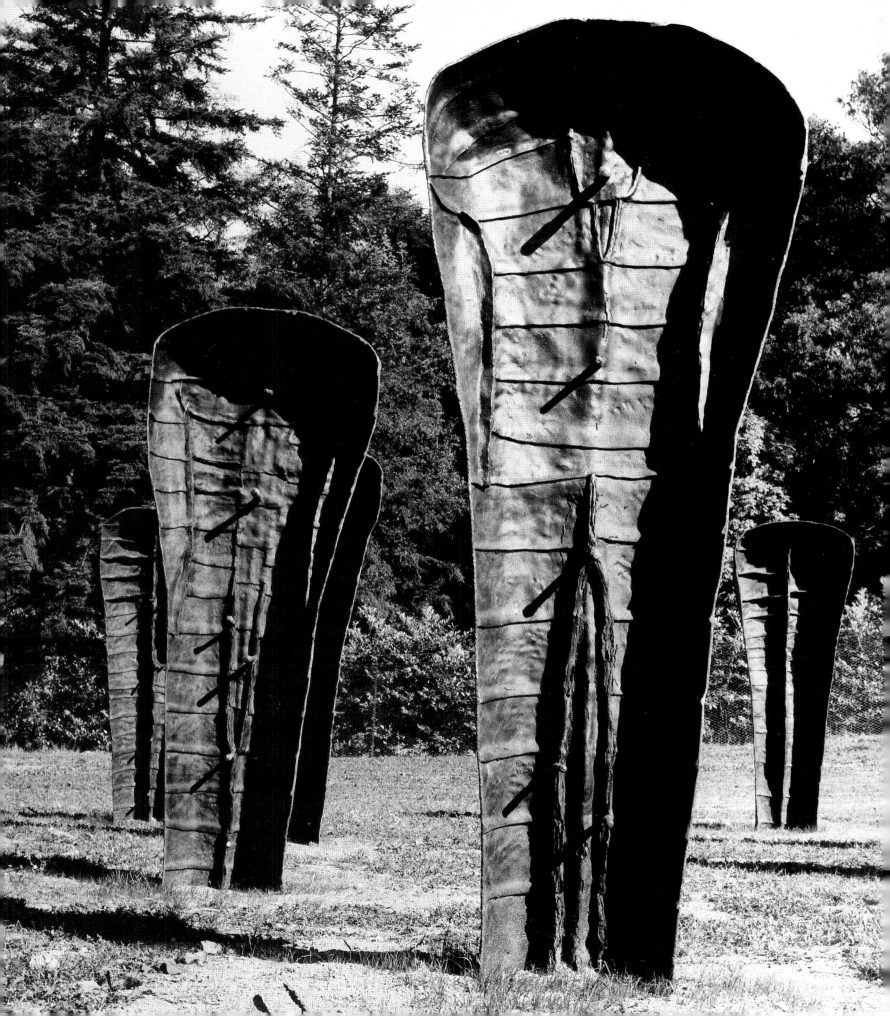

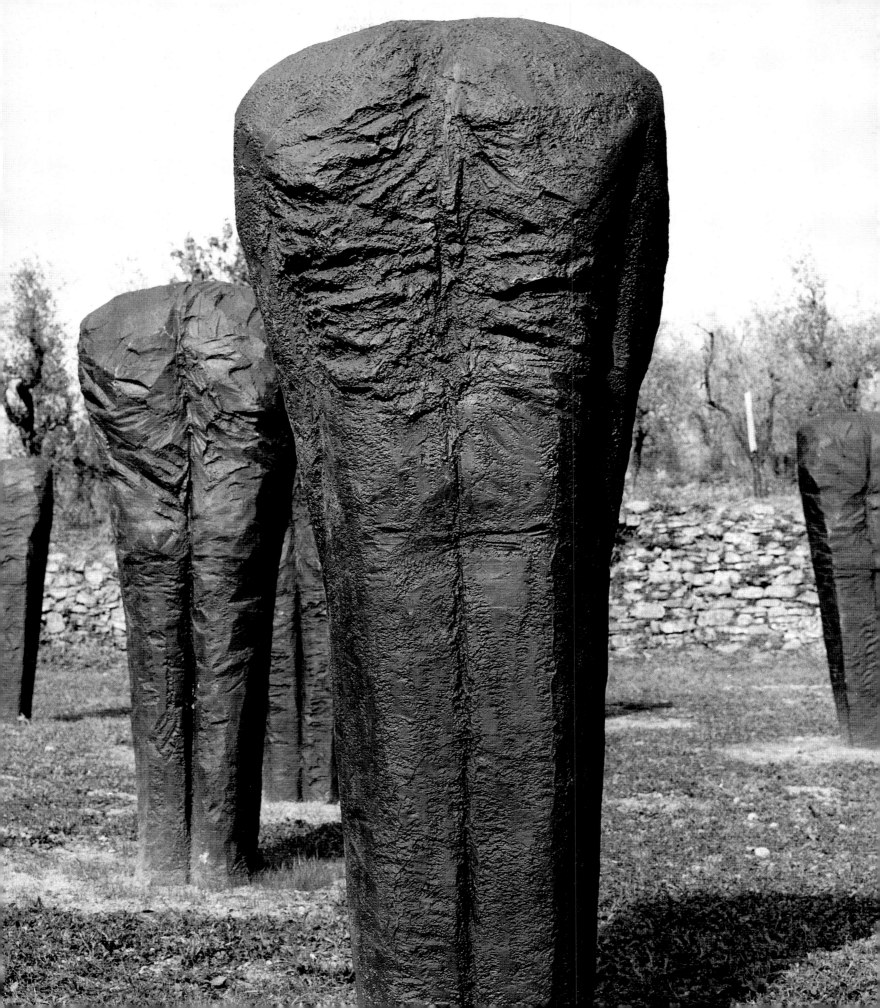

VIII : INCARNATIONS

The faces of Incarnations tell a nonverbal story about something that is fluent in time and in material consistency; many times passing all at once in the same face; many existences side by side, together with experiences etched in the skin.

These faces unveil elements of the inner chaos hidden behind the living face. Each of these rigid, metallic faces is a real or potential fragment of my own reality.

Magdalena Abakanowicz, 1988

Bronze had become an exciting new challenge for Abakanowicz, with enormous expressive potential. In 1985 she initiated a bronze cycle of self-portraits that she called *Incarnations*. The artist's first self-portrait, dating from 1976, had been made out of linen threads fixed with glue. It was followed almost a decade later by a series of self-portraits called *Anonymous Portraits*, made out of cotton fabric and fixed on wooden pedestals that were simultaneously part of the sculpture. *Incarnations*, and the cycle *Hoofed Mammal Heads*, of heads of imaginary animals, evolved out of these earlier works.

At the foundry in Bologna where she continues to work in bronze, Abakanowicz had become fascinated with the molten metal in its liquid state as it was being poured into the molds; she wished to preserve this living sense of liquidity in the masklike faces. The owner of the foundry, Mrs. Gabriella Venturi, encouraged the artist to intervene in the various steps involved in making a bronze cast, preserving the direct relationship of the artist's hand with the material that is the basis of her art and permitting an exceptionally experimental attitude toward bronze as a medium to be used in untraditional ways. In this supportive setting, Abakanowicz developed her own personal techniques for casting the metal. Now a sculptor working with the "noble" material of bronze, Abakanowicz nevertheless maintained the same sense of intimate contact she always has with her materials.

To create the *Incarnations*, she began with molds made by pressing her face in Plasticine, which she then filled with hot wax. The wax positive became the model for a porcelain mold for the final bronze-casting. In many pieces in the cycle, she tried to simplify the shape, reducing it to a very basic form with a rounded outline, often eliminating the nose, leaving only a fissure, along with nearly invisible traces of lips and eyes. The sculptures are thin-skinned surfaces, visibly hollow from the back. They evoke archaeological artifacts, perhaps death masks of a lost race. Abakanowicz has called these bronze faces "a perpetuation of fleeting moments, vibrations of

Self-portrait. 1976

Overleaf:
From the cycle
Anonymous Portraits.
1985–90

Pages 114–15:
From the cycle
Incarnations.
1985–89

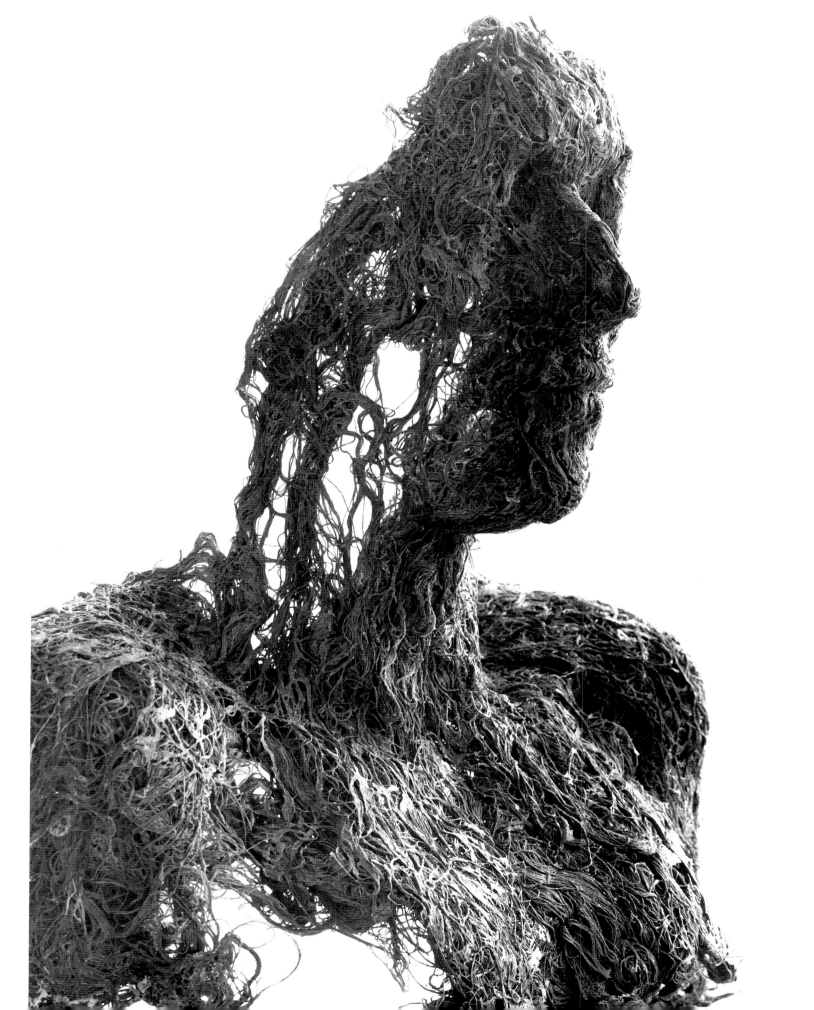

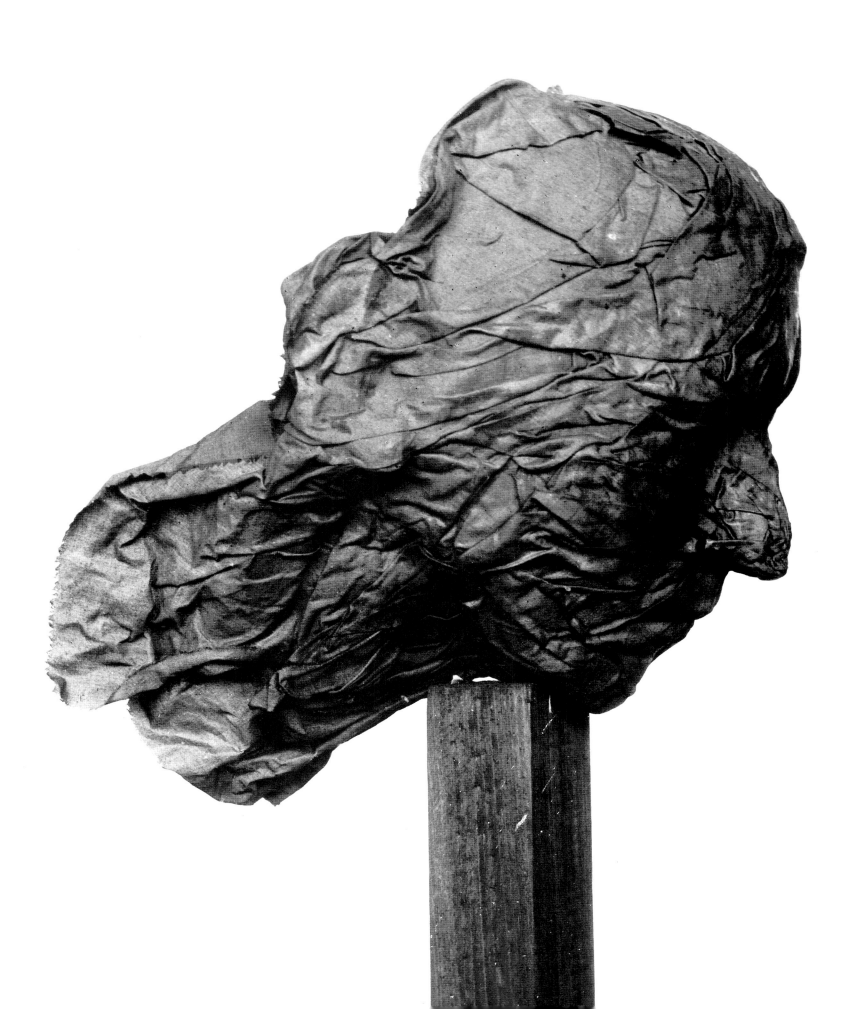

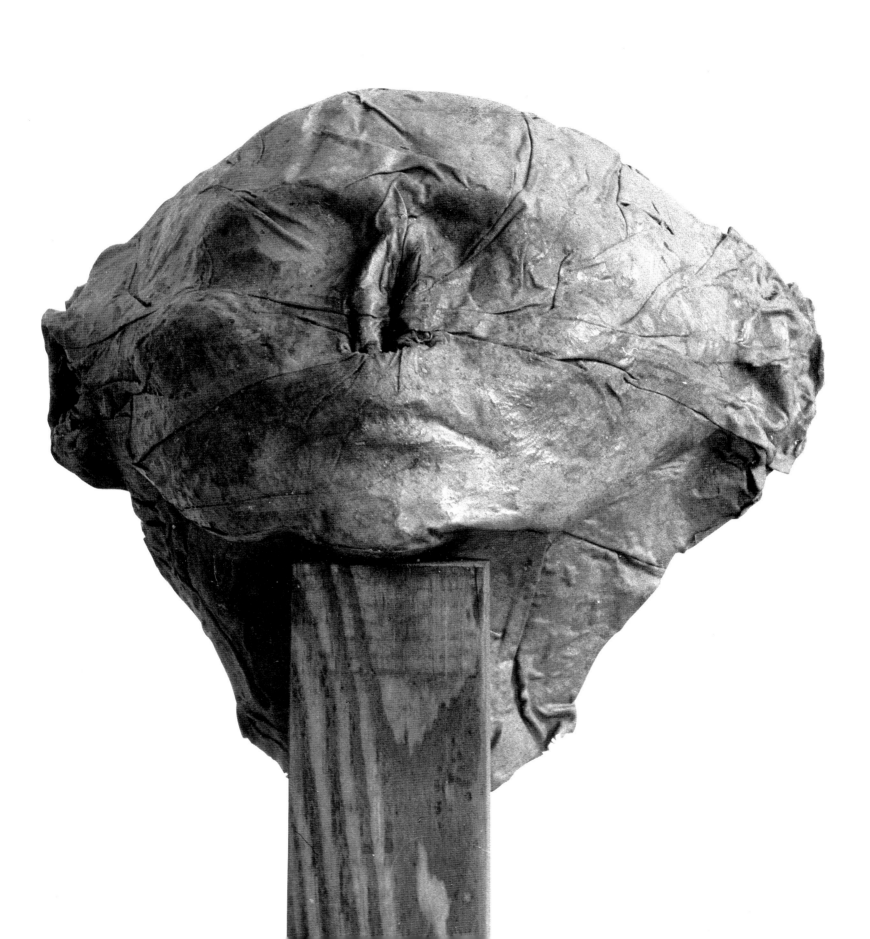

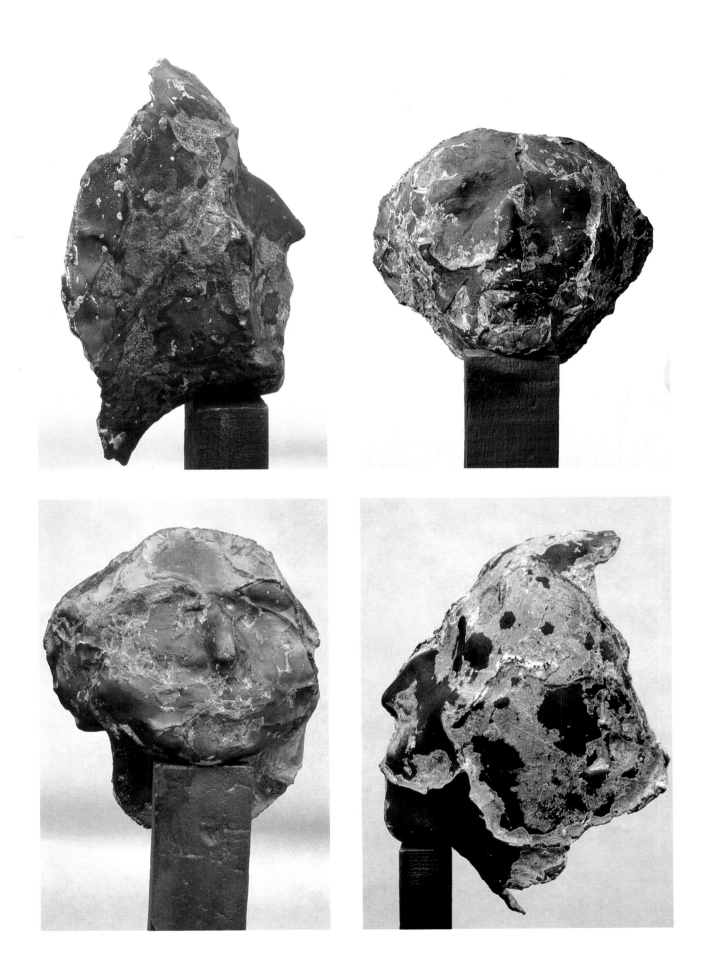

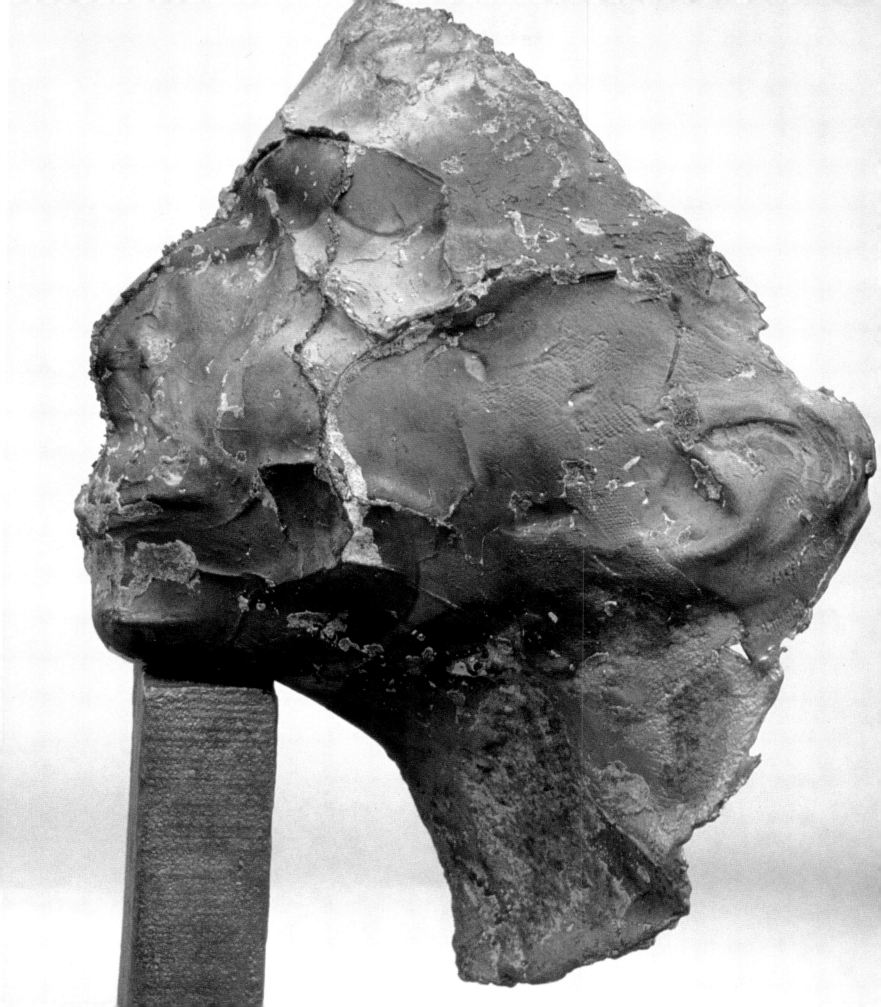

forms, appearances and vanishing of shapes." Each finished bronze does indeed carry traces of its past, its previous liquid state, and of the soft and malleable materials—Plasticine, wax—that are used to create it. Indeed, the *Incarnations* do not resemble any other bronzes because the material is left in its raw state; unexpected qualities emerge in this abruptly halted process that leaves the metal without its conventional finish and refinement. We know from historical examples, however, that genuinely innovative art often looks clumsy and unusual at first. On the other hand, because of the potential for exact reproduction that casting in porcelain molds permits, details of skin, lips, and eyes are often unexpectedly literal in these lifelike masks.

It took Abakanowicz some time to arrive at a solution for the pedestals. After trying various approaches, she finally attached the heads to vertical bronze planks. This method of presentation was not that of precious portraits; rather it resembled the display of the impaled head of a decapitated prisoner or, say, a French aristocrat guillotined in the Revolution's Terror, or, less disturbingly, a person looking out over a fence or barrier. Once again the artist chose to explore a border zone: in casting her own face she might feel what it was like not to breathe or swallow, but such morbid associations with embalming were contradicted by the liveliness of the resulting surfaces, which spoke, not of the immobility of death, but of life. This is how Renaissance art historian James Beck described the earliest of the *Incarnations* (the completed series actually numbers 110 bronze self-portraits): "Four of them have hollow, downcast eyes, sagging cheekbones, and distinct scars, like welts inflicted in some ancient painful tribal ritual. But these are modern faces, and the rituals are those of daily life. . . . These are not the formula evocations of postmodern angst . . . these are the faces we show to the world, stripped of cliché; the faces she meets in Warsaw every day."

The series of animal heads known as the *Hoofed Mammal Heads* cycle is more abstract than the *Incarnations*. Incorporating fingerprints and parts of human faces, they are primarily evocative of animals and are also mounted like trophies on bronze stakes.

By the time the *Hoofed Mammal Heads* were executed in 1989–90, Abakanowicz had learned a great deal about bronze-casting technology. Instead of applying any patina, she did not disturb the natural crystallization of the surface that was the result of the process of cooling, and that gave rise to often bright red, green, or yellow local colors. These intrinsic colors, up to now unacknowledged, or at least unused, are more durable than patina. Because she left remnants of the ceramic mold where it had adhered to the bronze, the material lost its metallic feeling and began to resemble natural conglomeratic rocks. Rough in texture and variegated in color, they have the look of petrified organic matter as opposed to the polish and refinement of Western art. The effect is startling: these "mammals" speak of the ages before *homo sapiens* had evolved to the point of destroying the balance of nature.

The Dog. 1986

Overleaf:
Hoofed Mammal Heads

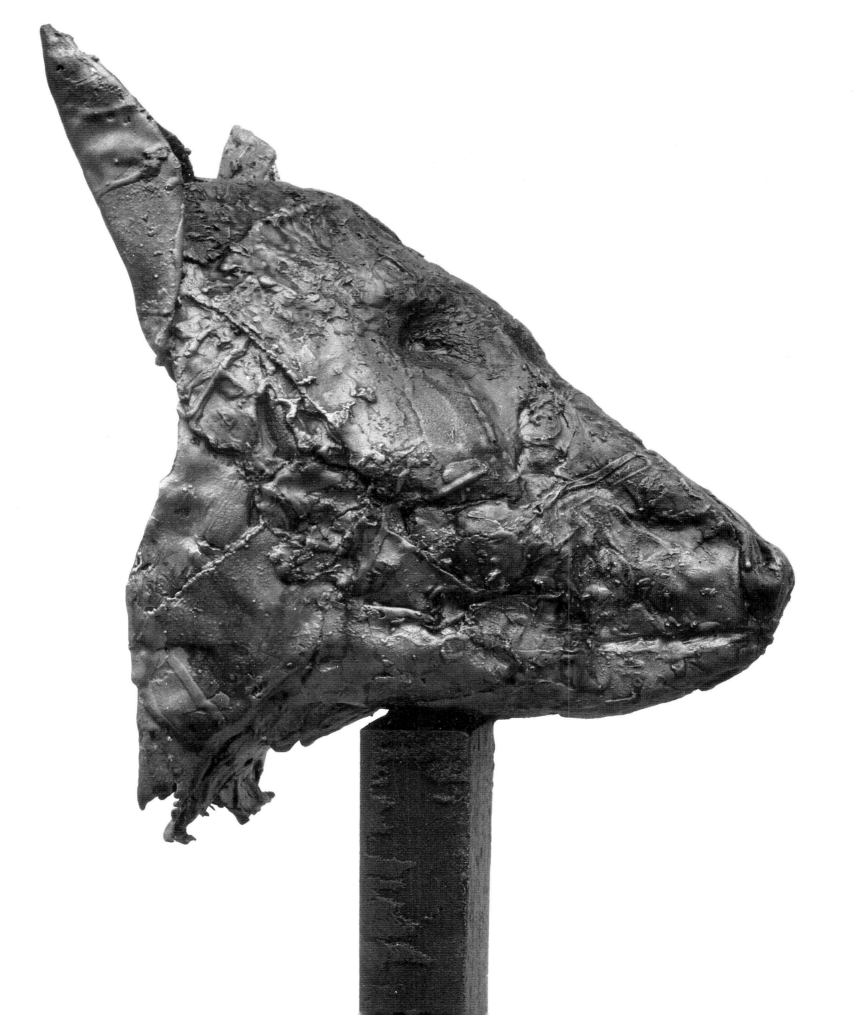

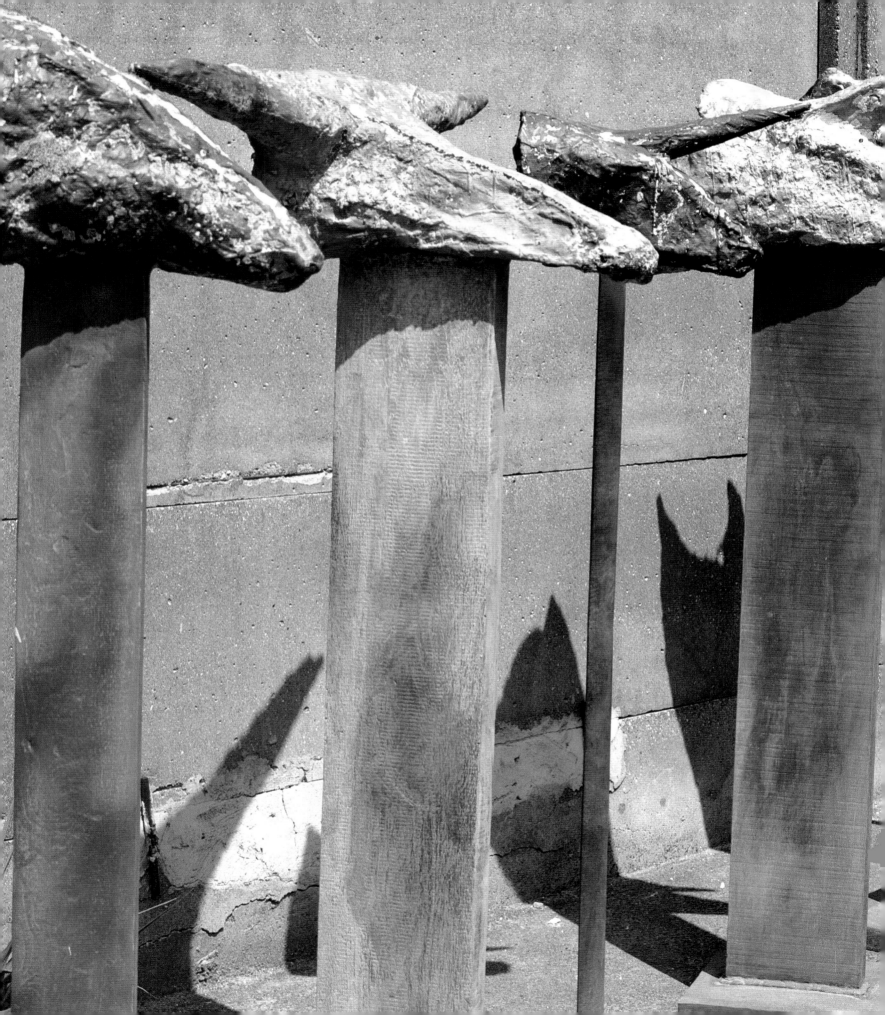

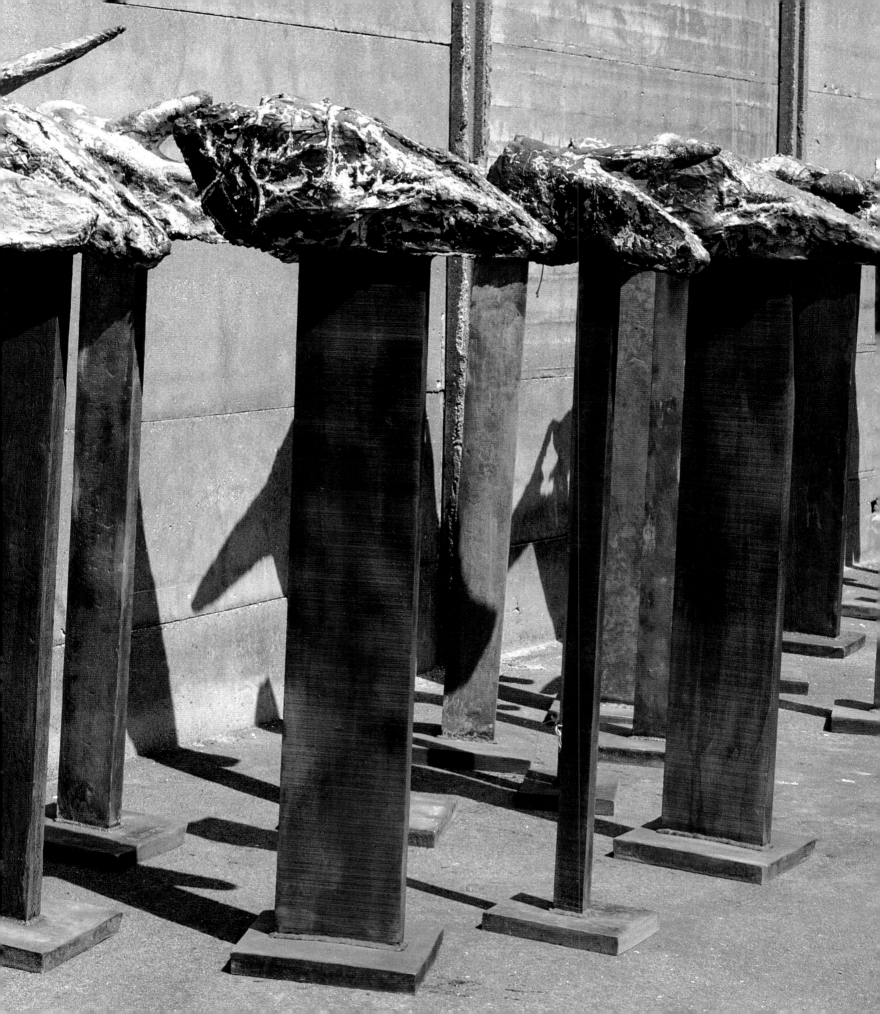

IX : NEGEV

My sculpture is free of the function of glorifying any doctrine, any religion, any individual. It is not decor for an interior, a garden, a palace, or a housing development. It is not a formal aesthetic experiment nor an interpretation of reality. . . .

I transmit my experience of existential problems, embodied in my forms built into space.

Magdalena Abakanowicz, 1987

Abakanowicz crossed the bridge from impermanence to permanence without delay and without reservations. The striking originality and emotional power of *Katarsis* brought her invitations to attend international sculpture symposia and to discuss theoretical subjects. She was also asked increasingly to undertake commissions for outdoor works. The execution of these projects, beginning with the creation of the models and experiments with new techniques and processes, usually requires her to remain at the site. Because her involvement in these substantial projects has been direct and physical, she continues to shape the work even as it is being produced. This approach to large-scale outdoor sculpture is the opposite of the way that most public art, usually blown up from a small model, is made. Different projects permitted Abakanowicz to remain true to her initial proposition that art was not an object, but a participatory experience, an environment into which the spectator enters bodily and experiences physically as well as mentally.

Early in 1987, the Israel Museum in Jerusalem sought a work by Abakanowicz for its world-famous sculpture garden, named for showman Billy Rose, and designed by Isamu Noguchi. She traveled to Israel, studied the site, and proposed an immense installation. Abakanowicz could not be content with the idea of a walled-off sculpture garden; to her it was a zoological park, which would domesticate art by confining it. She established with the museum curators that her work—seven huge limestone disks were taking shape in her imagination—should be installed on the edge of the formal sculpture park, where the lawn stops sharply in a steep rocky cliff at the very end of the museum's terraced gardens. There, the terrain rapidly drops away: suddenly the boundary of the park becomes the horizon line, beyond which only infinite sky can be seen. Her encounter with the historic landscape and blinding light of Israel became another struggle to realize her singular vision with the materials and space available.

Abakanowicz had wanted to work in stone for some time. Traveling through the desiccated Israeli landscape, she found the material that suited

Abakanowicz with *Negev*, Jerusalem, 1987

Overleaf: *Negev*. 1987

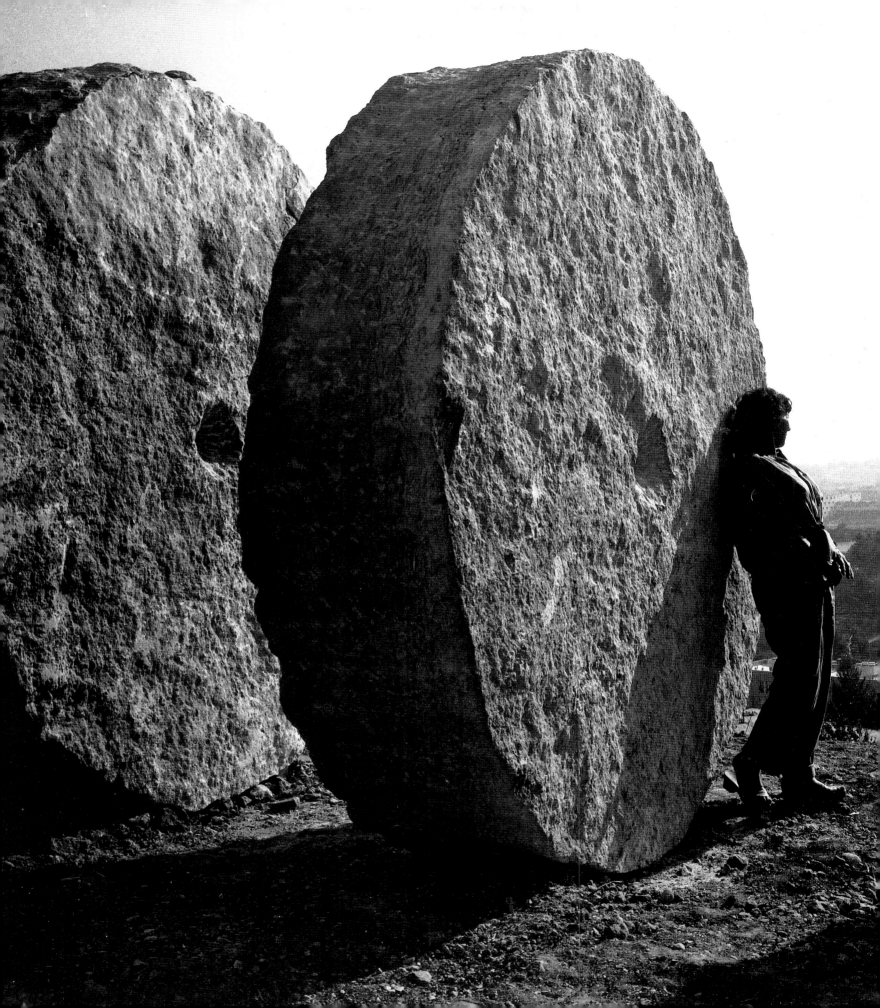

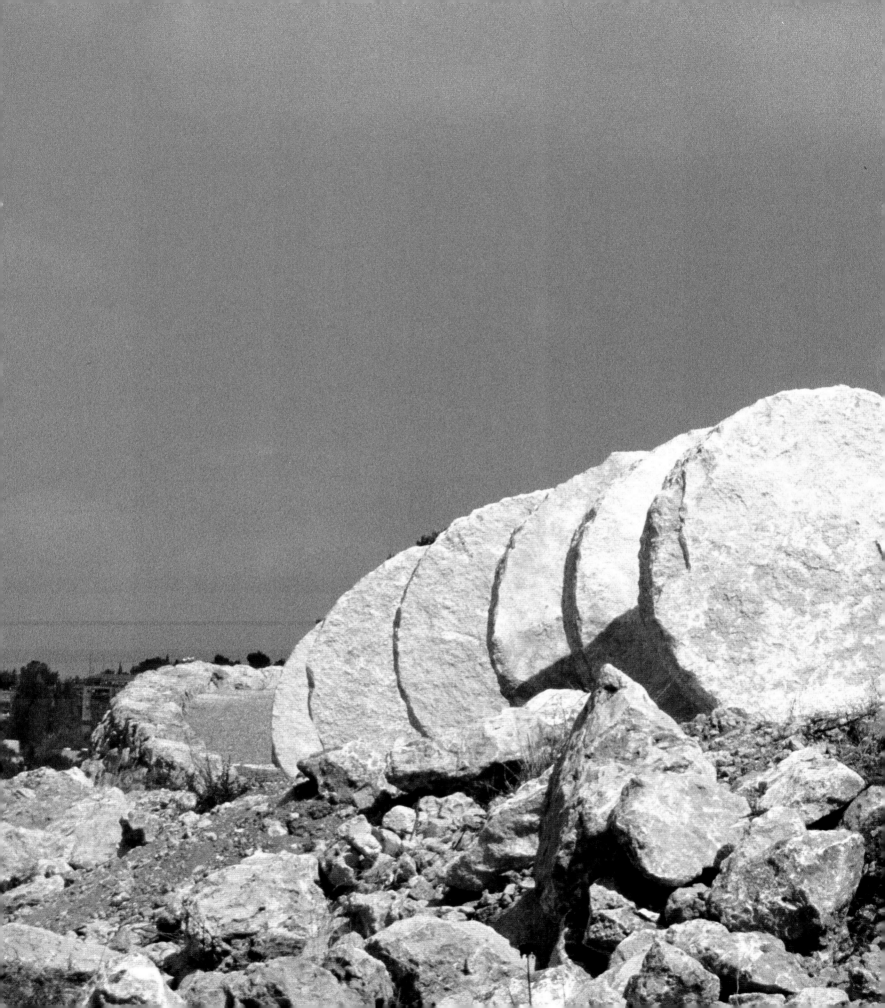

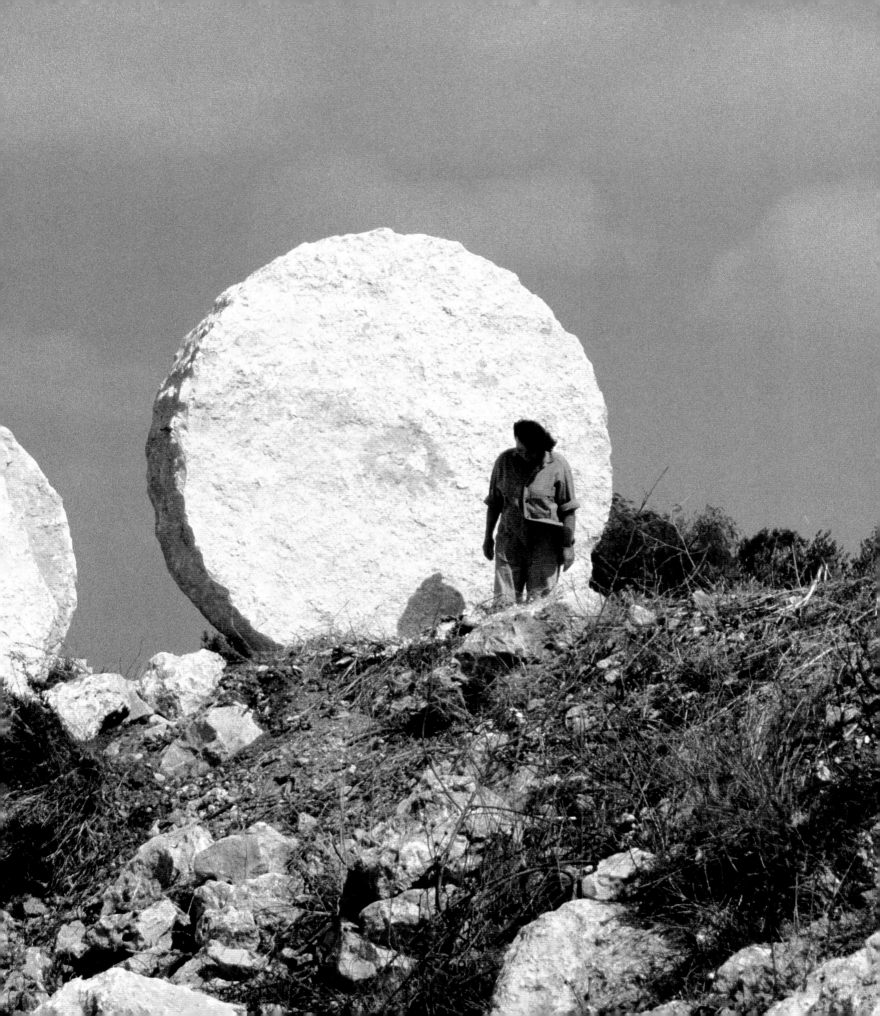

her purposes in the limestone plentiful in the quarries in the Negev desert. At the Mitspe Ramon quarry she found Moshe Ela, a Jewish Kurd from a family of seven brothers who worked in the local limestone that had been used for building since Biblical times, who agreed to execute the project for the amount budgeted. Artur Starewicz drove her back and forth between Jerusalem and the distant desert, crossing the dangerous occupied territories along the Gaza Strip. It was the eve of the Intifada, the Arab revolt that initiated a new round of violence in the Middle East, and in their Israeli-registered car, they were fortunate not to be stoned by Palestinians.

The mammoth twelve-ton disks that were to become the sculpture for the Israel Museum were cut with a pneumatic drill from the layers of sedimented limestone found in Mitzpe Ramon. Abakanowicz watched the Bedouin workers as they mined the huge, almost two-and-a-half-foot thick rocks directly from the desert. They knew how to drill and break the stone to get the desired rounded shape. The surfaces of the disks were as alive and uneven as the woven *Abakans*. They spoke of the countless sea creatures that, over millions of years, had formed the rock.

Abakanowicz had studied the lighting conditions in Jerusalem. She wanted to take advantage of the way its dazzling brightness would reflect off the stone. Her plans also took into account that the pale ocher pink of the stone would darken as the sun went down and that the disks would cast shadows like sundials. These shadows would change position and shape as the earth rotated. All these calculations played a part in the decisions Abakanowicz made regarding the distance between the stones and their relationship to the ground as well as to the other disks. Day after day she evaluated their positions, using a maquette built on the spot.

Abakanowicz's move from environmental installation to contextually sited sculpture began with *Katarsis* at the Villa Celle, where cast shadows and topographical features of the terrain are integral to the work itself. Like her earlier indoor installations, *Negev* is not an object or an icon to be looked at from a distance, but an articulated space to be experienced actively. Walking among the seven great upright disks of *Negev*, the viewer feels the great weight and density of the stones. They appear only provisionally anchored on the brink of the downward sloping incline. Allusions to precarious balance express the fragility of relationships between peoples and between man and nature. Silhouetted against the horizon with the brilliant changing sky as its backdrop, *Negev* has an exceptional relationship to an already dramatic site. Looking at the giant stone disks of *Negev*, which seem to have been placed on the earth by some unseen hand, one has a sense of humanity's relative insignificance in the universe. As her mysterious *Heads* recalled the enigma of the lost civilization of the Easter Islands, *Negev* speaks of such sacred places as Stonehenge, whose purpose we no longer comprehend but whose power we continue to respect.

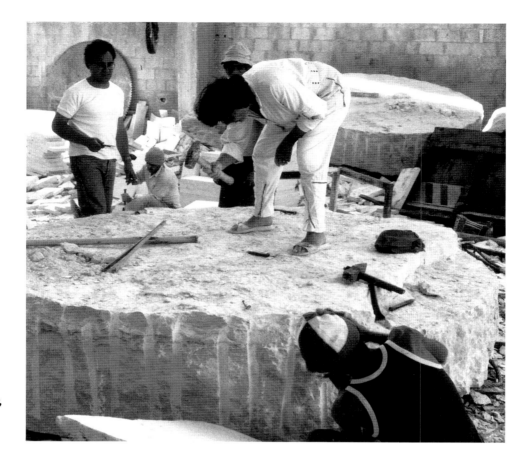

Abakanowicz
with assistants
carving one of the
stone disks in *Negev*,
Mitspe Ramon,
Israel

Perhaps because of its literal physicality in the world, sculpture has traditionally played a weightier role than painting, frequently addressing itself to human actions and their consequences, either by commemorating a victory or battle, or, as in the Middle Ages, by representing moral or spiritual conflict. This function of sculpture is rejected by contemporary avant-garde artists. To recapture for sculpture its original role as potent, sometimes frightening, totem or to evoke a moral lesson regarding the potential for aggression suggested by giant and heroic forms—which cannot help but signify power—are tasks that today's greatest sculptors have set for themselves. It is a mission that is doubly difficult in a world of authoritarian hierarchies, including architects who use painting and sculpture merely to adorn their buildings, as well as public officials anxious to please and to avoid controversy.

Art as adventurous and demanding as Abakanowicz's does not concede to this innocuous blandness. Its intention is to involve and to awaken the spectator to the reality of his or her immediate emotions and experience. For that reason her art can never be ingratiating or seductive. She demands that sculpture signify powerful realities: the courage to confront the potential for destruction, the memory of humanity's capacity to misuse power.

Overleaf:
Negev. **1987**

125

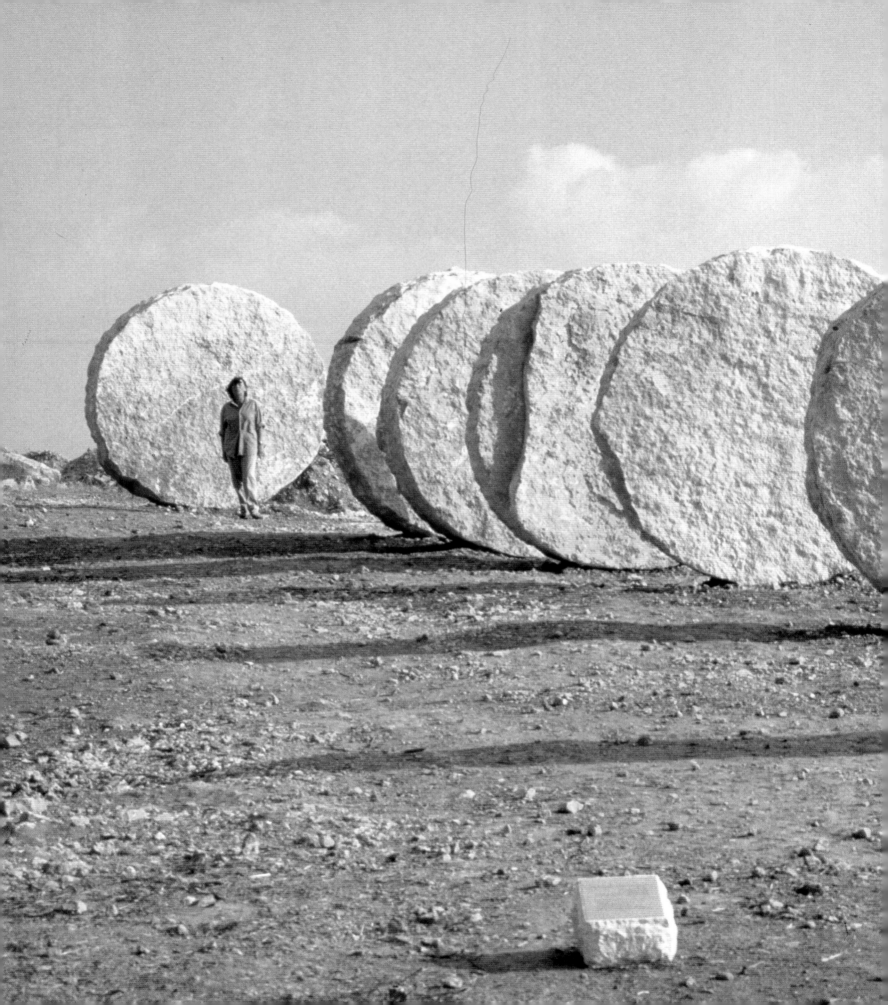

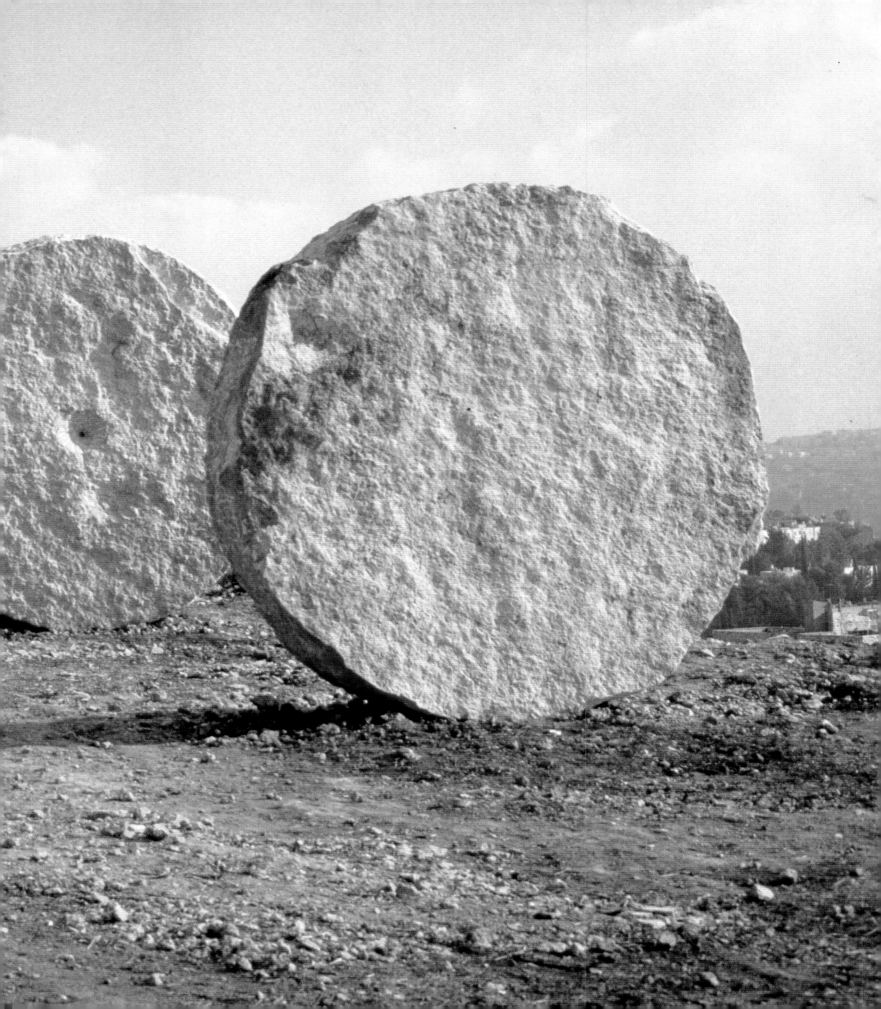

X : CROWDS

I once observed mosquitoes; swarming in gray masses. Host upon host. Little creatures in a slew of other little creatures. In incessant motion. Each preoccupied with its own spoor. Each different, distinct in details of shape. A horde emitting a common sound. Were they mosquitoes or people?

A crowd of people or birds, insects or leaves, is a mysterious assemblage of variants of a certain prototype. A riddle of nature's abhorrence of exact repetition or inability to produce it. Just as a human hand cannot repeat its own gesture. I invite this disturbing law, switching my own immobile herds into that rhythm.

Magdalena Abakanowicz, 1985

We have seen that the propensity of biological units to multiply is one of Abakanowicz's principle themes: the forms, like cells, spawning themselves in *Embryology*; the *Backs* giving birth to increasing numbers of their own kind; the numerous *Incarnations* of a single face. Even before the growth of popular awareness that overpopulation was an increasing threat to human survival, Abakanowicz's experiences of the behavior of dehumanized masses bewitched by cruel dictators led her to the theme of the crowd as a roving herd, easily driven in any direction. She confesses to a fear of crowds, and especially of the uncontrolled behavior caused when the excited masses turn upon one another, forgetting their common humanity. "A crowd," she has said, "is the most cruel because it begins to act like a brainless organism."

Crowd I consisted of fifty standing figures, made in 1986–87, that were relatively lifelike, with shoulders, arms hands, and articulated toes. It was first seen at a retrospective of Abakanowicz's work held at Mucsarnok, a public gallery for contemporary art in Budapest, in 1988.

Abakanowicz completed *Crowd II* when she and her husband moved to a proper house with a large studio on the outskirts of Warsaw late in 1988. It actually took them over a year to unpack because they were constantly traveling, realizing projects in countries all over the world, including Germany, Korea, Japan, and the United States. Again there were fifty figures: burlap and resin shells of sexless bodies. They were headless life-size figures cast from a tall man, and this time their hands were vestigial. The figures in the *Crowds* became increasingly abstract, forms whose trunklike torsos are closer to trees than to people. *Crowd III*, again fifty figures, was exhibited at Abakanowicz's first show at the Marlborough Gallery in New York in 1989. The most abstract group of the cycle, *Crowd IV* consisted of sixty standing

Detail of a figure in *Bronze Crowd*

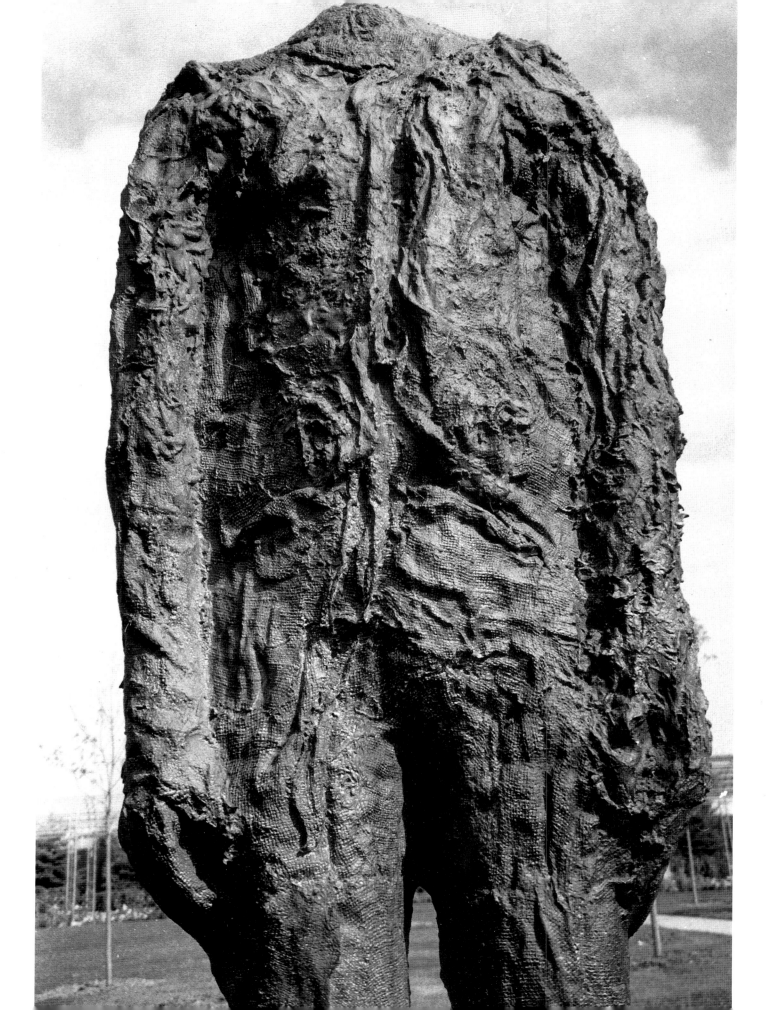

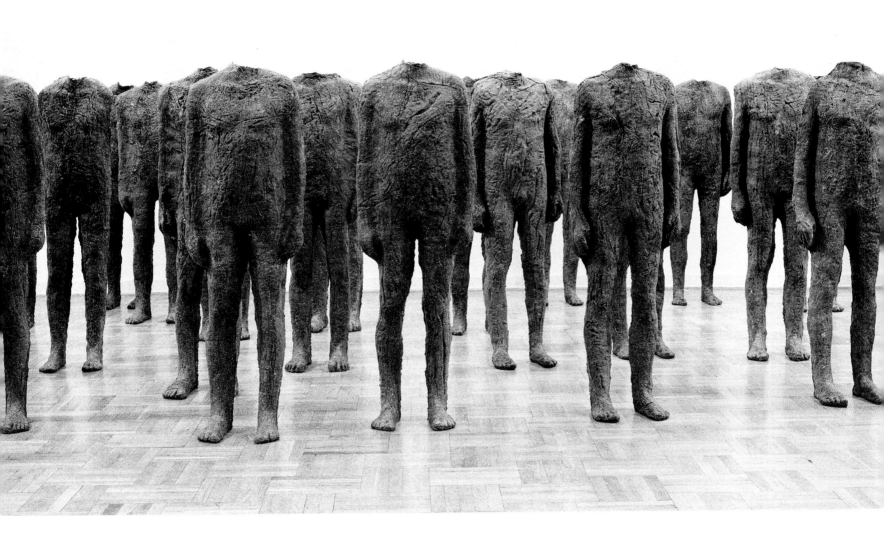

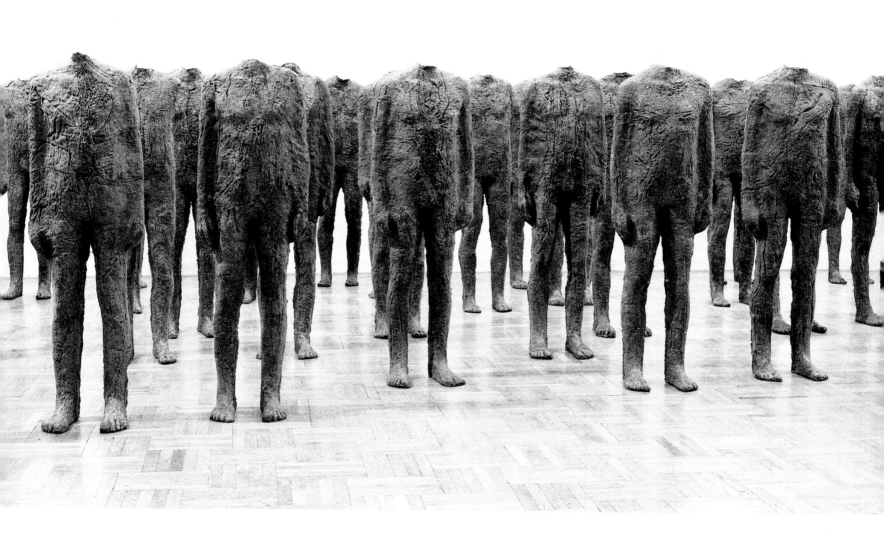

Crowd I. 1986–87

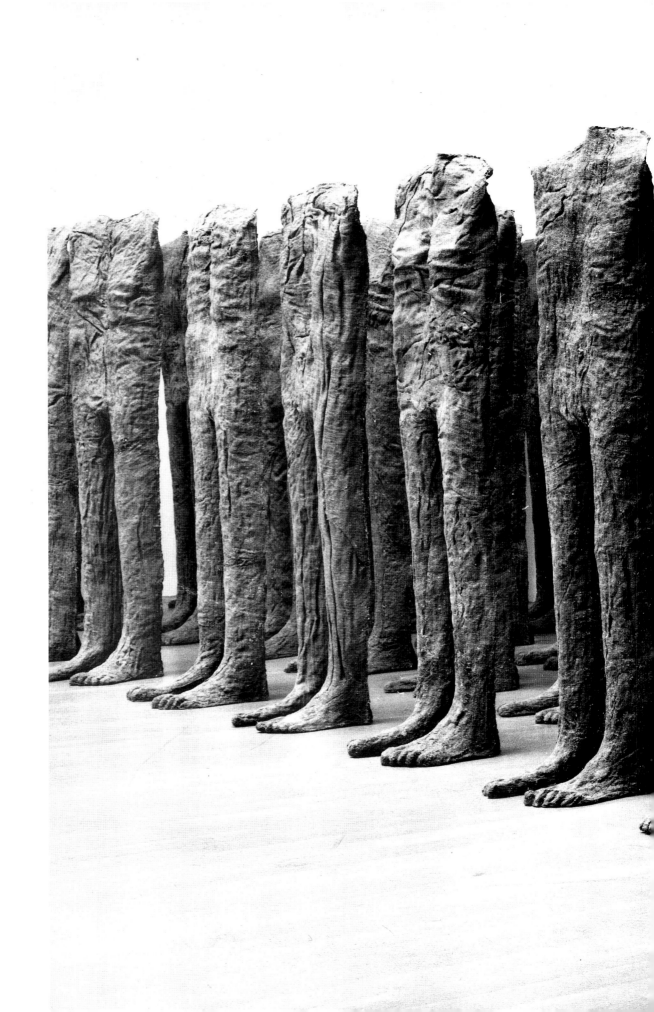

Crowd III. 1989

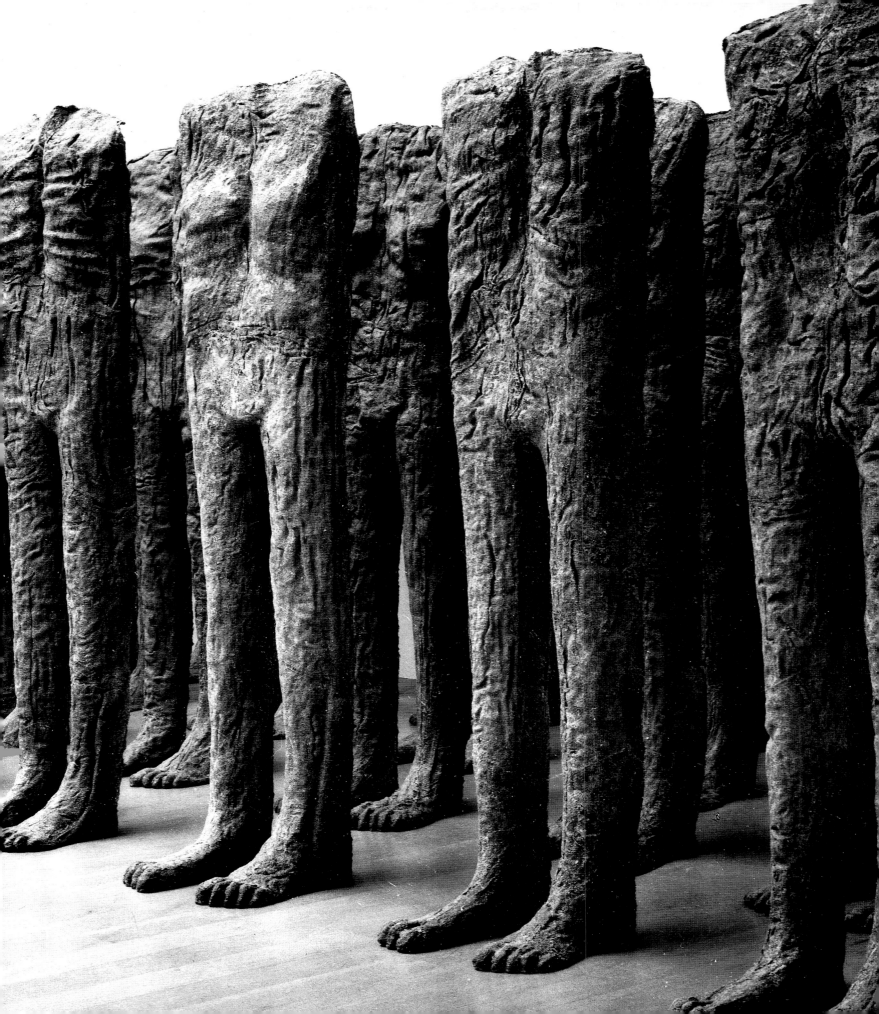

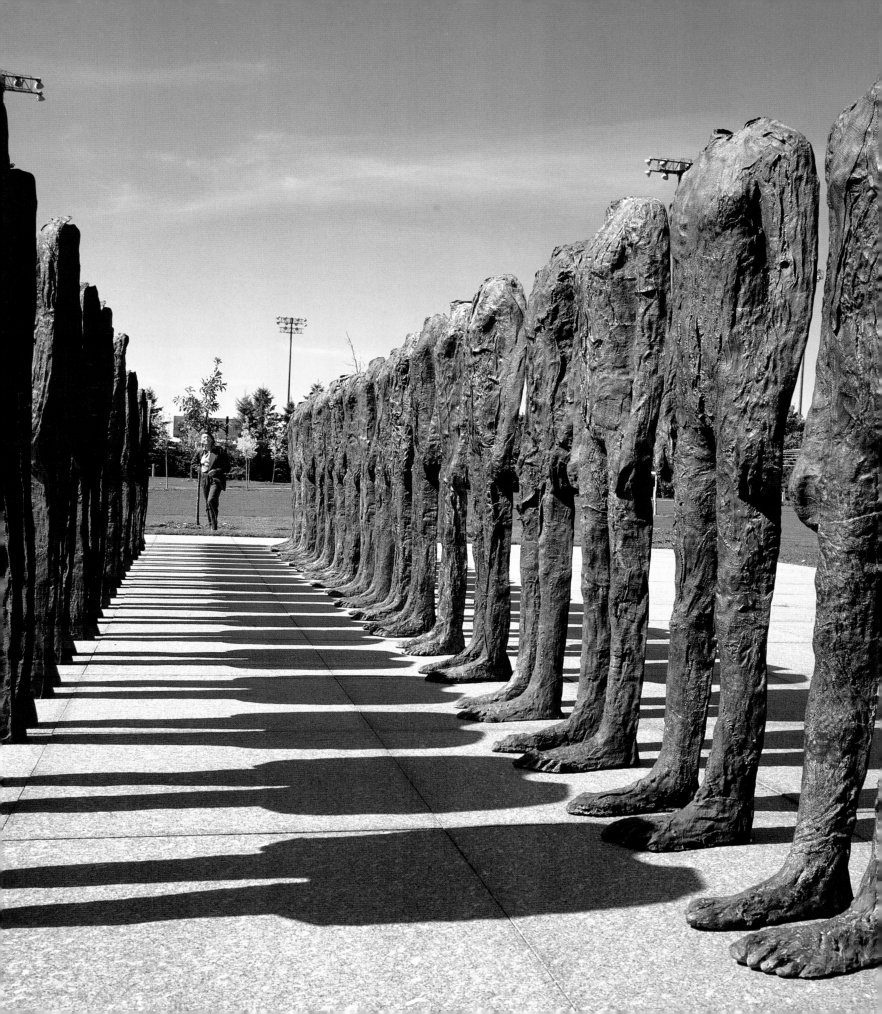

figures, and was exhibited for the first time in 1991 at the Sezon Museum in Tokyo.

The figures in all four versions of *Crowd* are made of burlap fixed with resin and formed in molds that were constantly reformed and reconfigured to give birth to new generations whose structure changes and evolves. As usual in Abakanowicz's groups, the figures in each cohort are similar, but not identical. The deep creases and built-up texture of the material suggest hard fibrous bark rather than soft human skin. The burlap cloth is neither clothing nor skin precisely, but another of the border zones that we have come to connect with Abakanowicz's way of thinking.

Abakanowicz's experience of crowds coincided with the brutal end of her childhood. Suddenly she was no longer an individual but just another body to be pushed or shoved or trod on. The depersonalizing experience of being herded into a crowd has been painful and oppressive to her. On the other hand, it sensitized her to the weight and value of the spaces between figures, which is an essential element in her installations. The heightened awareness expressed itself in an exceptional talent for organizing objects in spatial relationships: "I am sure that as in the case of a sensitivity for sound light or color there exists a common predisposition to sense space." The *Crowds* confront the unprepared viewer with a formation of standing headless troops whose numbers make them seem menacing. They also have the somnolent quality of sleepwalkers. They are the confused and dangerous men described by Spanish philosopher José Ortega y Gasset in *The Revolt of the Masses* (1929): "man believes himself fabulously capable of creation, but he does not know what to create. Lord of all things, he is not lord of himself. He feels lost amid his own abundance. With more means at his disposal, more knowledge, more technique than ever, it turns out that the world today goes the same way as the worst of worlds that have been; it simply drifts."

The coda to the *Crowd* cycle is a group of thirty-six figures cast in bronze in Bologna in 1991. *Bronze Crowd* was shown for the first time at the Walker Art Center in Minneapolis at Abakanowicz's exhibition inaugurating the new extension of the sculpture garden there. These dramatically expressive figures are larger than life-size: similar but never identical, they are subtly differentiated from one another in surface and silhouette. Abakanowicz modeled their interior structures suggesting skeletal bones as carefully as their exteriors. At the opening day ceremony, crowds of real spectators confronted the immobile bronze crowd. Children and adults looked, touched, and walked around and between the figures. Many would come back in the following days.

Bronze Crowd.
1990-91

XI : WAR GAMES

For a long time I couldn't use wood. I saw it as an entity finished in itself. Some years ago, suddenly I discovered inside an old trunk its core, as if a spine intertwined by channels of juices and nerves. I found the carnality of another trunk with limbs cut off, as if amputated . . .

Fascinated by the corporeality of trunks I decided to bring them into my domain. Doing so I felt encouraged by a strange similarity between us— a kind of relationship.

I bring out the features which strike me. I draw them out until I see no longer the wood but an object of many meanings; an object which carries associations unknown to the imagination of nature.

Magdalena Abakanowicz, 1988

Every August, Magdalena and Jan spend a month in the Polish countryside at the cottage of their friend Artur Starewicz in the Mazury Lake district north of Warsaw. Here, she feels at one with the familiar landscape of woods, marshes, and lakes. Away from the noise of contemporary life, she is regenerated. In the silence of the forest she can connect with the forces that, at the deepest level, inspire her work.

It was in such a mood of contemplation that she began the cycle of works eventually titled *War Games*. From time to time, as for example in the podlike *Geminati*, Abakanowicz had incorporated twigs and branches into her sculpture. *War Games* used the carcasses of giant trees, gnarled trunks in some cases up to twenty-five feet long that had been rejected by foresters. Abakanowicz worked on them with ax and chainsaw; she found a small factory that repaired agricultural tools and machines to make the steel blades, bands, and casings that she added to them and iron frame tables to mount them on. The startlingly aggressive works that resulted suggest both medieval siege machinery and primitive farm implements. At once, they incorporate the forms of weapons and tools—of spears, of swords, and of scythes—and of the wounds inflicted by these instruments, bandaged with ragged burlap and mended with iron. Mary Jane Jacob has spoken of them as projectiles ready to be fired, commenting on the extreme tension conveyed by their double meaning as victim/weapon.

War Games signals Abakanowicz's virtuosic ability to transform any material, from fabric to metal, into the emphatic textured surfaces and organic forms that we have come to recognize as specific to her work. Her

Abakanowicz working on a piece for the cycle *War Games*, 1987

136

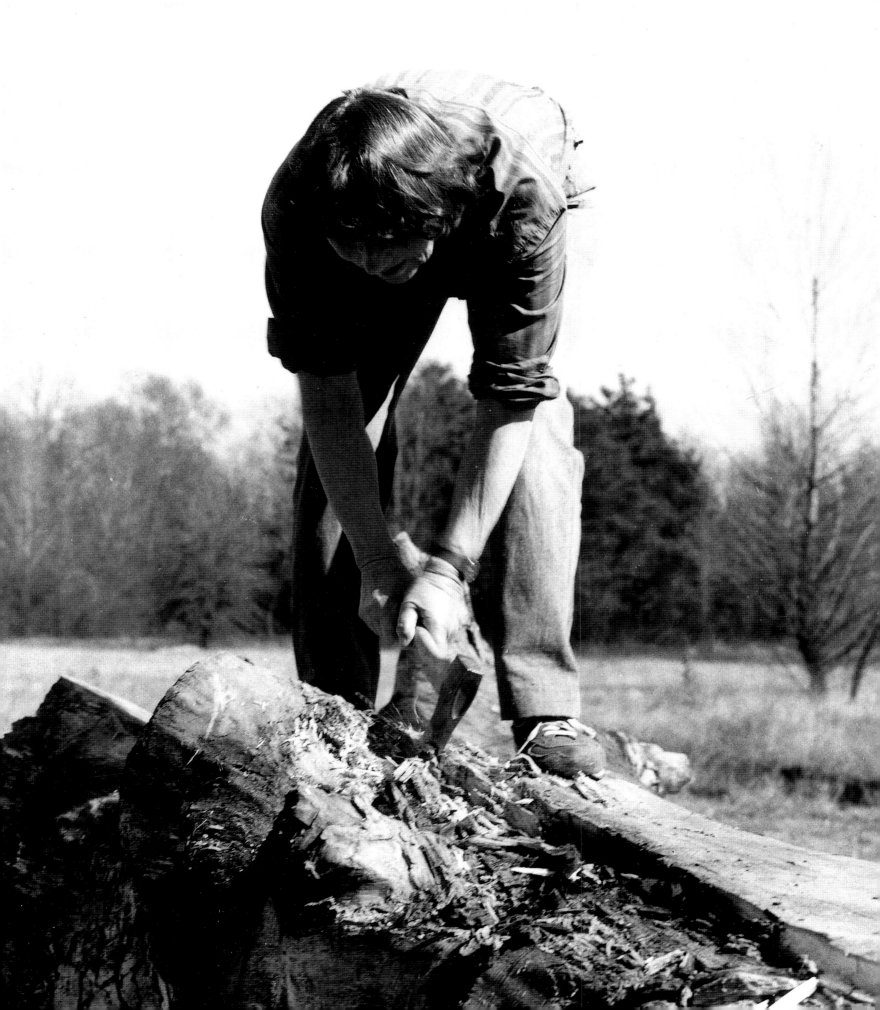

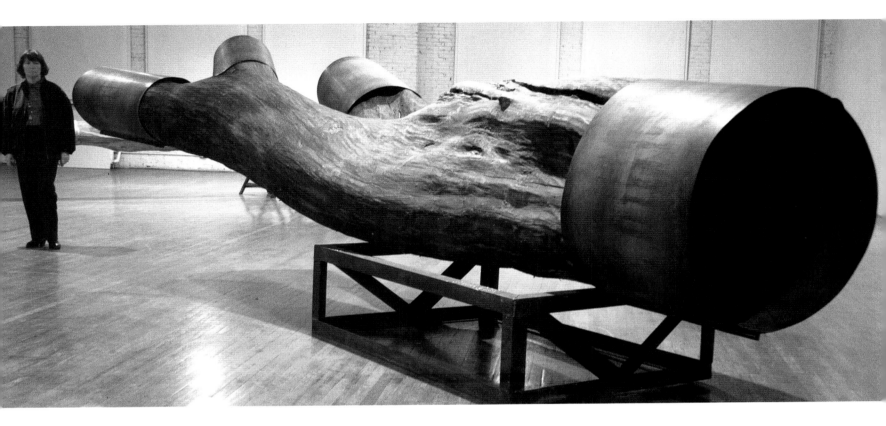

genius is to extract a maximum of associations and emotional reactions using a minimum of means. The sharp edges and pointed or blunted forms of *War Games* give rise, in a physically intense way, to a multitude of accessible meanings.

The *War Games* represent one extreme of Abakanowicz's thematic repertoire: the consequences, seen in the double-edged image of weapon and victim, of the instinct for destruction. They evoke a response of moral outrage that we can compare only with that aroused by the mangled corpses and hideous scenes of bloody carnage depicted by Francisco Goya in his *Disasters of War*, and like Goya, Abakanowicz witnessed murder and mutilation, during the terror of the Warsaw uprising and its aftermath.

Forcing us to confront the physical reality of pain, torture, aggression, confinement, captivity, and death in the fate of the trees whose trunks and limbs stand in for their human counterparts, Abakanowicz does not permit us to relax with art. She refuses to make a comfortable armchair for the tired intellectual worker, as Henri Matisse proposed. Nor will she let us escape the consequences of our actions, the source of our fears, the history of man's collective crimes. Her ability to articulate these ideas so clearly in her work moves spectators around the world who, although they do not share her specific cultural and historical experiences, can understand the artist's universal message.

Anasta,
from the cycle
War Games. **1989**

Opposite:
Booby Trap,
from the cycle
War Games. **1987**

Overleaf:
Bent Sword, **from**
the cycle *War*
Games. **1987–88**

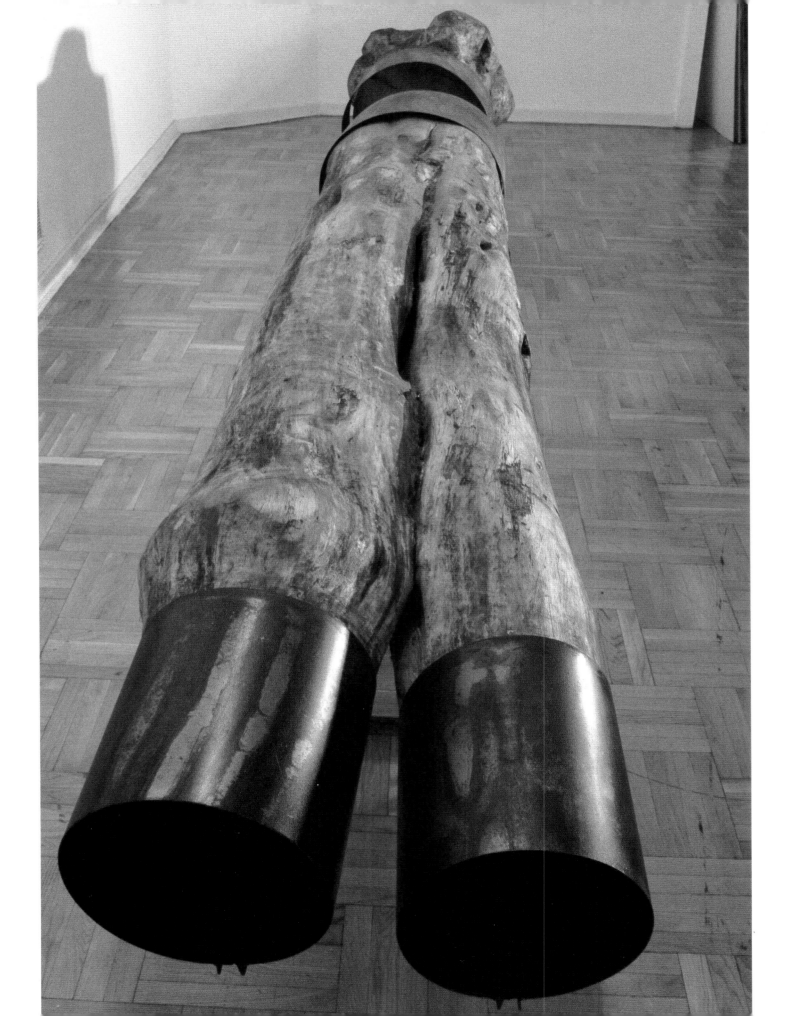

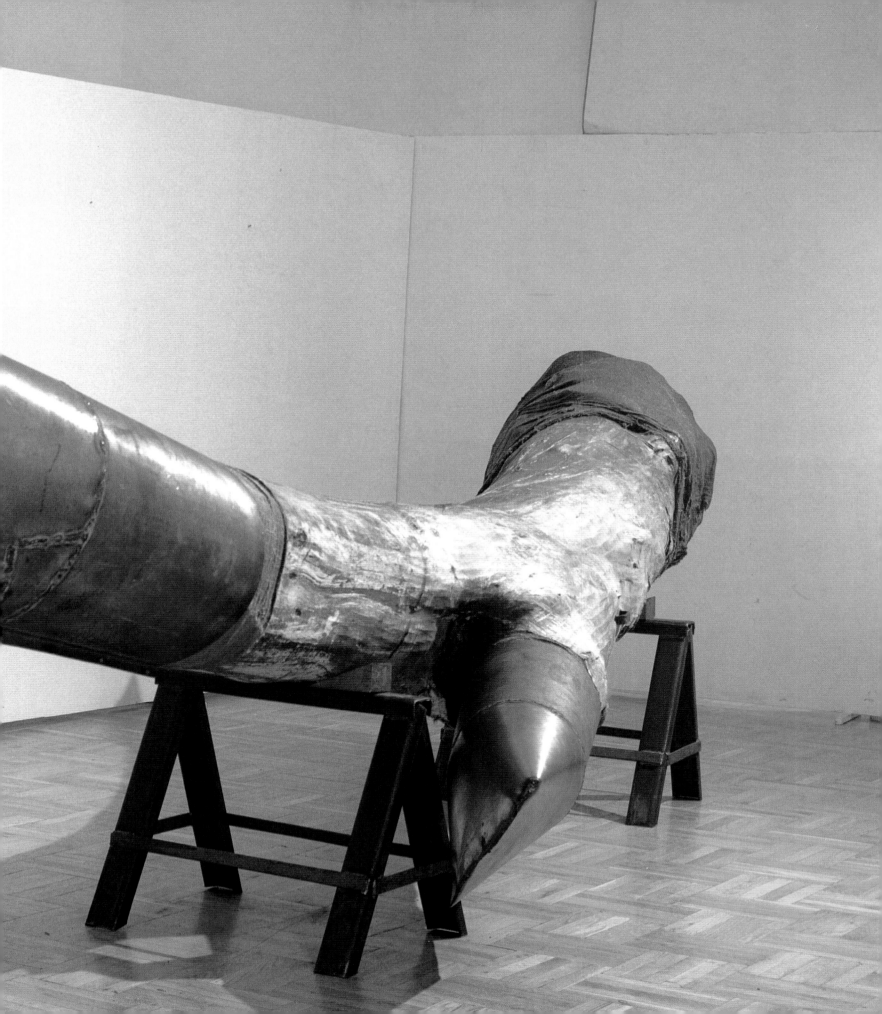

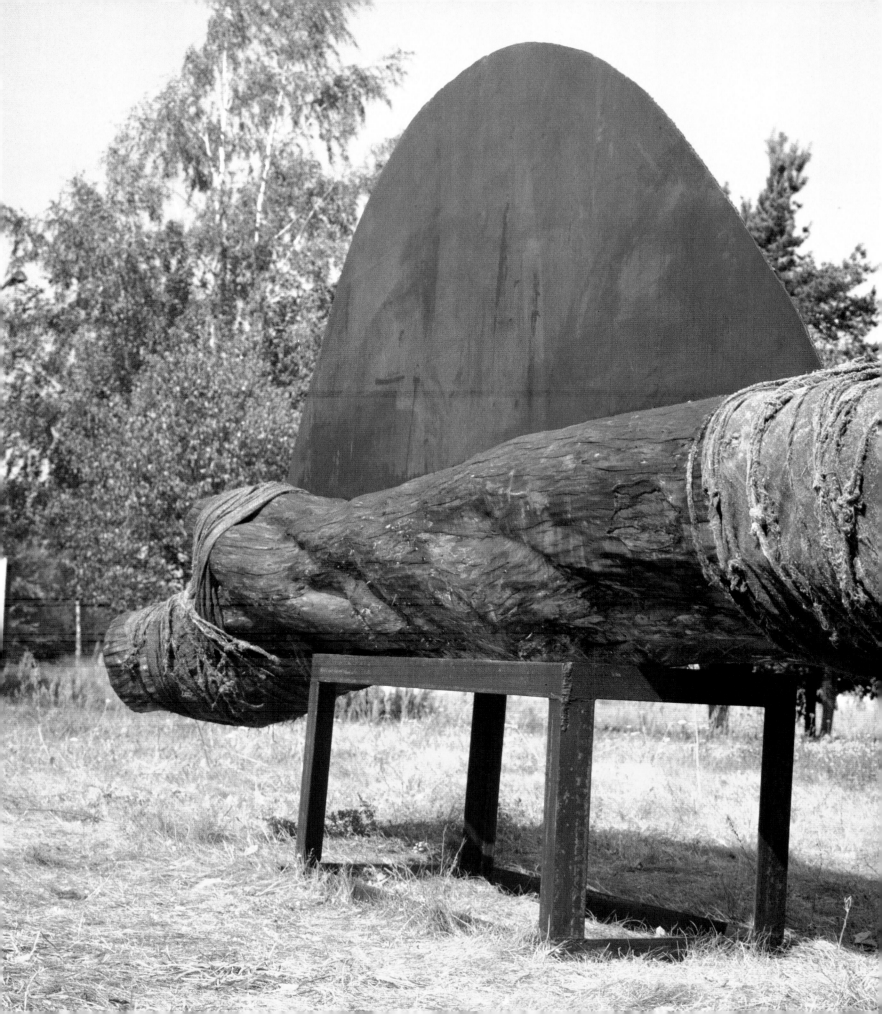

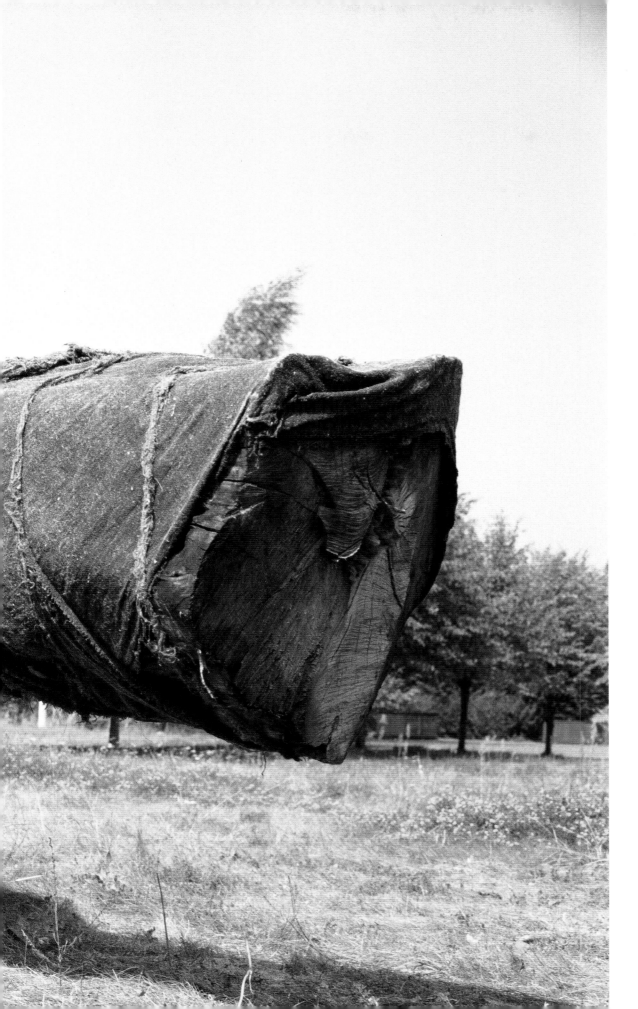

Winged Trunk,
from the cycle
War Games. 1989

Overleaf:
Zadra,
from the cycle
War Games. 1987

Pages 146–47:
Sroka,
from the cycle
War Games. 1992

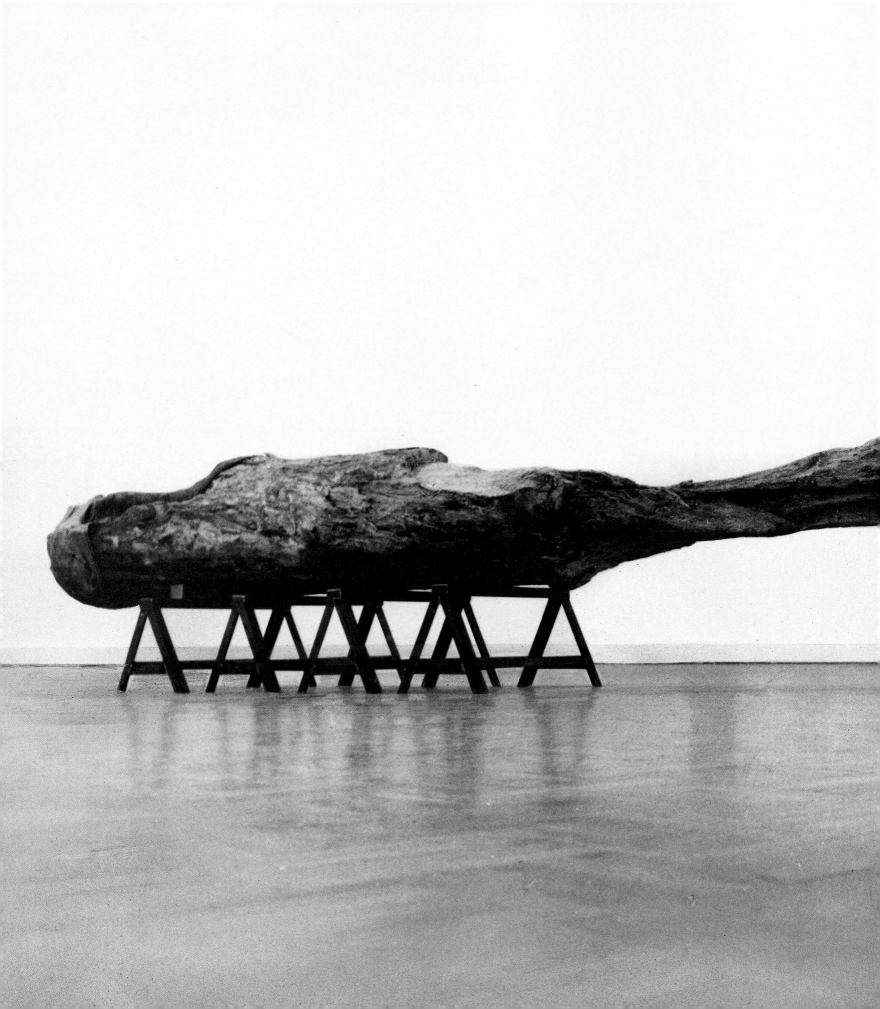

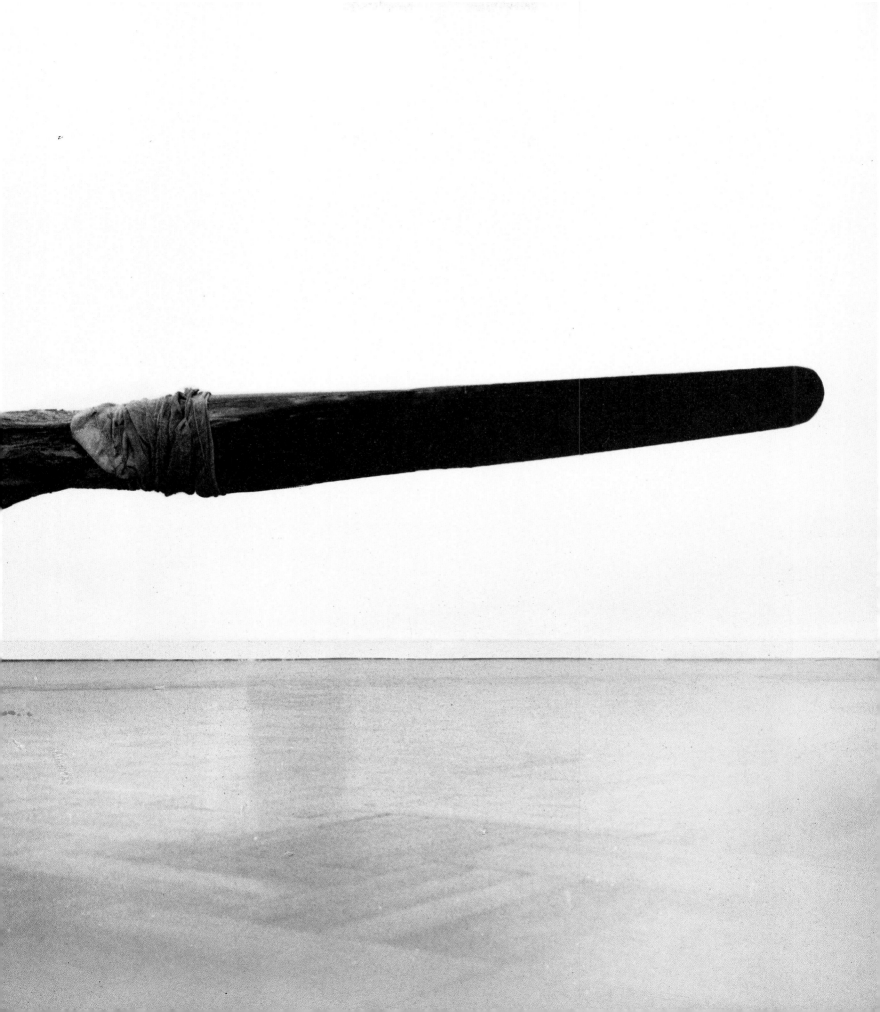

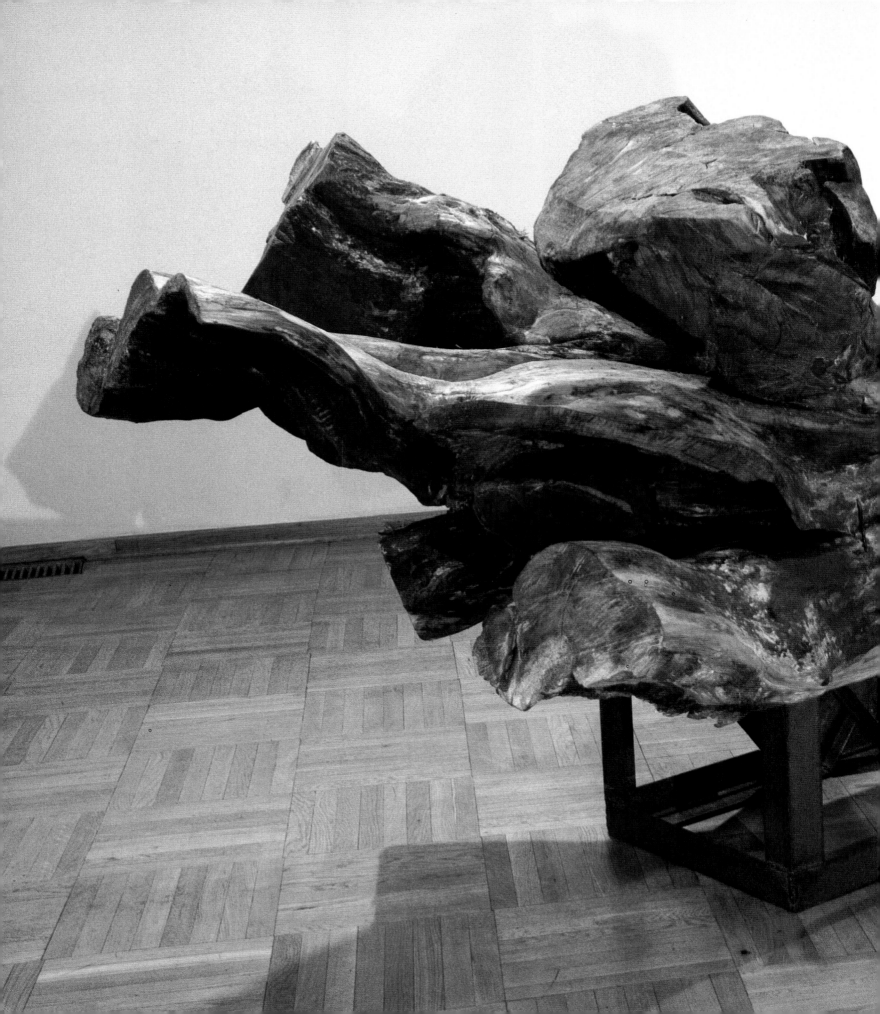

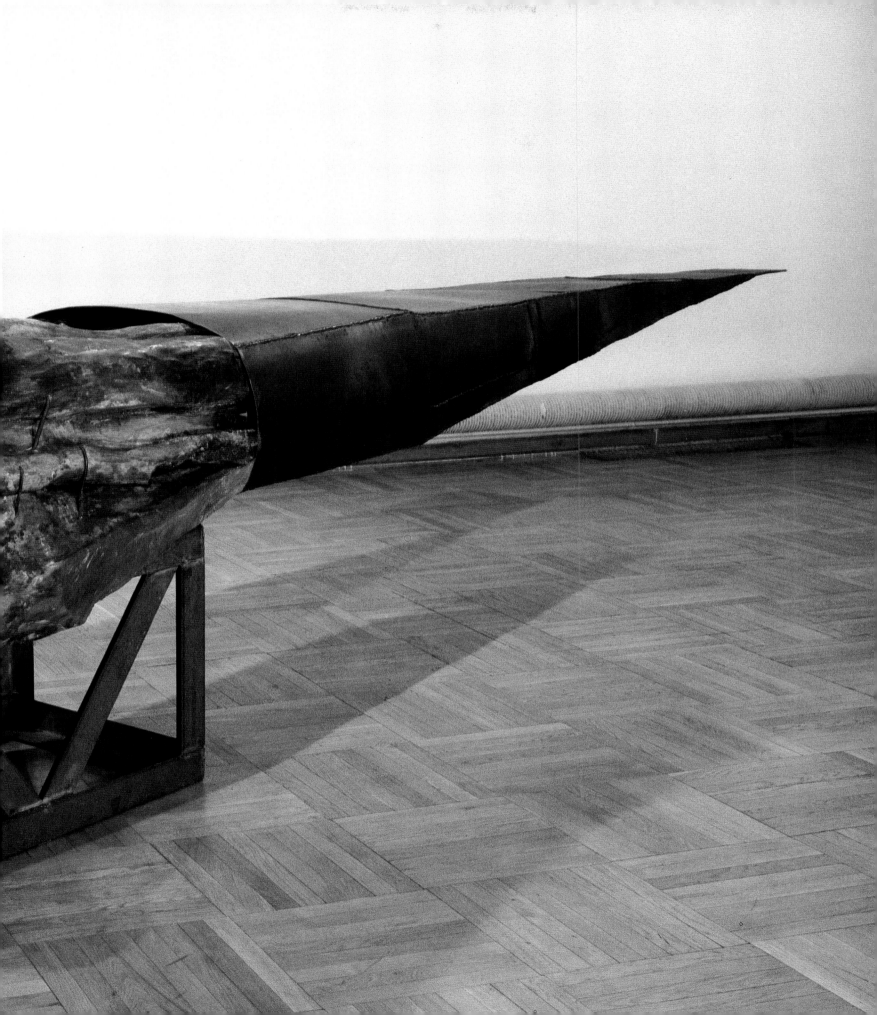

XII : SARCOPHAGI IN GLASS HOUSES

The forms of expression change. Only they can tell the truth about themselves.

In everything I do, however, the constant factor and the permanent necessity is to search for and reveal secrets. Also those inherent in structure; the structure being the phenomenon which all the organic world on our planet has in common.

The mystery which can never be fully revealed.

Magdalena Abakanowicz, 1976

Sarcophagi in Glass Houses began with four gigantic wooden sculptures that Abakanowicz created out of models for engine housings salvaged from the abandoned machine tool and arms factory of Schneider-Cruesot in Le Creusot, France. These were already of monumental dimensions: the artist cut away parts of each to arrive at a simple monolith with a powerful presence. Abakanowicz discovered that the form of the engines was related to the human body, and she became fascinated with the analogy: there was a kind of belly covering the moving parts, the machine's organs. She left the "swelling belly" shape of the wooden models intact, but detached them from their bases and raised them on new ones that she made out of new wood.

Abakanowicz began working on these pieces in 1983, but it was not until they were first exhibited at her 1989 retrospective exhibition at the Städelsches Kunstinstitut in Frankfurt that she considered them finished. She had come to the realization that, to achieve their full impact, each sculpture required its own context. Both to protect the untreated wood from humidity, so it could be exhibited outdoors, as well as to set up a polarity that would interact with the inert horizontal forms, she constructed large greenhouselike iron and glass structures, under which the wooden sculptures seem to lie in state. Choosing the form of a shelter designed not for humans but for plants gave the impression that inside the temperature was warm, as in real greenhouses. However, the glass house was also a cage, another image of confinement with special significance for Abakanowicz.

One of the significant features of Abakanowicz's art is its implicit evocation of both the past and the potential future of the objects, viewed both as image and as material, present in her environments. This sense of potentiality and imminence is thwarted by her inert and immobile forms: actions are arrested, motions frozen, the figures in a crowd halted in their march toward the viewer. Abakanowicz's sense of the meaning of the ephemeral moment

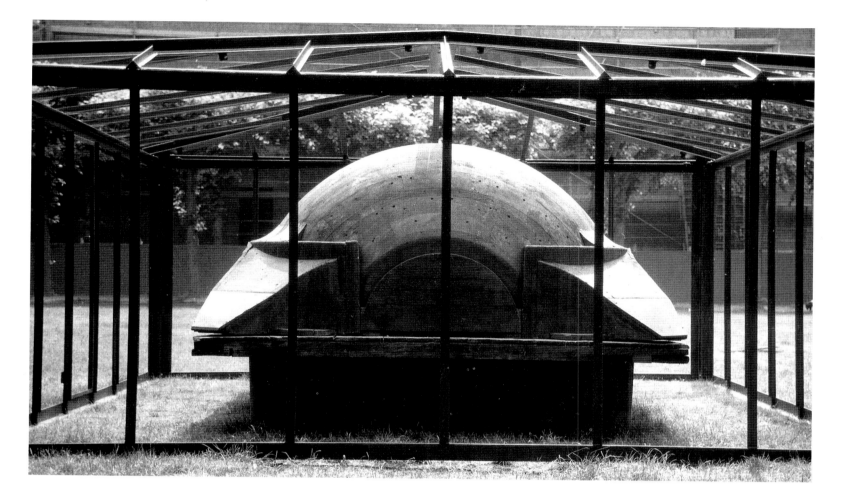

Above and Overleaf:
Sarcophagi in Glass Houses, 1983–89

made permanent is quite the opposite of that of the Impressionists, who were excited by the ability of photography to capture and to preserve a single moment in the flow of time. Contrary to the Impressionists' fleeting glimpses of joie de vivre, Abakanowicz's "frozen" moments have a portentous quality. Adding to this is the heaviness of her monolithic forms, which, in the case of the four *Sarcophagi*, become architectural, and which is emphasized by the relative absence of color and the tough, resistant quality of their surfaces. Against the monumental stillness of the *Sarcophagi in Glass Houses,* which are so large that we are forced to walk around them to see them in their entirety, is the possibility that whatever sleeps or gestates inside the wooden cases housed in glass, being protected and warmed by the sun's rays, may some day bloom.

Once again the recurrent motif of the opposition of inside and outside creates tension: the glass is both an obstacle as well as an invitation to physically enter the space of the work. The viewer's inability to penetrate this space becomes a source of irreconcilable frustration.

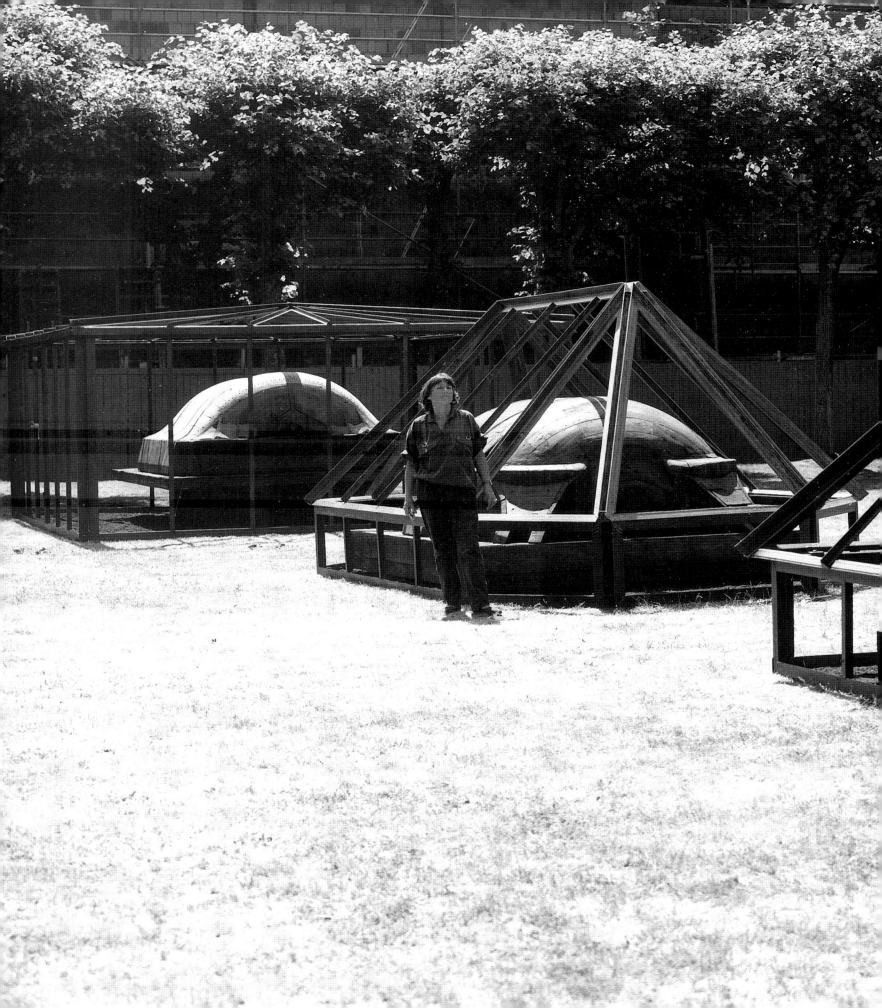

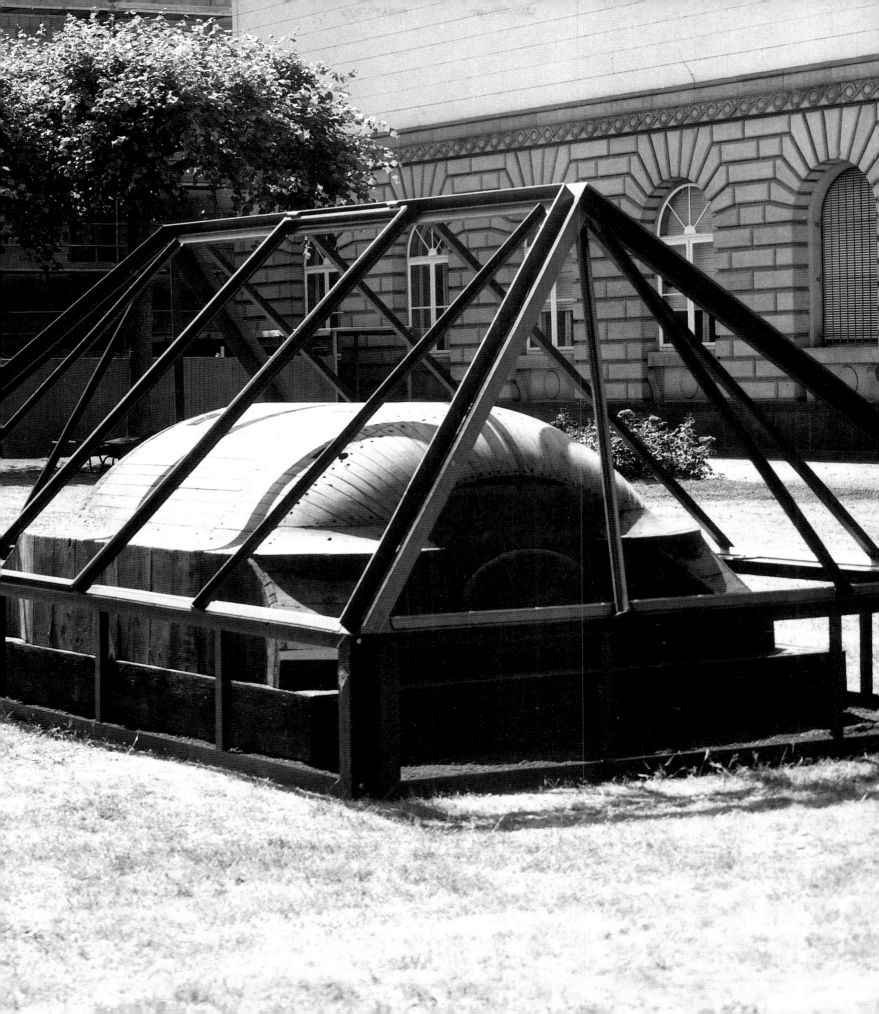

XIII : Space of Dragon/Sagacious Heads

Head eats. Head looks. Head speaks.

Always above or in front of the trunk, the head is first exposed to the unknown. It is responsible for the rest of the body, as a leader for its herd. Separated from the trunk the head becomes a shape which is an entity, and does not demand any completion. Alone, liberated from responsibilities and functions, it maintains the expression of its experiences.

The big heads invoke the living ones.

I have rummaged with both hands in the soft plaster to find the right form. I have scratched this white pulp into wanted shape. The surface, marked with countless traces of my fingers, of knife cuts or rag pieces, turns into the epidermis of invented heads. Astonishing, this texture appears as obvious as broken stone, animal fur, or human wrinkles, all originating from a natural process.

Magdalena Abakanowicz, 1990

Early in 1988, Abakanowicz was asked to participate in a symposium on sculpture in Seoul, South Korea. The Koreans invited artists to make works for the Olympic Park being constructed in conjunction with the fast-approaching 1988 Olympic Games, the first to be held in Asia.

Time pressures demanded quick decisions. Abakanowicz decided to create ten metaphoric animal heads, based on small models that she prepared in advance in her studio in Poland. Once in Korea, she worked at breakneck speed with her husband and Artur, with the assistance of a group of Korean helpers. She completed ten full-scale models in twelve days. For each one, they constructed a wooden armature covered with wire netting after a design of Jan's, and then plastered over the wire. These ten sculptures were to become the basis for the colossal work she titled *Space of Dragon*. During this formative period of intense pressure, Abakanowicz developed a spinal condition: every evening she went to the university hospital for acupuncture treatments and other Asian remedies to alleviate the pain.

The casting of the bronze presented many practical and technical problems, because the work was executed in four different small workshops on the outskirts of Seoul. This meant that the large sculptures had to be welded together from dozens of pieces. But the skill of the workers was extraordinary, as casting in bronze is an ancient craft in Korea.

Head from *Space of Dragon*. 1988

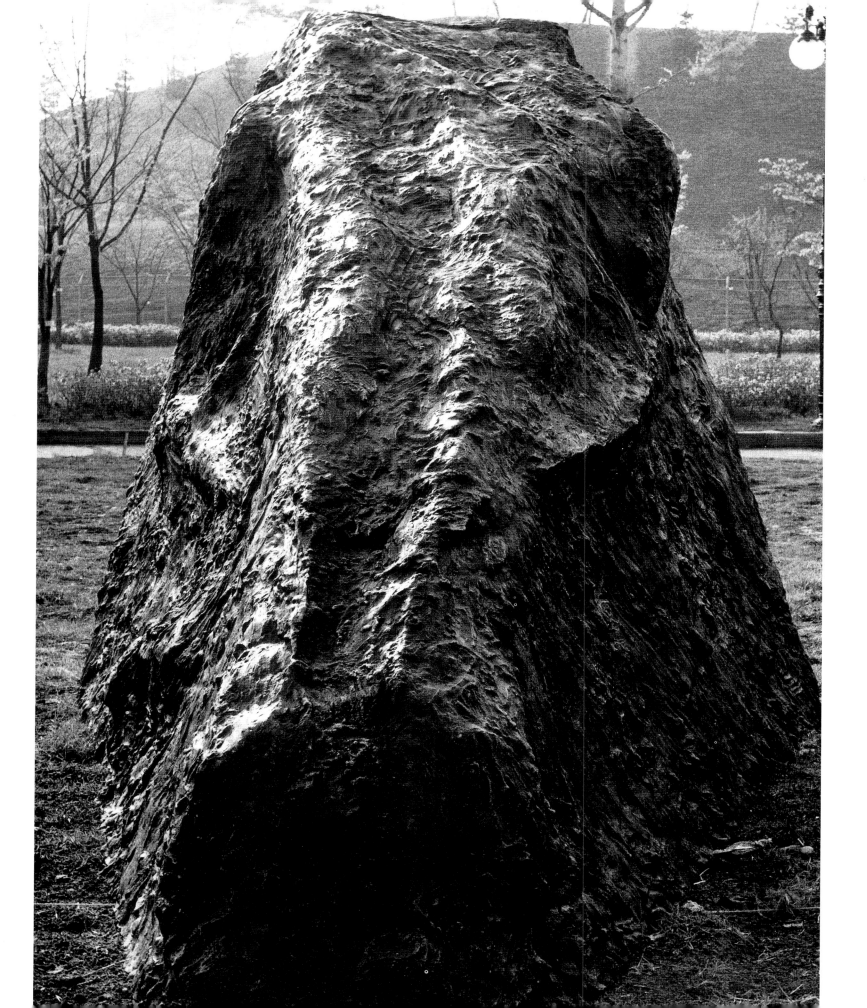

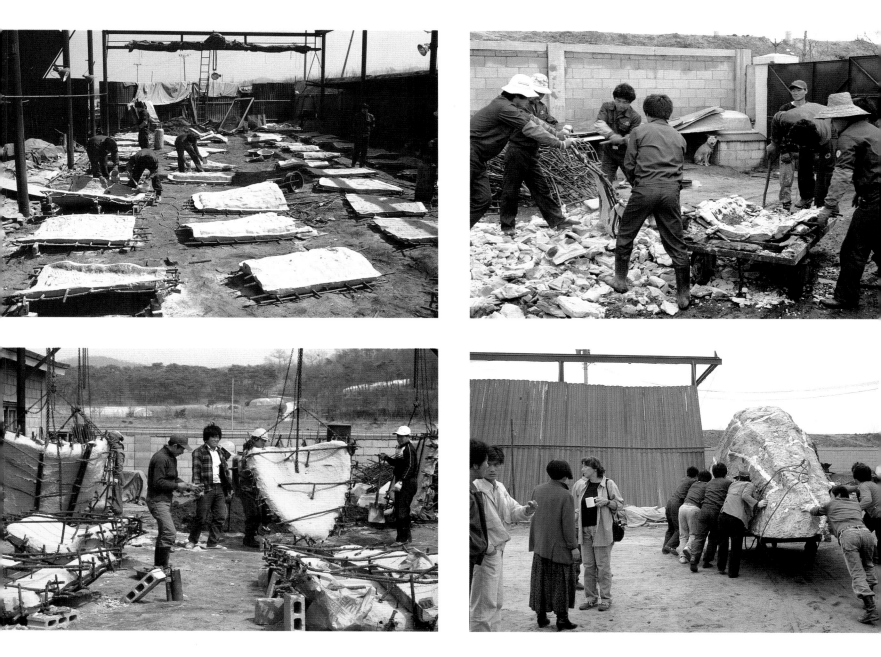

Working in the foundry on *Space of Dragon*, Seoul, 1988

The monoliths resemble isosceles triangles, with their bases tipped on a slight incline. The long muzzle is recognizable. Their concave eye sockets and the deep creases down the center of their muzzles ending in blunted nostrils evoke the rudiments of a head. Each has different features, although simplification and enlargement bring them close to abstraction. Resting directly on the ground, they seem to sink into or emerge from the grass.

Abakanowicz put the ten "dragon heads" on a small hill, roughly 150 feet by 50 feet, that she built, elevating them slightly above the level of the park surrounded by the stadiums and swimming pools. The articulation of space remains among her main concerns. In *Space of Dragon*, the spaces between the works are of paramount importance, to be experienced by the viewer who walks among the mammoth reclining forms that resemble the heads of mythical monsters. From the front, one feels the heaviness of the bronze, which looks solid. Walking around to the back, however, one discovers that they are hollow. These Jurassic creatures seem inert and immobile, yet as one walks among them, the illusion that the heads turn augments their mystery and uncanniness. The act of measuring one's relatively modest human scale against their grand proportions is humbling: the earth belongs to them.

Now that their patina has darkened to a stony gray, these monumental bronzes could easily be mistaken for ancient rocks: they are more like immense boulders or chunks of meteorite embedded in the earth than sculptures. The viewer surveys their dynamic formation—they seem to advance and retreat, some closer together, some farther apart—and is chilled by their inexplicably charged presences as they stare back. These ambiguous forms exist in the zone between animal and mineral. They inhabit a sacred place, like the mysterious burial mounds of the ancient Korean rulers that dot the countryside or the Polish *kopces,* the coaxial tumuli traditionally the burial barrow of Polish heroes.

Two other series followed the *Space of Dragon*: the *Sagacious Heads* and *Space of Nine Figures*. Mute, deaf, and dumb, the featureless *Sagacious Heads*, another cycle of monumental bronzes of 1989–91, sink into the ground in enigmatic silence. They evoke the memory of ancient cultures, of the giant obsidian heads of the Olmecs found in the jungles of Vera Cruz and in the archeological museum in Mexico City, or the stone heads of Easter Island, whose meaning also remains unknown. They are emphatically not the heads of specific individuals with their own lives and past histories; they are the faces of the crowd, portraits of a faceless species, "conceived," says the artist, "out of the fear about what living heads contain."

Four *Sagacious Heads* are placed on a green hill on the Virginia estate of John Kluge. These huge sculptures are bigger than the sculptures in Seoul. Variously cast from Styrofoam models like the figures in *Katarsis* and from plaster built up on an armature like the Seoul bronzes, their bronze surfaces

Overleaf:
Space of Dragon. 1988

Pages 158–59:
From the cycle
Sagacious Heads. 1989

155

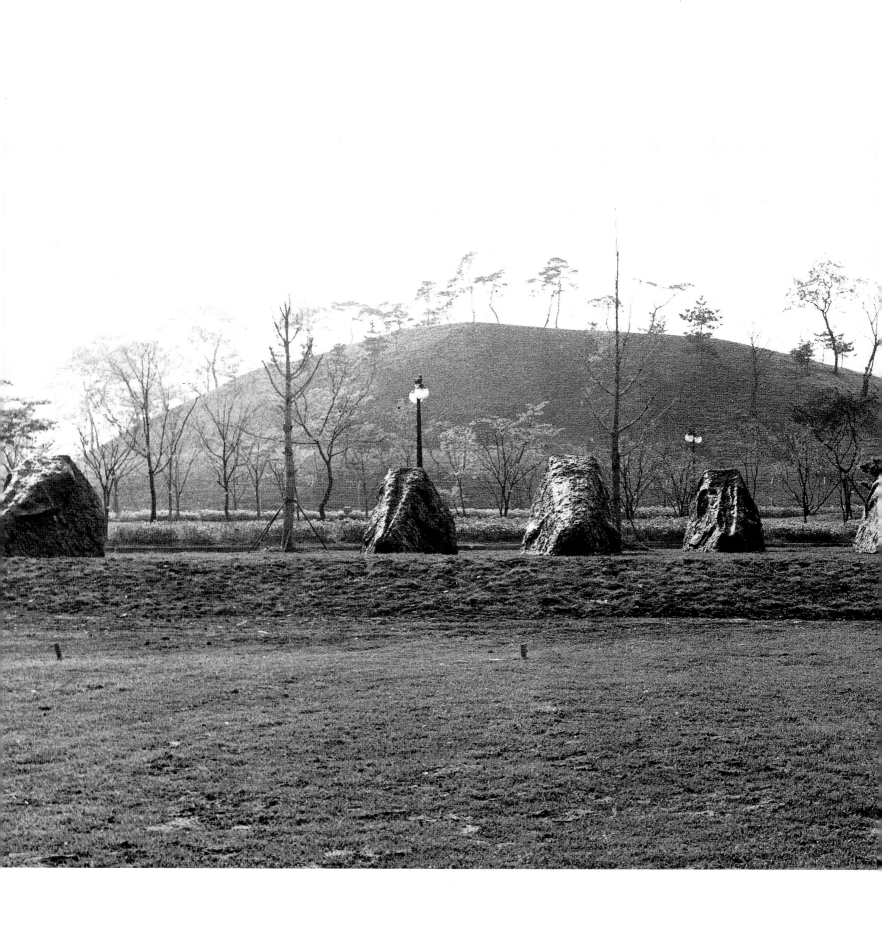

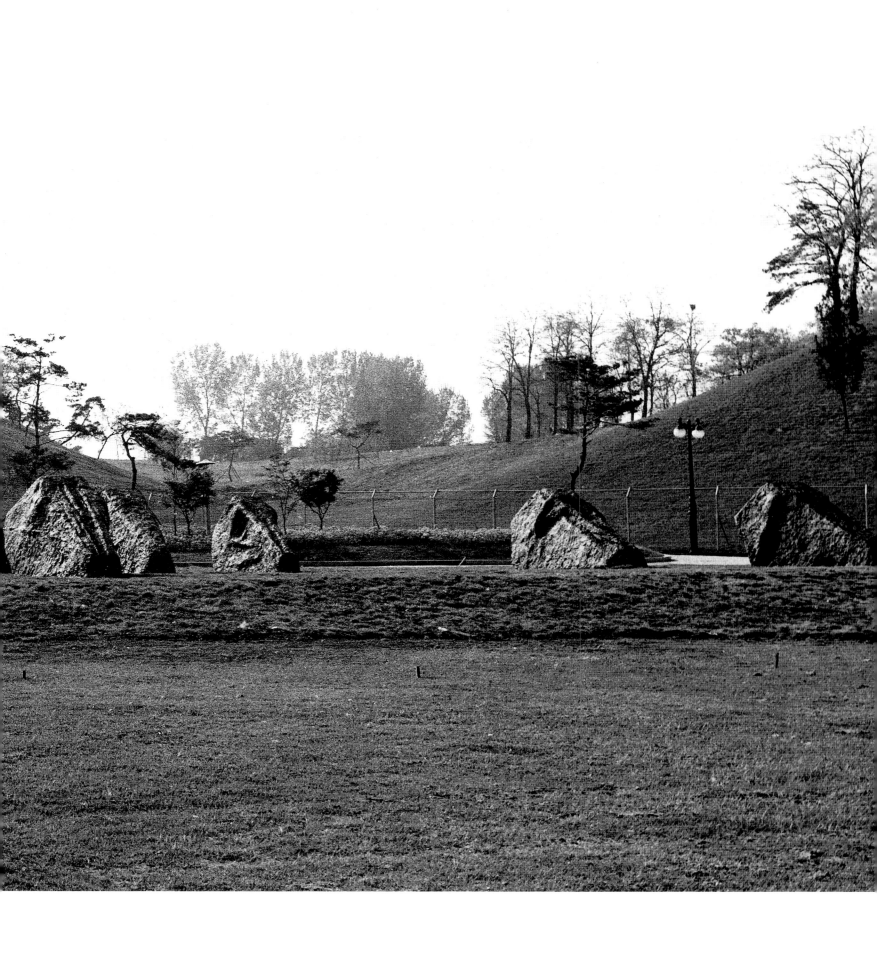

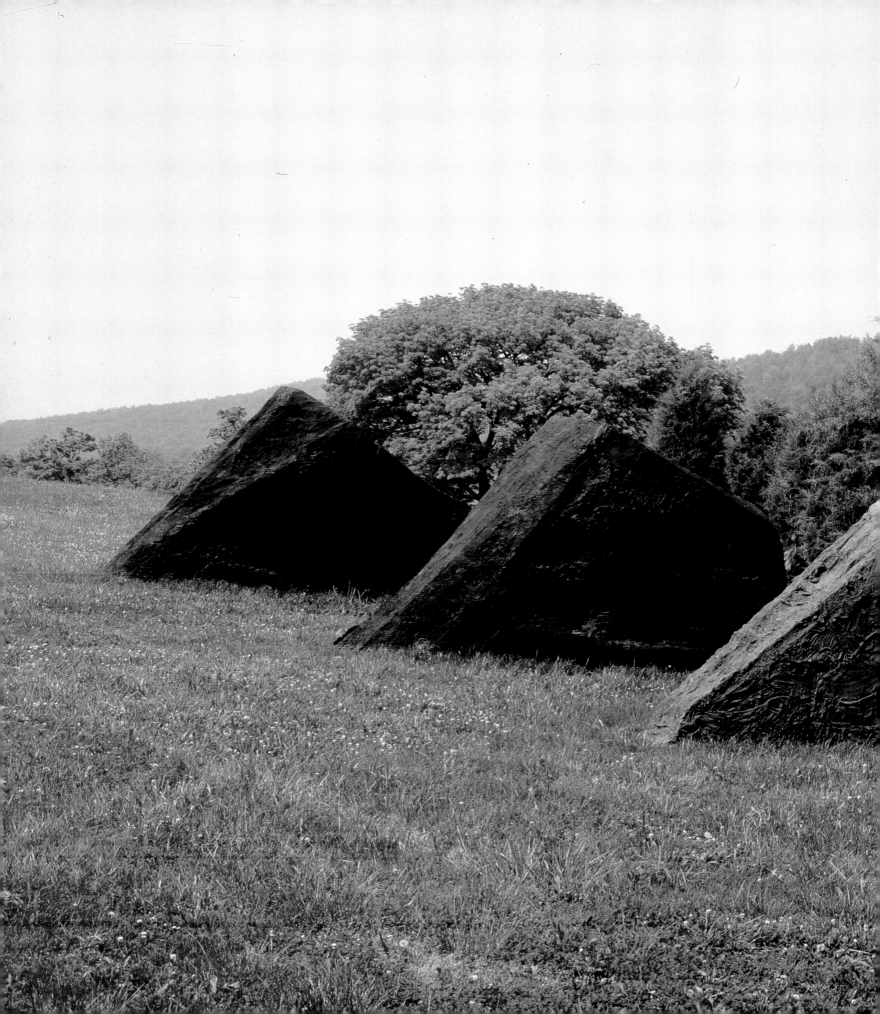

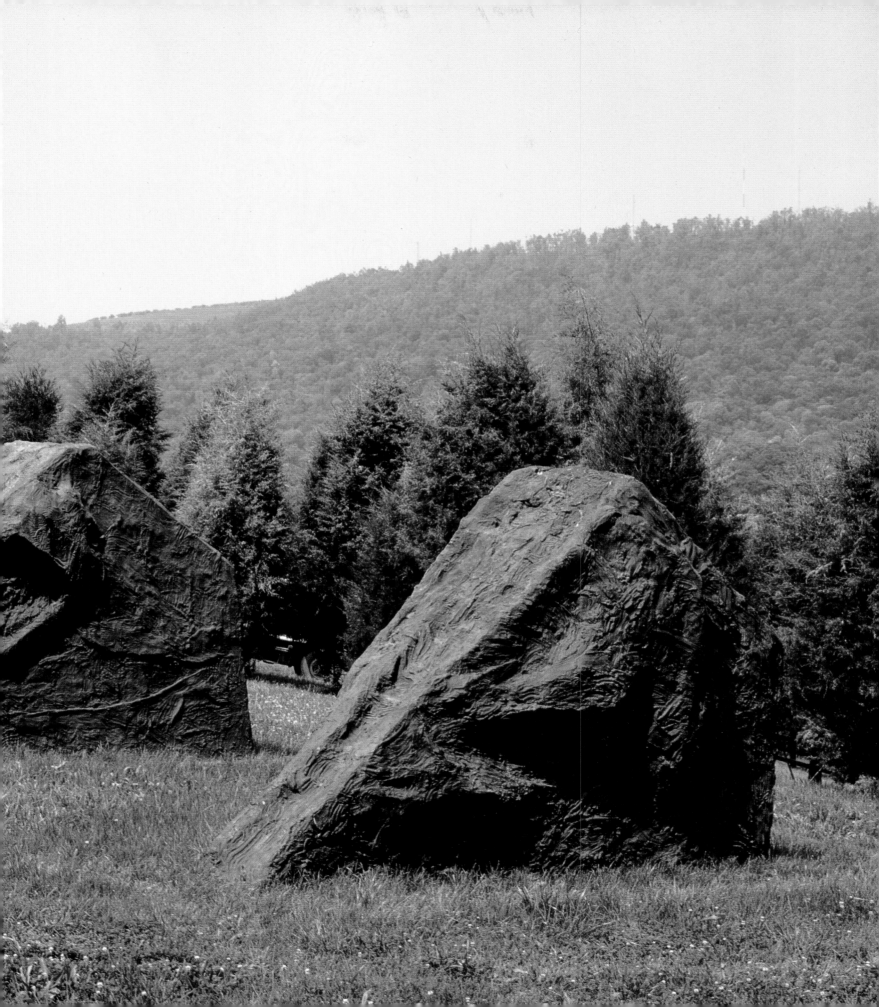

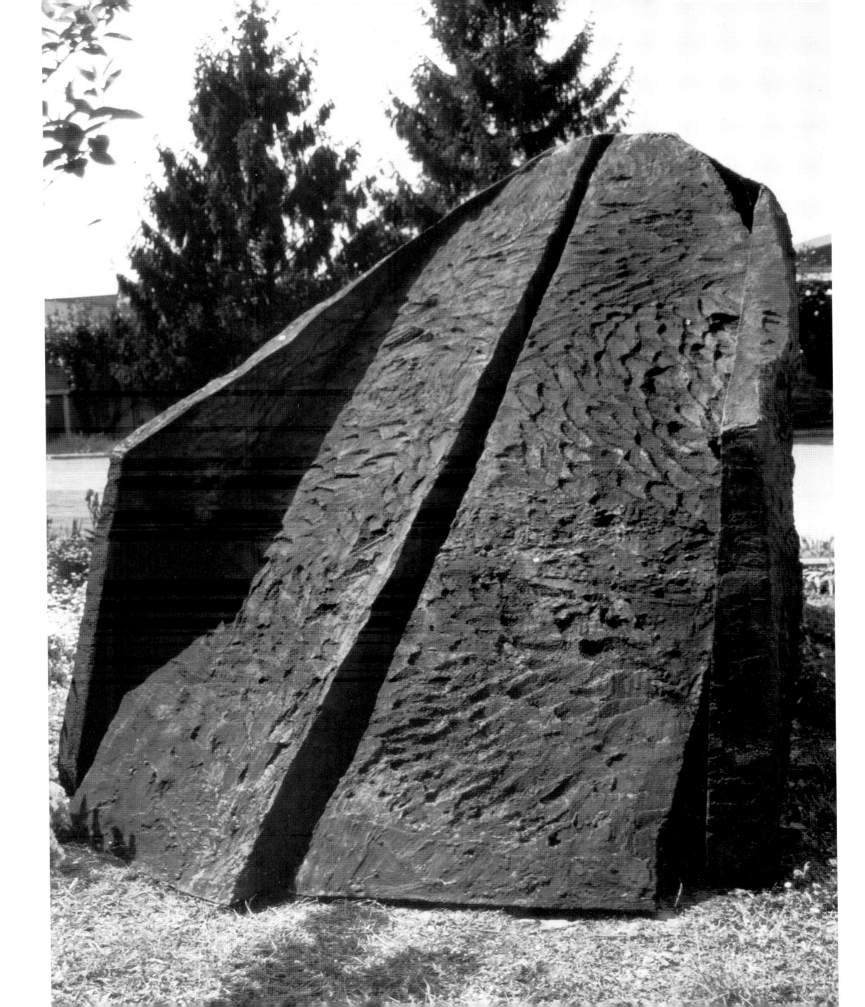

are activated by swirls and patterns made by the artist's fingers working in soft plaster and by her knife cuts in the Styrofoam. The simplicity of the forms is contradicted by the elaborate texture of the surfaces, whose complexity presents a puzzle because areas appear grafted, like skin that has been moved from one place to another.

Space of Nine Figures, a group of vertical forms commissioned by the Wilhelm-Lehmbruck-Museum in Duisburg, Germany, in 1990, continued the investigation begun with *Katarsis*. Reminiscent of Druid site markers or eroded gravestones, the finished cycle of nine bronzes evolved from a model for a group of standing figures that Abakanowicz had planned to execute in bronze or concrete. Cast from full-scale plaster models that Abakanowicz sculpted with her hands and wooden tools, the bronzes have a mottled, irregular surface that resembles stone more than bronze. In each monolith, the opposing forces of the downward-thrusting sides form a dynamic counterpoint to the upward-swelling front and back planes. The nine bronzes, like the other outdoor groups executed after *Katarsis*, function as an environment in relationship to one another, the space between them, the spectator walking among them, and the surrounding trees.

Opposite:
From the cycle *Sagacious Heads*. 1990

Overleaf left:
Abakanowicz working in the foundry on
***Space of Nine Figures*, 1990**

Overleaf right:
***Space of Nine Figures*. 1990**

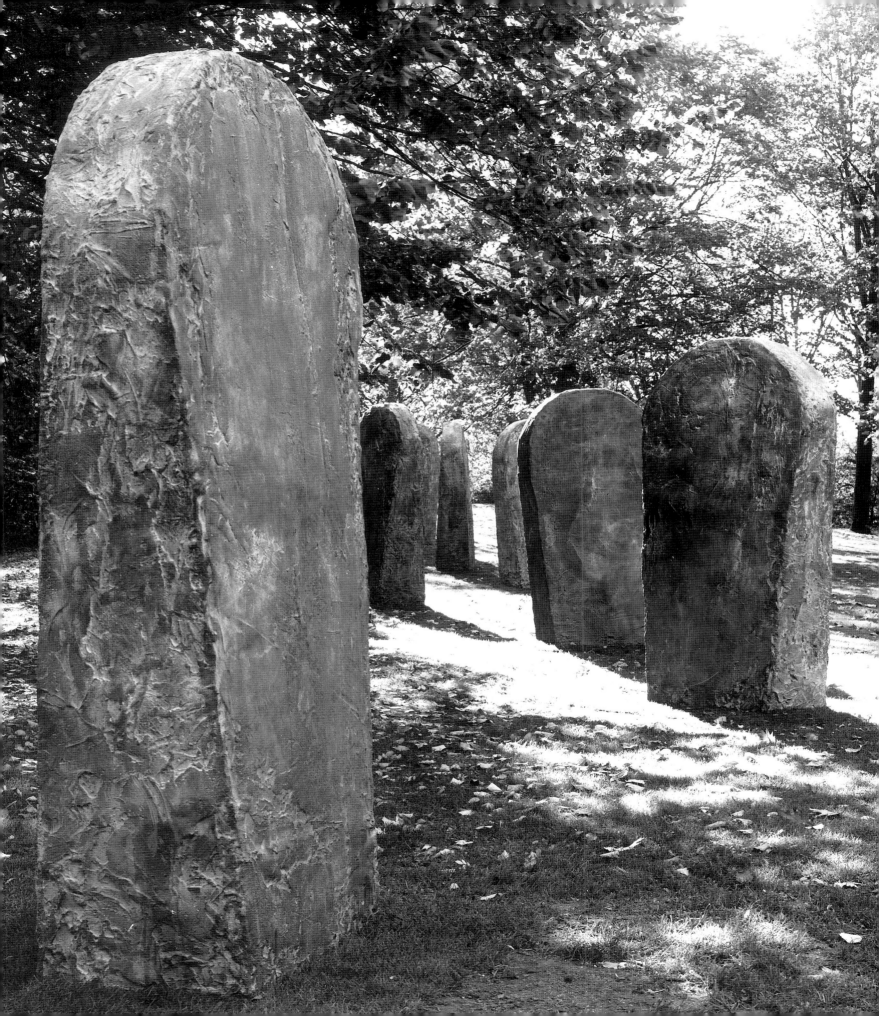

XIV : YOUTH AND AGE

I am in time, as if I were inside a tightly closed balloon. With me, strange events I went through, and others which I conceived.

Longings, disappointments, and fears teach me how to build their shapes. My imagination makes a choice.

I move along the vision groping detail by detail—until I feel the whole shape. I stay with it. I fit the shape of my body to it. And again I move along the imagined. I examine it. I compare it to known objects. Finally, in tension and haste I transform the vision into the real. Astonished by the result I reject it—I accept it. Independent of me, it follows me, as another piece of the past, inside of my balloon.

Magdalena Abakanowicz, 1989

Abakanowicz opened the decade of the 1990s with new explorations of the figure that continue her involvement with the human body. With the full vocabulary of forms and materials that she has developed over the years at her disposal, she works now in bronze and stone as well as in wood and fabric.

She began to make figures, in her studio in Warsaw, that suggest the supple agility and graceful lines of youth. In groups or single figures cast from childish and adolescent bodies, we see the possibility of a different experience of life, of a sense of relaxation, even in some cases of playfulness. Abakanowicz, having explored anonymous bodies for many years, wanted to capture the movement and behavior of adolescents; the way they sit and stand, and how they hold their legs, feet, and arms. She cast first one boy, then another one, then a small girl. She finished some seated figures, then some standing. She called the growing cycle *Ragazzi,* the Italian word for children.

The first group to emerge from her studio in 1989–90 were thirty-five standing teenagers with their arms held by their sides, made out of burlap. They were called *Flock.* Another group of thirty-three armless figures, slim but monumental and full of strength, followed in 1992. This group was called *Infantes.* The last group of thirty figures, titled *Puellae* and dating from 1992–93, is cast in bronze. Also among the *Ragazzi* were *Four on a Bench* (four figures standing on a wooden construction), single seated figures on light iron frames, and the figures in the cycle called *Circus,* which stand on constructions of metal wheels, wooden beams, and poles.

At the same time that she was casting adolescents, Abakanowicz also made a new series of seated figures that she called *Sages.* These were cast

Sage X. 1988

Overleaf:
Puellae. 1992–93

164

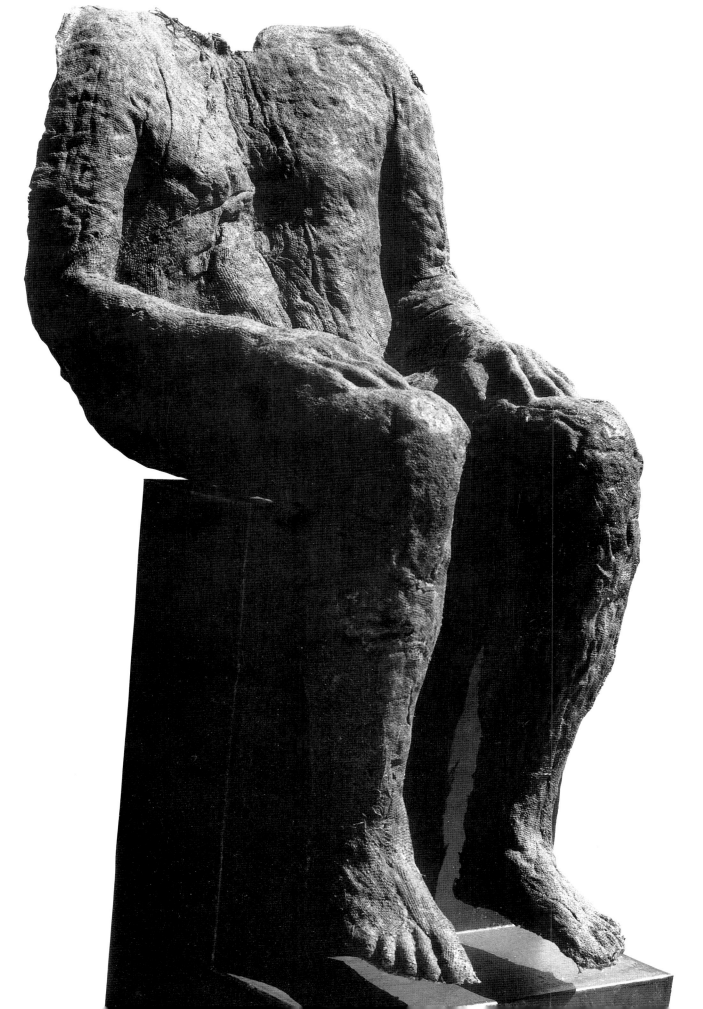

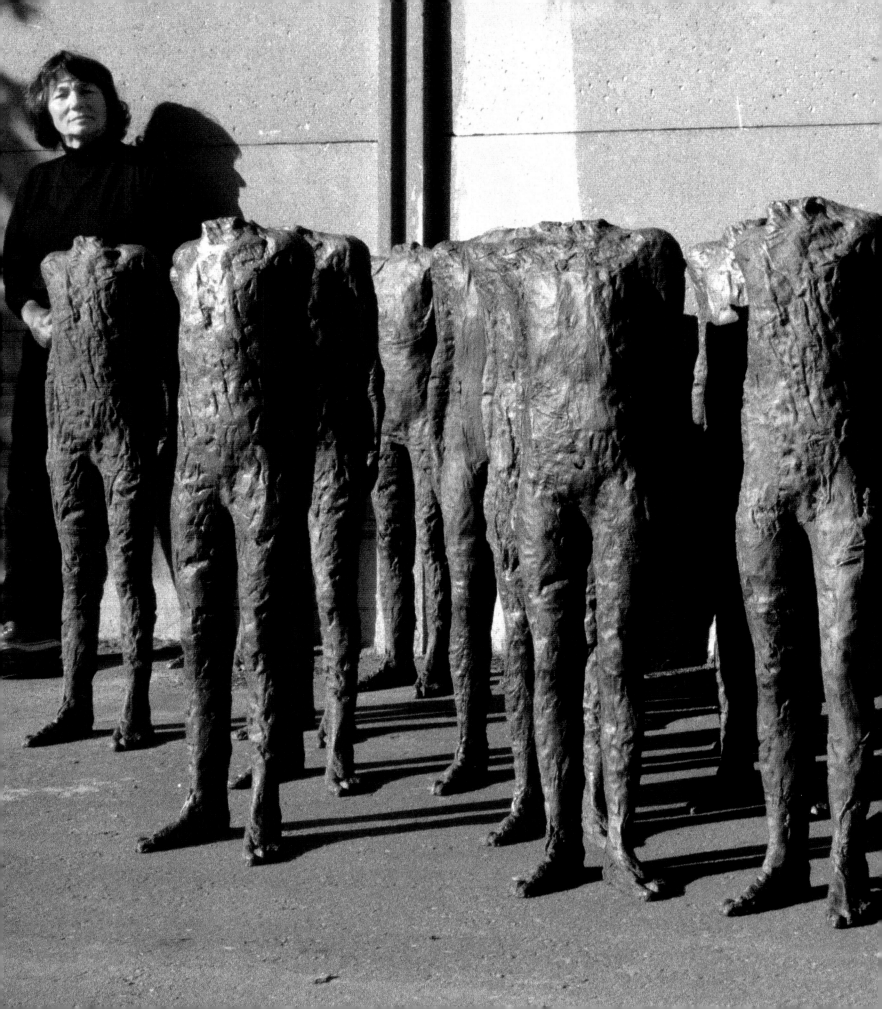

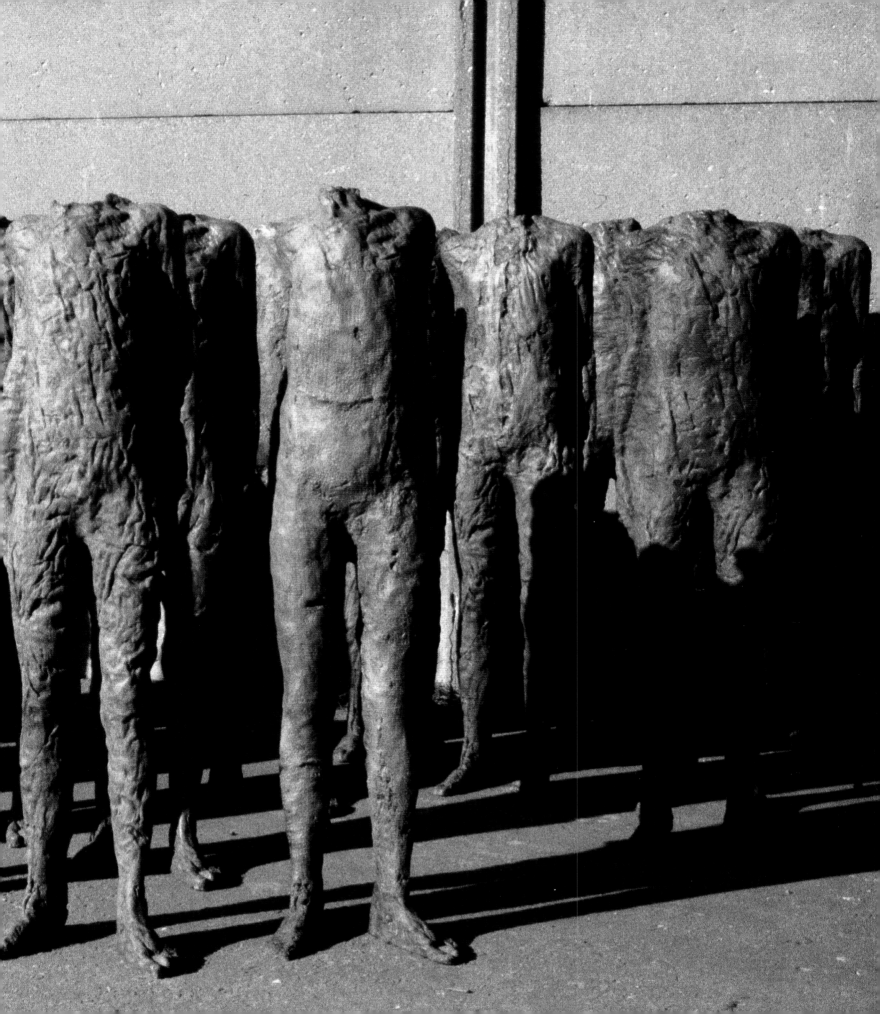

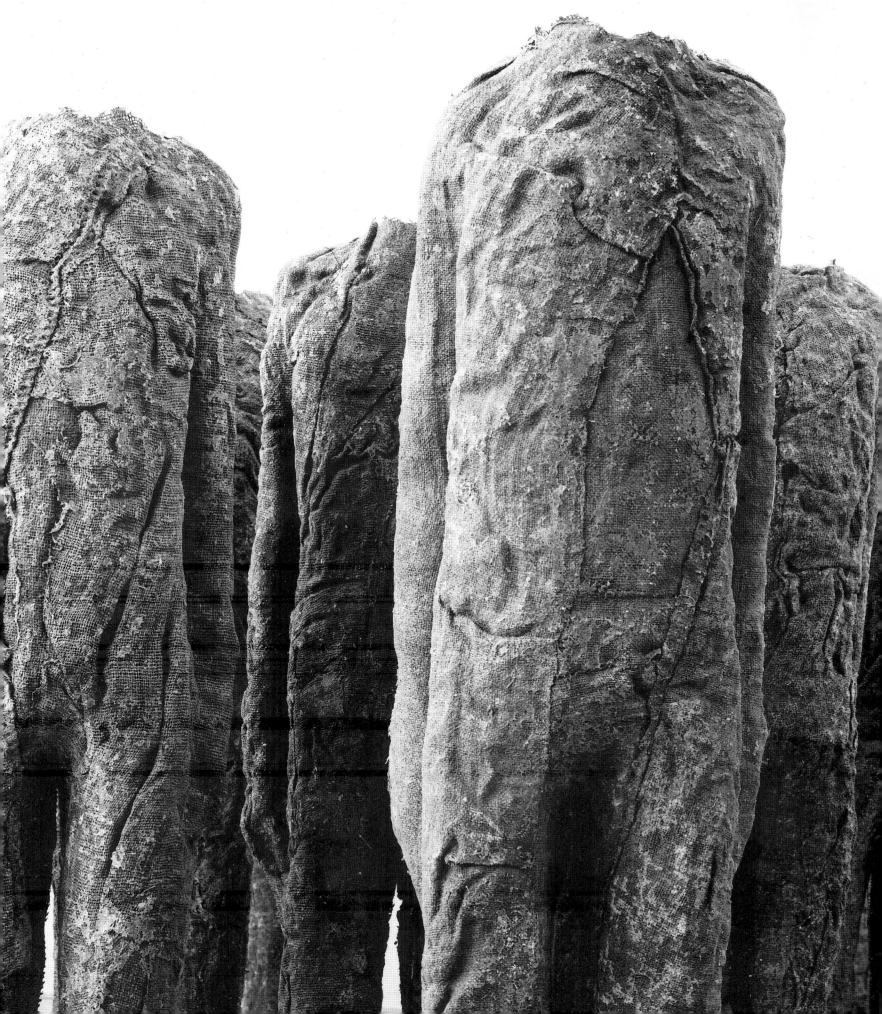

from the same person whose body provided the prototype for the gaunt *Seated Figures* of 1974. Now, however, the body is not that of a youth, but of a middle-aged man. The *Sage* was first seen in a burlap cast of a figure with hands resting on knees titled *Figure on Iron Seat,* made in 1988. This form was simplified and abstracted, the hands now a continuous line extending the arms into the knees in the cast bronze *Sages.* Like the *Incarnations* and *Hoofed Mammal Heads,* the *Sages* are not patinated, but partly covered with rough patches of ceramic from the mold that adhered to the raw bronze, creating an effect like mottled skin. Even headless, they convey a sense of ancient wisdom, suggesting an immobile timelessness and solidity.

In contrast to the unbending monolith of the *Sage,* the relaxed *Seated Child* of 1989, who grips a chair indicated by a transparent rectangle of iron rods with his thumbs, seems ready to jump up and play. His feet dangle without tension and his body is relatively smooth, unscarred by weariness or tragedy. The same is true of the youth called *Loukas* who sits on a high pedestal with his arms behind him, proudly pushing out his chest. The surface of these *Ragazzi,* which thus far have been cast only in burlap, is finer and its color lighter than in Abakanowicz's earlier burlap figures. The texture of the weave is not coarse but smooth, like the skin of young bodies. As always in Abakanowicz's work, differences and similarities are weighed against each other and the mind challenged to compare and contrast. In *Four Seated*, the slender torso used in *Loukas* is repeated in four different versions, so that the figure seems to shift position with adolescent impatience. Each has a different texture and is an individual sharing common features with a group while remaining isolated, seated on his own support.

At times the *Ragazzi* feel free and energetic enough to dance. The seven-year-old girl who is called *Dancer* stands up inside the transparent structure that holds her up off the ground. Her feet are balanced on thin rods in a position that suggests she may at any moment leap onto the floor. As animated as they occasionally are, however, the *Ragazzi* belong to the same headless and often handless tribe about which Abakanowicz has so much to say in her work.

Opposite:
Flock. **1989–90**

Overleaf:
Infantes. **1992**

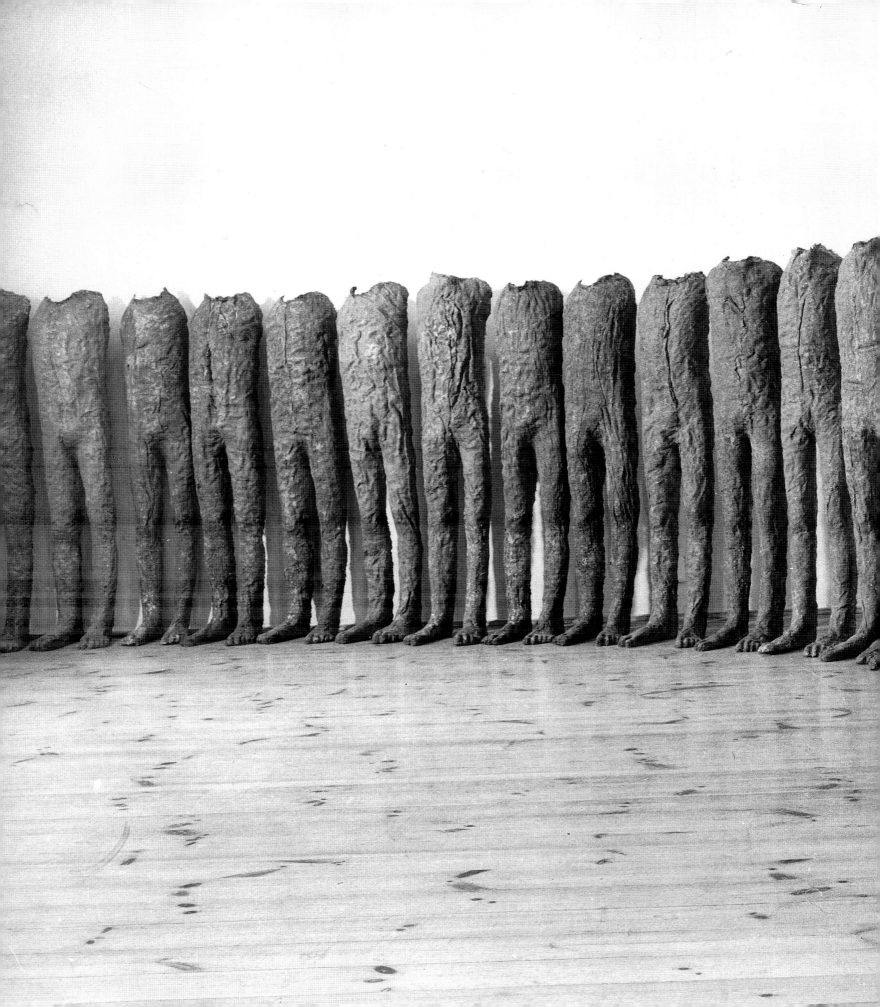

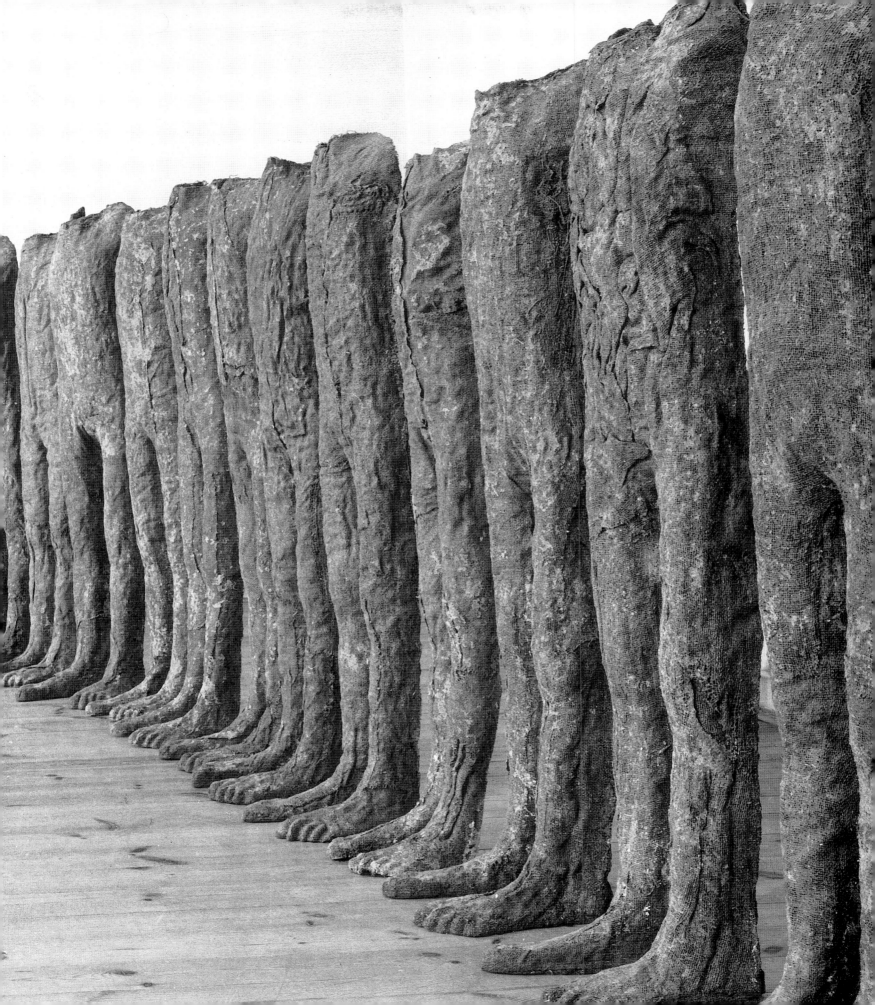

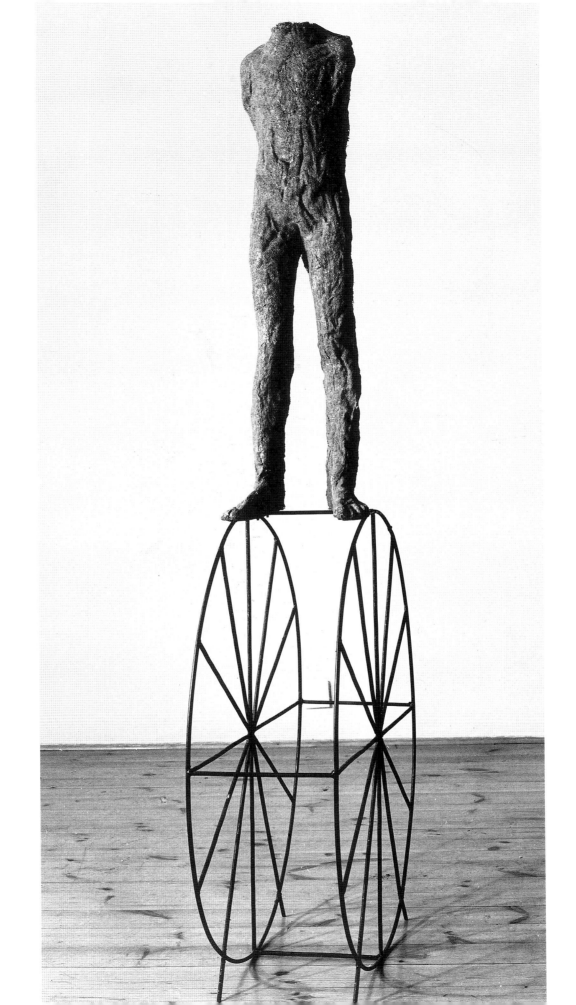

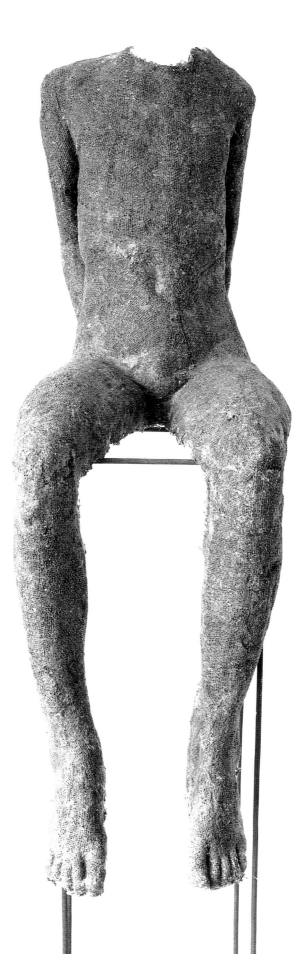

Opposite:
Small Figure on Wheel, from the
cycle *Circus.*
1992–93

This page:
Loukas. 1989

XV : Arboreal Architecture

The tree forms were born from my fascination with the Great Arch, its extraordinary unusual lightness and smoothness.

I walk and watch how in this landscape deprived of vegetation, children play with empty Coca Cola cans on the stone rectangles surrounded by stone and glass walls. To this sterile conceptual geometry I could only oppose an arboreal: organic, "disobedient," living, and green.

Once I opposed to the traditions of the French tapestries, my Abakans—magic, totemic forms, similar to the tree trunks and animal pelts. They and the Bois de Nanterre are in fact the result of the same fascination with organic corporeality; the same necessity to touch the mystery of nature . . .

In this longing for contact with vegetation there is also an irrational physical awareness of dependence of our body on it . . .

The twenty-five floors covered with a thicket of leaves and flower shapes, when filled with people, will help them to survive like a linden tree protects the tribe of bees . . .

I imagine the landscape of huge vertical shapes as powerful as in the rain forest.

<div align="right">Magdalena Abakanowicz, 1991</div>

In December 1990, the Etablissement public pour l'amenagement de la region de La Defense (EPAD) invited Abakanowicz to submit a proposal for the competition it called "Call for Ideas." The aim of this competition was to find a solution for the further extension of the existing Great Axis of the city, which extends from the Louvre, through the Arc de Triomphe, to the modern business district of La Defense. The new section of the Great Axis will pass through the suburban town of Nanterre and stop at the River Seine, where it will mark the western entrance to the French capital.

To define the concepts that would guide further development of this urban landscape, the EPAD called on ninety-two international teams of urban planners and twenty-two artists from around the world. From the artists' proposals, the jury singled out those of Piotr Kowalski and Jean-Pierre Raynaud from France, Alan Sonfist from the United States, and Magdalena Abakanowicz from Poland. Her project was called *Bois de Nan-*

terre—Vertical Green, but she later renamed it *Arboreal Architecture*. This project, and that of Jean-Paul Raynaud, were selected for further development.

In her initial replay to the EPAD, Abakanowicz referred significantly to the "body" of the Great Axis. The fundamentally humanistic basis of her concerns is indicated in her conception of landscape as a body and architecture as a living organism. From her earliest environments, the woven *Abakans*, to sculptural groups based on the human figure, to the *War Games*, which actually incorporate parts of trees, her work has been consistently based on the relationship between nature and culture. We can trace the transformation of the image of the human group into an ecological image of a forest from its origin in the grove of monumental bronzes at the Villa Celle, where the cast bronze trunks are implicitly compared with the trunks of the growing olive trees.

The gradual evolution of Abakanowicz's solution to the problem of humanizing the sterile urban environment of La Defense built upon these themes. It required translating the concept of the traditional tree-lined allée, typical of the entrances to cities and villages throughout France, into twenty-five-story-tall "arboreals." This was Abakanowicz's term for the multifunctional man-made trees covered with real vegetation indicated in the drawings and models for her project. The organic towers are designed to function as energy efficient, ecologically and economically productive residential and commercial spaces. Their planning and potential use indicates new ways of synthetic thinking that transcend the current boundaries of the isolated work of art.

When we realize that we are running out of space to house exploding populations, we understand the logic of creating a system that allows vines and plants to climb upward, to create vertical as opposed to conventionally horizontal zones of greenery. Abakanowicz's idea is to develop microclimates that preserve rather than destroy species, as well as serving literally as factories for manufacturing the oxygen required to clean the air of industrial pollutants. The greenery-covered towers are planned as freeform organic structures, offering maximum flexibility with regard to the needs and ideas of the owners of individual units. This stress on organic forms and individuality challenges the very concept of the skyscraper as a structure made up of identical modular boxlike units and the tenets of urban planning inspired by industry and the assembly line that took root in the 1930s, which resulted in nightmares of public housing projects all over the world. The arboreals look not to geometry or industry, but to advanced concepts in biology as models.

Acknowledging the dark meaning of her historical experience, Abakanowicz has struggled against accepting humanity's incapacity to give birth to a vision of a peaceful world whose problems are not political but

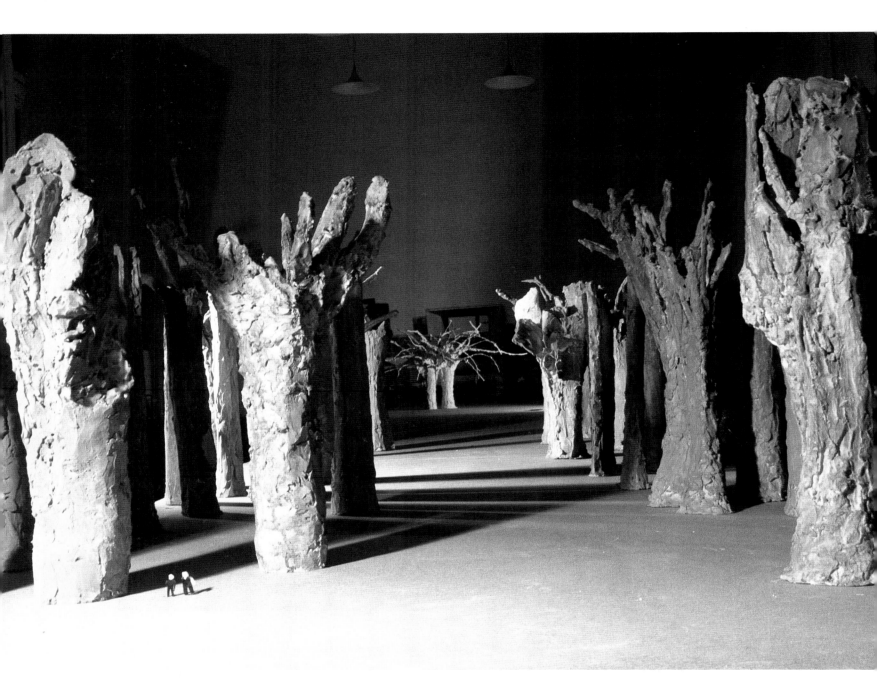

Above and opposite:
Model for *Bois de Nanterre—Vertical Green*
(renamed *Arboreal Architecture)*. 1991

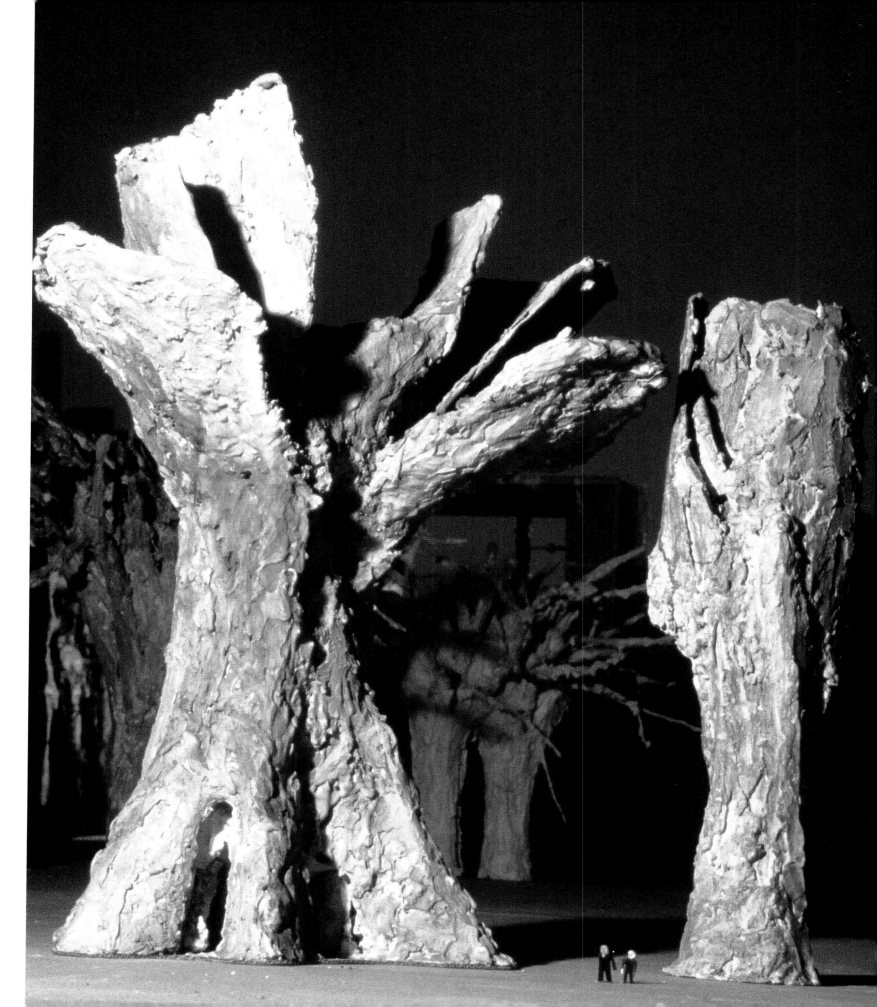

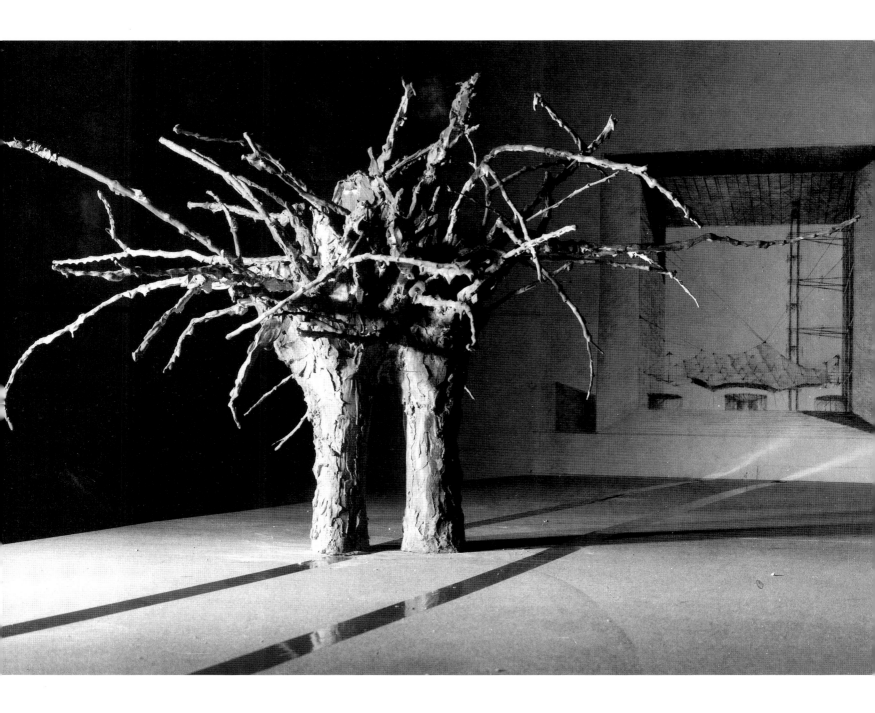

Model for *Bois de Nanterre—Vertical Green*
(renamed *Arboreal Architecture*). 1991

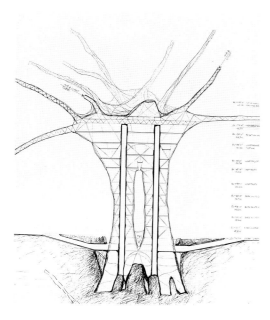

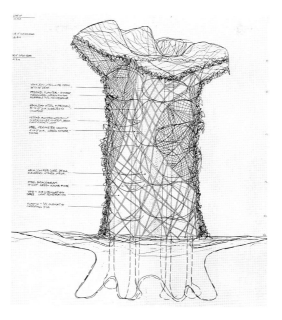

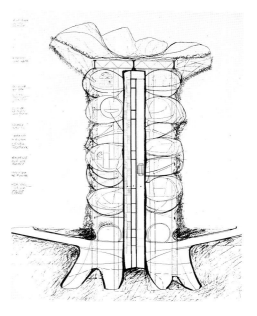

Arboreal Architecture:
**Cross-section of a twenty-five story
building showing structural system**

Arboreal Architecture:
**Elevation of a twenty-five story building
showing systems for planting and irrigation**

Arboreal Architecture:
**Cross-section of a twenty-five story
building showing interior spaces**

social, economic, and ecological. By collaborating with engineers and scientists to find the means to realize this urban project concretely and practically, she has demonstrated that she is no utopian theorist interested in imposing ideal forms on an unsuspecting public that prefers individuality above conformity. Abakanowicz's father, a landed aristocrat, believed in helping people, and she herself was once engaged by social problems. After her studies at the Academy of Fine Arts in Warsaw, she collaborated with a group of architects and scientists to create new systems of urban planning. With *Arboreal Architecture*, she offers people the opportunity to make better, easier, and healthier lives.

In question is not whether the *Arboreal Architecture* project can be realized, but rather whether the human brain can invent solutions to the problems created by the technology intended to bring material progress. Humanity at war with itself and with nature is what Abakanowicz has seen. The message of her art is that human survival depends on the capacity of the human race to evolve as an intelligent species conscious of history and capable of learning to change, grow, and survive. If artists are the antenna of the race, they, as André Gide maintained, rather than self-interested and conventional politicians, may turn out to be the new leaders we are seeking.

XVI : THE POWER OF MEMORY

I was destined to live during times which were extraordinary for their various forms of collective hate and collective adulation. As a small girl I even envied those youngsters in brown shirts from the neighboring country who so worshiped their leader and so firmly believed in his ideals. When they marched in to kill us, everything turned to hate, until the killers themselves were defeated and killed.

Then other enthusiastic marchers appeared, worshiping new ideals that would last forever and another leader, great and good. When it was noticed that the beloved leader was a mass murderer, a succession of lesser lights from the followers of the founding philosophers sprang up to replace him. Parades continued marching to celebrate visions that would bring happiness to all. With the enthusiasm of youth, I believed. With all my energy and dedication, I tried to put into practice this radiant and wonderful ideal. I understood soon enough: the country whose model was imposed on us, deprived us of identity. Hating each other, we simulated fraternity.

The reality that followed was unreal. Thoughts and words diverged. Actions followed an alien liturgy and an alien ritual. Love and hate were enforced. Finally, the common abhorrence of daily lies and a craving for truth prevailed. Those that were hated were made to yield to new leaders. Totalitarian oppression gave way to Liberty.

Within it, grasping ambitions have already started to hatch. Hand-to-hand fighting has begun, each against each, zealously trying to drag everything toward a private nest.

Magdalena Abakanowicz, 1990

The triumph of Solidarity in Poland in 1988, which was followed by the first free elections since World War II, made it simpler for Abakanowicz to travel abroad and to communicate directly with museums and institutions throughout the world. However, the logistical difficulties of creating and transporting her work, still conceived in the deliberate isolation of her Warsaw studio although often executed elsewhere, have, if anything, become more complex. Her endless world travels brought the realization that, as someone whose life was spent behind the Iron Curtain, her work does not fit the categories created by Western critics for Western art: her ideas about

Abakanowicz in the foundry working on models for *Hand-like Trees*, Bologna, 1992

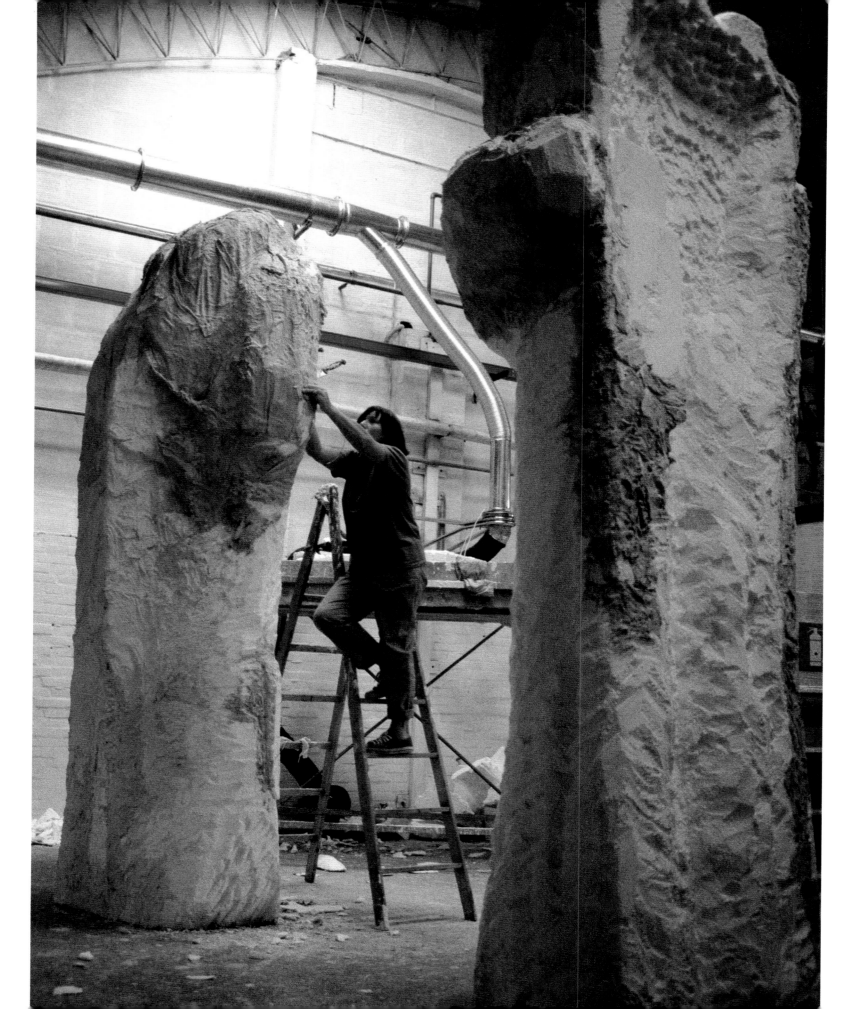

humanity, existence, philosophy, and history, like her art, were formed by circumstances unknown in Western Europe and North America.

Abakanowicz transforms lived reality into metaphor. We have observed that the forest image seems to have particular relevance for her. Recently, the American historian of Polish-Jewish descent, Simon Schama, has written eloquently of the endurance of the wooded landscape of Poland, whose beauty and purity no historical event could contaminate: "The fields and forests and rivers had seen war and terror, elation and desperation, death and resurrection. . . . It is a haunted land, where children pick up greatcoat buttons from six generations of fallen soldiers, lying amidst the woodland mushrooms."

This is the haunted land that continues to draw Abakanowicz back to her past and to that of her tragic country. The jungle tribes of Papua New Guinea, the Buddhist shrines of Japan, the frescoes of Giotto, the sculpture of Donatello, even Rodin's *Gates of Hell* could not inspire her as do the mysterious Polish landscape and the majesty of its ancient woodlands—what Schama described as "the black green phalanx of the primeval forest." Tragically, the grave markers and cenotaphs that populate Poland with the memory of human actions are as characteristic of its landscape as the great trees, and Abakanowicz's art recognizes their presence as well. A work like *Space for Nine Figures* is a reminder of what has happened, what we have done, and what has been done to us.

Working with the image of the giant tree trunk, which gave rise to *Arboreal Architecture*, Abakanowicz began in 1992 to create the huge vertical bronze trunklike forms that she calls *Hand-like Trees*. Their unexpected shape has something in common with her very first large gouaches of the 1950s, with their disobedient, asymmetrical organic forms. There is also in them something of the first metal sculpture she executed in 1965 for the city of Elblag. These new organic forms could be as well compared to the *Abakans* of the 1970s, but while the *Abakans* are soft, like living creatures, these bronze forms will remain as hard as rock. Having made a long journey dominated by human forms, Abakanowicz has returned, to her own surprise, to the tubular semiopen vertical shape where she began as an idealistic student.

The *Hand-like Trees* do not remind us of how bronze was used before. They seem to have been made by the invisible and inexorable forces of nature. Their secret inner cavities are partially exposed, inviting exploration. Art since Cubism demands a revelation of the truth—of materials, of process, of perceptual knowledge of the inside as well as the outside of an object—and by adhering to this principle, Abakanowicz defines herself as a sophisticated modernist, familiar with contemporary anti-illusionistic practices. At the same time, however, the *Hand-like Trees* seem ancient and primitive: in shamanistic societies, the hidden place, the secret inner cavity, is a shrine to the natural forces from which modern man is alienated. Putting us back

in touch with the terrible and the sublime is a goal of Abakanowicz's imagistic metalanguage that transcends artificial ethnic and cultural barriers in its openness to the collective unconscious.

Having at her disposal a vocabulary of charged forms, Abakanowicz has the means to communicate complex metaphors, the fruition of her long struggle to find a clear visual language that although intensely personal is neither privileged nor private. Gradually she has come to a syntactical conception of meaning: by altering the context, material, scale, and inflection of her forms, whether in the direction of abstraction or toward that of figuration, she is able to extract maximum variation and subtle alterations of mood and meaning. This capacity to generalize without simplifying or sacrificing specificity contributes to the power of her art.

Abakanowicz's originality is especially striking when we consider the global mass culture that standarizes experience and obliterates national boundaries. Turning her back on a world that desacralizes the sacred, negates distinctions, flattens individuals into conforming hordes of consumers, and flees the pain of tragedy through escapist entertainment, she dedicates her efforts to the preservation of memory, both historical and collective. Her solutions are never easy, either for herself or for the viewer, but her intention is not to ingratiate or please. Rather she forces us to confront and exorcise the demons of the dark side of humanity and to confront both nature's destructive and creative potential.

There is also an element of liberty and lightness in Abakanowicz's work since 1989. The first exhibition of the *Hand-like Trees* at Marlborough Gallery in New York in 1993 was also the first time that Abakanowicz showed a large group of *Ragazzi,* grouped together gracefully like a youthful corps de ballet. Figures from the cycle *Circus* evoked a motif that has frequently been used by artists to express their sense of fraternity with the nomadic troupes whose daredevil spectacles surprise and enchant the spectator. Abakanowicz included as a part of this installation a new arrangement of *Embryology,* as if to contrast its gravity and heaviness and the energy and delicate balance of the *Ragazzi.*

This dual vision, with its roots deep in traditional mysteries of nature, including human nature, and the more recent traditions of modern art is related to Abakanowicz's insistence that we examine her works from all angles until we come to know both inside and outside through our explorations. Her tendency to operate in shifting border areas where cognition is begins and takes shape, that unfamiliar territory where inchoate or amorphous forms can become, through slight alterations and inflection, eloquent polyvalent forms is intentional. She communicates not through the instant impact of easily read graphic images, but through the slow absorption of details and the gradual intimacy the viewer begins to feel as a physical and emotional reaction to sharing the same space as the artist's created forms.

Overleaf left:
Arami, Cecora, and Bason, **from the cycle** *Hand-like Trees.* **1992–93**

Overleaf right:
Bason, Cecora, and Dlon, **from the cycle** *Hand-like Trees.* **1992–93**

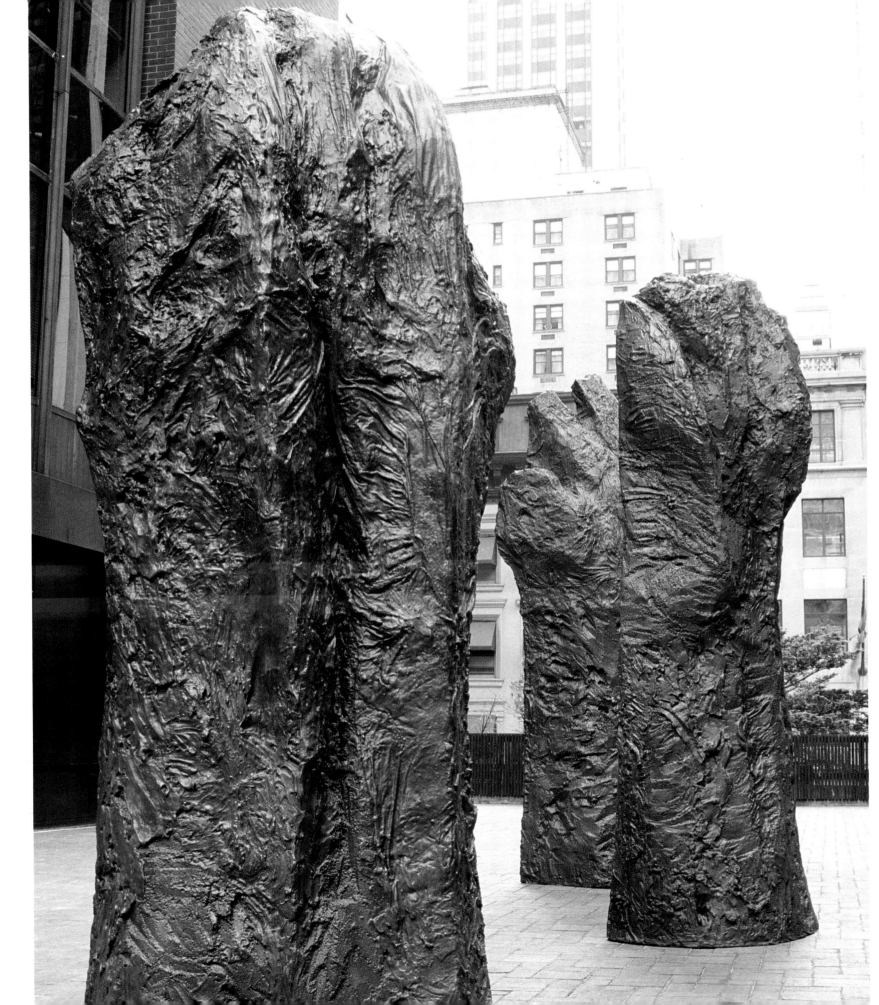

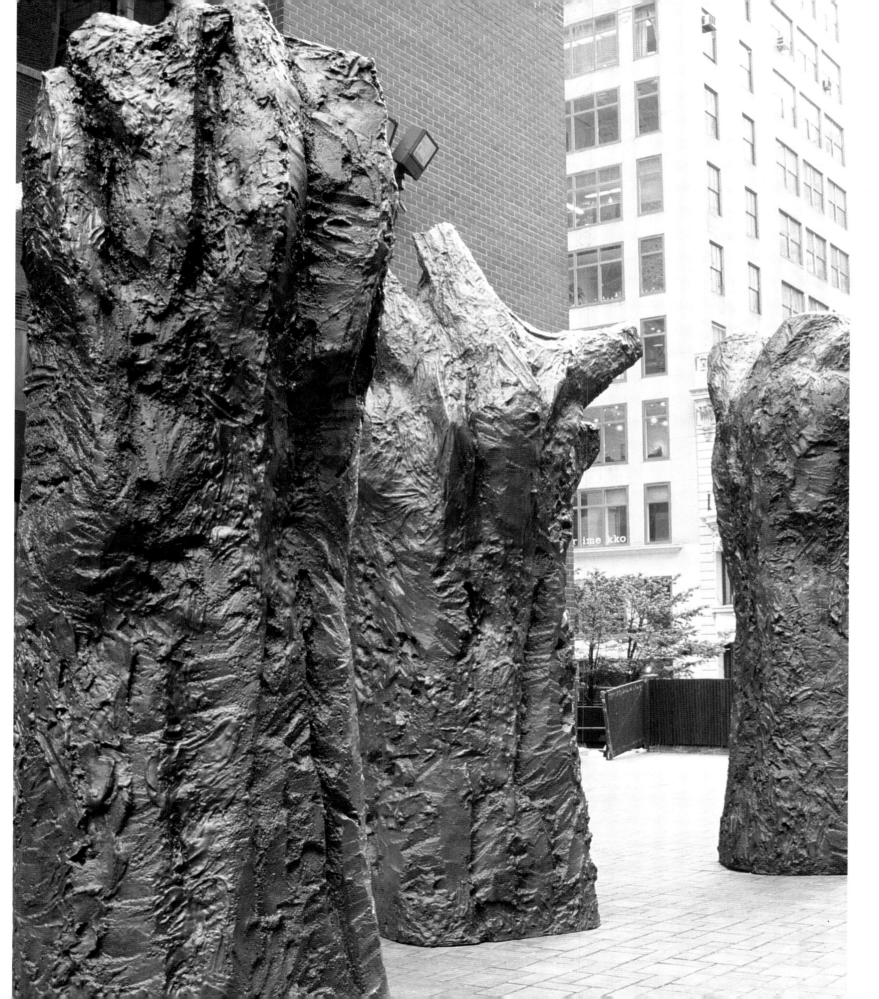

This communal space must be moved through and experienced as directly as the tactile sensations of assertive texture and irregular surfaces of her materials. Experiencing an Abakanowicz environment is akin to being lost in the woods. This is in keeping with the artist's own life: her first profound experiences with the Polish countryside remain a constant source of inspiration, and she periodically withdraws to the forest to recharge her imagination.

Living in a socialist country as she did, Abakanowicz could observe from a distance the Western world, with its different political systems and theories about the causes of crimes and wars, as well as its art. Through her art and her exhibitions, so numerous all over the world, she has tried to communicate to people her ideas about the problems of human growth. With a double vision of the tragedy of the past and the potential of the future, Abakanowicz returns to sculpture its memorial function. She commemorates not heroes or battles, but our species in its struggle to control destructive impulses and to evolve to the point that we may respect, rather than seeking only to tame, the forces of nature.

Opposite:
Arami, Bason, Cecora, and Dlon,
from the cycle *Hand-like Trees.* 1992–93

Overleaf:
Cecora, from the cycle *Hand-like Trees.* 1992–93

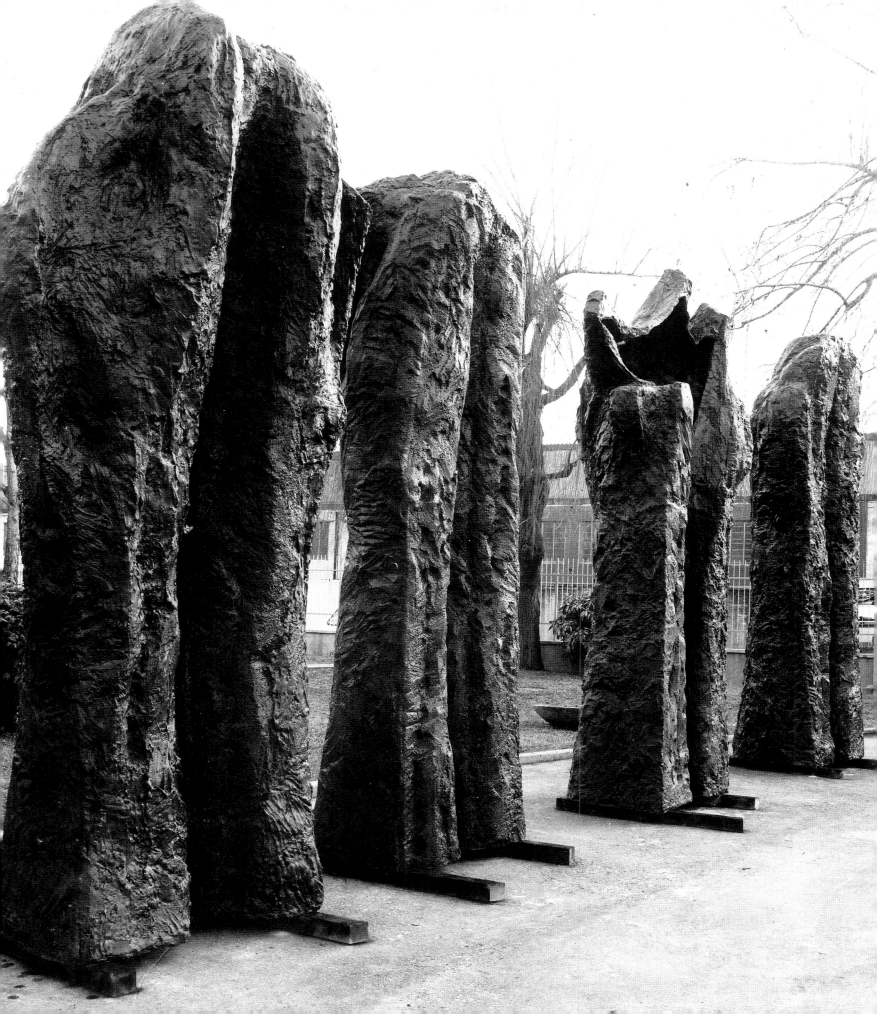

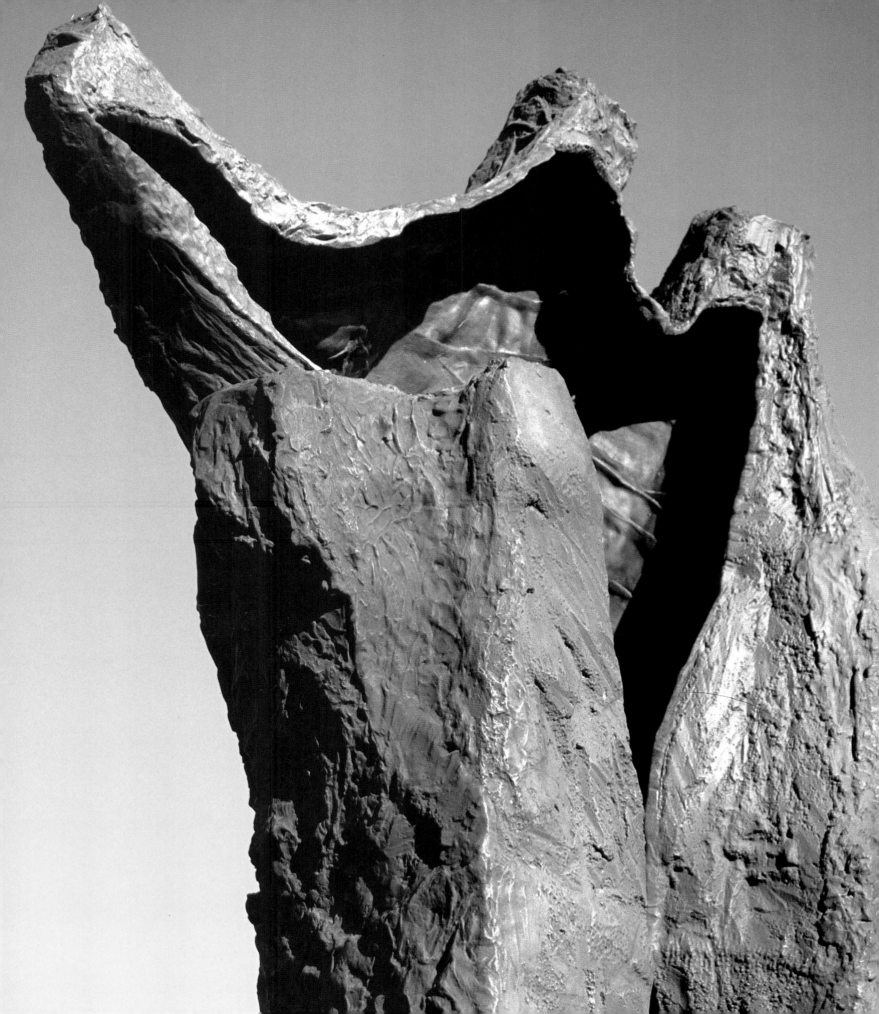

CHRONOLOGY

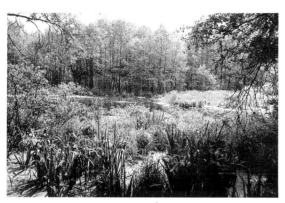

Falenty landscape

Abàkanowicz with *Butterfly*, 1956

1930 Born eight miles west of Warsaw in Falenty, Poland.

1931 Her family moves to her mother's country estate, 124 miles east of Warsaw. As a child, she makes sculptures and environments out of clay, stones, twigs, and broken china.

1939 Beginning of World War II. The Nazis invade Poland.

1944 The Red Army enters Poland. Her family leaves the estate and escapes to Warsaw. Insurrection against the Nazis in Warsaw. Complete destruction of the capital.

1945 End of World War II. The Communist revolution in Poland. Her family escapes to Gdansk area. She enters a public school for the first time, as she has previously had private tutors.

1947 She enters the high school of art in Gdynia, where she graduates in 1949 with a prize for painting.

1949 Enters the Academy of Fine Arts in Gdansk. She makes her living by teaching children French.

1950 She moves to Warsaw, enters the Academy of Fine Arts. Earns money from various jobs. Lives in student hostels. Socialist Realism, imposed by the Soviet Union and taught in art school, is the only officially sanctioned style.

1954 -56 Graduates from the Academy of Fine Arts in 1954. Starts working as designer in the silk industry. Begins to paint huge gouaches on paper and canvas, including *Composition with Plants* (1954–55), *Iris* (1954–55), *Butterfly* (1955–56), and *Fish* (1956–57)

1956 Marries Jan Kosmowski, a civil engineer. She leaves the silk industry. Concentrates on painting.

1957 Her first trip beyond the Iron Curtain to the West: a group excursion to Italy organized by the Artists Union. She admires not only the treasures of Italian culture but also the colorful, well-organized, and vigorous tone of everyday life there, which makes a strong contrast to her Communist homeland still recovering from the war. Meets the most important Polish Constructivist, Henryk Stazewski. Their longlasting friendship and his intellectual milieu have a strong impact on her development.

Magdalena and Stefania washing burlap sacks in the Vistula River, Poland, 1978

Magdalena Abakanowicz, 1960

Stefania Zgudka

1958 Travels to Russia: Kiev, Crimea, Georgia, and Moscow.

1960 Her first one-person exhibition in Warsaw is not permitted to open to the public, on the grounds that its "formalist" style runs counter to the officially sanctioned doctrine of Socialist Realism.

1961 Lives with her husband in a one-room apartment in Warsaw. Starts weaving in the basement of her friend Maria Laszkiewicz, which is used as a collective studio by the Artists Union.

1962 Participates in the first Biennale Internationale de la Tapisserie in Lausanne. *Composition of White Forms*, woven from thick cotton rope, strings, and hand-spun wool that she dyed herself, is well received. Receives a grant from the French Government to spend four months in France in the fall. Her ideas influence tapestry designers working for the Gobelin and Aubusson tapestry ateliers. Exhibits in Paris: weavings, gouaches, paintings, and small sculptures. The famous Aubusson tapestry atelier of François Tabard executes one of her gouaches in the Gobelin technique.

1963 Makes large relief weavings *Black Rhythm* and *Night Landscape*, using thick cotton rope and hand-spun wool. One-person exhibition in Poland, at the Galeria Sztuki Nowoczesnej, Warsaw.

1964 She creates *Helena*, *Andromeda*, *Kleopatra*, and *Dorota*, large weavings in a variety of materials, including sisal, rope, horsehair, fur, and silk, with organic relieflike surfaces. Travels with her exhibitions to Germany, England, and Switzerland. Meets Stefania Zgudka, who becomes her assistant for life.

1965 Creates *Desdemona*, *Dorota II*, *Anna*, *Relief with Hands* (integrating cast plaster hands into the woven relief), and *Black Relief*. Shows *Andromeda*, *Kleopatra*, *Helena*, *Anna*, and *Dorota* at the São Paulo biennial in Brazil and wins the Gold Medal. Shows *Desdemona* at the second tapestry biennial in Lausanne. Makes her first large steel sculpture for the Biennial of Space Forms organized by the marine engine industry in Elblag, Poland. Starts teaching at the Academy of Fine Arts in Poznań.

1966 Creates a series of monochromatic relief weavings, composed of several parts, with rounded shapes, including *Black Assemblage*, *White*, and *Leona*.

1967 Moves with her husband to a flat with a studio at the tenth floor of an apartment building, where she spends the next twenty-one years. Creates her first sculptures sewn out of thick organic material that she weaves herself. They are named *Abakans*; to the first group belong *Abakan Winged*, *Abakan 27*, *Abakan Open*, *Abakan Round*, and *Yellow Abakan*. Shows *Black Assemblage II* at the third tapestry biennial in Lausanne. Travels to Norway to install her first one-person museum exhibitions. Begins to exhibit with the Galerie Alice Pauli, Lausanne, which will be her only commercial representative for the next fifteen years.

1968 Creates *Brown Abakan* and *Brown Coat*. Travels to Switzerland and the Netherlands to install exhibitions.

Abakanowicz with her assistants Stefania, Krystyna, and Inka, working on *Bois-le-Duc*, 1970

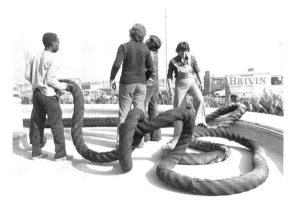

Abakanowicz installing a rope environment at the Bordeaux festival, 1971

Magdalena with Jan and Artur in the Mazury forest, 1981

1969 With her friend, the Polish film director, Jarosław Brzozowski, she works on a film about her creativity, named *Abakany*. For this film she creates an installation of *Abakans* and a rope knot on the sand beaches of the Baltic coast. Visits the United States and Mexico for the first time. Travels to Holland to install new works in the *Abakan* cycle, *Black Garment* and *Baroque Dress*, in a group exhibition at the Stedelijk Museum, Amsterdam. Shows *Abakan Red 1969* at the fourth tapestry biennal in Lausanne. Travels to Madrid to install *Abakan Winged* in a group exhibition at the Museo Español de Arte Contemporáneo. Travels to New York to install *Abakan 27* and *Yellow Abakan* in a group exhibition at the Museum of Modern Art.

1970 Travels to Sweden to create environmental installations for the Södertälje Konsthalle and the Nationalmuseum, Stockholm. Begins *Bois-le-Duc*, an environmental weaving commissioned for the Provinciehuis in s'Hertogenbosch, North Brabant, the Netherlands, completed in 1971.

1971 Creates *Orange Abakan*. Shows *Abakan—Situation Variable* (1970) at the fifth tapestry biennial in Lausanne. Travels to London to install her work in a group exhibition at the Camden Art Centre and meets Jasia Reichardt, director of the Institute of Contemporary Art, London. Travels to California to install her exhibition at the Pasadena Art Museum and lectures to enthusiastic audiences at UCLA, Fullerton State University, California, and Cranbrook Academy of Arts, Bloomfield Hills, Michigan.

1972 Creates *Abakan Brown Environment* and *Black Garment with Sack*. Shows her first human figures—dummies tightly sewn in black cloth—in her exhibition at the Kunstverein für die Rheinlande und Westfalen, Düsseldorf. At the Edinburgh International Festival she makes a rope environment by "sewing" through buildings, including the Richard DeMarco Gallery and Edinburgh Cathedral.

1973 Begins the cycle of sixteen *Heads,* originally called *Schizoid Heads,* in burlap and hemp on iron frames, completed in 1975. Shows *Wheel and Rope* at the sixth tapestry biennial in Lausanne. In London, receives honorary degree from the Royal College of Art and meets Artur Starewicz, the Polish ambassador to England, and a lifelong friendship develops. Exchanges with scientists in Poland, the United States, and England, regarding the philosophical consequences of the biology and structure of the human brain.

1974 Completes the first part of *Black Environment*, consisting of ten woven black forms, similar in general shape. The work—a total of fifteen pieces—is completed in 1978. She begins to work in new materials and in the scale of the human figure. She makes a plaster cast of a seated man. Using only the cast of the front part of the body, without head and hands, she makes the positive in burlap, stiffened with glue and resin. She repeats this figure with individual variations eighteen times, and calls the cycle *Seated Figures*. These figures and the *Heads* are the beginning of the *Alterations* cycle of figurative and nonfigurative works that develops in the 1970s and 1980s.

1975 Shows a selection of the *Abakans*, including *Black Environment, Wheel and*

Abakanowicz with Mary Jane Jacob and Jasia Reichardt,
Poland, 1979

Magdalena and Stefania working on
Four Standing Figures and Four Wheels,
Warsaw, 1983

Magdalena and Jan at their cottage in the country, 1980

Rope, Seated Figures, and *Heads* in the state gallery Zachęta in Warsaw and at the Whitechapel Art Gallery, London. Shows *Seated Figures* at the seventh tapestry biennial in Lausanne. She starts writing about her work.

1976 Invited by the Australia Council of the Arts, she travels to Australia to install retrospective exhibitions at the Art Gallery of New South Wales in Sydney and the National Gallery of Victoria, Melbourne, including all of the *Abakans, Wheel and Rope, Seated Figures,* and *Heads.* In Australia, she works on educational films and leads workshops. Trip to Papua New Guinea, a profound experience. Travels in Central Australia, Queensland, and to the Great Barrier Reef, and, on her return to Europe, visits Indonesia and Thailand. Travels to Japan, invited there to lecture by the National Museum of Modern Art in Kyoto. Meets Kuniko Lucy Kato, an art historian, and a lifelong friendship follows. Begins the cycle of *Backs,* burlap forms based on part of a cast of a human body, consisting of eighty pieces completed in 1980.

1977 Shows the first group of twenty *Backs,* called *Session,* from the *Alterations* cycle, at the eighth tapestry biennial in Lausanne. Shows *Abakans* and *Alterations* at the Malmö Konsthall in Sweden and the Sonja Henies og Niels Onstadts Stiftelser, Høvikodden, Norway.

1978 Starts working on the *Embryology* cycle of eight hundred soft forms. Writes *Portrait x 20,* a poem about her childhood.

1979 Shows the completed *Black Environment* in her last regular appearance at the ninth tapestry biennial in Lausanne, under the title *For contemplation.* With her Super 8 camera, she makes *John Baptist,* a three-minute-long film. Mary Jane Jacob, associate curator of the Detroit Institute of Art (later the chief curator of the Museum of Contemporary Art, Chicago) visits her studio in Warsaw to plan a large retrospective exhibition to travel in the United States, and to be accompanied by a book with an essay by Jasia Reichardt.

1980 She represents Poland at the Venice biennale with a one-person exhibition in the Polish Pavilion, showing forty *Backs, Embryology,* and *Wheel and Rope.* Shows forty *Backs* at "ROSC '80: The Poetry of Vision" in Dublin.

1981 Great liberation movements in Poland, suppressed on December 13th by the proclamation of the martial law. She creates *The Cage,* a sculpture constructed of thick wooden poles enclosing a figure, and *Trunks,* using fifteen carved logs. She begins two cycles of drawings, *Bodies* and *Faces,* and the cycle *Pregnant,* consisting of twenty-three forms of twigs and wire, completed in 1982. Makes a temporary installation of tarpaulins for a group exhibition at the Malmö Konsthall, Sweden.

1982 Martial law continues in Poland and the borders are closed. With difficulty, she gets permission to travel to Paris to install her exhibition at the Musée d'Art Moderne de la Ville de Paris: it includes the whole cycle of eighty *Backs,* the eight hundred pieces of *Embryology,* sixteen *Seated Figures, Wheel and Rope,* and the twenty-three pieces in the cycle *Pregnant.* Lectures at the Banff Centre of Continuing Education in Canada. There she creates sixteen ceramic pieces

Abakanowicz with old friends Henryk Stazewski (center)
and philosopher/poet Adam Mauersberger (left), 1981

Abakanowicz with Guiliano Gori
and *Katarsis,* 1985

Abakanowicz with Teddy Kolleck, the mayor of Jerusalem,
at the inauguration of *Negev,* 1987

called *Syndrome.* Travels to Japan under the auspices of the Abakano-Kai Association, to lecture at the universities in Tokyo and Kyoto and at the city lecture hall in Sapporo. Her large traveling exhibition, including pieces from the *Abakans* and *Alterations* cycles, opens in Chicago at the Museum of Contemporary Art and the Chicago Cultural Center.

1983 Creates *Four Standing Figures and Four Wheels,* a large outdoor composition, for the sculpture biennial in Middelheim, Belgium, and *Standing Figure and the Wheel,* which includes her first figure cast in aluminum, for the De Cordova Museum, Lincoln, Massachusetts. Travels in the United States and Canada to install her retrospective exhibition at each venue and to lecture. Participates in "Art '83" at the Museum of the Ateneum, Helsinki, and travels to Lapland, beyond the Arctic Circle. With her Super 8 camera, she makes *The Hand,* a short film. Travels to Le Creusot, France, where she creates four forms from old engine models, which become *Sarcophagi in Glass Houses* (1989).

1984 Visiting professorship at UCLA in the fall. Creates *Androgyn with Bricks,* an aluminum figure, at Fullerton State University, where she also casts her first bronze figure. The Xavier Fourcade Gallery in New York undertakes to represent her in the United States.

1985 Creates *Katarsis,* a work of thirty-three bronze figures, for the collection of Guiliano Gori in Pistoia, Italy. Shows *Androgyn I* at the twelfth tapestry biennial in Lausanne, as an invited guest. Begins the cycles called *Anonymous Portraits,* 30 self-portraits in cotton fabric completed in 1990, and *Incarnations,* 110 self-portraits in bronze completed in 1989.

1986 Creates a group of fifteen burlap sculptures called *Female Figures.* Seven of them are shown at the Sydney Biennial, Australia. Begins work on *Crowd I,* consisting of fifty standing figures with hands, completed in 1987.

1987 Creates *Negev,* seven monumental limestone disks, for the Israel Museum in Jerusalem Sculpture Garden. Begins work on the *War Games* cycle, consisting of massive constructions in wood and iron, using tree trunks from the Mazury forest in Poland. Death of Xavier Fourcade.

1988 She moves with her husband to their own house with a studio. Creates *Space of Dragon,* ten monumental metaphoric animal heads, for the Olympic Park in Seoul, South Korea; *Androgyn With Wheels* for the National Museum of Contemporary Art, Seoul; and *Crowd II,* consisting of fifty standing figures without hands. A large retrospective exhibition of her work in Budapest, at the Mucsarnok Palace of Exhibitions, draws 100,000 visitors, and her work is recognized as a political statement in view of the liberation tendencies still growing in the countries of the Socialist Bloc. The Marlborough Gallery in New York undertakes to represent her.

1989 The liberation of Poland from Communism. She completes *Sarcophagi in Glass Houses* for a retrospective exhibition at the Städelsches Kunstinstitut und Städtische Galerie, Frankfurt am Main. Creates *Crowd III,* a group of fifty standing figures in burlap and resin. Begins the cycle called *Sagacious Heads,*

194

Abakanowicz with Barbara Rose
in Israel

consisting of seven monumental bronze pieces completed in 1991; the cycle called *Hoofed Mammal Heads*, a group of thirty-eight small bronze animal heads on pedestals completed in 1990; and *Flock* in the cycle called *Ragazzi*, based on molds taken from children's bodies. *Flock*, consisting of thirty-five burlap and resin figures, is completed in 1990. She installs her first exhibition at the Marlborough Gallery, New York, which includes *Anasta* and *Ancestor* from the cycle *War Games*, *Crowd III*, *Jonas* and *Loukas* from the cycle *Ragazzi*, and *Sagacious Heads*.

1990 Creates *Space of Nine Figures*, with nine bronze forms, for the Wilhelm-Lehmbruck-Museum, Duisburg, Germany; the cycle called *Geminati*, consisting of six forms constructed of twigs and wire; and *Crowd IV*, a group of sixty figures. Begins *Bronze Crowd*, a group of thirty-six bronze standing figures completed in 1991 and installed in at the Walker Art Center, Minneapolis, in 1992. Travels to Japan under the auspices of *Asahi Shimbun* to prepare for her retrospective exhibitions in the main museums. Retires from her professorship at the Academy of Fine Arts, Poznan.

1991 Travels to Paris several times in connection with *Arboreal Architecture*, her proposal for the extension of the city's Great Axis beyond the district of La Defense. Travels to Japan to install her exhibitions, each as a separate work of art, in the museums of Tokyo, Shiga, Mito, and Hiroshima. She installs a retrospective exhibition in the Muzeum Narodowe, Wrocław, including *Zycie Warszawy*, a weaving of 1973; pieces from the cycles *Seated Figures*, *Standing Figures*, and *Embryology*; *Flock*; and *Baz* and *Lipis*, two new pieces in her *War Games* cycle.

1992 Creates *Infantes*, thirty-three standing figures in burlap and resin. Begins work on *Puellae*, thirty standing bronze figures, completed in 1993; *Sroka* and *Giver* in the cycle *War Games*; *Hand-like Trees*, five large bronze forms also completed in 1993; and *Becalmed Beings*, a group of forty backward seated figures in bronze, commissioned by the municipal authorities in Hiroshima, in response to a petition signed by 6,241 Japanese people. Exhibits *Arboreal Architecture* in the Marlborough Gallery, New York, and in the Museu Nacional de Belas Artes, Rio de Janeiro, as a general solution to the problems of big urban agglomerations. Receives an honorary degree from the Rhode Island School of Design, Providence.

1993 Creates *Kuka* and *Kos* in the cycle *War Games*. Exhibits recent pieces at the state gallery in Kraków Poland; the Institute of Contemporary Art PS 1 Museum, New York *(War Games)*, and Marlborough Gallery, New York *(Embryology, Infantes, Circus, Hand-like Trees, and Puellae)*. Travels to Japan to install *Becalmed Beings* at the Hiroshima City Museum, to install *One of the Crowd* in the Hakone Open Air Museum, and to be a guest at the Fuji Sankei biennial. Receives an award for distinction in sculpture from the Sculpture Center, New York.

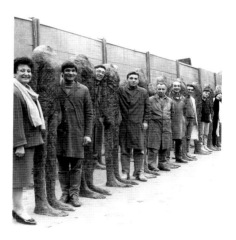

Bronze Crowd at the Venturi foundry, with Gabriella Venturi (left), the foundry craftmen, and Abakanowicz, Bologna, 1991

List of Plates

Retrospective Exhibition," Portland Art Museum, Oregon, 1984 (axle added for exhibition)

Page 38:
Rope installation, "Magdalena Abakanowicz/Textil Skulptur/ Textile Environment," Södertälje Konsthall, Sweden, 1970

Page 40:
Rope installation, "The Fabric Forms of Magdalena Abakanowicz," Pasadena Art Museum, California, 1971

Page 42:
Magdalena Abakanowicz with a piece from her *Heads* cycle in her studio, Warsaw, 1973

Page 43:
The Hand (two views), 1976
Sisal, 4³/₄ x 8 x 6" (12 x 20 x 15 cm)
Collection John Melin, Malmö, Sweden

Page 45:
From the cycle *Heads*. 1973
Burlap and hemp rope, 43 x 30 x 26" (109 x 76 x 66 cm)
Private collection

Pages 46–47:
Heads. 1973–75
Burlap and hemp rope, sixteen pieces, each one from 33 x 20 x 26" (84 x 51 x 66 cm) to 39¹/₂ x 30 x 28" (100 x 76 x 71 cm)
Collection of the artist, Courtesy Marlborough Gallery, New York

Installation view, "Magdalena Abakanowicz: Retrospective Exhibition," Montreal Musée d'Art Contemporain, 1983

Page 48:
Head and *Seated Figures*, installation view, "Magdalena Abakanowicz," Zacheta Gallery, Warsaw, 1975

Page 50:
From the cycle *Seated Figures*. 1974

Page 51:
From the cycle *Seated Figures*. 1974

Pages 52–53:
Seated Figures. 1974–79
Eighteen burlap and resin figures, each one approx. 41 x 20 x 26" (104 x 51 x 66 cm); steel stands, each one 30 x 18¹/₄ x 8³/₄" (76 x 46 x 22 cm)
Collection Virginia Museum of Fine Arts, Richmond

Page 55:
Magdalena Abakanowicz working on a piece in the *Embryology* cycle

Pages 56–57:
Landscapes I–IV. 1976
Burlap and resin, four pieces, each one approx. 55¹/₄ x 22¹/₂" (140 x 57 cm)
Collection Pierre Magnenat, Lausanne

Page 58:
Trunks. 1981
Wood, fifteen pieces, each one diameter 7" x 7'4¹/₄" (18 cm x 224 cm)
Collection of the artist

Page 59:
Backs at the artist's studio, 1980

Pages 60–61:
Backs. 1976–80
Burlap and resin, eighty pieces, each one approx. 25³/₄ x 21³/₄ x 23³/₄" (65 x 55 x 60 cm)
Collection Museum of Modern Art, Pusan, South Korea

Backs on the bank of the Vistula River, Poland, 1981

Page 62:
From the cycle *Backs*. 1976–80

Page 63:
From the cycle *Backs*. 1976–80

Pages 64–65:
Backs, installation view, "Abakanowicz: 'Alterations,'" Musée d'Art Moderne de la Ville de Paris, 1982

Pages 66–67:
Backs, installation near Calgary, "Magdalena Abakanowicz," Glenbow Museum, Calgary, Canada, 1982

Page 68:
The Cage. 1981
Figure: burlap and resin, 28¹/₂ x 23¹/₄ x 27¹/₄" (72 x 59 x 69 cm); cage: wood, 5'5³/₄" x 3'10" x 5'1" (167 x 117 x 155 cm)
Collection Museum of Contemporary Art, Chicago

Pages 70–71:
From the cycle *Embryology*. 1978–81
Burlap, cotton gauze, hemp rope, nylon, and sisal

Approximately 680 pieces: from 1¾″ to 8′2½″
(4 cm to 250 cm) long
Collection of the artist, courtesy Marlborough Gallery, New York

Installation view, Polish Pavilion, Venice Biennale, 1980

Page 73 (top):
Embryology, installation view, "Magdalena Abakanowicz:
Retrospective Exhibition," Museum of Contemporary Art,
Chicago, 1982

Page 73 (center):
Embryology, installation view, Polish Pavilion, Venice
Biennale, 1980

Page 73 (bottom):
Embryology, installation view, "Abakanowicz:
'Alterations,'" Musée d'Art Moderne de la Ville de Paris,
1982

Pages 74–75:
Embryology, installation view, "Magdalena Abakanowicz:
Retrospective Exhibition," Frederick S. Wight Art Gallery
of the University of California, Los Angeles

Page 77:
Becalmed Beings. 1992–93
Bronze, forty figures, each one from 33 x 24 x 30″
(85 x 60 x 75 cm) to 37 x 26 x 33″ (94 x 65 x 85 cm)
Collection Hiroshima City Museum of Contemporary Art

Page 79:
Abakanowicz drawing

Page 80:
From the cycle *Faces Which Are Not Portraits.* 1983
Oil on linen, each 47¼ x 35½″ (120 x 90 cm)

Page 82 (left):
From the cycle *Bodies.* 1981
Charcoal on paper, 39½ x 27¾″ (100 x 70 cm)

Page 82 (right):
From the cycle *Faces.* 1985
Charcoal on paper, 39½ x 27¾″ (100 x 70 cm)

Page 83 (left):
From the cycle *Faces.* 1985
Charcoal on paper, 39½ x 27¾″ (100 x 70 cm)

Page 83 (right):
From the cycle *Bodies.* 1981
Charcoal on paper, 39½ x 27¾″ (100 x 70 cm)

Page 84:
Inside Dwelling Trunk 1. 1992
Gouache and charcoal on paper, 39½ x 27¾″ (100 x 70 cm)
Collection of the artist, courtesy Marlborough Gallery, New York

Page 85:
Inside Dwelling Trunk 2. 1992
Gouache and charcoal on paper, 39½ x 27¾″ (100 x 70 cm)
Collection of the artist, courtesy Marlborough Gallery, New York

Page 87:
Standing Figure and the Wheel. 1983
Figure: aluminum, 5′11″ x 23¾″ x 8″ (180 x 60 x 20 cm);
wheel: wood, 9′10″ x 19′ x 4′7¼″ (300 x 580 x 140 cm)
Installation at the DeCordova and Dana Museum and Park,
Lincoln, Massachusetts, 1983 (destroyed)

Page 88:
Abakanowicz carving the model for the figure in *Standing
Figure and the Wheel.* 1983

Pages 90–91:
Four Standing Figures and Four Wheels. 1983
Figures: Burlap, resin, and sand, each one 5′7″ x 23¾″ x 4″
(170 x 60 x 10 cm); wheels: wood, each one diameter
9′2¼″ x 31½″ (280 x 80 cm)

Installation, "International Open Air Sculpture Biennial,"
Middelheim, Belgium, 1983 (destroyed)

Pages 92–93:
Androgyn with Bricks. 1984
Aluminum and bricks (figure) and steel (vehicle),
6′6¾″ x 8′6½″ x 4′11″ (200 x 260 x 150 cm)
Collection Sculpture Garden, Fullerton University, California

Page 95:
Androgyn with Wheels. 1988
Bronze (figure) and steel (vehicle), 7′2¾″ x 4′11″ x 19′8¼″
(220 x 150 x 600 cm)
Collection National Museum of Contemporary Art, Seoul,
South Korea

Pages 96–97:
Androgyn I. 1985

Wood, burlap, and resin, 3'11¼" x 9'10¼" x 3'11¼"
(120 x 300 x 120 cm)
Collection Los Angeles County Museum of Art

Page 98:
From the cycle *Geminati*. 1990
Birch branches, gauze, burlap, and wire, six pieces,
each one approx. 39½" x 39½" x 9'2¼" (100 x 100 x 280 cm)
Collection of the artist, courtesy Marlborough Gallery,New York

Pages 99–100:
From the cycle *Pregnant*. 1981–82
Birch branches and wire, twenty-three pieces, each one from
35½" to 8'10½" (90 to 270 cm) long
Collection, The Museum of Modern Art, New York

Pages 102–3:
Katarsis. 1985
Bronze, thirty-three figures, each one approx.
8'10½" x 39½" x 19¾" (270 x 100 x 50 cm)
Collection of Giuliano Gori, Fattoria di Celle, Santomato
di Pistoia, Italy

Page 105:
Abakanowicz preparing the model for the interior surface of
one of the figures in *Katarsis*, Fonderia Venturi Arti, Bologna

Pages 106–9:
Katarsis. 1985

Page 111:
Self-portrait. 1976
Linen, life size
Collection of the artist

Pages 112–13:
From the cycle *Anonymous Portraits*. 1985–90
Cotton and wood, thirty pieces,
each one approx. 27¾ x 8 x 8" (70 x 20 x 20 cm)

Pages 114–15:
From the cycle *Incarnations*. 1985–89
Bronze, 110 pieces, each one approx.
27¾ x 9¼ x 10¾" (70 x 23 x 27 cm)

Page 117:
The Dog. 1986
5'4" x 9¾" x 8¼" (162 x 25 x 21 cm)
Collection B. A. H. Jordi, Switzerland

Pages 118–19:
From the cycle *Hoofed Mammal Heads*. 1989–91
Bronze, thirty-eight pieces, each one approx.
5'1" x 14" x 20" (155 x 35 x 50 cm)

Page 121:
Abakanowicz with *Negev*, Jerusalem, 1987

Pages 122–23:
Negev. 1987
Limestone, seven disks, each one approx. diameter
9'2¼" x 23½" (280 x 60 cm)
Collection Israel Museum, Jerusalem

Page 125:
Abakanowicz with assistants carving one of the stone disks
in *Negev*, Mitspe Ramon, Israel

Pages 126–27:
Negev. 1987

Page 129:
Detail of a figure in *Bronze Crowd*

Pages 130–31
Crowd I. 1986–87
Burlap and resin, fifty standing figures, each one approx.
5'7" (170 cm) high
Hess Collection, Napa, California, and Collection Pels-Leusden,
Berlin

Installation view, "Magdalena Abakanowicz," Mucsarnok Palace
of Exhibitions, Budapest, 1988

Pages 132–33:
Crowd III. 1989
Burlap and resin, fifty standing figures, each one approx.
5'7" x 21¾" x 12" (170 x 55 x 30 cm)
Private collection, Courtesy Marlborough Gallery, New York

Installation view, "Magdalena Abakanowicz," The Museum of
Modern Art, Shiga, Japan, 1991

Page 134:
Bronze Crowd. 1990–91
Bronze, thirty-six figures, each one approx. 6' x 21¾" x 14"
(183 x 55 x 35 cm)
Collection of the artist, courtesy Marlborough Gallery, New York

Installation, Walker Art Center, Minneapolis, 1992–93

Page 137:
Abakanowicz working on a piece for the cycle
War Games, 1987

Page 138:
Anasta, from the cycle *War Games*. 1989
Wood, steel, and iron, 5'3" x 19'8¼" x 6'10¾" (160 x 600 x 210 cm)
Private collection, courtesy Marlborough Gallery,
New York

Page 139:
Booby Trap, from the cycle *War Games*. 1987
Wood, steel, and iron, 31½" x 4'1¼" x 16'5" (80 x 125 x 500 cm)
Collection Museum Moderner Kunst, Vienna

Pages 140–41:
Bent Sword, from the cycle *War Games*. 1987–88
Wood, steel, iron, and burlap, 5'7" x 6'3" x 22'11¾"
(170 x 190 x 700 cm)
Collection Hamburger Kunsthalle

Pages 142–43:
Winged Trunk, from the cycle *War Games*. 1989
Wood, steel, iron, and burlap, 8'10½" x 3'3½" x 16'5"
(270 x 100 x 500 cm)
Collection of the artist, Courtesy Marlborough Gallery,
New York

Pages 144–45:
Zadra, from the cycle *War Games*. 1987
Wood, steel, iron, and burlap, 4'3¼" x 3'3½" x 27'4¾"
(130 x 100 x 835 cm)
Hess Collection, Napa, California

Pages 146–47:
Sroka, from cycle *War Games*. 1992
Wood, steel, and iron, 5'3" x 19'5" x 5'5" (160 x 592 x 165 cm)
Collection of the artist, Courtesy Marlborough Gallery,
New York

Pages 149–51:
Sarcophagi in Glass Houses, 1983–89
Wood, iron, and glass, four pieces,
7'5½" x 22'3¾" x 16'4¾" (230 x 680 x 500 cm),
8'2½" x 22'3¾" x 16'4¾" (250 x 680 x 500 cm),
7'2½" x 16'4¾" x 9'10" (220 x 500 x 300 cm),
7'2½" x 19'8¼" x 9'10" (220 x 600 x 300 cm)
Collection of the artist, Courtesy Marlborough Gallery, New York

Installation, "Magdalena Abakanowicz: Skulpturen 1967–1989,"

Städelsches Kunstinstitut und Städtische Galerie, Frankfurt
am Main, 1989

Page 153:
Head from *Space of Dragon*. 1988

Page 154
Working in the foundry on *Space of Dragon*, Seoul, 1988

Pages 156–57:
Space of Dragon. 1988
Bronze, ten heads, each one approx. 7'6¾" x 7'10½" x 13'1½"
(230 x 240 x 400 cm), area 148 x 56' (45 x 17 m)
Olympic Park, Seoul, South Korea

Pages 158–59:
Sagacious Heads. 1989
Bronze, four pieces, each one approx. 8'6½" x 8'10½" x 15'5"
(260 x 270 x 470 cm)
Private collection, United States

Page 160:
Sagacious Head. 1990
Bronze, 8'6½" x 8'10½" x 15'5" (260 x 270 x 470 cm)
Collection Nagoya City Museum of Modern Art, Japan

Page 162:
Abakanowicz working in the foundry on *Space of Nine Figures*,
Duisburg, Germany

Page 163:
Space of Nine Figures. 1990
Bronze, nine figures, each one approx. 8'6½" x 4'11" x 23¾"
(260 x 150 x 60 cm)
Collection Wilhelm-Lehmbruck-Museum, Duisburg, Germany

Page 165:
Sage X. 1988
Burlap, resin, and iron, 5'1" x 33½" x 23¾" (155 x 85 x 60 cm)
Private collection, United States

Pages 166–67:
Puellae. 1992–93
Bronze, thirty figures, each one approx. 40 to 43½"
(101 to 110 cm) high
Collection of the artist, courtesy Marlborough Gallery, New York

Page 168:
Flock. 1989–90
Burlap and resin, thirty-five standing figures,

each one approx. 4'6" x 13" x 11½" (137 x 33 x 29 cm)
Collection Des Moines Art Center, Iowa

Pages 170–71:
Infantes. 1992
Burlap and resin, thirty-three figures, each one approx.
4'7¼" x 11½' x 12" (140 x 29 x 30 cm)
Collection of the artist, courtesy Marlborough Gallery,
New York

Page 172:
Small Figure on Wheel, from the cycle *Circus.* 1992–93
Burlap, resin, and steel, approx. 8'10½" x 12" x 39½"
(270 x 30 x 100 cm)
Collection of the artist, courtesy Marlborough Gallery, New York

Page 173:
Loukas. 1989
Burlap, resin, and iron, 4'11" x 23¾" x 15¾" (150 x 60 x 40 cm)
Collection Richard Gray, Chicago

Page 176:
Model for *Bois de Nanterre—Vertical Green*
(renamed *Arboreal Architecture*). 1991

Page 177:
Model for *Bois de Nanterre—Vertical Green*
(renamed *Arboreal Architecture*). 1991

Page 178:
Model for *Bois de Nanterre—Vertical Green*
(renamed *Arboreal Architecture*). 1991

Page 179 (left):
Arboreal Architecture: Cross-section of a twenty-five-story

building showing structural system

Page 179 (center):
Arboreal Architecture: Elevation of a twenty-five-story building
showing systems for planting and irrigation

Page 179 (right):
Arboreal Architecture: Cross-section of a twenty-five-story
building showing interior spaces

Page 181:
Abakanowicz in the foundry working on models for *Hand-like
Trees*, Bologna, 1992

Page 184:
Arami, *Bason*, and *Cecora*, from the cycle *Hand-like Trees.* 1992–93
Bronze, five pieces
Collection Runnymede Sculpture Farm, California

Arami: 10'8½" x 4'9" x 3'10" (326 x 145 x 110 cm)
Bason: 10'8½" x 3'7½" x 35½" (326 x 110 x 90 cm)
Cecora: 11'5" x 5'9" x 3'1½" (348 x 175 x 95 cm)
Dlon: 11'9" x 4'9" x 35½" (358 x 145 x 90 cm)
Enama: 10'5¼" x 3'6½" x 33½" (318 x 108 x 85 cm)

Page 185:
Bason, *Cecora*, and *Dlon*, from the cycle *Hand-like Trees.*
1992–93

Page 187:
Arami, *Bason*, *Cecora*, and *Dlon*, from the cycle
Hand-like Trees. 1992–93

Page 188:
Cecora, from the cycle *Hand-like Trees.* 1992–93

One-Person Exhibitions

Note the following abbreviations:
B.W.A. = Biuro Wystaw Artystycznych (Exhibition Hall)
C.B.W.A. = Centralne Biuro Wystaw Artystycznych (Central Exhibition Hall)
Z.P.A.P. = Związek Polskich Artystów Plastyków (Polish Artists Union)

1960 Warsaw. Kordegarda. "Wystawa Prac Magdaleny Abakanowicz-Kosmowskiej." Exhibition catalogue.

1962 Paris. Galerie Dautzenberg. "Tapisseries, Magdalena Abakanowicz, Pologne." Exhibition catalogue.

1963 Warsaw. Galeria Sztuki Nowoczesnej. "Magdalena Abakanowicz, Gobelin." Exhibition catalogue.

1965 Warsaw. Galeria Zachęta, C.B.W.A. "Wystawa Gobelinów Magdaleny Abakanowicz." Exhibition catalogue.

1966 Zielona Góra, Poland. B.W.A. "Wystawa Gobelinów Magdaleny Abakanowicz." Exhibition catalogue.

1967 Lausanne. Galerie Alice Pauli. "Abakanowicz." Exhibition catalogue.

Oslo. Kunstindustrimuseet. "Magdalena Abakanowicz: Arbeider i Vev." Traveled in Norway to Stavanger Kunstforening; Trondhjems Kunstforening, Trondheim; and Vestlandske Kunstindustrimuseum, Bergen. Exhibition catalogue.

Warsaw. Galeria Współczesna–Krzywe Koło. "Magdalena Abakanowicz." Exhibition catalogue.

1968 Eindhoven, the Netherlands. Stedelijk van Abbemuseum. "Abakanowicz: 2- en 3-dimensionale weefsels." Traveled in the Netherlands to Frans Halsmuseum, Haarlem; Groninger Museum, Groningen; and Stedelijk Museum, Schiedam. Exhibition catalogue.

Zurich. Züricher Kunstgesellschaft, Helmhaus. "Abakanowicz: Eine Polnische Textilkünstlerin." Exhibition catalogue.

1969 Arnhem, the Netherlands. Stedelijk Museum. "Magdalena Abakanowicz."

Lausanne. Galerie Alice Pauli. "Abakanowicz, Jagoda Buic." Exhibition catalogue.

Mannheim, Germany. Kunsthalle Mannheim. "Magdalena Abakanowicz: Tapisserien und Räumliche Texturen." Exhibition catalogue.

1970 Södertälje, Sweden. Södertälje Konsthall. "Magdalena Abakanowicz/Textil Skulptur/Textile Environment." Exhibition catalogue.

Stockholm. Nationalmuseum. "Abakanowicz: en konfrontation." Exhibition catalogue.

1971 Kraków. Galeria Pryzmat, Z.P.A.P. "Magdalena Abakanowicz." Exhibition catalogue.

Lausanne. Galerie Alice Pauli. "Magdalena Abakanowicz." Exhibition catalogue.

Pasadena, California. Pasadena Art Museum. "The Fabric Forms of Magdalena Abakanowicz." Exhibition catalogue.

Warsaw. Galeria Współczesna. "Magdalena Abakanowicz." Exhibition catalogue.

1972 Aberdeen, Great Britain. Art Gallery. "Abakanowicz."

Düsseldorf, Germany. Kunstverein für die Rheinlande und Westfalen. "Magdalena Abakanowicz: Textile Strukturen und Konstruktionen, Environments." Exhibition catalogue.

1973 Bristol, Great Britain. Arnolfini Gallery. "Magdalena Abakanowicz, Rope Structures."

1974 Łódź, Poland. Muzeum Sztuki w Łodzi. "Doswiadczenia i Poszukiwania."

1975 Lausanne. Galerie Alice Pauli. "Abakanowicz: Structures organiques et formes humaines." Exhibition catalogue.

London. Whitechapel Art Gallery. "Magdalena Abakanowicz: Organic Structures and Human Forms." Exhibition catalogue.

Warsaw. Galeria Zacheta, C.B.W.A. "Magdalena Abakanowicz." Exhibition catalogue.

1976 Sydney, Art Gallery of New South Wales, and Melbourne, National Gallery of Victoria. "Magdalena Abakanowicz: Organic Structures and Soft Forms." Exhibition catalogue.

1977 Høvikodden, Norway. Sonja Henies og Niels Onstad Stiftelser, Kunstsenter. "Magdalena Abakanowicz: Organiske Strukturer/Organic Structures." Exhibition catalogue.

Lausanne. Galerie Alice Pauli. "Magdalena Abakanowicz." Exhibition catalogue.

Malmö Konsthall, Sweden. "Abakanowicz: Organic Structures." Exhibition catalogue.

1978 Bydgoszcz, Poland. Salon Sztuki Wspólczesnej, B.W.A. "Magdalena Abakanowicz." Exhibition catalogue.

Łódź, Poland. B.W.A. "Magdalena Abakanowicz: Tkanina." Exhibition catalogue.

1979 Lausanne. Galerie Alice Pauli. "Abakanowicz Retrospective." Exhibition catalogue.

1980 Venice. La Biennale di Venezia, Polish Pavilion. "Biennale di Venezia '80: Magdalena Abakanowicz, Polonia." Exhibition catalogue.

1981 Lausanne. Galerie Alice Pauli. "Abakanowicz." Exhibition catalogue.

1982 Calgary, Canada. Walter Phillips Gallery, The Banff Centre, and Glenbow-Alberta Institute. "Magdalena Abakanowicz."

Chicago. Museum of Contemporary Art. "Magdalena Abakanowicz." Traveled in the United States and Canada to Musée d'Art Contemporain, Montreal; 1983: DeCordova and Dana Museum and Park, Lincoln, Massachusets; Visual Arts Center of Alaska, Anchorage; 1984: Portland Art Museum, Oregon; Dallas Museum of Fine Arts, Texas; Frederick S. Wight Art Gallery of the University of California and Claremont Graduate School Galleries, Los Angeles; National Academy of Sciences, Washington D.C. Exhibition catalogue.

Paris. ARC, Musée d'Art Moderne de la Ville de Paris. "Abakanowicz: Altérations." Exhibition catalogue.

Paris. Galerie Jeanne Bucher. "Magdalena Abakanowicz: 21 Dessins au Fusain." Exhibition catalogue.

1983 Lausanne. Galerie Alice Pauli. "Abakanowicz: Peintures, Dessins, Sculptures du Cycle Syndrome." Exhibition catalogue.

1985 Lausanne. Galerie Alice Pauli. "Abakanowicz: du cycle au sujet de l'homme." Exhibition catalogue.

New York. Xavier Fourcade Inc. "Magdalena Abakanowicz: About Men—Sculpture 1974–1985." Exhibition catalogue.

1986 Lublin, Poland. Galeria Sztuki K.U.L. Lubelskiego. "Magdalena Abakanowicz." Exhibition catalogue.

Richmond. Virginia Museum of Fine Arts. "Magdalena Abakanowicz." Exhibition catalogue.

Washington, D.C. McIntosh/Drysdale Gallery. "Magdalena Abakanowicz: Sculpture, Drawings, Prints."

1987 Gorzów Wielkopolski, Poland. B.W.A. "Abakanowicz." Exhibition catalogue.

Hiroshima. Muku Gallery. "Abakanowicz."

Wasserburg, Germany. Rathaus und Galerie im Ganserhaus. "Abakanowicz." Exhibition catalogue.

1988 Budapest. Palace of Exhibitions Mucsarnok. "Magdalena Abakanowicz." Exhibition catalogue.

Rennes, France. ARTS moins 7, Musée des Beaux-Arts. "Les Sarcophages." Exhibition catalogue.

St. Louis, Missouri. Laumeier Sculpture Park.

Scottsdale, Arizona. Riva Yarres Gallery.

Zurich. Turske and Turske. "Magdalena Abakanowicz: Inkarnationen und War Games." Exhibition catalogue.

1989 Frankfurt am Main. Städelsches Kunstinstitut und Städtische Galerie. "Magdalena Abakanowicz: Skulpturen 1967–1989." Exhibition catalogue.

New York. Marlborough Gallery. "Magdalena Abakanowicz:

Recent Work." Exhibition catalogue.

1990 Arnhem, the Netherlands. Gemeentemuseum Arnhem. "Magdalena Abakanowicz." Exhibition catalogue.

Chicago. Richard Gray Gallery. "Magdalena Abakanowicz." Exhibition catalogue.

London. Marlborough Fine Art (London) Ltd. "Magdalena Abakanowicz." Exhibition catalogue.

Storrs, Connecticut. Atrium Gallery, University of Connecticut. "Magdalena Abakanowicz: Sculpture and Drawings."

West Berlin. Galerie Pels-Leusden. "Magdalena Abakanowicz: Skulpturen." Exhibition catalogue.

1991 Białystok, Poland. Galeria Sztuki Współczesnej. "Magdalena Abakanowicz."

Łódź, Poland. Muzeum Sztuki. "Magdalena Abakanowicz."

Tokyo, Japan. Marlborough Fine Art Ltd., Tokyo. "Magdalena Abakanowicz." Exhibition catalogue.

Tokyo. Sezon Museum of Art. "Magdalena Abakanowicz." Traveled in Japan to The Museum of Modern Art, Shiga;

Art Tower Mito; and Hiroshima City Museum of Contemporary Art. Exhibition catalogue.

Warsaw. Galeria Kordegarda. "Magdalena Abakanowicz—rzezba." Exhibition catalogue.

Wrocław, Poland. Muzeum Narodowe. "Magdalena Abakanowicz."

1992 Kansas City, Missouri. The Nelson-Atkins Museum of Art. "Magdalena Abakanowicz."

Minneapolis. Walker Art Center. Installation in Sculpture Garden.

New York. Marlborough Gallery. "Magdalena Abakanowicz. Arboreal Architecture. Bois de Nanterre—Vertical Green." Exhibition catalogue.

1993 Kraków. Pawilon Wystawowy B.W.A. "Magdalena Abakanowicz." Exhibition catalogue.

New York. The Institute for Contemporary Art, P. S. 1 Museum. "Magdalena Abakanowicz—War Games." Exhibition catalogue.

New York. Marlborough Gallery. "Magdalena Abakanowicz—Sculpture." Exhibition catalogue.

SELECTED GROUP EXHIBITIONS

1962 Lausanne. Musée Cantonal des Beaux-Arts. "1-éme Biennale Internationale de la Tapisserie." Note that Abakanowicz also participated in the following tapestry biennials in Lausanne: 2nd (1965), 3rd (1967), 4th (1969), 5th (1971), 6th (1973), 7th (1975), 8th (1977), 9th (1979), and 12th (1985). Exhibition catalogues.

1965 São Paulo, Brazil. "VIII Bienal de São Paolo." Exhibition catalogue.

1968 Venice. "XXXIV Biennale Internationale d'Arte Venezia." Exhibition catalogue.

1969 Amsterdam. Stedelijk Museum. "Perspektief in Textiel." Exhibition catalogue.

New York. The Museum of Modern Art. "Wall Hangings." Exhibition catalogue.

1972 Edinburgh. Richard Demarco Gallery. "Edinburgh International Festival: 'Atelier '72.'" Exhibition catalogue.

1973 Bordeaux, France. "Festival d'art, octobre à Bordeaux, 8 artistes dans la ville." Exhibition catalogue.

1974 Łódź, Poland. Muzeum Sztuki. "Doswiadczenia i Poszukiwania."

1976 Kyoto, Japan. National Museum of Modern Art. "Fiber Works Europe and Japan."

1978 Paris. Galerie Jeanne Bucher. "L'espace en Demeure: Louise Nevelson, Marie-Hélène Vieira da Silva, Magdalena Abakanowicz." Exhibition catalogue.

1979 São Paulo, Brazil. "XV Bienal de São Paolo." Exhibition catalogue.

Zurich. Kunsthaus Zurich. "Weich und Plastisch/Soft Art." Exhibition catalogue.

1980 Dublin. National Gallery of Ireland and University College School of Architecture. "ROSC '80: The Poetry of Vision." Exhibition catalogue.

Paris. Musée d'Art Moderne de la Ville de Paris. "Sculptures Polonaises Contemporaines."

1982 West Berlin. Nationalgalerie. Staatliche Museen-Preussicher Kulturbesitz. "Kunst wird Material." Exhibition catalogue.

1983 Antwerp. Openluchtmuseum voor Beeldhouwkunst Middelheim. "Biennale 17." Exhibition catalogue.

Helsinki. Museum of the Ateneum. "ART '83." Exhibition catalogue.

1984 New York. The Museum of Modern Art. "An International Survey of Recent Painting and Sculpture." Exhibition catalogue.

Vienna. Wiener Festwochen (Museum des 20 Jahrhunderts and Museum Moderner Kunst). "Orwell und die Gegenwart 1984." Exhibition catalogue.

1985 Nürnberg, Germany. Kunsthalle Nürnberg. "3 Internationale Triennale der Zeichnung. Bildhauerzeichnung Abakanowicz, Chillida, Serra, Tinguely." Exhibition catalogue.

1986 Hamburg. Hamburger Kunsthalle. "Eva und die Zukunft." Exhibition catalogue.

1987 Los Angeles. Los Angeles County Museum of Art. "The Avant-Garde in the Eighties."

Mountainville, New York. Storm King Art Center. "The Reemerging Figure."

Sydney. Art Gallery of New South Wales. "The Sixth Biennale of Sydney: Origins, Originality + Beyond." Exhibition catalogue.

1988 Seoul, South Korea. Olympic Sculpture Park. "Olympiad

of Art." Exhibition catalogue.

Vienna. Museum Moderner Kunst. "Expressiv." Traveled to Hirshhorn Museum and Sculpture Garden, Wasington D.C.

1990 Columbus, Ohio. Wexner Center for the Visual Arts. "New Works for New Spaces."

1991 Tokyo. Gallery Ueda Ginza. "Human Figures from Ancient to Modern."

1992 Rio de Janeiro. Museu Nacional de Belas Artes. ". . .

Reperti . . . : Environment Through the Eyes of 18 of the World's Major Artists." Exhibition catalogue.

Tokyo. TOM Gallery of Touch-Me-Art. "Mask: Face, Expression." Exhibition catalogue.

1993 Paris. Galerie Art 4 and Galerie de Esplanade. "Differents Natures–Visions de l'Art Contemporain." Exhibition catalogue.

Utsukushi-Ga-Hara, Japan. Utsukushi-Ga-Hara Open Air Museum. "Fujisankei Biennial International Exhibition for Contemporary Sculpture." Exhibition catalogue.

WORKS IN PUBLIC COLLECTIONS

Arkansas Art Center, Little Rock
Art Gallery of Western Australia, Perth
Art Institute of Chicago
Art Tower Mito, Contemporary Art Gallery, Japan
Australian National Gallery of Art, Canberra
Centralne Muzeum Włókienniectwa, Łódź, Poland
Centre Georges Pompidou, Paris
Centrum Sztuki Wspólczesnej, Warsaw
City of Elblag, Poland
David and Alfred Smart Gallery, University of Chicago
Davis Museum and Cultural Center, Wellesley, Massachusetts
Denver Art Museum, Colorado
Des Moines Art Center, Iowa
Detroit Institute of the Arts
Fonds Regional d'Art Contemporain Rhône-Alpes, Lyon, France
Frans Halsmuseum, Haarlem, The Netherlands
Fullerton State University Sculpture Garden, California
Hakone Open Air Museum, Japan
Hamburger Kunsthalle, Hamburg
Hiroshima City Museum of Contemporary Art
Hirshhorn Museum, Washington, D.C.
Israel Museum, Jerusalem
Kulturen Historiska Museet, Lund, Sweden
Kunsthalle Nürnberg, Germany
Kunstindustrimuseet, Oslo
Los Angeles County Museum
Malmö Museums, Sweden
Metropolitan Museum of Art, New York
Milwaukee Art Museum, Wisconsin
Musée Cantonal des Beaux-Arts, Lausanne
Musée des Beaux-Arts, La Chaux-de-Fonds, Switzerland
Museo de Arte Contemporáneo de Caracas, Venezuela
Museo de Arte Contemporáneo Internacional Rufino Tamayo, Mexico City
Museu de Arte Moderna de São Paulo, Brazil
Museum am Ostwall, Dortmund, Germany

Museum Bellerive, Zurich
Museum Moderner Kunst, Vienna
Museum of Contemporary Art, Chicago
Museum of Contemporary Crafts, New York
Museum of Modern Art, New York
Museum of Modern Art, Shiga, Japan
Museum of Modern Art Hung Kim and Lee, Pusan, South Korea
Muzeum Narodowe, Poznań, Poland
Muzeum Narodowe, Warsaw
Muzeum Narodowe, Wrocław, Poland
Muzeum Pomorza Srodkowego, Słupsk, Poland
Muzeum Sztuki, Łódź, Poland
Muzeum w Gnieznie, Gniezno, Poland
Nagoya City Art Museum, Japan
Národni Galeri, Prague
National Museum, Budapest
National Museum of Contemporary Art, Seoul
National Museum of Modern Art, Kyoto, Japan
Nationalmuseum, Stockholm
Portland Art Museum, Oregon
Power Institute of Fine Arts, University of Sydney, Australia
Provinciehuis, 's-Hertogenbosch, The Netherlands
Röhsska Konstslöjdmuseet, Göteborg, Sweden
Seoul Olympic Garden
Sezon Museum of Art, Tokyo
Södertuälje Kommun Kulturnamnden, Sweden
Sonja Henies og Niels Onstadts Stiftelser, Høvikodden, Norway
Städtische Kunsthalle Mannheim, Germany
Stedelijk Museum, Amsterdam
Tokushima Prefectural Museum, Japan
Toyama Prefectural Museum, Japan
University of Oslo, Norway
Virginia Museum of Fine Arts, Richmond
Walker Art Center, Minneapolis
Wilhelm-Lehmbruck-Museum, Duisburg, Germany

SELECTED BIBLIOGRAPHY

Entries are arranged by year. Exhibition catalogues are entered by city.

1956 A., K. "Pokłosie Ładowskiego Konkursu." *Stolica* (Warsaw), May 6, p. 4.

Dzikowski, Ryszard. "Konkurs ŁADU." *Przemysł Ludowy i Artystyczny* (Warsaw), pp. 65-68.

Warsaw. Galeria Zachęta. *XXX-lecie Spółdzielni Artystów Plastyków "ŁAD."* Exhibition catalogue.

1957 Warsaw. Galeria Zachęta. *Ogólnopolska Wystawa Architektury Wnetrz 1957.* Exhibition catalogue.

Warsaw. Z.P.A.P. *Wystawa Zespołu Młodych Plastyków.* Exhibition catalogue.

1958 Kraków. Z.P.A.P. *Ogólnopolski Salon Architektury Wnetrz.* Exhibition catalogue.

1959 Radom, Poland. B.W.A. *Ogólnopolska Wystawa Plastyki w Radomiu.* Exhibition catalogue.

Sopot, Poland. C.B.W.A. *Wystawa Młodej Plastyki.* Exhibition catalogue.

Wróblewska, Danuta. "Tkaniny Malowane Magdaleny Abakanowicz-Kosmowskiej." *Przegląd Kulturalny* (Warsaw), April 16, p. 8.

1960 Grabska, Stanislawa. "W Poszukiwaniu Rzeczy Pięknych," *Wież* (Warsaw), May, p. 96.

Guze, Joanna. "Ceramika i Tkanina." *Nowa Kultura* (Warsaw), April 24, p. 10.

Sempolinski, Jacek. "Wystawy i Problemy." *Przegląd Kulturalny* (Warsaw), April 28, p. 8.

Sopot, Poland. B.W.A. *Festiwal Sztuk Plastycznych.* Exhibition catalogue.

Warsaw. Kordegarda. *Wystawa Prac Magdaleny Abakanowicz-Kosmowskiej.* Exhibition catalogue.

Warsaw. Muzeum Narodowe w Warszawie. *Wystawa Mal-* *arstwa z Cyklu: Polskie Dzieło Plastyczne w XV-lecie PRL.* Exhibition catalogue.

1961 Warsaw. Dom Artysty Plastyka. *Wystawa Pracowni Doswiadczalnej Tkactwa Artystycznego.* Exhibition catalogue.

1962 Bøe, Alf. "Var Tids Billedtepper." *Bonytt* (Oslo), November-December, pp. 267-70.

Chevalier, Denys. "La Première Biennale de tapisserie contemporaine." *Aujourd'hui/Art et Architecture* (Paris), September, p. 64.

G[rand], P[aul]-M[arie]. "Abakanowicz." *Le Monde*, November 29, 1962, p. 13.

Kuenzi, André. "Laine et couleurs. Un sommet la Pologne." *Gazette de Lausanne*, June 16-17, p. 19.

Lausanne. Musée Cantonal des Beaux-Arts. *1-éme Biennale Internationale de la Tapisserie.* Exhibition catalogue.

Paris, Galerie Dautzenberg. *Tapisseries, Magdalena Abakanowicz, Pologne.* Text by Michel Tourlière. Exhibition catalogue.

U., R. M. "Magdalena Abakanowicz—Recherches de relief." *Arts* (Paris), November 30, 1962, p. 13.

1963 Huml, Irena. "Tkanina Monumentalna Magdaleny Abakanowicz." *Projekt* (Warsaw), July-August, pp. 16-21.

Kuenzi, André. "La Tapisserie de demain est née en Pologne." *Gazette de Lausanne*, April 20-21, 1963, p. 19.

Warsaw. Galeria Sztuki Nowoczesnej. *Magdalena Abakanowicz, Gobelin.* Text by Wiesław Borowski. Exhibition catalogue.

Warsaw. Galeria Sztuki, Z.P.A.P. *Doswiadczalna pracownia tkactwa: Wystawa Tkanin Artystycznych.* Exhibition catalogue.

Warsaw. *Wystawa Rzeźb i Tkanin Okregu Warszawskiego Z.P.A.P.* Exhibition catalogue.

1964 Baukloh, Friedhelm. "Wandteppiche für Morgen." *Echo der Zeit* (Dortmund), April 19.

Dortmund, Germany. Museum am Ostwall. *Moderne Polnische Tapisserie*. Text by Ryszard Stanisławski. Exhibition catalogue.

Kesselbach, F. "Polnische Webkunst." *Stuttgarter Zeitung*, June 17, p.19.

Reuther, Hanno. "Webkunst aus Warschau." *Frankfurter Rundschau*, February 18.

Warsaw. Galeria Zachęta. *Ogólnopolska Wystawa: Tkanina, Ceramika, Szkło*. Exhibition catalogue.

Wrocław, Poland. Z.P.A.P. and B.W.A. *Wystawa Tkaniny*. Exhibition catalogue.

1965 Eindhoven, the Netherlands. Stedelijk van Abbemuseum. *Poolse Wandtapijten*. Exhibition catalogue.

Jobé, Joseph, ed. *Great Tapestries: The Web of History from the 12th to the 20th Century*. Texts by Michel Florisonne, Adolf Hoffmeister, François Tabard, and Pierre Verlat. Lausanne: Edita S. A. Lausanne.

Kuenzi, André. "2e Biennale Internationale de la Tapisserie." *Gazette de Lausanne*, June 19-20, p.5.

Oslo. Kunstindustrimuseet. *Moderne Polsk Billedev 1965*. Exhibition catalogue.

"Outweaving the French." *Newsweek*, August 23, p.42.

Ptaszkowska, Hanna. "Gobeliny Magdaleny Abakanowicz." *Kultura* (Warsaw), April 11, p.9.

São Paulo, Brazil. *VIII Bienal de São Paulo*. Text for Poland by Ryszard Stanislawski. São Paulo, Brazil: Fundação Bienal de São Paulo. Exhibition catalogue.

São Paulo, Brazil. Fundação Bienal de São Paulo. *Pologne à la VIII Biennale de São Paulo, 1965*. Texts by Wieslaw Borowski and Ryszard Stanislawski. Exhibition catalogue.

Warsaw. Galeria Zacheta. *Wystawa Gobelinów Magdaleny Abakanowicz*. Text by Wieslaw Borowski. Exhibition catalogue.

Whittet, G. S. "The Dynamic of Brazil: The VIII Bienal of São Paulo." *Studio International*, October 1965, pp.136-43.

1966 Collison, Judith. "From Polish Looms of Today." *Fotorama*, September, p.8.

Groom, Susan. "Modern Polish Tapestries." *Arts Review* (London), September 3, p.402.

Łódź, Poland. Muzeum Sztuki. *Wystawa Malarstwa z Cyklu Polskie Dzieło Plastyczne w XXV-lecie PRL*. Exhibition catalogue.

London. Grabowski Gallery. *Tapestries of Tomorrow from Polish Looms of Today*. Text by Judith Collison. Exhibition catalogue.

Mullaly, Terence. "Tapestries of Today." *The Daily Telegraph* (London), October 1, p.13.

Overy, Paul. "The Art of Detachment." *The Listener* (London), September 29, p.459.

Russell, John. "Playing a Defensive Game." *The Sunday Times* (London), September 18, p.20.

Santa Barbara, California. Santa Barbara Museum of Art. *Contemporary European Tapestries: The Collection of Mr. and Mrs. J. L. Hurschler*. Texts by J. L. and Flora Hurschler and Thomas W. Leavitt. Exhibition catalogue.

Sopot, Poland. B.W.A. *Festiwal Sztuk Plastycznych: Nurty, Poszukiwania, Propozycje*. Exhibition catalogue.

Spencer, Charles S. "Polish Tapestries." *The New York Times International*, October 4, p.5.

Twarowska, Maria. "Sous le Voies de l'art moderne: Abakanowicz, Sadley, Gostomski." *Projekt* (Warsaw), January 1966, pp.29-32.

Williams, Sheldon. "Polish Tapestries." *New York Herald Tribune*, September 6, p.5.

Zielona Góra, Poland. B.W.A. *Wystawa Gobelinów Magdaleny Abakanowicz*. Text by Wiesław Rustecki. Exhibition catalogue.

1967 Bøe, Alf. "Magdalena Abakanowicz i Kunstindustrimuseet." *Dagbladet* (Oslo), September 23, p.6.

Elblag, Poland. *II-e Biennale Form Przestrzennych*. (Exhibition catalogue includes first and second biennials).

G., S. "Sculpture in Tapestry." *Sculpture International* (London), January-March, pp.13-17.

Kohler, Arnold. "La Tapisserie révolutionnaire." *Coopération* (Geneva), July 1, p.27.

Kuenzi, André. "Magdalena Abakanowicz." *La Gazette Littéraire* (Lausanne), July 15-16, p.25.

Lausanne. Galerie Alice Pauli. *Abakanowicz*. Text by André Kuenzi. Exhibition catalogue.

Lausanne. Musée Cantonal des Beaux-Arts. *3-éme Biennale Internationale de la Tapisserie*. Exhibition catalogue.

Monnier, Jacques. "Les Tapisseries d'Abakanowicz." *Tribune de Lausanne*, August 10, p. 4.

Oslo. Kunstindustrimuseet. *Magdalena Abakanowicz: Arbeider i Vev*. Text by Alf Bøe. Exhibition catalogue.

Remfeldt Av, Per. "Polsk Tappe Kunstner i Kunstforeningen." *Stavanger Aftenblad* (Norway), November 13.

Riis, Harald. "Polske Bildtepper i Kraft og Skjonnhet." *Rogalands Avis* (Stavanger, Norway), November 18.

Stopczyk, Stanislaw K. "Abakanowicz i Inni." *Kultura* (Warsaw), April 23, p. 9.

Vaughan, Nicole. "Abakanowicz Seeks Tapestry in 3 Dimensions." *Weekly Tribune* (Geneva), August 13, p. 13.

Warsaw. Galeria Współczesna. *Magdalena Abakanowicz*. Text by Janusz Bogucki. Exhibition catalogue.

1968 Billeter, Erika. "Am Webstuhl einer neuen Kunstform." *Neue Presse* (Coburg, Germany), August 10, 1968.

Eindhoven, the Netherlands. Stedelijk van Abbemuseum. *Abakanowicz: 2- en 3-dimensionale weefsels*. Text by André Kuenzi. Exhibition catalogue.

Huml, Irena. "Magdalena Abakanowicz Arbeider." *Kunsten Idag* (Oslo), January, pp. 30-41.

Venice. *Catalogo della XXXIV Esposizione Biennale Internationale d'Arte Venezia*. Exhibition catalogue.

Wróblewska, Danuta. "Abakanowicz—ou la tapisserie structurale." *Opus International* 6 (Paris), April, pp. 42-43.

Zurich. Züricher Kunstgesellschaft, Helmhaus. *Abakanowicz: Eine Polnische Textilkünstlerin*. Texts by F. A. Baumann and Erika Billeter. Exhibition catalogue.

1969 *Abakany*. Film directed by Jarosław Brzozowski. Łódź, Poland: Wytwórnia Filmów Oswiatowych.

Amsterdam. Stedelijk Museum. *Perspectief in Textiel*. Exhibition catalogue.

Billeter, Erika. "Die Revolution des Kunstgewerbes." *Ex Libris* (Zurich), January 1, pp. 16-18.

Billeter, Erika. "Les Sculptures en matériaux de tissage." *Projekt* (Warsaw), April, pp. 33-37.

Bourgeois, Louise. "The Fabric of Construction." *Craft Horizons*, March-April, pp. 30-34.

F., T. "Perspectief in Textiel." *Eindhovens Helmonds Dagblad* (The Netherlands), January 5.

Grand, Paul-Marie. "A la Biennale de Lausanne—Quand la Tapisserie conteste le mur—La Tapisserie sculpture." *Le Monde*, June 26, p. 17.

Jarry, Madeleine. *World Tapestry*. New York: G. P. Putnam's Sons.

Kuenzi, André. "Lausanne IVe Biennale de la Tapisserie—Une Précurseur de la nouvelle tapisserie: Magdalena Abakanowicz." *La Gazette Littéraire* (Lausanne), June 14-15, pp. 5-6.

Larsen, Jack Lenor. "The New Weaving." *Craft Horizons*, March-April, p. 22.

Lausanne. Galerie Alice Pauli. *Abakanowicz, Jagoda Buic*. Texts by Magdalena Abakanowicz and Jagoda Buic. Exhibition catalogue.

Lausanne. Musée Cantonal des Beaux-Arts. *4-ème Biennale Internationale de la Tapisserie*. Exhibition catalogue.

Mannheim, Germany. Kunsthalle Mannheim. *Magdalena Abakanowicz: Tapisserien und Räumliche Texturen*. Text by Heinz Fuchs. Exhibition catalogue.

New York. The Museum of Modern Art. *Wall Hangings*. Text by Mildred Constantine and Jack Lenor Larsen. Exhibition catalogue.

1970 Södertälje, Sweden. Södertälje Konsthall. *Magdalena Abakanowicz/Textil Skulptur/Textile Environment*. Texts by Magdalena Abakanowicz, Erika Billeter, Eje Högestätt, and Jack Lenor Larsen. Exhibition catalogue.

Stockholm. Nationalmuseum. *Abakanowicz: en konfrontation*. Texts by Magdalena Abakanowicz and Bengt Dahlbäck. Exhibition catalogue.

Sydhoff, Beate. "Abakanowicz." *Form* (Stockholm), March, p. 140.

Wróblewska, Danuta. "Magdalena Abakanowicz: She Confronts the Viewer with Textile as Object and Environment." *Craft Horizons*, October, pp. 18-23.

1971 Daval, Jean-Luc. "La 5-ème Biennale de la Tapisserie." *Art International* (Lugano), October 20, pp. 41-47.

Kraków. Galeria Pryzmat. *Magdalena Abakanowicz*. Exhibition catalogue.

Kuenzi, André. "Oeuvres murales et spatiales récentes de Magdalena Abakanowicz." *Gazette de Lausanne*, September 26.

Larsen, Jack Lenor. "Two Views of the Fifth Tapestry Biennale, 'the Greatest Show on Earth.'" *Craft Horizons*, October, pp. 23-30.

Lausanne. Galerie Alice Pauli. *Magdalena Abakanowicz.* Text by A[ndré] K[uenzi]. Exhibition catalogue.

Lausanne. Musée Cantonal des Beaux-Arts. *5-ème Biennale Internationale de la Tapisserie.* Exhibition catalogue.

Los Angeles. Frederick S. Wight Art Gallery of the University of California. *Deliberate Entanglements.* Texts by Bernard Kester and Frederick S. Wight. Exhibition catalogue.

"Magdalena Abakanowicz at the Kunsthalle in Södertälje." *Polish Art Review* (Warsaw), January, pp. 24-27.

Pasadena, California. Pasadena Art Museum. *The Fabric Forms of Magdalena Abakanowicz.* Texts by Magdalena Abakanowicz and Eudorah M. Moore. Exhibition catalogue.

1972 Allen, Jane. "Soft Sculpture: Unraveling the Weavers." *Chicago Tribune*, October 25.

Billeter, Erika. "Magdalena Abakanowicz—Besuch im Warschauer Atelier." *Artis—Das Aktuelle Kunstmagazine* (Constance), June 6, pp. 25-29.

Constantine, Mildred, and Larsen, Jack Lenor. *Beyond Craft: The Art Fabric.* New York: Van Nostrand Reinhold Company.

Denver, Colorado. Denver Art Museum. *Fibre Structures.* Text by Imelda DeGraw. Exhibition catalogue.

Düsseldorf, Germany. Kunstverein für die Rheinlande und Westfalen. *Magdalena Abakanowicz: Textile Strukturen und Konstruktionen, Environments.* Texts by Magdalena Abakanowicz, Karl-Heinz Hering, and Jasia Reichardt. Exhibition catalogue.

Edinburgh. Richard Demarco Gallery. *Edinburgh International Festival: "Atelier '72."* Exhibition catalogue.

Interwencja. Film directed and produced by Magdalena Abakanowicz.

Oliver, Cornelia. "Edinburgh Festival." *The Guardian* (Manchester), August 21, p. 8.

Oseka, Andrzej. "Abakany." *Tygodnik Kulturalny* (Warsaw), July 23.

Paris. Manufacture Nationale des Gobelins. *L'Art du tissu en Pologne 1962–1972.* Exhibition catalogue.

"Varlsberömd Polska Gör Textil Skulptur." *Lanstidningen* (Södertälje), January 20.

1973 Anderson, Donald James. "Soft Walls." *Chicago Tribune*, November 26.

Daval, Jean-Luc. "De la Tapisserie au 'Textile-Relief.'" *Art International* (Lugano), Summer, pp. 20-21, 96-97.

Kuenzi, André. "Lausanne, Tapisseries en relief et environnement de Magdalena Abakanowicz et Jagoda Buic." *24 Heures* (Lausanne), June 28, p. 53.

Kuenzi, André. *La Nouvelle Tapisserie.* Geneva: Les Editions de Bonvent.

Lausanne. Galerie Alice Pauli. *Magdalena Abakanowicz, Jagoda Buic: textielreliefs.* Texts by Magdalena Abakanowicz, Jagoda Buic, and Jean-Luc Daval. Exhibition catalogue.

Lausanne. Musée Cantonal des Beaux-Arts. *6-ème Biennale Internationale de la Tapisserie.* Exhibition catalogue.

"Ropes at the Arnolfini." *Crafts* (London), May-June.

1974 Abakanowicz, Magdalena, and Bumpus, Judith. "Rope Environments." *Art and Artists* (London), October, pp. 36-41.

Zurich. Kunsthaus Zurich. *Kunst in Polen.* Zurich, Kunsthaus, and Łódź, Muzeum Sztuki. Exhibition catalogue.

1975 *Abakanowicz* (film). Sydney: The Australian Film and Television School.

Abakanowicz in Australia (film). Sydney: Film Australia.

Daval, Jean-Luc, ed. "Magdalena Abakanowicz" in *Skira Annuel No.1.* Geneva: Editions d'Art Albert Skira.

Daval, Jean-Luc. "A Propos des 'Altérations' de Magdalena Abakanowicz." *Art International* (Lugano), October, pp. 30-34.

Gosling, Nigel. "Haunted by Ghosts." *The Observer* (London), June 15.

Grand, Paul-Marie. "La Tradition du changement. L'Apocalypse d'Abakanowicz et les tissus." *Le Monde*, June 3.

Lausanne. Galerie Alice Pauli. *Abakanowicz: Structures organiques et formes humaines.* Texts by Magdalena Abakanowicz and Jean-Luc Daval. Exhibition catalogue.

Lausanne. Musée Cantonal des Beaux-Arts. *7-ème Biennale Internationale de la Tapisserie*. Exhibition catalogue.

Lerrant, J. "Un Nouvel Art de l'espace et de l'environnement." *Le Progrès Lyon*, June 22.

Mexico City. Museo de Arte Moderno. "Polonia en México, Festival de las Formas/Pintura Contemporanea." Exhibition catalogue.

Moraes, Dom. "Tapestries for Our Time." *Horizon*, Spring, pp. 22-31.

Mullaly, Terence. "Tapestry Behind a Curtain." *The Daily Telegraph* (London), May 31.

Overy, Paul. "Very Flat, Sculpture." *The Times* (London), June 4, p. 12.

Reichardt, Jasia. "Individuality and Imagination." *Architectural Design*, August, pp. 507-8.

Tisdall, Caroline. "Environments." *The Guardian* (Manchester), July 2.

Vaizey, Marina. "Seductive Features." *The Sunday Times* (London), June 8, p. 35.

Warsaw. Galeria Zachęta. *Magdalena Abakanowicz*. Text by Andrzej Osęka. Warsaw: Ministerstwo Kultury i Sztuki. Exhibition catalogue.

West, Virginia. "The Tapestry Biennial at Lausanne." *Craft Horizons*, October, pp. 16-19.

1976 Artner, Alan G. "Weavings at an Exhibition—The Magic Shines Through." *Chicago Tribune*, May 9.

Daval, Jean-Luc, ed. "Magdalena Abakanowicz" in *Skira Annuel No. 2*. Geneva: Editions d'Art Albert Skira.

Emery, Irene. *Fiber Structures*. New York: Van Nostrand Reinhold, in conjunction with the Handweaver's Guild of America, Inc., and the Weavers' Guild of Pittsburgh.

Krausmann, Rudi. "Magdalena Abakanowicz." *Aspect* (Sydney), p. 1.

"Magdalena Abakanowicz." *Craft Australia* (Sydney), February-April, pp. 25-27.

Makin, Jeff. "Magdalena Abakanowicz." *Quadrant* (Sydney), May-June, pp. 50-55.

Sydney, Art Gallery of New South Wales, and Melbourne,

National Gallery of Victoria. *Magdalena Abakanowicz: Organic Structures and Soft Forms*. Text by Jasia Reichardt. Exhibition catalogue.

Warsaw. Galeria Zachęta. *Festiwal Sztuk Plastycznych*. Exhibition catalogue.

1977 Amaral, Cis. "What Is Tapestry." *Arts and Artists* (London), August.

Conroy, Sarah Booth. "Fiber Structures from Poland's New Wave of Textile Artists." *The Washington Post*, July 3.

Daval, Jean-Luc. "La Biennale de la Tapisserie de Lausanne, pour conserver son rôle international, doit changer." *Gazette de Lausanne*, June 12.

Eliasson, Karl Erik. "Abakaner Och Mycket Annat." *Hälsingborgs Dagblad* (Helsingborg, Sweden), March 4.

Høvikodden, Norway. Sonja Henies og Niels Onstad Stiftelser, Kunstsenter. *Magdalena Abakanowicz: Organiske Strukturer/Organic Structures*. Texts by Magdalena Abakanowicz, Ole Henrik Moe, and Jasia Reichardt. Exhibition catalogue.

Johnsrud, Even Hobbe. "Abakanowicz På Hovikodden." *Aftenposten* (Oslo), November 30.

Kato, Kuniko Lucy. "Fabric Art in Evolution." *Mainichi Daily News* (Japan), September 14.

Kraków. Galeria 100. *Życie*. Exhibition catalogue.

Kuenzi, André. "Huitième Biennale de la Tapisserie, Petit Coup d'oeil dans les coulisses." *24 Heures* (Lausanne), May 27.

Lausanne. Galerie Alice Pauli. *Magdalena Abakanowicz*. Text by Jasia Reichardt. Exhibition catalogue.

Lausanne. Musée Cantonal des Beaux-Arts. *8-ème Biennale Internationale de la Tapisserie*. Exhibition catalogue.

"Lausanne Tapestry Biennale." *Craft Horizons*, October, p. 22.

Lund, Bente Onsager. "Flaset Kunst Anmeldelse." *Arbeider Bladet* (Oslo), November 26.

Malmö Konsthall, Sweden. *Abakanowicz: Organic Structures*. Texts by Magdalena Abakanowicz, Eje Högestätt, and Jasia Reichardt. Exhibition catalogue.

Moser, Charlotte. "Weaving, Paper Fibers Gain Stature as Art Media." *Houston Chronicle*, October 8.

Oliveria, Mario de. "Na Fundação Gulbenkian 8 Bienal Internacional de Tapecaria de Lausana." *O Pais Lisboa*, December 30.

Romdahl, Margareta. "Biennal i Kris." *Svensk Form* 6-7.

Romdahl, Margareta. "Fiberkonst Kritik Mot Overbefolkningen." *Dagens Nyheter* (Stockholm), March 1.

Styczynski, Jan. *The Artist and His Work*. Warsaw: Interpress Publishers.

Waller, Irene. *Textile Sculptures*. New York: Taplinger Publishing Company.

Warnod, Jeanine. "Elle fait le mur." *Le Figaro*, June 10.

Washington, D.C. Smithsonian Institution Traveling Exhibition Service. *22 Polish Textile Artists*. Texts by Rita J. Adrosko and Krystyna Kondratiukowa. Washington, D.C.: Smithsonian Institution Press. Exhibition catalogue.

Wentinck, Charles. "Na de Revolutie Komen de Kleren." *Elseviers Magazine*, July 30, pp. 53-54.

1978 Bochum, Germany. Museum Bochum. *Imagination (Internationale Ausstellung Bildnerischer Poesie)*. Text by Milan Napravnik. Exhibition catalogue.

Bydgoszcz, Poland. Salon Sztuki Współczesnej, B.W.A. *Magdalena Abakanowicz*. Texts by Magdalena Abakanowicz, Kuniko Lucy Kato, and Jasia Reichardt. Exhibition catalogue.

Darkiewicz, Wiesław. "Chcę tworzyć obiekty do kontemplacji." *Za i Przeciw* (Warsaw), August 6, pp. 19-23.

Fiberworks: Symposium on Contemporary Textile Art. Berkeley: Fiberworks.

Huml, Irena. *Polska Sztuka Stosowana XX Wieku*. Warsaw: Wydawnictwa Artystyczne i Filmowe.

Łódź, Poland. B.W.A. *Magdalena Abakanowicz: Tkanina*. Text by Magdalena Abakanowicz. Exhibition catalogue.

Paris. Galerie Jeanne Bucher. *L'Espace en demeure: Louise Nevelson, Marie-Hélène Vieira da Silva, Magdalena Abakanowicz*. Text by Bernard Noël. Exhibition catalogue.

Park, Betty. "Fiberworks, Fireworks." *Crafts Horizons*, July, p. 3.

Warsaw. Galeria Zachęta. *Festiwal Sztuk Plastycznych*. Exhibition catalogue.

1979 Abakanowicz, Magdalena, and Huml, Irena. "Abakany—Nowy

Gatunek Sztuki Tkackiej; Wszystko Co Tworze Jest Dla Mnie Ważne." *Słowo Powszechne* (Warsaw), October 12, p. 3.

B., V. "Les Plus Grands Artistes textiles à Lausanne." *Femina Zürich*, July 11.

Billeter, Erika. "Lausanne Biennial: An Endangered Tradition." *American Craft*, October-November, pp. 20-25.

Copenhagen. Galerie Asbaek. *Modern Polish Art*. Exhibition catalogue.

Cruchet, B.-P. "Retrospective Magdalena Abakanowicz." *Gazette de Lausanne*, June 29, p. 2.

Daval, Jean Luc. "La Biennale de la Tapisserie devient un salon." *Journal de Genève*, June 23.

Daval, Jean-Luc, ed. "Magdalena Abakanowicz" in *Skira Annuel No. 5*. Geneva: Editions d'Art Albert Skira.

"G.-V. Herder Preise." *Wiener Zeitung* (Vienna), February 7.

Grand, Paul-Marie. "Un Biennale taille court." *Le Monde*, June 28.

Kato, Kuniko Lucy. "Magdalena Abakanowicz: Art is Eternity Made Tactile." *A Bi-Montly Review of Design* (Tokyo), March, pp. 35-70.

Kuenzi, André. "Magdalena Abakanowicz à la Galerie Pauli." *24 Heures* (Lausanne), July 5, p. 41.

Lausanne. Galerie Alice Pauli. *Abakanowicz Retrospective*. Texts by Magdalena Abakanowicz and Andrzej Oseka. Exhibition catalogue.

Lausanne. Musée Cantonal des Beaux-Arts. *9-ème Biennale Internationale de la Tapisserie*. Exhibition catalogue.

MacIntyre, Joyce. "The 9th Biennial of Tapestry, Lausanne." *Arts Review* (London), August 31.

Nowicka, Zofia. "Requiem Magdaleny Abakanowicz." *Gazeta Pomorska* (Bydgoszcz, Poland), January 16, p. 3.

Pulleyn, Rob. "9th International Biennial of Tapestry." *Fiberarts*, July-August, pp. 62-64.

São Paulo, Brazil. *XV Bienal São Paulo*. Exhibition catalogue.

Zurich. Kunsthaus Zurich. *Weich und Plastisch/Soft Art*. Texts by Magdalena Abakanowicz, Erika Billeter, Mildred Constantine, Richard Paul Lohse, Klaus Rinke, Willy Rotzler, and André Thomkins. Exhibition catalogue.

1980 "Biennale—Arte: Le Incognite." *Il Gazettino* (Venice), May 28.

Breerette, Genevieve. "A la Biennale de Venise: Pardessus le marche." *Le Monde*, June 15.

Buschbeck, Malte. "Was ersetzt uns den Fortschriftsglauben." *Suddeutsche Zeitung* (Munich), June 14-15, p.135.

Daval, Jean-Luc, ed. "Magdalena Abakanowicz" in *Skira Annuel No. 6*. Geneva: Editions d'Art Albert Skira.

Dublin. National Gallery of Ireland and University College School of Architecture. *ROSC '80: The Poetry of Vision*. Exhibition catalogue.

Gendel, Milton. "Ebb and Flood Tide in Venice." *Artnews*, September, pp.118-20.

Hermansdorfer, Mariusz. "Polska Sztuka w São Paulo." *Kultura* (Warsaw), January 13, p.11.

Jespersen, Gunnar. "Kunstents Opror Mod Terroren (Venezia)." *Berlingske Tidende* (Copenhagen), June 5.

Magnaguagno, Guido. "Weichgebilde: Zur Ausstellung 'Weich und Plastisch—Soft Art.'" *Du*, January-June, pp.70-72.

Malarcher, Patricia. "Crafts." *The New York Times*, November 23.

McGuire, Sr. Therese B. "Magdalena Abakanowicz—Polish Pavilion." *Artery* (William Patterson College, Wayne, New Jersey), November-December, pp.8-9.

Muller, Hans-Joachim. "Biennale Venedig 1980." *Das Kunstwerk*, Fall, pp.58-69.

Nemeczek, Alfred. "Biennale 1980 oder das Debut der Neuen Milden." *Art* (Hamburg), August.

Neray, Katalin. "A pluralismus evizede? 39 Velencei Biennale 1980." *Muveszet* (Budapest), October.

New York. Pratt Manhattan Center Gallery. *Contemporary Tapestry*. Exhibition catalogue.

Overy, Paul. "Dublin: ROSC '80." *Flash Art*, November, p.57.

Overy, Paul. "'ROSC '80'—A Melange of Modernism." *International Herald Tribune*, August 9-10, p.11.

Overy, Paul. "The Venice Biennale: More Baffling than Ever." *International Herald Tribune*, June 14-15, p.7.

Paris. Musée d'Art Moderne de la Ville de Paris. *Sculptures Polonaises Contemporaines*. Texts by Jean-Dominique Rey and Aleksander Wojciechowski. Exhibition catalogue.

Risatti, Howard. "Descending from Olympus. 1980 Venice Biennale: Art in the Seventies." *New Art Examiner*, December, pp.10-11.

Vaizey, Marina. "Dublin Opens the Window." *The Sunday Times* (London), August 3.

Vaizey, Marina. "This Way to the Eighties." *The Sunday Times* (London), June 8, p.39.

Venice. La Biennale di Venezia. *Biennale di Venezia '80: Magdalena Abakanowicz, Polonia*. Texts by Magdalena Abakanowicz and Aleksander Wojciechowski. Warsaw: Ministry of Culture and Arts of the People's Republic of Poland, Central Office of Art Exhibitions. Exhibition catalogue.

Venice. La Biennale di Venezia. *La Biennale di Venezia: Section of Visual Arts, General Catalogue 1980*. Exhibition catalogue.

Washington, D.C. Smithsonian Institution Traveling Exhibition Service. *The Art Fabric: Mainstream*. Texts by Mildred Constantine and Jack Lenor Larsen. New York: Van Nostrand Reinold Company. Exhibition catalogue.

1981 Abakanowicz, Magdalena. "Magdalena Abakanowicz." *Du-Die Kunstzeitschrift* (Zurich), January, pp.45-47.

Ballatore, Sandy. "The Art Fabric: Mainstream." *American Craft*, August-September, pp.34-39.

Hennessey, W. J. "Reflections on the 39th Venice Biennale." *Art Journal*, Spring, pp.69-72.

L'Art et les hommes. Magdalena Abakanowicz. Film directed by Jean-Marie Drot. Paris: Société Française de Production et de Création Audiovisuelles.

Lausanne. Galerie Alice Pauli. *Abakanowicz*. Text by Magdalena Abakanowicz. Exhibition catalogue.

Malmö, Sweden. Malmö Konsthall. *Malmoe*. Texts by Magdalena Abakanowicz, Eje Högestätt, and others. Exhibition catalogue.

Osęka, Andrzej. "Niepokojący Gwar." *Polska* (Warsaw), January, p.25.

Wolf, Rene. "Eine Polin packt ihre Mythen in Jute." *Art* (Hamburg), March.

1982 Abakanowicz, Magdalena, and Jacob, Mary Jane. "Magdalena Abakanowicz." *Tri-Quarterly* (Northwestern University, Evanston, Illinois), Winter, pp.166-69.

Arnim, Gabriele. "Plastik mit Eigenleben—Chicago: Abakanowicz." *Art—das Kunstmagazin* (Hamburg), November, pp.136-38.

Artner, Alan G. "The High-fiber World of a Pioneer Sculptor." *Chicago Tribune Art and Books*, October 31.

Baudrillard, Jean. "Ottage et terreur: L'echange impossible les illustrations de cet article. Le Peur. Traverses/25 Centre Georges Pompidou." *Revue du Centre de Création Industrielle* (Paris), June.

Bisset, Pierre. "Magdalena Abakanowicz à l'ARC." *L'Oeil* (Paris), January-February, p.107.

Bouisset, Maïten. "Abakanowicz: La Pénélope de Varsovie." *Le Matin*, January 14.

Breerette, Geneviève. "'Abakanowicz,' ARC, Musée d'Art Moderne de la Ville de Paris." *The Guardian* (Manchester), February 14.

Breerette, Geneviève. "Magdalena Abakanowicz à l'ARC: Altérations et métamorphoses." *Le Monde*, January 17-18, p.1.

Chicago. Museum of Contemporary Art. *Magdalena Abakanowicz*. Texts by John Hallmark Neff, Mary Jane Jacob, Jasia Reichardt, and Magdalena Abakanowicz. New York: Abbeville Press. Exhibition catalogue.

Daval, Jean-Luc. "Magdalena Abakanowicz. L'homme devient le sujet et le support de nouvelles formes." *Textile/Art* (Paris), January.

Faucher, Pierre. "Magdalena Abakanowicz." *Arts* (Paris), January 22.

Franca, Jose Augusto. "Duas exposikoes de Magdalena Abakanowicz (Paris)." *Colloquio Artes Fundation Calouste Gulbenkian No. 53* (Lisbon), pp.42-45, 81.

Gibson, Michael. "Art beyond Mere Explanation." *International Herald Tribune*, January 23-24, p.7.

Hahn, Otto. "Magdalena Abakanowicz à l'ARC." *L'Express* (Paris), January 29.

Hugonot, Marie-Christine. "Magdalena Abakanowicz." *Le Quotidien de Paris*, February 5.

Huser, France. "Images pour l'imagination deux polonais et deux techniques pour alimenter nos rêves." *Le Nouvel Observateur* (Paris), January 30.

Kassel, Germany. Kasseler Kunstverein. *Torso als Prinzip.*

Texts by Karl Oskar Blase, Gunter Schweikhart, Herbert Malecki, Rolf Wedewer, and Bernhard Schnackenburg. Exhibition catalogue.

Kato, Kuniko Lucy. "World of Abakanowicz Bearing Weight of Existence." *The Hokkaido Newspaper* (Japan), September 21.

Kinzie, Mary. "Haunting." *American Poetry Review*, September-October.

Le Bot, Marc. "Les Ecorchés de Magdalena Abakanowicz." *Quinzaine Littéraire* (Paris), February 15.

Leveque, Jean-Jacques. "Magdalena Abakanowicz à l'ARC." *Les Nouvelles Littéraires* (Paris), February 4.

Lyon, Christopher. "Polish Artist Shares Mysteries." *Sunday Sun-Times* (Chicago), November 14, p.10.

Milliot, Anne-Marie. "Le Mystère de la naissance. Le Mythogramme de Magdalena Abakanowicz." *Textile/Art* (Paris), January.

Moulin, Raoul-Jean. "Archéologie du corps. La Sculpture textile de Magdalena Abakanowicz." *L'Humanité* (Paris), January 26.

N., N. "Chicago Sees Two Decades of Abakanowicz Works." *The New York Times*, November 25.

N., N. "Interview with Abakanowicz from Poland." *The Hokkaido Newspaper* (Japan), October 22.

Paris. ARC, Musée d'Art Moderne de la Ville de Paris. *Abakanowicz: Altérations*. Texts by Magdalena Abakanowicz, Jean-Luc Daval, and Suzanne Pagé. Exhibition catalogue.

Paris. Galerie Jeanne Bucher. *Magdalena Abakanowicz: 21 Dessins au Fusain*. Text by Magdalena Abakanowicz. Exhibition catalogue.

Park, Betty. "Interview with Mary Jane Jacob." *Fiberarts*, November-December, pp.14-16.

Rose, Barbara. "Ugly? The Good, the Bad and the Ugly; Neo-Expressionism Challenges Abstract Art." *Vogue*, March, p.370.

Segard, Michel. "Magdalena Abakanowicz. Reflections on the Awesome Powers of Nature." *New Art Examiner* (Chicago), December, p.6.

Selz, Peter. "Knox and Bolts." *Art in America*, February, pp.107-15.

Thomas, M. "La Vérité du corps imaginaire." *Textile/Art* (Paris), January.

Tousley, Nancy. "Polish Artist Explores Humanity in Fibre Sculpture." *The Calgary Herald* (Canada), August 12.

Warnod, Jeanine. "Le Cri muet d'une artiste polonaise." *Le Figaro*, January 16, magazine section, p. 27.

West Berlin. Nationalgalerie. Staatliche Museen-Preussicher Kulturbesitz. *Kunst wird Material*. Exhibition catalogue.

1983 Allen, Jane Adams. "A Powerful Artistry in Mysterious Lines." *The Washington Times*, August 18, p. 3B.

Antwerp, Belgium. Openluchtmuseum voor Beeldhouwkunst Middelheim. *Biennale 17*. Exhibition catalogue.

Boulanger, Chantal. "Magdalena Abakanowicz: Musée d'Art Contemporain Montreal." *Vanguard* (Montreal), May, pp. 29-30.

Bromell, Nicolas. "Soft." *Boston Review*, December, pp. 3-4.

Daigneault, Gilles. "Expositions: Le Palmares de 83." *Le Devoir* (Montreal), December 31.

Daigneault, Gilles. "Magdalena Abakanowicz. Une lente plongée à l'interieur du corps." *Le Devoir* (Montreal), February, pp. 17-32.

Francblin, Catherine. "Magdalena Abakanowicz. Figures sans visage." *Art Press* (Paris), June, p. 34.

Gosselin, Claude. "Magdalena Abakanowicz: L'imaginaire et le monde organique." *Vie des Arts* (Montreal), March-April, pp. 43-45.

Helsinki. Ateneum. *ART '83*. Exhibition catalogue.

Heon, Michelle. "Magdalena Abakanowicz." *Cahiers* (Montreal), Winter, pp. 28-29.

Ingram, Jan. "Art Shows Disturbing Power." *Anchorage Daily News*, December 4, Sec. J, p. 3.

Jaameri, Hannele. "Sanoja Kuvista (Ars '83 Helsinki)." *Suomen Kuvalethi* (Finland), October 18, pp. 67-68.

Kato, Kuniko Lucy. "Magdalena Abakanowicz." *Textile Art* (Sapporo), May 17.

Krancowa, Felicja. "Magdalena Abakanowicz." *Kultura* (Paris), March, pp. 131-33.

Lausanne. Galerie Alice Pauli. *Abakanowicz: Peintures, Dessins, Sculptures du Cycle Syndrome*. Text by Magdalena Abakanowicz. Exhibition catalogue.

Lincoln, Massachusets. De Cordova Museum. *Magdalena Abakanowicz: A Retrospective Exhibition*. Exhibition catalogue.

Lowry, Shannon. "Polish Artist's Fiber Works Go Against Traditional Grain." *The Anchorage Times*, November 27, p. K1.

N., N. "17e Biennale de la Sculpture Contemporaine dans le Parc-musée Middelheim." *La Semaine d'Anvers* (Belgium), June 10, pp. 1-3.

Sabbath, Lawrence. "The Weaving of Magic. Polish Woman Creates Electricity with Jute, Hemp, Burlap." *The Gazette Montreal*, February 19.

Stabler, David. "Eerie Images from Poland." *Anchorage Daily News*, November 27, p. D1.

Toupin, Gilles. "Magdalena Abakanowicz: La grande dame de la tapisserie mondiale." *La Presse Montreal*, February 19, pp. 1, 25.

Washington, D.C. National Academy of Sciences. *Magdalena Abakanowicz: Charcoal Drawings*. Exhibition catalogue.

1984 Abakanowicz, Magdalena. "Magdalena Abakanowicz." *Sztuka* (Warsaw), pp. 2-5.

Artner, Alan G. "Museum of Contemporary Art Chicago. Magdalena Abakanowicz." In *World Art Trends 1983/84*, edited by Jean-Louis Pradel. New York: Harry N. Abrams.

Brewster, Ted. "Art of Anguish." *Life*, May, p. 116.

Chicago. The Museum of Contemporary Art. *Selections From the Permanent Collection*. Exhibition catalogue.

Dienes, Katherine. "The Visions of Abakanowicz." *Claremont Courier* (California), October 6, pp. 8, 9.

Drohojowska, Hunter. "Out of Shortages and Hardship, Polish Artist Weaves Works in Implication." *Los Angeles Herald Tribune*, September 25, p. C1.

Hickey, Dave. "Craft of Past Crossed Threshold as Art of Today." *Fort Worth Star Telegram*, July 25, p. C1.

Kohn, Michael; Ottmann, Klaus; and Levin, Kim. "MOMA: An International Survey." *Flash Art*, July.

Marvel, Bill. "Artist Weaves Haunting Yesterdays into Fabric Today." *Dallas Times Herald*, July 25, Sec. C.

Marvel, Bill. "The Fine Art of Fiber." *Dallas Times Herald*, June 21, p. E1.

Muchnic, Suzanne. "Weaving Her Way to a New Art Form." *Los Angeles Times*, November 22, part 6, p. 1.

New York. The Museum of Modern Art. *An International Survey of Recent Painting and Sculpture*. Text by Kynaston McShine. Exhibition catalogue.

Portland, Oregon. Portland Art Museum. *Magdalena Abakanowicz: A Retrospective Exhibition in Three Locations*. Text by Donald Jankins. Exhibition catalogue.

Rose, Barbara. "Magdalena Abakanowicz: The Force of Gravity." *Vogue*, July, p. 220.

Rosenberg, Scott K. "Artist Magdalena Abakanowicz: Imagination Unleashed." *Downtowner* (Portland), January 23, p. 1.

Schmitt, Anne. "An Abakanowicz Retrospective (Portland)." *Artweek*, February 18.

Stapen, Nancy. "Magdalena Abakanowicz: De Cordova and Dana Museum." *Artforum*, January, p. 80-81.

Vienna. Wiener Festwochen (Museum des 20 Jahrhunderts and Museum Moderner Kunst). *Orwell und die Gegenwart 1984*. Exhibition catalogue.

1985 Balmer, Monique. "Magdalena Abakanowicz à l'échelle de l'homme." *Femina* (Paris), August 13, pp. 42-43.

Dornberg, John. "One Way to Create Fine Art Is to Take the Greatest Risks." *Smithsonian*, April, pp. 110-19.

Drohojowska, Hunter. "Magical Mystery Tours." *Artnews*, September, pp. 108-13.

Dzikowska, Elżbieta. "Każda Wystawa Jest Inną Ceremonią." *Radar* (Warsaw), May 16, p. 1.

Dzikowska, Elżbieta. "L'Art est un mode d'existence." *Perspectives Polonaises*, Summer, pp. 55-60.

Glueck, Grace. "Art: Exhibit Introduces Abakanowicz of Poland." *The New York Times*, September 20, p. C20.

Gree, Barbara. "Artist Goes Deep Inside for Images." *The Richmond News Leader* (Virginia), November 25, p. 12.

Gurrieri, Francesco. "Bosco magico a Pistoia. Singolare opera d'arte dall'aperto." *Nazione Prato* (Italy), August 21, p. 3.

Lausanne. Galerie Alice Pauli. *Abakanowicz: du cycle au sujet de l'homme*. Text by Marc Le Bot. Exhibition catalogue.

Lausanne. Musée Cantonal des Beaux-Arts. *Sculpture Tex-tile—12-ème Biennale Internationale de la Tapisserie*. Text by Erika Billeter. Exhibition catalogue.

Levin, Kim. "Bodies Politic." *Village Voice* (New York), October 8, p. 91.

McLaughlin, John. "Magdalena Abakanowicz. The Human Condition in Fiber Forms." *International Sculpture* (Washington, D.C.), April-May, p. 6.

Meritt, Robert. "Faceless Figures Rooted in Ritual." *Richmond Times-Dispatch* (Virginia), December 1, p. L1.

N., N. "Kunst-Tempel in Fruchtbaren Katastrophenland." *Der Spiegel*, December 30, p. 114.

New York. Xavier Fourcade Inc. *Magdalena Abakanowicz: About Men—Sculpture 1974–1985*. Exhibition catalogue.

Nürnberg, Germany. Kunsthalle Nürnberg. *3 Internationale Triennale der Zeichnung. Bildhauerzeichnung Abakanowicz, Chillida, Serra, Tinguely*. Exhibition catalogue.

Richmond. Virginia Museum of Fine Arts. *Magdalena Abakanowicz*. Texts by Paul N. Perrot, Julia W. Boyd, and Margo A. Crutchfield. Exhibition catalogue.

Stavitsky, Gail. "Magdalena Abakanowicz." *Arts* (New York), December, p. 120.

Upshaw, Reagan. "Magdalena Abakanowicz at Fourcade." *Art in America*, December, p. 124.

Wan. "Bildhauerzeichnungen." *Nürnberg Zeitung*, October 10, p. 23.

1986 Abakanowicz, Magdalena; Le Bot, Marc; Daval, Jean-Luc; and Thomas, Michel. "Magdalena Abakanowicz." *Dossier d'Argile No. 2, Corps Degout*, Autumn, pp. 65-76.

Beck, James. "Magdalena Abakanowicz in the Apennines." *Arts* (New York), December, pp. 30.

Brockhaus Enzyklopadie, Vol. I. Mannheim, Germany: F.A. Brockhaus, 1986.

Daval, Jean-Luc. "Sculptures dans la ville—Et si la sculpture n'etait pas ce que l'on croit." *Art Press*, March, pp. 28-31.

Glueck, Grace. "Kritiker Umfrage." *Art das Kunstmagazin* (Hamburg), January, p. 7.

Hamburg. Hamburger Kunsthalle. *Eva und die Zukunft*. Exhibition catalogue.

Lameński, Lechosław. "Rzeżby Magdaleny Abakanowicz." *Tygodnik Powszechny* (Warsaw), July 13, p. 6.

Le Normand-Romain, Antoinette; Pingeot, Anne; Hohl, Reinhold; Rose, Barbara; Daval, Jean-Luc. *Historie d'un Art, La Sculpture, XIX et XX Siècle*. Geneva: Editions d'Art Albert Skira.

Lewis, Jo Ann. "The Shapes of Endurance." *The Washington Post*, November 1, p. G2.

Lublin, Poland. Galeria Sztuki Sceny Plastycznej Katolickiego Uniwersytetu Lubelskiego. *Magdalena Abakanowicz*. Exhibition catalogue.

Panecka, Agnieszka. "Ucieczka Trwa-Rozmowa z Magdaleną Abakanowicz." *Polityka* (Warsaw), November 22, pp. 1-8.

Rose, Barbara. "Art as Risky Business." *Vogue,* September, p. 642.

Sydney. Art Gallery of New South Wales. *The Sixth Biennale of Sydney: Origins, Originality + Beyond*. Exhibition catalogue.

Warsaw. Galeria Zachęta. *Życie Ludzkie—Los Ziemi*. Exhibition catalogue.

1987 Abakanowicz, Magdalena, and Restany, Pierre. *Katarsis*. Florence: Stamperia della Bezuga.

Beck, Ernest. "Zurich, Magdalena Abakanowicz, Turske and Turske." *Artnews*, October.

Brenson, Michael. "Images That Express Essential Human Emotions." *The New York Times*, July 26, p. 29.

Gorzów Wielkopolski, Poland. B.W.A. *Abakanowicz*. Text by Magdalena Abakanowicz. Exhibition catalogue.

Harati, Eliahu. "Negev at the Israel Museum." *Jerusalem Post*, September 19.

"Polish Artist Exhibits in Jerusalem." *The New York Times*, September 10, p. C 15.

Ronnen, Mair. "Rolling Stones." *The Jerusalem Post Magazine*, September 18.

Taranienko, Zbigniew. "Przestrzeń Zastygłych Ceremonii." *Literatura* (Warsaw), January, pp. 40-45.

Zimmer, William. "Summer Splendors Outside the City." *The New York Times*, August 14, p. C 1

1988 Allen, Jane Addams. "Huge Hurdles Lay in the Way of Central Europe Art Project." *The Washington Times*, February 24, Sec. E.

Augarde, Tony. "Polish up on Polish Art." *The Oxford Times*, September.

Borchgrave de, Helen. "Art at the Edge: Six Polish Artists." *Arts Review*, October 7.

Brenson, Michael. "Haunting Heads from Abakanowicz." *The New York Times*, July 1.

Budapest. Mucsarnok. *Magdalena Abakanowicz*. Texts by Katalin Neray, Mariusz Hermansdorfer, and Magdalena Abakanowicz. Exhibition catalogue.

Chayat, Sherry. "Sculpture Exhibit Opening at Everson Comments About Dehumanization." *Syracuse Herald-Journal* (New York), September 22.

Flam, Jack. "The Gallery: Joan Mitchell; East Europe's Avant-Garde." *The Wall Street Journal*, March 29.

Forgey, Benjamin. "Out of Isolation—The *Expressiv* Show." *The Washington Post*, February 18.

Getlein, Frank. "A Generation of Artists Grieves for the Human Condition." *Sculpture*, March-April, pp. 24-26.

Getlein, Frank. "Anxiety: Contemporary Art from Central Europe." *New Art Examiner*, January.

Grohotolsky, Ernst. "*Expressiv* in Wien Bilder auf Papierfahnen." *Die Welt*, January 6.

Guthrie, Derek. "Cracking the Ice." *New Art Examiner*, March, pp. 22-26.

Hammacher, A. M. *Modern Sculpture: Tradition and Innovation*. New York: Harry N. Abrams.

Kato, Kuniko Lucy. "Wriggling Material: Challenge to Historical Reality." *Monthly Ryusei* (Japan), July, pp. 20-22.

Kenessei, Andras. "Abakanowicz Budapesten." *Magyar Hirlap* (Budapest), February 6, p. 6.

Kimmelman, Michael. "Stark Visions of Life from the Lands of Kafka." *The New York Times*, March 27, p. C 4.

Lloyd, Jill. "Connoisseurs and Constructivists." *Art International*, Winter, pp. 76-78.

London. Marlborough Fine Art (London) Ltd. *A Selection

of Important Sculpture. Exhibition catalogue.

Madelin, Dinah. "Art at the Edge." *The Oxford Times*, September.

Oliver, Paul. "The Unpersons Speak." *Architects Journal*, October 12.

Plotkin, Lynn. "Traditional Concepts of Sculpture Unstuck by Burlaps, Fiber, Glue." *Ladue News* (Missouri), November 4.

Rennes, France. ARTS moins 7, Musée des Beaux-Arts. *Les Sarcophages*. Texts by Magdalena Abakanowicz, Martine Horel, and Christian Ryo. Exhibition catalogue.

Rose, Barbara. "The Art of Confrontation." *Vogue*, April, pp. 354-56.

Rozsa, Gyula. "Abakanowicz budapesti muve." *Nepszabadsag* (Budapest), February 13, p. 16.

Schwartz, Claudia. "Skulpturen im mystischen Kreislauf von Leben, Tod und Neubeginn. Eine Ausstellung der polnischen Kunstlerin Magdalena Abakanowicz." *Zurichbieter*, August 10.

Seoul, Korea. Olympic Sculpture Park. *Olympiad of Art*. Exhibition catalogue.

Sherman, Mary. "Artists Look Inward in *Expressiv* Exhibit." *Chicago Sun Times*, February 21, p. 9.

Syracuse, New York. Everson Museum of Art. *Figures: Form and Fiction*. Texts by R. A. Kuchta, Dominique Nahas, Tom Finkenpearl, Claudia Gould, and Linda Montano. Exhibition catalogue.

Szucs, Julianna P. "Protest gegen Systematisierung von Leben und Kunst." *Budapesten Rundschau* (Budapest), March 7, p. 9.

Torday, Aliz. "Abakanowicz a Mucsarnokban." *Vas Nepe* (Hungary), March 12.

Weder-Arlitt, Sabine. "Magdalena Abakanowicz Schicksalraume." *Turicum*, Winter, pp. 77-80.

Zurich. Turske and Turske. *Magdalena Abakanowicz: Inkarnationen*. Text by Magdalena Abakanowicz. Exhibition catalogue.

Zurich. Turske and Turske. *Magdalena Abakanowicz: War Games*. Text by Barbara Catoir. Exhibition catalogue.

1989 Auffermann, Verena. "Frankfurt: Magdalena Abakanowicz." *Die Zeit* (Hamburg), July 14.

Brenson, Michael. "Art: A Selective Guide." *The New York Times Magazine*, September 10, Part 2, p. 65.

Brenson, Michael. "Magdalena Abakanowicz, Jenny Lee and Shigeo Toya." *The New York Times*, April 14.

Brenson, Michael. "Review/Art. Magdalena Abakanowicz. Marlborough Gallery." *The New York Times*, November 3, p. C30.

Dittmar, Peter. "Magische Spiele aus der Kindheit mit Holzern, Wurzeln und Steinen." *Die Welt* (Hamburg), August 10.

Forman, Alice. "College's *Figure* Exhibits Add Up to Two Fine Shows." *Poughkeepsie Journal*, May 21.

Frankel, Claire. "A Vintage California Collection." *International Herald Tribune*, November 17.

Frankfurt am Main. Städelsches Kunstinstitut und Städtische Galerie. *Magdalena Abakanowicz: Skulpturen 1967–1989*. Texts by Klaus Gallwitz, Ursula Grzechca-Mohr, Magdalena Abakanowicz, and Mariusz Hermansdorfer. Exhibition catalogue.

Giessler, Ursula. "Die Sterbenden Stucke bewahren." *Wiesbadener Kurier*, August 3.

Hamburg. Hamburger Kunsthalle. Stiftung zur Forderung der Hamburgischen Kunstsammlungen. *Erwerberungen 89/90*. Exhibition catalogue.

Helmolt von, Christa. "Die undurchdringliche Mauer der Invasoren." *Frankfurter Allgemeine Zeitung*, August 21.

Herr, Marcianne. "Eastern European Art Since 1960." *Dialogue* (Columbus, Ohio), January-February, p. 34.

Hierholzer, Michael. "Die Welt, ein undusrichtiges Gewebe; Skulpturen der Polnische Kunstlerin Magdalena Abakanowicz im Frankfurter Stadel." *Frankfurter Allgemeine Zeitung*, June 29.

Huther, Christian. "Aggresion und Schutz. Magdalena Abakanowicz im Frankfurter Stadel." *Main Echo*, June 30.

Huther, Christian. "Gesichter auf Pfahlen." *Mannheimer Morgen*, July 24.

Krance, Felicja. "Spotkanie z Magdaleną Abakanowicz." *Przeglad Polski* (New York), October 26.

"Magdalena Abakanowicz at Marlborough." *New York City Tribune*, November 14.

"Magdalena Abakanowicz in Frankfurt: Polish Sculptor

Has Retrospective Exhibition in Germany." *The Journal of Art*, June-July, p. 30.

Mexico City. Museo de Arte Contemporáneo Internacional Rufino Tamayo. *Tapiz Polaco Contemporáneo de la coleccion del Museo Central del Tejido en Lodz*. Texts by Raquel Tibol and Halina Jurga. Exhibition catalogue.

N., N. "Magdalena Abakanowicz." *Frankfurter Allgemeine Zeitung*, June 21.

N., N. "Magdalena Abakanowicz." *Frankfurter Rundschau*, June 22.

N., N. "Magdalena Abakanowicz in Frankfurt." *The Journal of Art*, June-July, p. 30.

New York. Marlborough Gallery. *Magdalena Abakanowicz: Recent Work*. Text by Magdalena Abakanowicz. Exhibition catalogue.

New York. Marlborough Gallery. *Sculpture by Abakanowicz, Botero, Bruskin, Davies, Grooms, Mason*. Exhibition catalogue.

Raynor, Vivien. "Figurative Allusion: Anniversary Show of Robust Drawings." *The New York Times*, May 14, p. C32.

Russell, John. "Contemporary Museum in a Winery." *The New York Times*, June 13, p. C15.

Russell, John. "What's at the Modern? All New That Endured." *The New York Times*, August 25, p. C1.

Schlagheck, Irma. "Das Innere ist so wichtig wie die Hulle." *Art das Kunstmagazin* (Hamburg), pp. 78-87.

Schmidt, Doris. "Mit der Verganglichkeit leben." *Suddeutsche Zeitung*, July 19.

Suermann, Marie-Therese. "Magdalena Abakanowicz, Stadelsches Institut Francoforte." *Contemporanea*, July-August.

Zimmer, William. "The Aldrich Fills Its Rooms with Expansive Sculptures." *The New York Times*, November 12.

1990 Arnhem, the Netherlands. Gemeentemuseum Arnhem. *Magdalena Abakanowicz*. Text by Liesbeth Brandt Corstius. Exhibition catalogue.

Bass, Ruth. "Magdalena Abakanowicz." *Artnews*, February, p. 151.

Berlin. Galerie Pels-Leusden. *Magdalena Abakanowicz: Skulpturen*. Text by Magdalena Abakanowicz. Exhibition catalogue.

Chicago. Richard Gray Gallery. *Magdalena Abakanowicz*. Exhibition catalogue.

Crigler, Cynthia. "Images of Death in Contemporary Art." *Art Muscle*, March 15.

Dreishpoon, Douglas. "Monumental Intimacy. An Interview with Magdalena Abakanowicz." *Arts* (New York), December, pp. 45-49.

Gibson, Michael. "A Government of Souls. Tracing the Other History of Art." *Art International*, Summer.

Hammel, Lisa. "Seeing the World in Its Entirety." *The World and I*, February, pp. 204-9.

Hoyer, K. H. "Spuren der Gewalt. Werke von Magdalena Abakanowicz in Berlin." *Nordfriesische Nachrichten*, March 9.

Hughes, Robert. "An Interview." *Connaissance des Arts*, October.

K., F. "Neun Figuren-Raum wird im Kantpark aufgestellt." *Neue Ruhr Zeitung* (Duisburg), September 13.

Kachur, Lewis. "Overwhelming the Gallery Cube." *Art International*, Spring.

London. Marlborough Fine Art (London) Ltd. *Magdalena Abakanowicz*. Text by Magdalena Abakanowicz. Exhibition catalogue.

Meutgeert Door, Henk. "'Verbeelding laat zich niet door grenzen inperken.' Poolse Magdalena Abakanowicz exposeert in Gemeentemuseum Arnhem." *Arnhem*, September 21.

Miliszkiewicz, Janusz. "Sztuka dla Fanatyka. Rozmowa z Magdaleną Abakanowicz." *Przegląd Tygodniowy* (Warsaw), May 6.

N., N. "Magdalena Abakanowicz. Marlborough Fine Art." *Daily Telegraph* (London), November 15.

N., N. "Ubergabe der Abakanowicz—Skulpturen." *Westdeutsche Allgemeine Zeitung* (Duisburg), October 19.

Ohff, Heinz. "Die Unmittelbarkeit der Hand. Magdalena Abakanowicz in der Galerie Pels-Leusden." *Der Tagesspiegel* (Berlin), February 1.

Overy, Paul. "In Bronze and Burlap." *The Independent Magazine*, November 10.

Princenthal, Nancy. "Abakanowicz: Memories and Monuments." *Art in America*, March, pp. 179-83.

Russell, John. "A Connoisseur's Art." *House and Garden*, July, pp. 110-15.

T., R. "Skulptur Wachst den Hugel hinab." *Rheinische Post*, September 13.

Vaizey, Marina. "Drawing Out the Feminine." *The Sunday Times* (London), November 4.

1991 Artner, Alan G. "In the Doldrums." *Chicago Tribune*, October 6, p. 17.

Bellars, Peter. "Reflections of Solitude. Abakanowicz—Memory/Silence/Life." *Asahi Evening News* (Japan), April 13.

Białystok, Poland. Muzeum Okręgowe w Białymstoku—Galeria Sztuki Współczesnej. *Magdalena Abakanowicz*. Exhibition catalogue.

Bochwic, Teresa. "Swiat swój niosę na sobie jak plecak." *Spotkania* (Warsaw), June 19, pp. 34-36.

Chicago. Chicago Cultural Center. *Sowers of Myth. Magdalena Abakanowicz, Robert Irwin, Magdalena Jetelova, Attila Kovacs, Ursula von Rydingsvard*. Exhibition catalogue.

Ein Harod (kibbutz), Israel. Mishkan Le'omanut Museum of Art. *Contemporary Polish Fiber Art*. Exhibition catalogue.

Hamburg. Universität Hamburg und der Hoschschule für Bildende Kunste in cooperation with the Gertrud Bing Verein. *Das Andere Gedachtnis*. Texts by Marianne Schuler, Kirsten Herfel, Anne Hoormann, Irene Mees, Isabel Schulz, and Ellen Thormann. Exhibition catalogue.

Hiroshima, Japan. Muku Gallery. *Sisters—Ancestors—Family*. Exhibition catalogue.

Hobbs, Robert. [untitled]. *Sculpture*, March-April.

Howell, John. *Breakthroughs: Avant-Garde Artists in Europe and America, 1950–1990*. New York: Rizzoli International Publications in association with the Wexner Center for the Arts.

Kandel, Susan. "Empty Metaphors; Magdalena Abakanowicz." *Los Angeles Times*, October 17.

Kato, Kuniko Lucy. *Magdalena Abakanowicz. Tangible Eternity*. Tokyo: International Art Research, 1991.

N.,N. "Abakanowicz—Hiroshima City Museum of Contemporary Art." *Asahi Shimbun* (Hiroshima), September 14, p. 22.

Ratajczak, Mirosław. "Abakanowicz—dzieło otwarte."

Gazeta Wyborcza (Warsaw), June 10.

Sakai, Tadayasu. "Abakanowicz." *Rynsei* (Japan), July, pp. 16-21.

Sondej, Maria. "Abakanowicz: artysta to szaman." *Gazeta Wyborcza* (Warsaw), March 14.

Taranienko, Zbigniew. "Magia Magdaleny Abakanowicz." *Kultura i Życie* (Warsaw), *Dodatek Życia Warszawy*, April 20-21.

Tokyo. Marlborough Fine Art Ltd., Tokyo. *Magdalena Abakanowicz*. Exhibition catalogue.

Tokyo. Sezon Museum of Art. *Magdalena Abakanowicz*. Texts by Masao Kobayashi, Ioshiaki Inui, Magdalena Abakanowicz, and Mariusz Hermansdorfer. Tokyo: Asahi Shimbun. Exhibition catalogue.

Warsaw. Galeria Kordegarda. *Magdalena Abakanowicz—rzezba*. Texts by Danuta Wróblewska and Zbigniew Taranienko. Exhibition catalogue.

Wasserman, Tina. "Magdalena Abakanowicz. Richard Gray Gallery." *New Art Examiner*, March.

Wróblewska, Danuta. "Abakanowicz—routes of exhibitions." *Text-i-textil* (Łódź, Poland), December, p. 13.

1992 *Abakanowicz, Kuehn, Gojowczyk, Lutz*. Texts by Francis Greenburger, Richard Gray, George Segal, Werner Schmalenbach, and Agnes Gund. Francis J. Greenburger Foundation.

Amsterdam. Stedelijk Museum. *Het Beeld van de Eeuw*. Texts by Jan Hein Sassen, Bert Jansen, Robert Jan Muller, Marja Bloem, and Liesbeth Crommelin. Exhibition catalogue

Brenson, Michael. "Survivor Art." *The New York Times Magazine*, November 29, p. 46.

Daval, Jean-Luc. *Paris—La Défense. L'art contemporain et l'Axe historique. Magdalena Abakanowicz, Piotr Kowalski, Jean-Pierre Raynaud, Alan Sonfist*. Geneva: Editions d'Art Albert Skira and EPAD, Paris.

Kato, Kuniko Lucy. "Magdalena Abakanowicz: Group of Houses with Sculpture of Forest; Presenting Urban Construction for the 21st Century" (text in Japanese). *The Asahi Newspaper* (Japan), April 23.

King, Sarah. "Art Park Planned for La Défense." *Art in America*, February, p. 29.

New York. Marlborough Gallery. *Magdalena Abakanowicz. Arboreal Architecture. Bois de Nanterre—Vertical Green.* Texts by Barbara Rose, Magdalena Abakanowicz, and Andrzej Pinno. Exhibition catalogue.

Rio de Janeiro. Museu Nacional de Belas Artes. . . . *Reperti . . . : Environment Through the Eyes of 18 of the World's Major Artists.* Exhibition catalogue.

Rose, Barbara. "Abakanowicz Defends La Défense." *Art and Auction*, March, pp. 42-44.

Starewicz, Artur, and Pinno, Andrzej. "Drzewa-domy, czyli architektura arborealna." *Architektura i Biznes* (Kraków), December, pp. 1, 8, 9.

Tokyo. TOM Gallery of Touch-Me-Art. *Mask: Face, Expression.* Exhibition catalogue.

Watanabe, Hiroko. "Interview with Magdalena Abakanowicz" (text in Japanese). *Kawashima* (Japan), January, pp. 1-42.

1993 Castro, Jan Garden. "New York–Magdalena Abakanowicz." *The New Art Examiner,* October p. 47.

Cotter, Holland. "Magdalena Abakanowicz." *The New York Times*, May 14.

Heartney, Eleanor. "Figures of the Apocalypse." *Artnews,* September, p. 167.

Hughes, Robert. "Desde Polonia, con horror y esperanza." *Domingo, El Nuevo Dia,* June 27, pp. 12-15.

Hughes, Robert. "Dark Visions of Primal Myth." *Time*, June 7, p. 64.

K., C. "Wystawy—Abakanowicz." *Nowy Dziennik—Polish Daily News* (New York), May 12.

Kraków. Pawilon Wystawowy B.W.A. *Magdalena Abakanowicz. Prace z kolekcji Muzeum Narodowego we Wroclawiu i zbiorów wlasnych artystki.* Text by Magdalena Abakanowicz. Exhibition catalogue.

Larson, Kay. "The Trees of Life." *New York Magazine*, June 7, p. 59.

Małkowska, Monika. "Twory natury w stadach. Wydarzeniem kulturalnym jest wystawa prac Magdaleny Abakanowicz w krakowskim Biurze Wystaw Artystycznych." *Kultura i Życie* (Warsaw), *Dodatek Życia Warszawy*, January 28, p. 13.

Minneapolis. The Walker Art Center. *Magdalena Abakanowicz—An Installation in the Minneapolis Sculpture Garden Organized by the Walker Art Center, Minneapolis.* Texts by Martin Friedman and Magdalena Abakanowicz. Exhibition catalogue.

New York. Marlborough Gallery. *Magdalena Abakanowicz—Sculpture.* Text by Michael Brenson. Exhibition catalogue.

New York. The Institute for Contemporary Art, P. S. 1 Museum. *Magdalena Abakanowicz—War Games.* Texts by Michael Brenson, Alanna Heiss, and Magdalena Abakanowicz. Exhibition catalogue.

Padon Thomas. "Review." *Sculpture,* September-October, pp. 53, 54.

Plagens, Peter. "Sculpture to the Point: Magdalena Abakanowicz Shines in Two Shows." *Newsweek*, May 31, p. 58.

Rose, Barbara. "Magdalena Abakanowicz: Universal Statements That Bear Witness to Man's Barbarism." *Art & Antiques,* May, p. 84.

Sozanski, Edward J. "Expression of a Polish Sculptor in 2 Exhibits." *The Philadelphia Inquirer*, May 16, p. F1.

Taranienko, Zbigniew. "Drewno-tkanka ludzkiego ciała. Wystawa prac Magdaleny Abakanowicz w Krakowie." *Rzeczpospolita* (Warsaw), January 19.

Taranienko, Zbigniew. "Energia otoczenia. Z Magdalena Abakanowicz rozmawia Zbigniew Taranienko." *Rzeczpospolita* (Warsaw), *Dodatek Tygodniowy*, February 6-7.

Tarshis, Jerome. "An Artist Who Re-creates Her Environments." *The Christian Science Monitor,* March 15, pp. 16, 17.

Wallach, Amei. "Making a Pact with Desolation." *New York Newsday*, May 16, "Fan Fare," p. 21.

Wilkinson, Jeanne C. "Forms Unfold Where Tears are Forbidden." *Cover* (New York), Summer.

PHOTOGRAPH CREDITS

ACKNOWLEDGMENTS

This book has been a difficult project involving the help of many collaborators in France and Italy as well as in Poland and the United States. The patience and intelligence of our editor, Eric Himmel, was essential in organizing and coordinating material assembled over a period of years by the artist and the author.

Without the full participation of Magdalena Abakanowicz herself, this monograph, which traces the evolution of a body of work initiated when the Iron Curtain still divided Eastern Europe from the West, could not have been realized. The documentary and photographic archives maintained by the artist with the help of Artur Starewicz and Jan Kosmowski provided the basis for further research.

I was fortunate enough to see several different installations of many of the works illustrated. This lead to a greater understanding of the artist's primary concern with spatial relationships and the combination of related groups of sculptures from different series.

My special thanks to Frank Lloyd and Pierre Levai of the Marlborough Gallery for sharing my enthusiasm for Abakanowicz's work, and to Giuliano Gori, who spent many hours discussing the conception and execution of the group of monumental bronzes titled *Katarsis* at the Villa Celle.

Barbara Rose
Perugia, Italy, 1993